EARLY CHILDHO P9-BJF-427 A R T

EARLY CHILDHOOD A ' R ' T

Fourth Edition

Barbara Herberholz

California State University, Sacramento

Lee Hanson

Palo Alto Unified School District, Palo Alto, CA

Wm. C. Brown Publishers

Book Team

Editor Meredith M. Morgan Developmental Editor Cindy Kuhrasch Production Coordinator Carla D. Arnold

Wm. C. Brown Publishers

President G. Franklin Lewis Vice President, Publisher George Wm. Bergquist Vice President, Publisher Thomas E. Doran Vice President, Operations and Production Beverly Kolz National Sales Manager Virginia S. Moffat Advertising Manager Ann M. Knepper Marketing Manager Kathleen Nietzke Production Editorial Manager Colleen A. Yonda Production Editorial Manager Julie A. Kennedy Publishing Services Manager Karen J. Slaght Manager of Visuals and Design Faye M. Schilling

Cover design by Tara L. Bazata

Cover photo by Erika Stone

Copyright © 1974, 1979, 1985, 1990 by Wm. C. Brown Publishers. All rights reserved

Library of Congress Catalog Card Number: 89-60212

ISBN 0-697-05863-8

No part of this publication may be reproduced, stored in a retrieval system, or transmitted, in any form or by any means, electronic, mechanical, photocopying, recording, or otherwise, without the prior written permission of the publisher.

Printed in the United States of America by Wm. C. Brown Publishers, 2460 Kerper Boulevard, Dubuque, IA 52001

10 9 8 7 6 5 4 3

Contents

Color Gallery xiii
Foreword xv

Introduction: Education and the Twenty-First Century xvii

Art and Divergent Thinking xviii

Art and the Neglected Hemisphere xx

Two Ways of Knowing xx

The Creative Leap xx

Growing Awareness of the Need for Art Education xxii

Public Attitude toward Art Education xxiii

Barriers to Acceptance of Art Education xxiv

"Intertwined" or "Interdisciplinary" Art Education? xxv

Looking Forward xxv

For Discussion xxvi

Notes xxvi

1. Art Education in the Early Years 1

Developmental Needs of Young Children 2
Characteristics of Creative People 2
An Art Program of Quality 5
Aesthetic Perception: Seeing in a Special Way 7
Art Production: Making Art 9
Art Heritage: Art from Past Ages 12
Art Criticism and Aesthetic Judgment: Informed Responses 14
For Discussion 17
Notes 18

2. Avenues to Artistic Growth: Responding to Artworks 19

The Language of Art 20
Elements of Art 20
Color: In the Classroom 21
Value: In the Classroom 23
Line: In the Classroom 25
Shape/Form: In the Classroom 27
Texture: In the Classroom 29
Space: In the Classroom 31

Principles of Art 32 Balance 32 Emphasis 33 Proportion 34 Movement 35 Rhythm/Repetition/Pattern 36 Variety and Unity 37 Getting Acquainted with Artworks: Strategies for Art Criticism and Art Heritage 38 Description 38 Analysis 39 Interpretation 39 Judgment 40 A Model for Art Criticism/Art Heritage 40 Description 40 Analysis 41 Interpretation 41 Judgment 41 Motivational Strategies for Eliciting Student Responses to Artworks 41 For Discussion 43 3. Reaching Out: Accessing Artworks Museums and Galleries 44 Artmobiles 45 Art-in-a-Trunk 45 Contacts with Artists in School and Community Folk Art: An Ethnic and Multicultural Emphasis Thematic Presentations: Portfolios 52 "Artists Paint People Doing Things": A Sample Lesson for a Thematic Portfolio 54 Thematic Questions 56 Classroom Gallery of Art: Postcard Reproductions 56 Art Games 58 "Artcentration" "Art Squares" "Art Words" "Arty-Knows" 59 "Bag of Textures" 60 "Circle-in-a-Picture" "Color: Tint and Shade Cards" "Match-It" 60 "Matching Halves" "Match the Paintings" 61 "Multi-Game Cards" 61 Game 1: "Museum" Game 2: "Old Master" Game 3: "Paintbrush" "Perceptual Recall" 62 "Postcard Puzzles" "See, Touch, and Tell" 62 "Secret Guessing" 63 "Tactile Dominoes" "Tell about It" 64

"Three-Dimensional Jigsaw Puzzles" 64
"Touch and Guess" 64
"Visual Perception Game" 64
"Verbal/Visual Match-It" 66
For Discussion 66
Notes 66

4. Artistic Development in the Early Years 67

General Developmental Characteristics 67 The Scribbler 68 Irregular Scribbling Controlled Scribbling 70 Symbolic Scribbling 70 Communicating with the Scribbler 71 The Schema Emerges 73 Circles and Simple Configurations Responding to Early Drawings Topics for Drawing 76 Schematic and Spatial Concepts Symbols Emerge 78 Exaggeration as an Expressive Quality Characteristics of the Schematic Years Chart: Achievement Expectations, Completion of Grade 3 For Discussion 84 Notes 84

5. Identifying Talent and Special Needs 85

Identifying the Artistically Talented 85 Challenging the Exceptionally Talented 87 91 The Creative Environment for Exceptional Talent Exceptional Opportunities for Exceptional Talent 92 Gifted and Talented? Students with Special Needs 94 95 Appropriate Art Activities for Special Education Using a Toy 96 Using Themes 97 Preshaped Paper 99 Chance Manipulation Process Rather Than Product Adaptive Tools and Aids Museum Visits for the Disabled Child 101 Abilities of the Handicapped Child 102 For Discussion 103 Notes 103

6. Art Production: Motivating and Evaluating 104

Innate Awareness 104
Providing Options 106
Photographic Materials for Visual Information 106
Actual Objects As a Motivational Strategy 109
Thematic Groups of Artworks 110
"Take 5!" 113
Evoking Images with Words 114

7.

8.

"Acting It Out" Motivations 115 Fantasy and Humor for Motivation 116 Evaluating Student Development in Art Production 116 Process and Product: Reviewing and Reflecting 118 Process 118 Product 119 For Discussion 119 Notes 120
The Teacher as Motivator and Facilitator 121
The Teacher: A Key Person 121 Teacher Contact with Parents 122 Time for Art: Regular and Frequent 123 Art Materials: Suitable, Safe, and Varied 124 Space: The Classroom as Studio and Gallery 126 Art Learning Stations 128 Art Learning Station Activities 129 String Starters 130 Crayon Melter 130 Warming Tray 130 Catalog Clips 132 Instructional Materials for Art Learning Stations 132 For Discussion 132 Notes 133
Drawing and Painting 134
Drawing: External Thinking 134 Exploring Images 136 When Children Draw 138 When Children Paint 140 At Easels 140 Tabletop Painting 141 Size, Design, Color in Painting Experiences 142 Painting Skills to Be Expected of Young Children 144 Crayons and Oil Pastels 146
Resist Techniques 148
Wax Resist 148 Paint Resist 148 Batik 149 Paste Batik 150 Drawn Batik 152 Simplified Batik 152
Glue-It-On Drawings 153
Clothing and Faces 153
Yarn 153
Seeds 153 Flags 153
Murals 156
Tall, Wide, Round, and Square Formats 156
Tall Paper 157
Long, Wide Paper 157
Round Paper 158
Square Paper 160

Drawing with Glue 160
Sand Drawings 160
Painting with Melted Crayons 162
Crayon Melter 162
Warming Trays 162
Peepface Figures 164
Colored Chalk 164
Starch Dip for Chalk 164
White Tempera Dip for Chalk 166
Themes for Drawing and Painting 167
Assignment Interpretations 168
For Discussion 169

9. Tearing, Cutting, and Pasting 170

Why and How to Tear 170 Torn-Paper People 171 Cutting and Pasting 171 Collage Pictures 174 Zigzag Books 175 Corrugated Paper Crowns Paper Medals for Heroes/Heroines 178 Pass-It-On Pictures 178 Crayon Rubbings 179 Tissue-Paper Collages 180 181 Cut-Paper Assembled Murals Paper Sculpture 184 185 Fold-Over, Stand-Up Animals Bird Masks 185 Cylinder Sculpture 185 Hidden Homes 186 Homes in Caves 186 Homes in Tree Trunks 186 For Discussion 187

10. Printmaking 188

Potato Prints 190 Felt Prints 191 Clay Prints 192 Insulation Tape Prints 192 Scratchfoam Prints 193 Carbon-Paper Prints 193 Card Prints 194 Printing with Cardboard Strips 196 Eraser Prints 196 Gadget Prints and Paper Shapes 196 Monoprints 197 Transfer Print 197 Carbon-Paper Print 198 Tempera Print 198 For Discussion 198

11. Modeling, Shaping, and Constructing 199

A Child's Three-Dimensional World 200 Constructing with Clay 201 Recipes for Additional Modeling Media 206 Salt Ceramic 208 Baker's Clay 208 Beads and Pendants 208 Salt-Sculpture Figures 211 Baker's Clay Murals 211 Edible Art 214 Bread Sculpture 214 Candy Clay 217 Edible Jewelry 218 Fruit and Vegetable Assemblage Puppets and Other Edibles 220 Wadded Paper Creatures 221 Boxy Constructions 221 Cardboard Stabiles 224 Miniature Houses and Buildings 226 Wood Scraps and Glue 227 Masks and Mask Making 228 Found-Object Masks 229 Sack Masks 230 Stocking Masks 231 Paper Masks 231 For Discussion 232

12. Puppet People 233

Paper Puppets 233 Flat-Stick Puppets 233 Lollipop Puppets 234 Paper-Plate Puppets 234 Folded-Paper Puppets 234 Fold-Over Puppets 235 M-Fold Puppets 236 Cootie-Catcher Puppets 236 Stuffed Paper-Bag Puppets 236 Sock Puppets 237 Box Puppets 238 Finger Puppets 238 Stick Puppets 239 Tongue-Depressor Puppets 239 Salt Ceramic on a Stick 240 Puppet Situations 241 For Discussion 242

13. Fabric and Fiber 243

Banners and Flags 243
Stuffed Stuff 247
Fabric Crayons 250
Stitchery—Basic Beginnings 250
Weaving 253
Paper Weaving 253
Advanced Paper Weaving 254
Weaving on Cardboard Looms 254
Soda-Straw Weaving 256
Wood Frame Looms 256
Rug Pictures 258
For Discussion 262
Notes 262

14. Celebrations 263

Familiar Ideas with a New Twist
Backgrounds and Origins 264
Festivals and Parades 265
The Coming of Spring 265
Mini-Celebrations 267
Celebrating with Gifts 268
Creative Gifts 268
Calendars 270
Bookmarks 272
Weed and Candle Holders 272
Plastic Plates 273
Decorating Paper for Gift Wraps
Making Paper for Greeting Cards
For Discussion 277

Resources for Art Education 279 Glossary 281 Index 289 East Warmer

Ameder Market

Color Gallery

1.	The color wheel	
2.	Mary Cassatt	The Bath
3.	Marc Chagall	Green Violinist
4.	Constance Marie Charpentier	Mlle. Charlotte du Val d'Ognes
5.	Edgar Degas	The Millinery Shop
6.	André Derain	London Bridge
7.	Lyonel Feininger	Zirchow VII
8.	Vasily Kandinsky	Painting No. 198
9.	Paul Klee	Rolling Landscape
10.	Franz Marc	Yellow Cow
11.	Henri Matisse	The Wild Poppies
12.	Joan Miró	Prades, the Village
13.	Amedeo Modigliani	Head of a Woman
14.	Piet Mondrian	Composition
15.	Henry Moore	Reclining Figure
16.	(unknown)	Empress Theodora and Retinue
17.	Pablo Picasso	Family of Saltimbanques
18.	Pablo Picasso	Still Life
19.	Georges Seurat	Sunday Afternoon on the Island of La Grande Jatte
20.	Jan van Eyck	The Marriage of Giovanni(?) Arnolfini and Giovanna Cenami(?)
21.	Vincent van Gogh	The Bedroom at Arles
22.	Jan Vermeer	The Girl with a Red Hat
23.	Andy Warhol	A Set of Six Self-Portraits

and the second s

ne de la companya de Autoria de la companya del companya de la companya de la companya del companya de la companya del la companya del la companya de la companya de la companya de la companya de la companya del la companya d

Foreword

This fourth edition of Early Childhood Art brings a fresh perspective and new insights to the subjects of art education and aesthetic learning for the young child. Building on solid foundations of earlier works, authors Barbara Herberholz and Lee Hanson enrich this publication with sagacious analyses of current trends in comprehensive arts education. They give examples of exemplary art projects across the nation and solid strategies for implementing instructional frameworks for art learning. They advocate a significant place in the curriculum for art at all grade levels and for all students.

Important additions have been made in this latest edition of the Herberholz/ Hanson classic text for preschool and elementary teachers and teachers-to-be. For the first time, the authors have provided, at the end of every chapter, a short list of questions titled "For Discussion." These guidelines for analyzing and internalizing the text will lead readers to actively consider the philosophy, methods and content of the material in a context of reality. The questions direct the reader to imagine and develop ways in which one will actually put to use, in the classroom, the material presented in each chapter.

This edition adds, also, a unique "Color Gallery" section. Full-color reproductions of famous masterpieces of art are presented as a reference for parts of the text that deal with Avenues to Artistic Growth: Responding to Art Works, Reaching Out: Accessing Art Works, and Art Production: Motivating and Evaluating. The Color Wheel is located in the "Color Gallery" section as well, giving the reader ready access to the essential visual reference for dealing with the teaching of color relationships.

The book is organized in a logical and practical manner. Research on aesthetic education in the early years is followed by a philosophical base for educating children in art as a separate discipline, and as an avenue to other learning. Explicit examples define four components of art in early childhood: (1) aesthetic perception, (2) creative expression, (3) aesthetic judgment and valuing of art, and (4) art heritage. Photographs and illustrations of children's art animate the text in every section, and each chapter abounds with down-to-earth methods for connecting the child's natural growth and development with appropriate learning experiences.

A blueprint is offered here for the art education of children from preschool through third grade, a critical span of time for the establishment of the youngster's aesthetic beginnings. The art tasks described are planned to elicit creative solutions and informed aesthetic responses through heightened awareness of how to see, feel and know about art. The artistic sequences outlined serve as a detailed map, a workable plot plan for the development of children's art skills, aesthetic perception, original expression and learning attitudes. Adults in charge of children's art education will find in these pages well-tested methods allowing for individual art expression in a variety of media. The making of art has a firm conceptual basis here, and the reader will find research-backed approaches to high quality aesthetic experiences, a background for study of art heritage and an emphasis on children's original thinking in art production.

Expanded chapters have been developed covering ways to analyze works of art (Chapters 2 and 3), and identifying talent and special needs (Chapter 5). The outlined strategy of having young children view thematic groupings of art reproductions is effective with all groups. Excellent guidance for use of this technique is found in the "For Discussion" questions coupled with the "Color Gallery" reference pages. The special needs of children who reveal developmental characteristics in their art products either earlier or later than would be expected, are addressed with authority. Of great value is the commentary on challenging the exceptionally talented, and the section on appropriate art activities for special education.

The authors relate recent developments in discipline-based art education and arts in general education, and provide a substantial rationale for art as basic in any balanced program of education. Aesthetic education attends to the refinement of all of the senses and is basic to all learning. Art as a first language for all children—a visual language rich in symbolism and metaphor, and uniquely non-verbal—is a vital part of the growth of the intellect and the development of intelligence. Recent research supports the role of art in the total educational process, as well as in the fostering of reading and language development. Across the country there is a long overdue shift away from methods of teaching art in which the end product is predetermined by the adult who dictates step-by-step copying and use of patterns and prepared outlines, to methods that stress visual problem-solving. The art production chapters assure that children will have diversified and repeated experiences in all areas-both two and three dimensional, individually and in group situations. Children are encouraged to hazard guesses, test their ideas and enjoy the delights of discovery. While designed to foster specific cognitive and expressive skills, these tasks appeal to the child's natural curiosities and desire to explore, experiment, and communicate ideas in a beautiful visual way.

Throughout the text, multi-cultural crafts are related to the materials and to the expression of young children. In this edition, the interrelationship of culture and crafts with folk art is emphasized. Design craftmanship is rooted in the artistic heritage of peoples, and reflects the direct and honest expression of their everyday life. Folk art is, in fact, akin to child art in which materials and subject matter are often similar. A chapter on Celebrations turns the focus away from the holiday stereotypes that have haunted America's schoolrooms for so long, and toward original and unique art expression closer to historical backgrounds and the cultural origins of holidays. Techniques and materials appropriate to the early years are incorporated. Ranging from making paper and creating brightly-colored prints, to designing story-book puppets, creating group wall hangings with crayon on fabric, weaving, stitchery, designing gifts and participating in multi-arts celebrations, projects in this revised edition will aid the classroom teacher in exploring a number of art activities in depth and in skill-learning sequences.

To see the world through the eyes of children is, perhaps, one of the greatest rewards for the adult in charge of structuring and facilitating the child's artistic encounters. This book urges teachers to experience again, with the children under their direction, the delight of visual discovery, ideation, aesthetic involvement and emotional response to the world of art. This ongoing, never-ending, very human process of self-awareness and fulfillment in creative expression renews us and keeps us all "young in art."

Audrey A. Welch Art Consultant, Gifted/Talented Education Glendale Unified Schools Glendale, California

Introduction: Education and the Twenty-First Century

To the child of the twenty-first century, who needs to be: flexible, self-disciplined, self-reliant, creative, imaginative, self-confident, perceptive, self-motivated, adaptable, responsible, and appreciative.

Dedication from Visual and Performing Arts Framework for California Public Schools (K-12)

Whole generations of children have participated in classroom science experiments in growing bean plants. There is a sense of wonder in watching the seeds trapped between a damp blotter and the glass sides of a jar: The seed pushes forth a nodule that grows and unfurls a pair of tiny leaves, and soon the stalk thrusts toward light in a tremendous burst of energy. Almost overnight, the common bean has developed and grown into a plant. Few advances of humankind in all the laboratories and factories of the world will ever match this tiny miracle that so intrigues the small child in all of us.

Teachers often experience the same sense of wonder as they watch the growth and development of young children. As the persona, mind, and uniquely creative energy of each individual grow and burst forth, this, too, seems a miracle. Those who have the task of nurturing and caring for young learners often are in awe at the potential and gifts of each student.

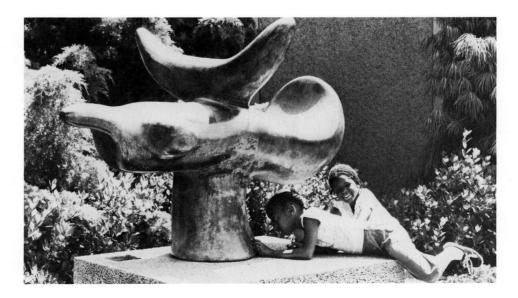

Students check to see the artist's name on this work by Miró in the Sculpture Garden of the San Diego Museum of Art.

How to *channel* and *challenge* the unique combination of abilities in individual learners is a tremendous responsibility—more so in the next century than perhaps at any other time. This is clearly evident from looking at the last fifty years and the fifty years preceding it—the decades in which our parents, grandparents, and great-grandparents were being educated.

There have been enormous technological advances over the past century—the first automobiles, sewing machines, and electric kitchen appliances; the invention of radio and television; the first satellites and the landing of men on the moon—advances that could only have been predicted in science fiction. In the past hundred years, we have passed through the Industrial Revolution and are well into the Computer Revolution. Physicists predict even more wonders as the enormous potential of super conductors is harnessed. Knowledge and technology are expanding at ever-increasing rates. Teachers and parents are deeply concerned about preparing the child of today for the challenge of the future. Much of what was learned in schools fifty years ago now seems outdated. How, then, can we expect to educate young learners for the unknown decades of the twenty-first century?

Art and Divergent Thinking

Other than creative writing and art, few places in the curriculum of elementary schools require or even encourage creative problem solving. A great deal of learning in the early years concentrates on convergent thinking skills—knowing the one right answer—to compute answers in arithmetic, to recite in reading, or to develop basic skills in penmanship. Although all of these skills are necessary, the acquisition of them does little to nurture a love of learning or to assure success in the unknown century to come. Only through a multifaceted education program that develops divergent as well as convergent thinking—that encourages intuitive as well as rational thought processes—can today's young learner begin to be prepared to cope with the rapidly changing aspects of a technologically oriented world.

For fifteen years, the "Learning to Read through the Arts Project" in New York City has designed and implemented curriculum in the arts for students who are performing below grade level in reading and/or mathematics. The program is an outgrowth of a pilot initiated at the Guggenheim Museum and blends language and the arts to stimulate learning. Year after year, nationally named tests indicate that the majority of the participating students demonstrate a dramatic increase in reading scores at each grade level.

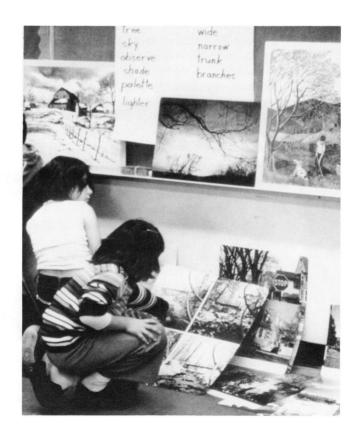

The importance of developing imagination and divergent thought processes is substantiated in the fairly recent but now familiar research on brain hemisphericity. Neuropsychiatrists conducting research on bicameral brain functions have introduced the possibility that the arts are intrinsic in mental development. Neurologists have known for some time that the left hemisphere of the brain controls movements on the body's right side, while the right hemisphere controls movements on the left. Recently, however, researchers have found indications that the hemispheres are specialized in other ways and may be the cause of behavioral and learning differences.¹

The two major modes of brain hemisphere function were first described by psychobiologist Roger W. Sperry in pioneering work that was honored by a Nobel Prize for Medicine in 1981. Sperry and his associate Joseph Bogen have continued their research at the California Institute of Technology, studying electroencephalograms of normal people while the individuals are thinking verbally and spatially. Bogen concludes that information processing is quite different in each of the two hemispheres. A series of subtle and ingenious tests revealed that each hemisphere, in a sense, perceives reality in its own way, that is, has parallel ways of knowing:

Left Hemisphere	Right Hemisphere
Intellect	Intuition
Convergent	Divergent
Digital	Analogic
Secondary	Primary
Concrete	Abstract
Directed	Free
Propositional	Imaginative
Analytic	Relational
Lineal	Nonlineal
Rational	Intuitive
Sequential	Multiple
Analytic	Holistic
Objective	Subjective
Successive	Simultaneous ²

Robert E. Ornstein, another scientist involved in right brain/left brain research, reports that these experiments at Cal Tech have reaffirmed that the brain *does* have specialized thought processes. He states that, if a person does a verbal task, for example, the alpha rhythm in his or her left hemisphere often increases. Increased alpha production is a sign of decreased information processing; the brain appears to reduce the operation of the side not in use.³ Ornstein is quick to point out that activities of the right and left hemispheres are not exclusive of one another; rather, each is a specialist in its functions.

If research in brain hemisphericity continues to substantiate some of the early theories, educators may have to investigate the implied insights into the learning/teaching process. The left hemisphere, which is the major controller of speech, reading, and writing, is dominant for most people and is also the hemisphere toward which education has traditionally been directed. Many educators claim that the right hemisphere has been neglected in the schools. Marilyn Winzenz, a noted educator, has stated that, by ignoring creative, intuitive, visual, spatial aspects of the brain, those valuable thought processes may stagnate.⁴

Art and the Neglected Hemisphere

Since art is largely a right-brain activity in the theory of hemisphericity, many advocates of educational programs with balanced left-brain/right-brain activities would place a greater emphasis on art than it is currently given in schools. Betty Edwards, author of *Drawing on the Right Side of the Brain*, has been doing research using art to unlock right-brain potential. Edwards used a pre- and post-test model with four treatment groups in a study designed to investigate whether an individual's realistic drawing capability is facilitated by instructional methods that tend to suppress symbolic and analytic perceptions of visual images (the left-hemisphere mode of processing) and facilitate relational, visuospatial perceptions (the right-hemisphere mode). The hypothesis predicted that the relational instructions would elicit more realistic drawing. Drawings were scored by five art teachers, and the results of the analysis indicated significantly increased accuracy of perception and ability to draw realistically. Edwards states that the results of the study may also imply that training in art might be used as a means of teaching students to improve their perceptual skills and to utilize more fully their right-hemisphere capabilities.⁵

Two Ways of Knowing

Research has provided the educational field with substantial evidence that alternating modes of thinking during the school day can provide a definite stimulus in the learning environment. When the two hemispheres or two ways of knowing cooperate and are not in conflict, the person has a better balance in his or her life activities. To live successfully in our constantly changing world, the child needs to establish early patterns of synthesizing the knowledge logically stored by the left brain into new solutions and relationships with the intuitive, gap-jumping, innovative thinking of the right hemisphere. Schools must provide a climate in which both sides of the brain are cherished and nourished. Some learning calls for logical, analytical thinking. However, computers and data banks can hold more information than one mind ever could, and it is here that the ability to think creatively and with feeling will be crucial in the child's future.

The flexibility necessary to think imaginatively about an idea or combination of ideas is largely a function of the intuitive, synthesizing right hemisphere. The analytical linear thinking of the left hemisphere is needed in the subsequent development of a project to a solution. Coping with difficulties that appear while solving a problem usually requires a return to the freewheeling flexibility of the right hemisphere, while the final evaluation is largely a left-hemisphere function.

Carl Sagan of Cornell University also subscribes to the idea of stimulating both sides of the brain to full potential. To Sagan, the process of genius involves a dominance of neither side of the brain, but rather a vision, or intuition, emanating from the right brain, which is then confirmed by the logical left brain and expressed in language or mathematical symbols. Sagan postulates that no work of artistic or scientific genius has ever emanated first from the left brain, but that it has always been a vision of the right brain first, and then collaborated and proved logically by the left brain.⁶

The Creative Leap

Creative thinking requires an unconscious switching from one side of the brain to the other. A child whose education has only equipped him or her to reiterate and reuse information lives less than a whole life. Arthur Koestler in *The Act of Creation* documents statements of geniuses who testify as to the origins of their creative breakthroughs. Finstein, Coleridge, Faraday, Wiener, and others received their initial ideas

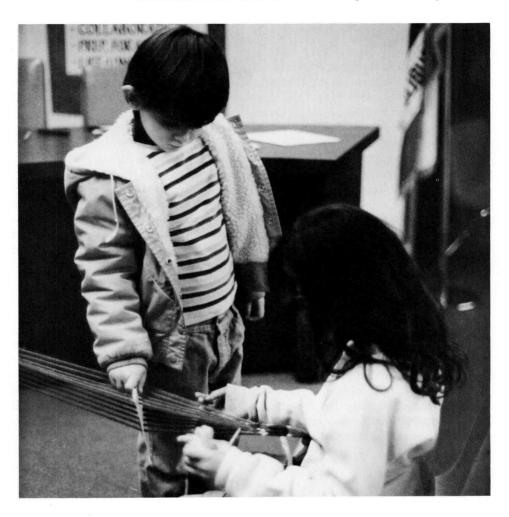

In gathering information for the report *Toward Civilization*, the National Endowment for the Arts first answered the question, "What is basic arts education?" It was decided that first and foremost, basic arts education would provide *all* students with knowledge of, and skills in, the arts.

not from logic but from kinesthetic or visual imagery. Intuitive leaps were described by all of them, leaps that followed immersion in the logical, factual background of problems. This sudden insight, springing forth as intuition from the subconscious, was subsequently worked upon by the left hemisphere to verify it.

Both logic and metaphor, analytic and holistic thinking, must work together, synergically, for true creativity. Art has a great deal to do with the kind of thinking associated with the right hemisphere; therefore, all children need opportunities to experience all of the arts as well as science, math, and language if they are to develop their full potential. Art places rich emphasis on visual imagery, touching the child's feelings and emotions, providing impetus for fluency, flexibility, uniqueness, and originality. Hence, art, with its striving for synthesis, closure, and cohesiveness, should play a vital part in developing both hemispheres of the brain, providing that balance that is imperative not only for survival but for abundant living.

Creative thinking involves both of the highly complex modes of knowing. Through art activities, children are given the opportunity to use creative and intuitive approaches to solving problems. In school programs that are becoming increasingly oriented toward test scores related to science and the three Rs, art can provide balance for the development of both halves of the brain.

Growing Awareness of the Need for Art Education

National concern for the arts was evidenced in 1977 when a twenty-five-member panel, chaired by David Rockefeller, Jr., issued a 330-page report containing ninety-nine recommendations for improving the condition of art education. This landmark study, entitled *Coming to Our Senses*, addressed government, teachers, art specialists, school administrators, and parents. The report called for the schools to make creative work in the arts available for all students. It also recommended that in-service and academic programs be revised to provide teachers, art specialists, and administrators with experience in a variety of arts and an understanding of their correlation to each other and to other disciplines.

The panel made the assertion that American education exaggerates the importance of words for transmitting information. Torrents of information are sent and received through our senses, and we use these senses to interpret and convey complexities of daily life. The report affirms, therefore, that all of our sensory languages need to be developed, as well as verbal and written language, if words are to fulfill the deeper function and deliver both vivid and subtle messages.

The panel supported "basic education" but maintained that the arts are basic to individual development since, more than any other subject, they awaken all the senses—the learning pores. The panel's report endorsed a curriculum that proposes a concept of literacy that goes beyond word skills alone, that maintains the arts as basic to education.8

In the decade that followed *Coming to Our Senses*, few of the recommendations to improve the condition of art education were implemented. Charles Fowler, one of the researchers on the original study, forcefully presents his own arguments, as well as essays from leading educators, in the book *Can We Rescue the Arts for America's Children?* Fowler addresses many of the long-standing issues of educational reform, as well as the need for advocacy:

Taking the entire country into account, by and large, support for substantive and comprehensive programs of instruction in the arts, K-12, is insufficient, and as a consequence, far too many art programs are compromised to a fragmentary, meager, and second-rate level; that is why advocacy is so necessary in the arts, but almost unheard of in English, science, mathematics, and history.⁹

Perhaps American education has come to its senses more than we realize, however. The primary recommendation of *Toward Civilization*, a report mandated by Congress on the state of art education in the country, is that all students from kindergarten through twelfth grade should receive a basic sequential art education. Prepared and published in 1988 by the National Endowment for the Arts, *Toward Civilization* sets forth compelling arguments for the arts as a basic part of education so that children are prepared to deal with the challenges of the future. According to Frank Hodsoll, chairman of the National Endowment for the Arts, the nation's cultural literacy is at stake; basic art education is needed to understand civilization, to develop creativity and problem-solving skills, and to learn the tools of verbal and nonverbal communication.¹⁰

In the private sector, the Getty Center for Education in the Arts was formed in 1982 to focus on the issues confronting art educators and policymakers. The Getty Center is one of the seven operating activities formed by the Getty Trust to address the critical needs related to the presentation, conservation, and understanding of art. After a yearlong examination of the substance and quality of public school art education programs, the Getty Center published a report entitled *Beyond Creating: The Place for Art in America's Schools*. Based on research by the Rand Corporation, the document identifies the conditions and factors that must exist for substantive visual

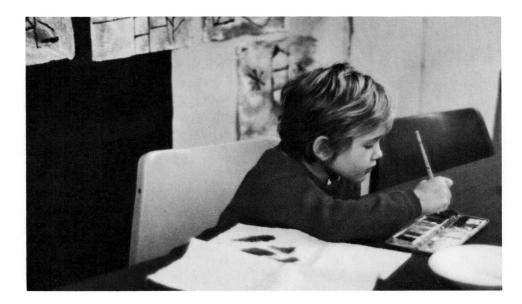

One of the recommendations in *Toward Civilization: A*Report on Arts Education
(presented in May 1988 to the U.S. Congress) was that elementary schools provide basic arts instruction for about 15% of the school week.
Additional time would actually occur when any of the arts are combined with other subject areas during the school day.

art education programs to be successful, presents conclusions, and provides commentaries on the value of art education. As stated by Leilani Lattin Duke, director of the Getty Center:

It is the Center's belief that a more substantive and rigorous approach to teaching the visual arts is consistent with the ambitious challenge of education reform and that it is incumbent upon all of us—parents, teachers, and educators—to explore how we can work together within the American system of education to achieve academic excellence that is all-encompassing.¹¹

Public Attitude toward Art Education

Despite increased attention and advocacy for art education, many people—parents and educators—hold to the belief that any activity that takes away from reading, writing, and arithmetic interferes with children reaching acceptable levels of proficiency. The public does not clamor for attention to the arts in education of the young. A recent Gallup Poll indicates that art and music are at the bottom of a thirteen-item list of subjects that the public considers important for high school students planning to go on to college. Sensitive to college entrance requirements and career opportunities, parents do not consider the arts as important as the sciences or social studies. At the same time, we are being told by such writers as Allan Bloom¹³ and E. D. Hirsch¹⁴ that students, even those in prestigious universities, are culturally illiterate.

Although art education seems to have a low priority, there are indications that the arts themselves are gathering greater audiences. In 1984, an annual expenditure for the arts of \$48.50 per capita was recorded; a mere three years later, this increased to \$61.50 per capita. The National Research Center of the Arts further reports that 70 percent of the American public would pay an extra ten dollars in federal tax to support the arts. As more and more data are gathered, it becomes clear that the public's attitude toward the arts is markedly ambivalent.

Perhaps the reason why art education is placed at the bottom of the list in parental priorities is that much of the public does not know the new developments that have evolved over the past few decades. The type of art education that most people experienced in elementary school probably fell into one of two categories: dictated art

or something called "creative self-expression." In the late 1960s, Blanche Jefferson described the six easily distinguishable methods of teaching art. Four of them—patterns, prepared outlines, step-by-step directions, and copying adult examples—are considered "dictated art," in which the end product is predetermined by the adult. Two other methods of art instruction allow for self-expression and are categorized as either thematic or self-directed. The end products in these two methods are unique, each child's artwork different from that of the other students who participated in the activity.

For a number of years, "self-directed" art activities were prevalent in the schools, and many of today's adults experienced a form of "creative self-expression." In this situation, the teacher provided some art materials and stood back as an observer. Art was not something children learned to do; it was something they did with neither thought nor direction. While the experience may in some cases have contributed to emotional health, it did little to stimulate creative thinking or develop problem-solving abilities.

The concept of art education has gradually evolved so that current thought maintains that there is something to *learn* in art, in addition to something to *express*. Although creative expression is still an important part of art, it is often guided, challenged, and stimulated by skilled teachers so that students acquire not only the skills of art production but the skills of perception as well. Furthermore, a quality art education provides opportunities for students to examine art as part of the culture from which it emerged and to make informed judgments based on specific criteria. In other words, an art program best suited for meeting the challenge presented in *Toward Civilization*, the basic sequential art education so badly needed by our young people, is one in which students not only learn how to make art but also how to see it, understand it, and form judgments about it and in which students are stimulated to their highest potential with regard to creative thinking and problem solving.

Barriers to Acceptance of Art Education

Efforts to place art in a more central role in education are likely to encounter obstacles. Some people with lukewarm enthusiasm for art education believe that one either has talent or one does not, in which case intervention by schools makes little difference. Another rigid perceptual barrier is the notion that art really does not contribute much to the child's intellectual development.

Ironically, resistance may emerge from statements made in support of art education. Some eloquent generalities tend to obscure the pragmatic benefits of involvement in learning through art experiences. For example, the President's Commission on Excellence in Education concluded that art education, when properly intertwined with the five basics, "constitutes the mind and spirit of our culture." In his report on secondary schools, some of Ernest Boyer's words are similar: "From the dawn of civilization, men and women have used music, dance, and the visual arts to transmit the heritage of a people and express human joys and sorrows. They are the means by which a civilization can be measured." A teacher or school administrator, even if philosophically in agreement with these sentiments, may see little connection between measuring civilization and the whimsical student drawings and paintings pinned to school bulletin boards. Few teachers acknowledge the possibility that the capacities needed for understanding and enjoying works of art may be as basic as those required for numerical and verbal literacy.

Lethargy also accounts for resistance to educational reform, and many school administrators are convinced that the old, traditional approaches are about the best we can realistically expect. In a survey of eighty-two administrators, fewer than half believed that more substantial art programs are needed and that the programs should continue through the high school years. ¹⁸ Moreover, these respondents also indicated that art programs will continue to lose out as budgets are trimmed and the "standard"

basics" draw most of the improvement dollars. Traditionally, the arts have been seen as properly functioning in an enrichment status—activities to be granted serious attention only when time and resources are plentiful. To a great extent, establishing quality programs in art education will depend on how administrators, teachers, and parents are able to change long-standing perceptions; the arts will continue to remain on the periphery of the school day until they are seen as essential with a rightful and strong claim to curricular time, space, funding, administrative support, and staff development.

"Intertwined" or "Interdisciplinary" Art Education?

Just how the President's Commission on Excellence in Education sees art education as "properly intertwined with the five basics" is not clear. The vagueness of such a statement—as well as the assumption that the arts are not fully valuable as distinct disciplines—denigrates art education. Admittedly, learning is an integrative process—one in which explorations in one discipline can clarify or enhance ideas, concepts, and skills in another. But as John Goodlad pointed out in his report on the six-year Study of Schooling: "The impression I get of the art programs is that they do little beyond coloring, polishing, and playing—and much of this goes on in classes such as social studies as a kind of auxiliary activity rather than art in its own right." Teachers in these classrooms are using art rather than utilizing it, and ignoring the unique content and distinct characteristics of a quality art education.

Is it possible to integrate art with other areas of the general curriculum in such a way that both are enhanced? The answer is: "Of course." As Daniel C. Jordan points out: "Working with relationships across disciplines . . . always produces new perspectives and insights." The key to successful interdisciplinary relationships is to search for commonalities, to discover relationships that lead to the formation of ideas and concepts. This way of learning provides an intellectual stimulation that involves thinking, feeling, and doing behaviors that enable students to be more flexible and inventive in their approaches to problem-solving processes. Abraham Maslow states that the best way of teaching, "whether the subject is mathematics, history, or philosophy, is to make the students aware of the beauties involved." Certainly, the arts provide a more imaginative, stimulating, and rewarding approach to teaching and learning than has been evident in the strategies that exclude them.

Looking Forward

Like the young child in awe of the miracle of the emerging bean plants, we look with wonder toward a rapidly unfolding future. Teachers preparing for their profession and the children described in this book will shortly advance into the twenty-first century. The "young learners" discussed in the chapters that follow will enter their chosen professions during the first decades of the new century, and the education they receive will need to prepare them for unknown social changes and technological advances. The child of the 1990s will have to become an adult of 2020 who is perceptive, flexible, creative, adaptable, and—most of all—a person able to solve problems and make decisions in a multiplicity of personal and professional situations as yet unimagined. For these reasons, it is essential to provide experiences that stimulate the imagination and pose problems that require creative solutions. We must, in our schools, do more than guide children down narrow intellectual paths. For all students, the study of art helps to develop creative and intuitive thinking processes not always inherent in other academic pursuits. The unique properties of the art experience enhances the development of vital, fully functioning individuals—the citizens of the twenty-first century who will cope with the challenges of our evolving culture.

For Discussion

- List a dozen art experiences you can remember from your early childhood.
 Organize these into categories to show the following: (a) self-directed activity, (b) dictated activity, (c) activity involved creative problem solving, (d) activity included art history, (e) activity included art of other cultures, (f) activity required using criteria for making judgments. Discuss what these listings show about your art education.
- 2. In your own words, define divergent and convergent thought processes. Give an example of an activity that would utilize each of these.
- 3. What evidence is there that the human brain has specialized thought processes?
- 4. How can alternating modes of learning during a school day provide stimulus in the learning environment? In what ways would experiences in art stimulate one or both hemispheres of the brain?
- 5. Discuss Carl Sagan's theory concerning the process of genius, and compare it to Arthur Koestler's findings.
- Summarize the major findings and recommendations of Coming to Our Senses and Can We Rescue the Arts for America's Children? Discuss ways that individual teachers can make a difference in the advocacy for art education.
- 7. What indicators are there that the arts are gaining public support? What in your own experience supports this?
- 8. How does current thought about art education differ from that of the past?
- 9. What are the characteristics of a quality art education?
- 10. How would the new concept of quality art education change art programs?

Notes

- 1. Roger W. Sperry, "Left Brain-Right Brain," Saturday Review, 9 August 1975, 33.
- Joseph E. Bogen, "Some Educational Aspects of Hemisphere Specialization," UCLA Educator 17(1975): 24–32.
- 3. Robert E. Ornstein, "Right and Left Thinking," Psychology Today, May 1973, 81.
- 4. Marilyn Winzenz, "Reading Comprehension and Right/Left Brain Thinking" (Paper presented at the Eleventh Annual Meeting of the California Reading Association of the International Reading Association, Anaheim, Calif., November 2–5, 1977).
- 5. Betty A. Edwards, "An Experiment in Perceptual Skills in Drawing," Dissertation Abstracts International, 10 November 1979, 1.
- Richard Louv, "Which Side of Your Brain Are You On?" San Diego Magazine, April 1979, 207.
- 7. Arthur Koestler, The Act of Creation: A Study of the Conscious and Unconscious in Science and Art (New York: Macmillan, 1964), 32.
- 8. The Arts, Education, and Americans Panel, Coming to Our Senses: The Significance of the Arts for American Education (New York: McGraw-Hill, 1977), 248-54.
- Charles Fowler, Can We Rescue the Arts for America's Children? Coming to Our Senses— Ten Years Later (New York: American Council for the Arts, 1988), 143.

- 10. The National Endowment of the Arts, *Toward Civilization: A Report on Arts Education* (Washington, D.C.: U.S. Government Printing Office, 1988).
- 11. The Getty Center for Education in the Arts, Beyond Creating: The Place for Art in America's Schools (Los Angeles: The Getty Center for Education in the Arts, 1985), iv-v.
- 12. "The 19th Annual Gallup Poll of Public Attitudes toward Public Schools," *Phi Delta Kappan*, September 1987, 69.
- 13. Allan Bloom, The Closing of the American Mind (New York: Simon and Schuster, 1987).
- 14. E.D. Hirsch, Jr., Cultural Literacy: What Every American Needs to Know (Boston: Houghton Mifflin, 1987).
- 15. National Research Center of the Arts, "For the Love of Art" (Reported by the Universal Press Syndicate, 1988).
- The National Commission on Excellence in Education, A Nation at Risk: The Imperative for Educational Reform (Washington, D.C.: U.S. Government Printing Office, 1983), 27.
- 17. Ernest L. Boyer, *High School: A Report on Secondary Education in America* (New York: Harper and Row, 1983), 97.
- 18. David C. King, Must the Arts Go Beyond "Coloring Polishing, and Playing" to Include Substance and Rigor? (Alexandria, Va.: Association for Supervision and Curriculum Development, December 1985), 5.
- 19. John I. Goodlad, A Place Called School (New York: McGraw-Hill, 1983), 220.
- Daniel C. Jordan, "The Arts—Neglected Resources in Education," in Controversies in Education, eds. Dwight W. Allen and Jeffrey C. Hecht (Philadelphia: W. B. Saunders, 1974), 39.
- 21. Abraham H. Maslow, The Further Reaches of Human Nature (New York: Viking, 1983),

1 Art Education in the Early Years

If we hope for our children that they will become full human beings and that they will move toward actualizing the potentialities that they have, then, as nearly as I can make out, the only kind of education in existence today that has any faint inkling of such goals is art education.

ABRAHAM MASLOW The Farther Reaches of Human Nature

I must study politics and war, that my sons may have liberty to study mathematics, philosophy, and commerce, so that their children, in turn, may have the right and privilege to study painting, poetry, and music.

JOHN ADAMS

In a society tending more and more to be technological, complex, and mass-oriented, art education has the responsibility of fostering and preserving an individual's human identity and self-esteem. Young children reflect the experience of beauty, so that when they engage in art production and view works of art and the world around them, they come to a better understanding of themselves and others. The main objective of art education should be to bring children in contact with and give them a better understanding of visual culture.¹

Education in art is essential and is designed to enrich students' lives by increasing their capacity to use their senses and minds joyfully and confidently in experiencing their environment. Such aesthetic encounters are for all children, and the values of educational experiences such as these are best transmitted through the schools, since these are the institutions that provide for personal development and the transmission

Five feet square, this felt-covered bulletin board infuses math with visual/tactile perception and good design. (Designed by Nancy and Wally Remington for a preschool classroom at Inverness Day School, Carmichael, Calif.)

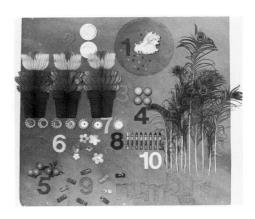

of cultural heritage. The results of art education should enable students to make personal choices relative to life and to be responsible for what they reject or prize in our society.²

Developmental Needs of Young Children

The American Association of School Administrators has taken the position that:

It is important that pupils, as a part of general education, learn to appreciate, to understand, to create, and to criticize with discrimination those products of the mind, the voice, the hand, and the body which give dignity to the person and exalt the spirit of man.

Boys and girls in the awakening, formative years of early childhood have special developmental needs. These include perceptual, emotional, artistic, and creative implications that can best be fostered through an art program that incorporates four principal content areas, as listed by the National Art Education Association.³ These are art production, aesthetics, art criticism, and art history.

A school art program that has depth and meaning and that is dynamic must include all of these components. They are not separate entities; rather, they are interrelated, and knowledge of and experience with each of them enriches and nourishes the others. For early childhood, a sequential and developmental art program that is based upon these content areas recognizes that not every child is destined to become an adult artist but that art can enrich the present and future lives of all children by giving them satisfaction and joy. Through a personal involvement in art, positive attitudes are developed, an appreciation for and an understanding and enjoyment of art are stimulated, and capacities for thinking and expressing oneself creatively are advanced.

Characteristics of Creative People

Except for differences in terminology, researchers generally agree on the characteristics of the creative person. Charles Schaefer lists the following ten characteristics of the creative child and states that these characteristics are evident from the earliest years:

- 1. A sense of wonder and heightened awareness of the world
- 2. Openness to inner feelings and emotions
- 3. Curious, exploratory, adventuresome spirit
- 4. Imagination, the power of forming mental images of what is not actually present to the senses or of creating new images by combining previously unrelated ideas
- 5. Intuitive thinking, the solving of problems without logical reasoning
- 6. Independent thinking, the desire to find things out for oneself rather than accepting them on authority
- 7. Personal involvement in work, total absorption in meaningful activities
- 8. Divergent thinking, thought patterns that seek variety and originality, that propose several possibilities rather than seeking one right answer
- 9. Predisposition to create rather than considering how things are supposed to be or always have been expressed
- Tendency to play with ideas, to mentally toy with the possibilities and implications of an idea⁴

Paul Torrance also states that the creative behavior of preprimary children is characterized by a spirit of wonder and magic; most healthy young children have this spirit unless they have been victims of neglect, harshness, lack of love, coercive punishment, or sensory deprivation.⁵ It is natural for children to be creative, and the characteristics of creativity can be kept alive as children mature if the children are regularly

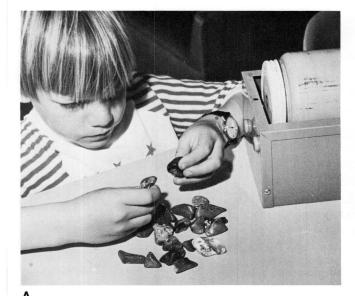

- A. Rock polisher produces smooth, sculpturelike forms from ordinary pebbles. The colors, patterns, shapes, and surface qualities invite the child to examine them.
- B. Early childhood is a time for many intake experiences, and art is a means of activating the child's sensibilities.
- C. Created by a sculptor, this "limbic system" installed in the San Francisco Exploratorium is in the shape of a multicolored bubble and reflects a child's image into infinity.

involved in quality art experiences. These experiences, when based on the content areas and interrelated through meaningful, sequential instruction, stimulate attitudes and awareness that are the foundation of both the creative thought process and the quality art program.

Creative people are perceptually very aware of their environment. They are visually observant of the world, and they are curious to know how things feel to the touch. They listen to sounds and are sensitive to the ways things smell and taste. They are able to take in information without prejudging it; they delay structuring the information until after they have had a chance to look at things from several points of view. Imagination relies upon this sort of perception to be recharged and enhanced.

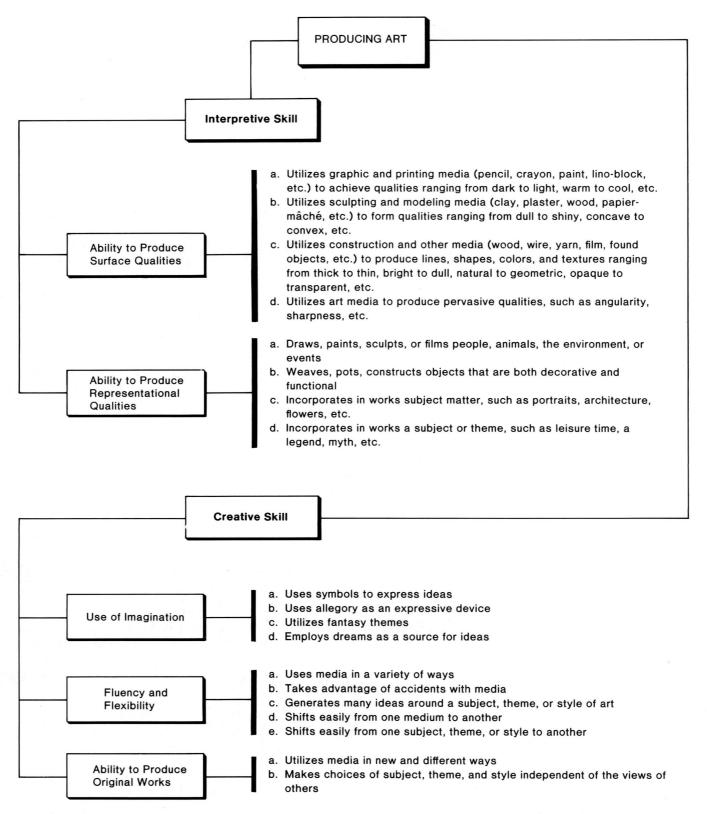

Interpretive skill and creative skill in producing art.

The relationship between creativity and the production of art is shown in the chart on page 4, developed by Dr. Ronald Silverman and printed in the newsletter of the California Art Education Association.⁷ In his column, Silverman points out that interpretive skill and creative skill are equally important in the production of a work of art and that each relates directly to the goals and objectives of a program in visual art education.

An Art Program of Quality

The National Art Education Association (NAEA) states that art is one of the most revealing of human activities, as well as one of the richest sources for understanding cultures, since the earliest things we know of ourselves are recorded in visual forms and images. People have made and used art to communicate and express ideas and to convey hopes and feelings throughout history. Art is a way of giving form to our imagination, of defining our surroundings, and of expressing our hopes and aspirations for the future. A quality art education integrates a number of opportunities, including making beautiful things; learning to look at artworks with pleasure, sensitivity, and appreciation; using creative and imaginative ways to solve problems; integrating art in all subjects; finding outlets for feelings and emotions; and increasing perceptual sensitivity.

The NAEA goals for a quality art education mandate that students complete a sequential program of instruction in art that integrates the study of art production, aesthetics, art criticism, and art history. In defining what is meant by a "quality art education," NAEA states that, through such an art program, students learn to develop, express, and evaluate ideas. They produce, read, and interpret visual images in an increasingly visually oriented world. They recognize and understand the artistic achievements and expectations of civilized societies.

The content of art is significant. Its educational value and expressive power demand sequential instruction in a quality art education program. Sequential lessons provide continuity and build upon the skills, concepts, themes, and knowledge that students have encountered previously, moving from simple things to more complex and demanding ones. Each art activity is related to the next so that what is learned today can be expanded upon and used tomorrow. Sequential lessons provide students with a chance to grow, sharpen their perceptions, practice skills, and make connections with what they have already learned. A stimulating program of logically sequenced lessons in art provides the structure that gives students access to visual literacy. Some school districts provide a printed curriculum with sequential lesson plans that take into consideration a balance of media, themes, and skills, as well as the developmental needs of different grade levels. Some districts provide leadership in the form of an art specialist who assists teachers in planning a sequential program. Recently, publishers have released textbooks and packaged programs that provide sequential lessons beginning with level or grade 1.9 In some instances, however, teachers must plan their own sequential lessons for their students for the entire year's art program.

In defining more clearly what is learned from a sequential quality art program, NAEA states that making art is central to the art education of all pupils and that, in the early grades, it is the primary mode through which students can fluently tell stories, relate experiences, fantasize, convey messages, express feelings, and give ideas concrete form. In so doing, children learn to observe, recall, find relationships, make choices, accept or reject alternatives, respond, value, and make decisions.

The content of art instruction as specified by the NAEA goals must be an integration of art production, aesthetics, art criticism, and art history, but the view is taken that producing artworks has always been and probably will continue to be central to the art education of students since it is an "activity that comes naturally to the young and can continue to be a rewarding experience throughout life." When students make

drawings, paintings, or other artworks, they are challenged to observe in a special way, ways used by artists to help them perceive with greater clarity, precision, and discrimination those things that are significant for interpreting in their artwork. They remember and recall experiences, places, events, people, and objects. They explore their feelings, emotions, and attitudes toward the subject or theme with which they are dealing. They make decisions relative to the composition, working within the format of the paper and the limitations or special characteristics of the medium. They make aesthetic judgments about the colors and space and lines they will use to best show their ideas.

The branch of philosophy known as **aesthetics** provides complex structures for interpreting the meaning of art and beauty. Its complicated ideas about the responses of human beings to nature and artworks provide a means for analyzing and interpreting some of the deepest of human emotions. The *California Visual and Performing Arts Framework* perceives aesthetic perception as designating a specific aspect of perception, learning to see the world metaphorically as well as directly: ". . . a tree may be viewed as a symbol which expresses majesty or somberness in contrast to a source of wood for building a structure." 11

Aesthetic considerations in early childhood begin with the easiest and most understandable basis possible. Questions deal with students' responses to artworks as well as to beautiful things they see in the natural world. Students explore the differences between nature and art. They begin to ask themselves why they feel a special way when they look at a particular painting, how they may feel differently when they look at a tree and then at a painting of a tree, how they would go about making a picture that shows a lot of movement and action, how they would go about choosing colors so that they can give another person the same feelings they have. NAEA states that attention to aesthetics is important in a quality art education in that:

It causes students to question, weigh evidence and information, examine intuitive reactions, and come to tentative conclusions about their experience. It begins with simple concrete experience in thinking and discussing art at the very earliest elementary grades.¹²

Laura Chapman has stated that aesthetic perception is not simply learning to decode symbols with fixed meanings. ¹³ She believes that aesthetics pertains to perception based on feeling and sensation and is not generalized for all instances. For this reason, she affirms that the perceptual skills that children normally learn from reading, science, and mathematics must be complemented with experiences that stimulate multisensory awareness and that promote a sensitivity to expressive meanings and to contexts.

When children find reasons for selecting one artwork as being more interesting than another, they are engaging in art criticism. When they have good reasons for liking one artwork more than another, they are making aesthetic judgments. NAEA believes that there is an important difference between ". . . because I like it," and "I like it because. . . ." From their first guided encounters with art, young children progress in making careful, sensitive observations and thoughtful interpretations. In practicing techniques of art criticism, they begin making comparisons that are based on their increased viewing of artworks. Early practice in art criticism begins an individual's lifelong habit of arriving at judgments about the value and intent of visual images, reasoned judgments that are based on the person's knowledge and visual sensitivity.

NAEA believes that knowledge of art history must be fully integrated with the other parts of a quality art program to help students understand how people have recorded experiences and events and expressed ideas and feelings throughout time. Art history provides an enriched source of inspiration for today and connects us with our artistic roots.

Emphasis on the four separate content areas of a quality art program is not equally divided. Stephen Dobbs defines "discipline-based art education" as an approach to teaching art in which ideas and skills from the four disciplines of studio art, art history,

art criticism, and aesthetics are integrated in a written and sequential curriculum "whose content leads to cumulative knowledge, skills, and understanding in art." He further states that discipline-based art education does not require equal time and attention to each discipline: The "amount of time and attention to be devoted to each of the art disciplines is likely to depend upon the different forms DBAE curricula will take and the populations of the students being taught." He emphasizes that, in elementary schools, art production "might be expected to receive a major share of attention because of the developmental capacities of students."

Many local school district curriculum guides, along with state frameworks, agree that art production or studio art is a central feature, as does the National Art Education Association's Quality Goals Statement. Dobbs emphasizes that discipline-based art education "does not seek to replace art-making with talking about art, but reinforces, through a variety of learning modes, the multifaced character of the visual arts." ¹⁵

In summarizing the effects of a sequential quality art program, NAEA lists the following visual literacies needed by students to give them control over their responses to the vast visual material they will encounter during the rest of their lives:

- 1. An understanding of and the ability to apply their own intellectual and creative potential to situations they will encounter
- 2. An appreciation for the magnificence of the creative power of others as encountered in architecture, painting, sculpture, and other visual arts
- 3. An ability to make informed choices related to the many visual options available to them, choices based on intellectual and emotional validities
- 4. A sensitivity to the environment and to the impact individuals have on nature, architecture, city planning, monuments, and so on
- 5. An understanding of the past and its artistic triumphs and tragedies
- 6. An appreciation for and understanding of the cultural values of different peoples of different times and places
- 7. A reinforcement of their own beliefs and values by being awakened to achievements and contributions of visually creative people

NAEA emphasizes in its conclusion that quality art education, presented consistently and regularly throughout the entire period of each student's education, can contribute to society's need for "well-rounded, intelligent, informed, sensitive, self-confident, and contributing people." ¹⁶

Aesthetic Perception: Seeing in a Special Way

What we know of the world, we take in through our senses. The refinement and sharpening of these senses, then, becomes paramount in the development of the student. Education of the senses in early childhood is crucial for later life. It forms the basis for judging artworks and valuing the things we see in our environment. While aesthetics is a noun and deals with extremely complex issues that are more suitable for college classes and philosophy courses than primary school, the phrases aesthetic perception and aesthetic judgment—using the word as an adjective—are applicable in early childhood art programs. Aesthetics is a rather complex branch of philosophy concerned with giving meaning to artworks and is somewhat different from the aesthetic experiences of aesthetic perception and aesthetic judgment that very young children encounter. Also, some answers to aesthetic inquiries are best found in discussion strategies that combine art criticism and art history.

Young children are enthusiastic, curious, and eager participators, interested in exploring everything around them. The quality and quantity of that exploration must not be left solely to chance. Rather, the teacher should lead, guide, and direct children's perceptual experiences to help them to become better able to recognize and discriminate art elements in both the natural world and in objects of human origin. Through

Sensitive observation is involved when third graders make contour drawings of each other wearing Victorian half-masks. Masks remove the self-consciousness of the model who is posing. Variations of lines and linear patterns intrigue studentartists and give them an opportunity to make visual images from direct observation.

these experiences, the child becomes more skillful in recalling observations and better able to understand, describe, and make use of colors, textures, lines, and shapes. Design is found everywhere in the world, but it may go unnoticed until the individual becomes aware of it.

French artist Henri Matisse was a keen and sensitive observer of the world. He still had a rich "library of images" in his head when he became bedridden at age seventy-one. He had observed nature all his life and had drawn and painted the world around him so many times that he felt that these images now "belonged" to him. He was able to represent them with his own shapes and signs, using his own language of shapes and colors.

If perception is basic to all learning, if selective viewing is a desirable kind of behavior, and if conceptualization comes after sensory experiences, then it becomes imperative that teachers provide paths for numerous visual and tactile explorations and experiences so as to keep all of the child's senses alive and active. If left to their own devices, children are not as apt to discover these aesthetic learnings by themselves.

Art gives children new ways of seeing and knowing. Through looking at nature and artworks and through discussions—whether in the form of a motivational dialogue before they draw or paint or whether after they have completed making art—their ways of seeing are expanded. Discussions may revolve around such concepts as: close-up, magnified, transparent, bird's eye view, worm's eye view, silhouette, larger or smaller, thick or thin, rough or smooth. Visual factors can involve movement as well and can be experienced by exploring such concepts as: spirals, curving, straight, zigzags, backward, forward, swing, spin, burst, and flow in kinesthetic ways.

As children mature, they become more aware of spatial relationships and have more detailed perceptions of objects. They understand more about overlapping shapes, dark colors in contrast to light colors, and bright versus dull. They perceive things from above and below, inside and out.

Through heightened perceptual experiences, the child often discovers in both new and familiar things a beauty and uniqueness that one whose senses are dulled might dismiss or overlook. Sensory encounters give wings to children's imaginations and at the same time enable them to relate and react to the real world around them and to

A

A. Colored, wooden shapes to fit and arrange in a box frame give children experiences in color and space.

- B. A set of plastic bracelets can be a teaching toy. Bracelets are graded in value, and the child must stack them on a round, wooden post in a light to dark arrangement.
- C. Seven-piece tangram puzzle originated in China in the 1800s and involves arranging a square, parallelogram, and five triangles into silhouettes of people, animals, and objects. Manipulations aid the child in developing concepts of size, shape, symmetry, and similarity.

think in terms of visual images. Through personal involvement in quality art activities, children's increasing perceptual powers continue to develop and to provide the mental images needed for creative thinking and problem solving. According to Paul Torrance, a child must have a rich store of imagery to go very far in developing creative powers. This quality is essential in the scientific discoverer, inventor, and creative writer, as well as in the artist.¹⁸

Art Production: Making Art

Art production is a creative process for the child; it is an avenue through which all kinds of experiences are expressed in a nonverbal as well as a verbal way. Involvement with art tasks provides experiences for young children that can be derived in no other way. When very young children pick up a crayon or brush, they have taken the first step in the creative act: that of selecting and making a decision. As they mature, they develop meaningful artistic expressions involving their personal feelings, their cognitive awareness, and their sensory impressions, and they use these expressions to communicate with others. If the environment is warm, supportive, and receptive, children enjoy and freely incorporate moods and original concepts in all sorts of subject matter and use many kinds of art materials.

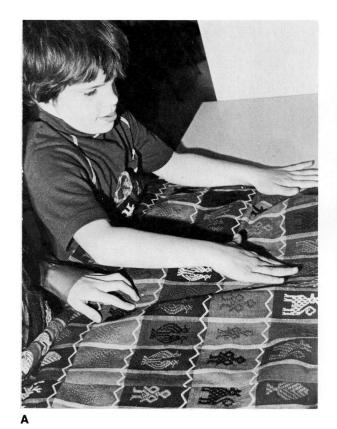

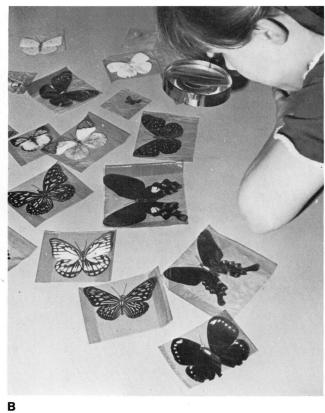

A, B, and C. The child's visual language expands if he or she is surrounded with materials and an encouraging and many-faceted atmosphere. "Come touch, come see" should be bywords in the early years.

С

Felt-covered bulletin board in preschool invites small children to touch and feel a variety of appealing objects. Small, round mirrors catch the children's reflections.

Art production involves having the skill and power to show clearly what one is thinking, feeling, or perceiving in a unique and individual way. Prior to production comes perceiving, searching, discriminating, selecting, and enjoying the visual world. Art production is a way of expressing individual uniqueness.

Two of the leading specialists commenting on Piaget, an authority on the general intellectual development of children, believe that the leading argument for teaching Piaget's theory is that young children learn best from concrete activities. ¹⁹ Since Piaget believes that it is advisable to permit children to absorb experiences in their own ways and at their own rates, teachers must provide a rich environment that permits a maximum number of concrete activities. And they must keep to a minimum those situations in which children are shown exactly how to structure their responses.

Situations in which children are unable to fall back on preconceived ideas and in which they explore previously undiscovered areas have educational value. The early childhood art program should promote children's own personal production of concepts and should develop their skills in painting, drawing, cutting, pasting, modeling, constructing, weaving, printmaking, and so on. Art productions in both two and three dimensions are important and reinforce each other.

Paul Torrance lists three fundamental attributes that seem to characterize learning activities that facilitate creative behavior and motivate learning: (1) the incompleteness or openness of the learning experience, (2) the requirement to produce something and utilize it, and (3) the use of children's questions (the "wanting to know") to capture the excitement of learning. Creative expression in art also originates in openended problem-solving activities in which the child's creation is not predetermined by adult dictates. The adult's role in the art production arena is to motivate in ways that stimulate perceptions, thoughts, and feelings and to provide instruction in any necessary media skills.

Very young children need exceedingly little stimulation to begin art production. They are eager to respond to the visual attraction of brightly colored paint and paper and to the tactile appeal of modeling or collage materials. They delight in cutting paper for the sake of cutting and in pounding and squeezing pliable materials for the kinesthetic enjoyment it gives them. They may not always choose to recount an experience, but in the exploration of materials, they develop the skills that they will need when they do wish to communicate an idea or tell a story about something important to them.

Art production activities make especially meaningful connections when students view artworks by famous artists and see the artworks as having such commonalities as similar themes or emotions, universal subject matter, or familiar styles or media.

The educational significance of art production is that children use a broad range of cognitive and affective learnings:

- 1. They must form a concept of what it is they want to draw, paint, or make.
- They must call upon feelings and emotions related to what it is they want to draw or make.
- 3. They must use memory of events and objects as well as perceptual intake of the environment to help them record and interpret things in their artworks.
- 4. They must develop skills in different media to achieve the effects they desire.
- 5. They must order and arrange the composition through the use of color, line, shape, and so on, so that the end result is satisfying to them.
- 6. They must decide when the work is finished and what they feel is right and good about it.
- 7. They become acquainted with how inspired artists in other times and places expressed and communicated their observations, thoughts, and feelings.

As Frederick Spratt of San Jose State University once said, "It is through art production that we 'reaffirm discovery' in the students, as in each young artist we witness the reinvention of art."²¹

Art Heritage: Art from Past Ages

Our history as human beings is vividly portrayed through art, and thus we can better understand ourselves by understanding our ancestors and their cultures. Different places and different times have always been expressed through art. In looking at primitive cultures, we realize that art cannot be separated from the everyday life of the tribe, a people in tune with nature and natural laws. Art has been valued by people from the very beginning of recorded history. Today, painters, sculptors, craftspeople of all kinds, photographers, filmmakers, industrial designers, fashion designers, architects, graphic artists, and city planners all influence the quality of our lives.

When young children view different kinds of art, they come to know the different purposes that art has served and the different reasons why artists have produced art, including the following:

- Artists record historical events in their artworks and make visual images about myths and great pieces of literature. Narrative art tells stories about people, places, and events.
- 2. Artists show us how people and places looked at various periods of time.
- 3. Artists have made artworks to inspire people to take social action. Some have used their art to promote their political ideals, to spread propaganda, and to show the horrors of war.
- 4. Artists have created artworks to inspire, persuade, and inform people with regard to religion.
- 5. Some artists express their feelings about the world they see around them through landscapes, the city, people, still-life subjects, animals, and so on.
- 6. Some artists show us a dreamlike world of fantasy and of the imagination.
- Some artists explore and invent new ways to use art materials and to make artworks.
- 8. Some artists choose little if any subject matter from the real world but concentrate on portraying the pure impact of colors, shapes, textures, and lines.
- 9. Some artists design and/or make usable objects: buildings, furniture, dishes, jewelry, clothing, containers, and so on.

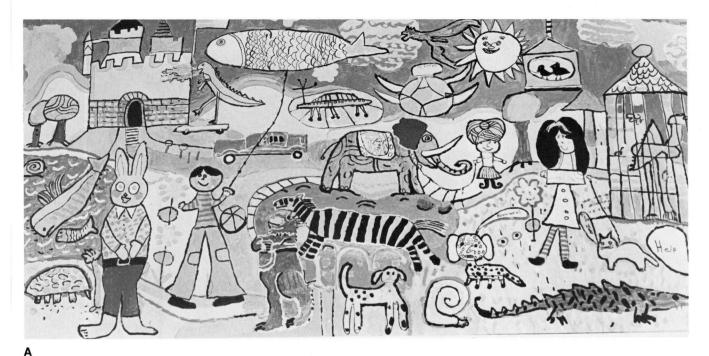

A. Many painting experiences and follow-up discussions on aesthetic concepts increase children's skills and self-judgment for future productions. This large mural was painted by second- and third-grade children for the Bryant Elementary School Library in San Francisco.

B. Bronze dolphin by a contemporary sculptor is being explored as to its curving, leaping form and its touch-inviting surface. Sixyear-old children learned how the metal was melted like wax with a very hot torch to form the undulating texture that they loved to feel.

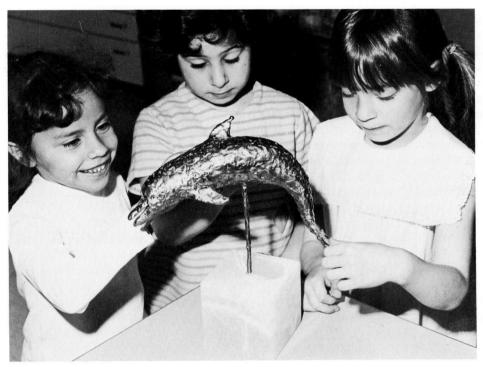

In their early years, children can begin to learn that art and culture interact and are one. The culture determines its art. The needs of culture are met by the artist. Artists are influenced by the events and world around them, as well as by what other artists are doing. They are influenced by what has gone before them, and, in turn, they influence artists who follow them.

Young children can come to know that art has changed over the years and that artworks in different places and different periods of history may be quite different. Artists have been limited by the art materials and technology of the time in which they lived. Renaissance artists, for instance, made much use of egg tempera and fresco, while artists today may choose from a broader range of media.

Young children are not expected to achieve a keen understanding of the chronological aspects of art history; dates and sequencing of art come later in their school years. Rather, it is better to focus on the different purposes that art has served and the many ways that art has interacted with and reflected culture throughout time. Very young children profit from viewing thematic groups of artworks. Such a grouping may emphasize the commonalities of subject matter. Portraits made centuries apart and created in vastly different styles, for instance, introduce children to the idea that some artists choose to record likenesses, while others choose to focus on showing character and personality, while others choose to use their imagination and take delight in working with colors, lines, and shapes.

Art Criticism and Aesthetic Judgment: Informed Responses

Werner von Braun has reflected on the idea that we would all have dead souls if we had no aesthetic values. Children early in life need to recognize and become familiar with different kinds of art. They will respond in their own way, often having different feelings toward art than adults. In sequential programs where the artworks of painters, architects, craftspeople, and sculptors play an important role, it is feasible and desirable to build and expand upon the child's knowledge and judgment of some of the roles that art plays in everyday life, government, religion, and business.

When art criticism is introduced in early childhood classrooms, children are given the opportunity to learn to see and describe the visual world in a special way. Instead of only using their eyes in a practical way—to identify things, recognize them, categorize them, and keep from bumping into them—children learn to take a contemplative, reflective look and expand their perceptual skills. They learn to direct their attention to the aesthetic aspects of artworks, as well as to their surroundings.

Children need repeated and regular opportunities to describe what they see in an artwork. They may notice how one artist used thick paint and made curving brush-strokes and how another applied the paint in broad, thin washes of color. These are the technical properties of an artwork. Children can use words to describe the elements of art that they see in the artwork—colors, lines, shapes/forms, textures, value, and space. They can look for how these elements are arranged and ordered within the composition—the principles of art. They can seek out the emphasis of an artwork and describe how their eyes are led to this focal point. They can try to discern how the artist balanced the dark and light places or how the artist repeated a shape to make a patterned area. They can find ways that the artist provided variety and yet achieved a unified look of completeness and harmony.

Children react to artworks with their own feelings and emotions, perhaps empathizing with the subject matter and projecting their own feelings. They give studied thought as to how successful the artist was in making an extremely real and lifelike artwork, or one that expresses a strong feeling, or one that makes use of colors, lines, and shapes (perhaps without relying on any real subject matter at all), or one that represents dreams and fantasy. They may come to the conclusion that artists sometimes combine two of these different ways of making art.

A. Through art, children take from their world the ordinary and heighten their awareness by using it for subject matter. They accent its essence and find delight in the sensuous beauty of paint. They communicate to others.

B. Children paint what they know and see around them. The entire length of the playground in this San Francisco school is bright with paneled murals painted by the children in the primary grades.

В

Looking, thinking, and talking are involved when art criticism and aesthetic judgment are aspects of the art program. In large or small groups, or on an individual basis, the teacher can guide the children in learning to describe, analyze, select, interpret, appraise, and evaluate. Children can begin to name and describe the art elements and principles and to recognize different media and individual artist's works, as well as an artwork's technical properties. Vocabulary development is important because words are needed to discuss, identify, compare, contrast, and interpret artworks—either their own, those of their peers, or those of adult artists. The children can begin to recognize some styles of artists, some cultural expressions, movements in art, and different kinds of art, such as realistic, abstract, expressive, and surrealistic.

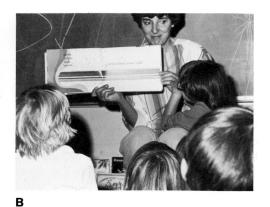

A. Bright colors in *The Purple Robe* by Henri Matisse are enjoyed by kindergartners as they look at these small reproductions. Lamination assures protection and longer use.

C. Albums are decorated with printed designs and contain small reproductions of great works of art.

D. A small reproduction of Van Gogh's *Starry Night* is one of a number of great works of art that were made into badges by one third-grade teacher. Children may choose one badge for wearing each day as they learn to recognize specific artists and their works.

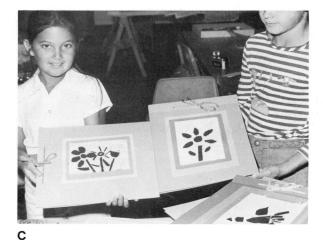

If children do not experience art and its value as an important human endeavor, they are culturally handicapped. Becoming literate is one of the main goals of education. If children are encouraged to speak of their attitudes, feelings, and perceptions relative to a work of art, their educational years are not left devoid of a body of enriching ideas related to the artistic contributions of human beings. Acquiring and using art terminology with an easy fluency is an important part of children's visual learning. They respond to each art encounter with attitudes, judgment, and nonverbal feelings, and words can help to sharpen and direct their perceptions with regard to their own work and the works of others.

Elliot Eisner distinguishes between aesthetic judgment and preference, with judgment being the process whereby an individual not only appraises the import, significance, and quality of something, but also has some basis for justifying that judgment.²² On the other hand, one's preference is a simple statement of like or dislike, approval or disapproval. Therefore, aesthetic judgment involves evaluating and judging what is artistically excellent, rather than making statements of what we may "like" or "not like."

Aesthetics pertains to the sense of the beautiful; the word has its roots in the Greek word aisthetikos, pertaining to sense perception. Its opposite is anesthetic, which has to do with the loss of the senses. Aesthetics is defined as a branch of philosophy that provides a theory of the beautiful and of the fine arts. It was first used to mean "the science of the beautiful." For early childhood, we may think of aesthetics as trying to understand those things that we find attractive and interesting to our senses. We usually qualify it as being a philosophical discipline that is primarily concerned with artworks, and as such it poses complex questions that have to do with the nature of art, how art provides knowledge, and appropriate ways for appraising quality in art. It is an arena in which students reflect and make judgments on the quality of artworks, as well as on the qualities they see in the world around them.

When children encounter a new work of art, verbalizing about it with familiar words can make for a nonthreatening starting point. Preschool and kindergarten children can begin to use elementary art terms and add to their basic vocabulary every time they handle art materials or look closely at natural objects or works by famous artists. They can talk about how the colors, lines, and images evoke in them feelings of happiness or sadness. Very young children are able to look at reproductions of art created by such artists as Picasso, Klee, Modigliani, Calder, van Gogh, and Matisse and discuss such concepts as real and not real, curved and straight, big and small, bright and dull. They can point out paintings that look like dreams and paintings that exaggerate and distort what is real, as well as enjoy patterns and colors for their own sake.

Preprimary children can become aware of art that shows pleasing relationships, harmonious organizations, rich textures, and such. Through handling art materials and seeing original and reproduced items of art, they can come to identify a variety of art forms, such as paintings, sculpture, ceramics, woven works, and architecture.

Aesthetic judgment involves an awareness of our environment. The humanities stress this relationship and the relevance of art to society. We are concerned not only with clean air and water, green spaces, and protecting nature's balance, but also with guarding against visual pollutants. A visually literate populace demands an aesthetically pleasing environment, which means good design qualities in homes and home furnishings, schools, office buildings, city planning, transportation, television, and films.

Early childhood is the time for these critical beginnings and aesthetic foundations.

For Discussion

- 1. In what ways does art enrich the lives of students?
- 2. What are the characteristics of creative people? How does art reinforce these characteristics?
- 3. How does the National Art Education Association define art in school, and what are the characteristics of a quality art program, as described by the NAFA?
- 4. What is "discipline-based" art education, and how does it align with the components of art education as described by the NAEA?
- 5. In your own words, describe "visual literacies" and the areas of learning reinforced by a sequential quality art program.
- 6. What is aesthetic perception, and how can it be nurtured in young children?
- 7. What is the educational significance of art production activities?
- 8. List some of the characteristics you would expect to observe in an activity focused on art criticism and aesthetic judgment. How is a teacher able to guide students in this process?

- 9. What are the purposes of art? How do these influence culture, and how does culture reflect the work of artists?
- Describe a theoretical concept from this chapter that you believe to be particularly significant in the development of your own views about art education.

Notes

- 1. C. E. Silberman, "How the Public Schools Kill Dreams and Mutilate Minds," Atlantic (1970).
- Aesthetic Education Program, Aesthetic Education: A Social and Individual Need (St. Louis, Mo.: CEMREL, 1973), 4–5.
- 3. National Art Education Association, Quality Art Education, Goals for Schools, An Interpretation (Reston, Va.: National Art Education Association, 1986).
- Charles E. Schaefer, Developing Creativity in Children (Buffalo, N.Y.: D.O.K. Publishers, 1973).
- 5. Paul E. Torrance, Creativity (San Rafael, Calif.: Dimensions Publishers, 1973), 1.
- 6. Donald W. Herberholz and Kay Alexander, *Developing Artistic and Perceptual Awareness*, 5th ed. (Dubuque, Ia.: Wm. C. Brown Publishers, 1985), 7-8.
- 7. Ronald Silverman, "Curriculum Corral," The Painted Monkey 8(February 1983): 2.
- 8. National Art Education Association, Quality Art Education, Goals for Schools, An Interpretation (Reston, Va.: National Art Education Association, 1986).
- 9. Kay Alexander, Clear (Wilton, Conn.: Communicad, 1987).
 - Kay Alexander, Spectra Program (Menlo Park, Calif.: Dale Seymour Publications, 1987). Art Works (Austin, Tex.: Holt, Rinehart and Winston, 1989), grades 1-6.
 - Monique Briere, Art Image (Champlain, NY: Art Image Publications, 1989), grades 1-6.
 - Brooks, et al., Through Their Eyes, Primary Level—A Sequentially Developed Art Program for Grades 1-3 (Austin, Tex.: W. S. Benson, 1989).
 - Laura Chapman, Discover Art (Worcester, Mass.: Davis, 1985), grades 1-6.
 - Laura Chapman, Teaching Art 1-3 (Austin, Tex.: Henrick-Long Publishing, 1989).
 - Lee Hanson, Creative Expressions: An Art Curriculum (Menlo Park, Calif.: Dale Seymour Publications, in press), grades K-8.
 - Guy Hubbard, Art in Action (Austin, Tex.: Holt, Rinehart and Winston, 1987), grades 1-8.
- 10. National Art Education Association, Quality Art Education, Goals for Schools, An Interpretation (Reston, Va.: National Art Education Association, 1986).
- 11. Visual and Performing Arts Framework, Kingergarten through Grade Twelve (Sacramento, Calif.: State Department of Education, 1989), 5-7.
- 12. National Art Education Association, Quality Art Education, Goals for Schools, An Interpretation (Reston, Va.: National Art Education Association, 1986).
- Laura Chapman, Approaches to Art in Education (New York: Harcourt Brace Jovanovich, 1978), 172–73.
- Stephen Dobbs, "Perceptions of Discipline-Based Art Education and the Getty Center for Education in the Arts" (Paper presented at the California Art Education Association Conference, Los Angeles, Calif., April 1988).
- 15. Stephen Dobbs, "Perceptions of Discipline-Based Art Education and the Getty Center for Education in the Arts" (Paper presented at the California Art Education Association Conference, Los Angeles, Calif., April 1988).
- 16. National Art Education Association, Quality Art Education, Goals for Schools, An Interpretation (Reston, Va.: National Art Education Association, 1986).
- 17. Mary Erickson, "Teaching Aesthetics K-12," in Research Readings for Discipline-Based Art Education: A Journey Beyond Creating (Reston, Va.: National Art Education Association, 1988), 148-61.
- 18. Paul E. Torrance, Creativity (San Rafael, Calif.: Dimensions Publishers, 1973), 40.
- 19. Herbert Ginsburg and Sylvia Opper, *Piaget's Theory of Intellectual Development: An Introduction* (Englewood Cliffs, N.J.: Prentice-Hall, 1969), 221.
- 20. Paul E. Torrance, Creativity (San Rafael, Calif.: Dimensions Publishers, 1973), 43.
- 21. Frederick Spratt, Discipline-Based Art Education: What Form Will It Take? (Los Angeles: The Getty Center for Education in the Arts, 1987).
- 22. Elliot Eisner, Instructional Monographs: Ideas to Provoke the Thoughts and Actions of Education (Sacramento, Calif.: Sacramento County, Superintendent of Schools Office, 1968).

Avenues to Artistic Growth: Responding to Artworks

The arts are a vital part of human experience. In the eyes of posterity, the success of the United States as a civilized society will be largely judged by the creative activities of its citizens in art, architecture, literature, music, and the sciences.

Goals for Americans: The Report of the President's Commission on National Goals

Children respond to looking at artworks and to making art with a natural enthusiasm and can readily acquire, with appropriate guidance and, of course, the visual materials, the necessary vocabulary and concepts.

Works of art can be likened to people: Getting to know them often takes time and effort. When a new student enrolls in class, teachers encourage the other students to be friendly, to find out what the new person is like rather than forming a quick impression and judgment. Often, a person that we tend to dislike at first becomes a good friend when we get to know him or her better. In fact, the person we find more difficult to become acquainted with often turns out to be a more interesting friend in the long run. The same is true with a painting or any work of art.

Which works of art by adult artists appeal to the very young? Generally speaking, children like to see things that have something in common with their own world and lives. They love to see paintings and sculptures of children (both those who lived long ago and contemporary children), animals, people doing things, narrative art, fantasy and imaginative types of themes, landscapes and seascapes (perhaps showing action and adventure), and works of art in which they can identify with the artist's love of colors, paints, lines, and textures. Large reproductions, filmstrips and videos, and, of course, student art textbooks showing great works of art all facilitate bringing a "museum into the classroom."

Through viewing a thematic grouping of reproductions, students can arrive at the important understanding that different artists express the same theme or subject matter in vastly different ways and, therefore, that there is no one "correct" or "best" solution in making visual images. Today's child is bombarded with coloring books, plastic models, paint-by-number kits, and ready-made, repetitive images on computer games. Here, the emphasis is usually on control, following directions, and imitating others to arrive at the predetermined solution. Even in school, there is only one "right" answer in an arithmetic problem, and no one encourages a creative speller.

Exposing children to a variety of all kinds of art helps them to come to know that people express themselves in many ways. Artistic encounters that compare and contrast art can free young artists to create expressive and imaginative images that reflect their unique personalities.

Although art galleries and museums are ideal places to view original art, visits are usually limited by finances or availability. Therefore, large reproductions are appropriate for helping students to become acquainted with artworks and for preparing them for seeing original artworks at a later time. The artworks can be presented one at a time or thematically, in portfolio groups, by the teacher or by trained volunteers called docents.

The Language of Art

To carry on a meaningful dialogue about art, both teachers and students need to become acquainted with art vocabulary—the verbal tools that will help them to identify, describe, analyze, and react to an artwork, whether it is their own production or one created by a famous artist.

Elements of Art

The basic components that all artists use are called the **elements of art.** They can be thought of as the "ingredients" of both two-dimensional and three-dimensional art. **Color, value, line, shape and form, texture,** and **space** are the elements of art.

Color Color can be used in a realistic manner, in a decorative manner, or in an expressive or emotional way, and it also can be used symbolically. A color wheel, a device invented by Isaac Newton around 1666, makes it easy to understand about different colors and to learn how to mix them and use them in producing artworks. The three primary colors are placed equidistant apart on the wheel, and the secondary colors are placed between them. The primary colors are red, yellow, and blue. Mixing any two of these produces the secondary colors: orange, green, and violet (red + yellow = orange; yellow + blue = green; blue + red = violet). The order on the wheel is: red, orange, yellow, green, blue, violet. The intermediate colors are between each of these colors. They are: red-orange, yellow-orange, yellow-green, blue-green, blue-violet, and red-violet.

Colors can be grouped in several ways. Red, orange, and yellow are thought of as warm colors in that they remind us of fire and heat. Blue, green, and violet are called cool colors because they make us think of water, cool lakes, and icy snow. Two colors that are opposite each other on the color wheel are called complementary colors. Complementary colors contrast strongly with each other. In addition, when a small amount of one complementary color is mixed with its opposite, it tends to dull the other color slightly. Complementary colors mixed together in somewhat equal amounts results in a dull gray. Analogous colors are a family of colors that are adjacent to each other on the color wheel and that all resemble each other. Each color in an analogous group—for instance, red, red-orange, orange, and yellow-orange—has one color in common: red. A monochromatic group of colors is made by selecting one color and mixing a variety of its tints and shades. Tints are made by adding a small amount of a color to white; shades are made by adding a small amount of black to a color. Neutrals are black, white, and gray. Though they are not on the color wheel, they are usually thought of in relation to color and are used as colors.

A challenging assignment is to select any one of these groups of colors as a "limited palette" and make an entire painting. For instance, students may be given their choice of one of the pairs of complementary colors, plus black and white. The focus another time might be on mixing tints and shades of one color and creating a composition with only those colors. Another focus might be on making a picture with very light tints of several colors.

The "Color Gallery" can help us to identify and describe some ways that artists have used color. There may be several different answers to the queries that follow. Discuss the reasons for your answers.

- 1. In his *Painting No. 198*, Kandinsky used mostly primary colors. Find other artworks that are made up of both primary and secondary colors.
- 2. Which secondary color did Matisse not use in The Wild Poppies?
- 3. Which artwork has only the secondary colors along with neutrals?
- 4. Van Eyck used a pair of complementary colors to emphasize the bride in *The Marriage of Giovanni(?) Arnolfini and Giovanna Cenami(?)*. Can you find another artwork that creates strong contrast with the use of complementary colors?
- 5. Select four artworks that have red in them. Try to decide why the artist used red in the manner that he or she did.
- 6. Find an artwork that uses colors in (a) a very realistic way, (b) a decorative or imaginative way, and (c) an expressive way.
- 7. Which artworks have shades and dulled tones as important parts of the composition?
- 8. Select four artworks, and rank them in order of brightest to dullest use of color.
- 9. Which artwork is mostly made up of tints?
- 10. Find an artwork that is mostly cool colors, and describe its mood. Do the same with an artwork that is mostly warm colors.
- 11. Find the (a) happiest colors, (b) softest colors, (c) delicate colors, and (d) strong colors.

COLOR: IN THE CLASSROOM

These four art reproductions in the "Color Gallery" can help young children to identify and describe some ways that artists have used color: Paul Klee: Rolling Landscape; André Derain: London Bridge; Jan van Eyck: The Marriage of Giovanni(?) Arnolfini and Giovanna Cenami(?); and Andy Warhol: A Set of Six Self-Portraits.

QUESTIONS ABOUT COLOR FOR PRESCHOOL-AGE CHILDREN

Which artwork has faces of all different colors? (Warhol's) Do the faces look real? Why or why not?

Are there colors in the other pictures that make you feel happy? Why or why not?

Some colors make us feel warm—like we're sitting in sunshine. Can you find colors like that in any of these paintings? Which ones? Where?

Which painting uses the softest colors? (Klee's)

Which artwork uses the *strongest* colors? (Derain's)

In this picture (van Eyck's), what color is the little dog? Why is he so hard to see? (same color used behind him, so no contrast)

QUESTIONS ABOUT COLOR FOR EARLY SCHOOL-AGE CHILDREN

Which painting is very light? (Klee's)

When an artist mixes white with colors, he or she makes a "tint." Can you show me some places in these paintings where there are tints?

When an artist mixes black with a color, a "shade" is created. Can you show me some places in these paintings where there are shades?

Can you find some places where there are shades and tints right next to each other? Artists call that "contrast."

Which artwork has bright colors on one side and dark or dull colors on the other side? (van Eyck's)

QUESTIONS ABOUT COLOR FOR UPPER PRIMARY-AGE CHILDREN

Which artist painted a picture that looks real but with colors that are "unreal"? (Derain)

Colors that are across from one another (opposites) on the color wheel are called "complements." Can you find colors in these paintings that are complements? (red/green, blue/orange, yellow/violet)

Can you find places in the paintings where the artist used complementary colors right next to one another? (can be found in all the paintings)

In van Eyck's picture, why does the bride stand out more than the groom? (bright colors versus dull colors; the bride is against a complementary color while the groom is against beige/gray/neutrals)

Which artwork seems the most warm? The most cool? The darkest? The lightest? What is the mood of each artwork?

Before going on to the next section, look at other artworks in the "Color Gallery," and formulate questions about color that you might use with young children. Georges Seurat's Sunday Afternoon on the Island of La Grande Jatte and Franz Marc's Yellow Cow are particularly suitable for a dialogue focused on color concepts.

Value Value has to do with the lightness or darkness of a color in an artwork. Light colors, to which white has been added, are called tints. Dark colors, to which black has been added, are called shades. A value scale shows a gradual transition from a very light tint to a very dark shade. If an artwork is made up of lights and darks of one color, we say that it has a monochromatic color scheme, and this can contribute a great deal to the artwork's mood or emotion.

Some artworks, including pen and ink, charcoal, and pencil drawings, black and white photographs, and various forms of printmaking, depend a great deal on value alone and not on color.

With a gradual, blended transition from light to dark values in an artwork, artists can create the illusion of three-dimensional form. Sharp changes in value are seen on angular surfaces of buildings, and this helps us to see the buildings as three-dimensional. A strong directional light creates a great contrast in light and darks, which results in dramatic and expressive impact.

Changes in value can be achieved by shading techniques called hatching (many parallel lines), cross-hatching (crossed parallel lines), stippling (dots), or blending (smooth transition from dark to light).

The "Color Gallery" can help us to identify and describe some ways that artists have used value. There may be several different answers to the queries that follow. Discuss the reasons for your answers.

- 1. Picasso has used light and dark values of two colors in his painting *Family of Saltimbanques*. How would the mood of the artwork change if he had used five or six different colors instead?
- 2. Compare the use of value in Charpentier's Mlle. Charlotte du Val d'Ognes and Cassatt's The Bath.
- 3. Where are the light tints in Vermeer's *The Girl with a Red Hat?* Where are the darkest values?
- 4. In Kandinsky's *Painting No. 198*, we see a strong contrast of dark and light. How does this contribute to the feeling of movement and restlessness?
- 5. Select an artwork that has a dramatic impact due to the use of value, and explain the reasons for your choice.
- 6. Notice the dark and light areas created by the light striking the three-dimensional form of Modigliani's sculpture. Is the change of value gradual or sharp?

VALUE: IN THE CLASSROOM

These three art reproductions in the "Color Gallery" can help young children to identify and describe some ways that artists have used value: Pablo Picasso: Family of Saltimbanques; Lyonel Feininger: Zirchow VII; and Constance Marie Charpentier: Mlle. Charlotte du Val d'Ognes. (Note: Sometimes, value is more evident if the viewer squints while looking at objects or the artwork.)

QUESTIONS ABOUT VALUE FOR PRESCHOOL-AGE CHILDREN

Which artwork has dark places? Can you show me some dark places? Which artwork has light places? Can you show me some light places? Which artworks have light and dark places right next to one another? Can the girl who is drawing (Charpentier's picture) see her paper? Where is the light coming from? Where is there dark in the picture? Which picture is almost all dark? How does it make you feel?

QUESTIONS ABOUT VALUE FOR EARLY SCHOOL-AGE CHILDREN

Can you show me some tints (colors with white added) in some of the artworks?

Can you show me some shades (colors with black added) in some of the artworks?

Is there is a person in one of the pictures who seems to be sitting in a dark room? (Charpentier's) Where is the light coming from in the picture? Help me find some big, dark shapes that are around some objects. Can you trace the dark shapes with your finger?

Which artwork uses light and dark shapes of color that look very flat? (Feininger's)

QUESTIONS ABOUT VALUE FOR UPPER PRIMARYAGE CHILDREN

Which artwork has lights and darks of only two colors?

Can you find an artwork that has shapes of light and dark? (Feininger's) Do the shapes have *sharp* or *fuzzy* edges?

Do the other two artworks have any light or dark shapes with hard, sharp edges?

Some artists blend light and dark so that things look rounded. Can you find places in these artworks where this has been done? (heads, hands, bodies of people in Picasso and Charpentier's paintings)

Where are the areas of greatest contrast (lightest and darkest areas next to one another)?

Before going on to the next section, look at other artworks in the "Color Gallery," and formulate questions about value that you might use with young children. Jan Vermeer's Girl with the Red Hat and André Derain's London Bridge are particularly suitable for a dialogue focused on value concepts.

Line Line is thought of as a continuous mark or stroke made on a surface by a point of a moving tool, such as a pencil, crayon, or pen. It is usually associated with two-dimensional artworks, but it can also be an important part of three-dimensional art.

The usual way we think of line is in relation to **edges** or **contours.** Where one object stops and meets another, even if it is the air, an edge is formed. Some artists make definite outlines around the objects they draw or paint; others separate the shapes by different colors or textures.

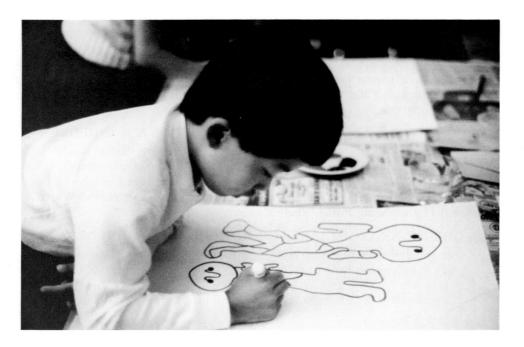

Whimsical line drawings are the result of an art activity motivated by a discussion on Joan Miró. Art heritage lessons designed for the young learner introduce concepts and vocabulary in meaningful ways.

Lines can be implied; that is, a line begins and may be interrupted, but its direction sends our eye on its journey through the composition anyway, filling in what is missing. The tool that the artist uses somewhat controls the line quality; a line made with a crayon is quite different from a line made with a pen or one made with a brush and ink. Likewise, the surface of paper lends different characteristics to line. Lines made on rough paper are quite different from those made on smooth paper, even if the drawing tool is the same.

Lines have direction—horizontal, vertical, diagonal—and different feelings and responses are suggested by each. Strength, stability, and dignity are communicated when artists use vertical lines. Horizontal lines, on the other hand, tend to remind us of restful, quiet, calm, peaceful things. When artists want to create tension or movement or even an illusion of action, they use diagonal lines. Such lines lead our eyes in slanting directions, upward, downward, or forward.

Other characteristics of line include whether the line is straight or curving, long or short, thick or thin, blurred and uneven, or sharp and clear-edged. If a line changes as it moves along and goes from thick to thin, it is a gradated line. Lines may meander, be continuous or broken. Lines may be repeated in a regular or random manner to create a pattern or to lend a feeling of rhythm to an artwork.

The "Color Gallery" can help us to identify and describe some ways that artists have used line. There may be several different answers to the queries that follow. Discuss the reasons for your answers.

- 1. Picasso used some definite contour lines in drawing the figures in *Still Life*. Find more artworks in which the artist used lines to separate some of the shapes. Find some artworks in which no lines were used to separate the shapes.
- 2. What kind of feeling do all of the straight, vertical lines give you in the *Empress Theodora and Retinue?* Can you find another artwork with many straight, vertical lines on the figures? Contrast the lines in these two artworks with the diagonal lines in *Zirchow VII*.
- 3. Marc used curving and diagonal lines in his *Yellow Cow*. How would your response to the artwork change if he had used only vertical and horizontal lines?

- Find important diagonal lines in the artworks by Degas, van Gogh, Derain, and Seurat.
- 5. How do the curving lines in Charpentier's Mlle. Charlotte du Val d'Ognes contribute to the mood?
- 6. Find artworks that have lines that could be described as (a) graceful, (b) bold, (c) angular, (d) smooth, and (e) thick.

LINE: IN THE CLASSROOM

These four art reproductions in the "Color Gallery" can help young children to identify and describe some ways that artists have used line: Mary Cassatt: *The Bath;* Georges Seurat: *Sunday Afternoon on the Island of La Grande Jatte;* Piet Mondrian: *Composition;* and Joan Miró: *Prades, the Village*.

QUESTIONS ABOUT LINE FOR PRESCHOOL-AGE CHILDREN

Can you find some lines that go up and down—the way we do when we stand up straight and tall? Where?

Which artwork has lines that look like stripes? (Miró's)

Can you find some lines that look like they are lying down? Where?

Where did the artists use curved lines? Straight lines? Wavy lines? Show me.

Where are some thin lines? Where are some thick lines? Where did the artist use both thick lines and thin lines in the same picture?

QUESTIONS ABOUT LINE FOR EARLY SCHOOL-AGE CHILDREN

Lines can go in many directions. Can you find vertical (up and down) lines? Can you find horizontal lines (ones that go across the picture)?

Which lines separate two areas of color? (several places, but especially the black lines in Mondrian's *Composition*)

Can you find some places where lines cross one another? (many places, but especially the painted black lines in Mondrian's *Composition*)

Lines have color. Where in the artworks can you find colored lines?

Which artwork uses lines to show the edges of things? (places can be found in all four paintings; the students should point them out)

OUESTIONS ABOUT LINE FOR UPPER PRIMARY-AGE CHILDREN

Lines that are repeated over and over again and go in the same direction form a pattern called "stripes." Which artwork uses striped patterns?

In which direction do the stripes go? (vertical, horizontal, and diagonal) Miró's painting uses lines that are repeated to form patterns. Can you point

out some of the patterned places?

Point out some lines in each of the artworks. What words would you use to describe these lines? (busy, heavy, sharp, wavy, swirling, moving)

What are the mother and child looking at in Cassatt's *The Bath?* Trace the invisible lines from their eyes to the bowl of water. What other lines can you find that lead your eyes toward the water? (stripes in mother's sleeve, child's straight arm and legs)

Before going on to the next section, look at other artworks in the "Color Gallery," and formulate questions about line that you might use with young children. Paul Klee's *Rolling Landscape* and Vasily Kandinsky's *Painting No. 198* are particularly suitable for a dialogue focused on line concepts.

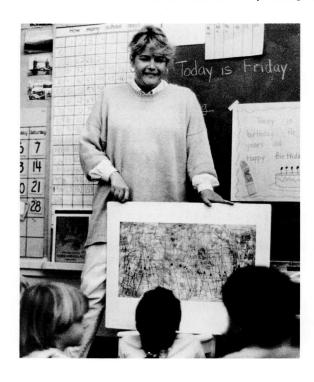

Students are eager to discuss the reproduction of a painting by Ben Shahn as the teacher directs questions about line and shape.

Shape/Form Shape is an enclosed space on a two-dimensional surface. When a line moves around and comes back and meets where it began, it creates a shape. Shapes may be determined either by a definite outline or by color or texture. Shapes may be flat, like a silhouette, or they may be shaded, so as to give the illusion of the form of solid three-dimensional objects in the real world. Shapes may overlap to give this illusion also.

Form has to do with three-dimensional artworks—sculpture, architecture, and craft objects.

Shapes can be described in many ways. They have size and can be large or small. They can have hard, crisp edges or soft, blurred contours. When the same shapes are repeated many times, they create a pattern. Shapes can be described as geometric and remind us of squares, rectangles, triangles, and circles. They can be organic or freeform and remind us of natural objects. When a number of similar shapes are close together in an artwork, they give us a feeling of closeness, unity, and compactness.

A shape that is realistic represents something we recognize in the real world, but sometimes artists simplify, distort, and change the shapes they see. This is called abstraction.

A positive shape in a composition is the object itself; the space that surrounds it is called the negative shape. Artists always want to make both of these shapes relate to each other harmoniously.

The "Color Gallery" can help us to identify and describe some ways that artists have used shape and form. There may be several different answers to the queries that follow. Discuss the reasons for your answers.

- 1. Mondrian used all flat geometric shapes in his Composition. Describe the shapes Matisse used in The Wild Poppies.
- 2. The geometric shapes of the buildings in Feininger's Zirchow VII give us a feeling of orderly arrangement. Find another artwork in which the shapes create this feeling.

- 3. Charpentier has given us the illusion of three-dimensional form in her *Mlle*. Charlotte du Val d'Ognes. Find two other artworks in which the realistic shapes and shading create this illusion.
- 4. Find a landscape in which the shapes are repeated in a decorative manner to create a pattern.
- 5. Describe Modigliani's limestone sculpture *Head of a Woman*. How do distortion and elongation contribute to the mood?
- 6. Find two landscapes in which the same shapes are repeated with variation.
- 7. Describe the variety of shapes in Picasso's *Still Life*. Can you find any hard-edged geometric shapes in Chagall's *Green Violinist?*
- 8. Shapes that are larger seem closer to us. Notice the two chairs in van Gogh's *The Bedroom at Arles*. Make similar observations about the shapes in Derain's *London Bridge* and Seurat's *Sunday Afternoon on the Island of La Grande Jatte*.
- 9. How is the form of Moore's *Reclining Figure* like natural objects? How would you decribe its form?
- 10. How do the shapes in Degas's *The Millinery Shop* contribute to a feeling of unity?
- 11. Compare the realistic shapes of the figures in van Eyck's *The Marriage of Giovanni(?) Arnolfini and Giovanna Cenami(?)* and Vermeer's *The Girl with a Red Hat* with the figures in Chagall's *Green Violinist*.
- 12. Find a painting with soft-edged shapes, and compare it with one with hard-edged shapes.
- 13. Discuss the variety and relationships of positive shapes and negative spaces in Moore's sculpture *Reclining Figure* and Picasso's *Still Life*.

SHAPE/FORM: IN THE CLASSROOM

These six art reproductions in the "Color Gallery" can help young children to identify and describe some ways that artists have used shape and form: Pablo Picasso: Still Life; Vasily Kandinsky: Painting No. 198; Henri Matisse: The Wild Poppies; Franz Marc: Yellow Cow; Henry Moore: Reclining Figure; and Amedeo Modigliani: Head of a Woman.

QUESTIONS ABOUT SHAPE AND FORM FOR PRESCHOOL-AGE CHILDREN

Where do you see a big blue shape? Can you find a little blue shape in the same picture? (Matisse's)

Can you find a shape that reminds you of a leaf? Of a butterfly?

Which artwork has the shape of a big animal? What is the animal? Can you find some little animal shapes in the picture, too? (Marc's)

Which artwork has many wiggly shapes? (Kandinsky's)

Which artwork has shapes that do not touch? (Matisse's)

Which artworks look like people? (Modigliani and Moore's)

Show me a place where there is a shape inside a shape.

Which artworks look very round? Which ones look very flat?

QUESTIONS ABOUT SHAPE AND FORM FOR EARLY SCHOOL-AGE CHILDREN

When a line comes around and meets where it began, it makes a shape. Find a line that makes a shape in Kandinsky's *Painting No. 198*. How many can you find?

Which artwork has many squares, rectangles, triangles, and circles? (Picasso's) Can you find some other shapes, too?

Do any of the artworks have shapes with hard edges? Soft edges?

(Kandinsky's painting has a wide variety)

What artwork looks as if it has shapes cut from paper? (Matisse's)

Which artwork looks very, very long? (Modigliani's)

Which artworks are flat? (the four paintings)

Which artworks are *not* flat? (the two sculptures)

QUESTIONS ABOUT SHAPE AND FORM FOR UPPER PRIMARY-AGE CHILDREN

The curving shape of Marc's *Yellow Cow* gives us a feeling of movement and action. Which other artwork has curved shapes? Does it seem as if it has action, too?

The two sculptures have forms that remind us of something familiar. What are they? (people)

In the photographs of the two sculptures, can you find forms that look like heads?

Which artist used lines and shapes to make a painting that does not look like anything? (Kandinsky) How would you describe the shapes in his artwork? In Matisse's *The Wild Poppies*, find an interesting shape in the space between the colored shapes.

Find an artwork that has distorted shapes. (Picasso's *Still Life* is particularly good)

In Picasso's *Still Life*, what shapes remind you of things in the real world? (some are recognizable as a vase, guitar, table) These are called abstractions.

Before going on to the next section, look at other artworks in the "Color Gallery," and formulate questions about shape and form that you might use with young children. The mosaic of *Empress Theodora and Retinue* and Lyonel Feininger's *Zirchow VII* are particularly suitable for a dialogue focused on concepts about shape and form.

Texture Texture refers to how things feel to the touch or to the illusion of how something would feel. An object's tactile quality is appealing. Through our sense of touch, we learn about the world. Some of the words we use to describe texture include soft, furry, rough, fluffy, smooth, bumpy, grainy, slick, and hard.

Actual textures are those surfaces that we can really feel. Sculpture, architecture, and craft objects often rely on actual texture as one of their main elements. The smoothly polished surface of marble or wood, the woolly feel of a woven tapestry, the shiny or rough feel of metal are all vital parts of such artworks. We tend to like variety in texture and choose different fabrics for our clothing and home furnishings. Some painters apply the paint to their canvases in such a way as to create an impasto effect; that is, thick paint applied in broad strokes or swirls creates a real texture.

Another kind of texture is visual or simulated. This kind is created by artists in two-dimensional artworks to give the illusion of real texture. Our eye is attracted to texture, so artists often include several contrasting textured areas or use an interesting texture to direct our attention to a focal point.

The "Color Gallery" can help us to identify and describe some ways that artists have used texture. There may be several different answers to the queries that follow. Discuss the reasons for your answers.

- 1. Compare the actual textural differences between Modigliani's *Head of a Woman* and Moore's *Reclining Figure*. How do the materials the artists used contribute to textural qualities?
- 2. Discuss the variety of simulated textures in van Eyck's *The Marriage of Giovanni(?) Arnolfini and Giovanna Cenami(?)* and Charpentier's *Mlle. Charlotte du Val d'Ognes*.

Actual "found textures" are combined in this scarecrow to create an inviting piece of sculpture. A nature-walk search for a variety of textured objects can lead to increased student awareness of tactile qualities and can expand children's vocabularies.

- 3. The mosaic *Empress Theodora and Retinue* is made up of thousands of very small pieces of glass or stone set in plaster. How do you think its texture contributes to its feeling of dignity and richness?
- 4. From which direction is the light coming that reveals the rich textures in Vermeer's portrait of *The Girl with a Red Hat?*
- 5. Compare the actual textures of the paint on the canvas in works by Derain, van Gogh, and Seurat. In which do you see brushstrokes? Which is made up of many tiny dots of color that give it a grainy texture?

TEXTURE: IN THE CLASSROOM

These four art reproductions in the "Color Gallery" can help young children to identify and describe some ways that artists have used texture: Amedeo Modigliani: Head of A Woman; Jan Vermeer: The Girl with the Red Hat; the mosaic: Empress Theodora and Retinue; Vincent van Gogh: The Bedroom at Arles.

OUESTIONS ABOUT TEXTURE FOR PRESCHOOL-AGE CHILDREN

Which picture shows something that is soft and fuzzy? (Vermeer's)

Which artwork would you like to touch? Why?

Touch something in the room that feels the way part of the artwork looks.

Which artworks would feel very hard if you could touch them? (Modigliani's and the mosaic)

Find the brushstrokes in van Gogh's painting, and imagine how the painting would feel if you could touch it.

QUESTIONS ABOUT TEXTURE FOR EARLY SCHOOL-AGE CHILDREN

Where in the artworks are there both rough and smooth parts? Which artwork looks as if the artist used very thick paint to make texture? (van Gogh's) How would you describe the textures of the girl's hat, coat, and blouse in Vermeer's artwork?

In which artwork can you see the artist's brushstrokes?

In the mosaic, we can see different kinds of textured clothing. If you could touch the mosaic, how do you think it would really feel?

QUESTIONS ABOUT TEXTURE FOR UPPER PRIMARY AGE CHILDREN

If the *real* artworks were here, which ones do you think would feel smooth? Which artwork has a great deal of visual texture but is probably fairly smooth? (Vermeer's)

Which artwork looks rather rough and is probably also rough to the touch? Which artwork shows the most variety of textures? Explain your choice.

Before going on to the next section, look at other artworks in the "Color Gallery," and formulate questions about texture that you might use with young children. Pablo Picasso's Still Life and Jan van Eyck's The Marriage of Giovanni(?) Arnolfini and Giovanna Cenami(?) are particularly suitable for a dialogue focused on concepts about texture.

Space Three-dimensional space is all around us, and such artworks as architecture, sculpture, and crafts are concerned with both functional and artistic ways of creating forms that have height, width, and depth. Artists who draw and paint on two-dimensional surfaces also deal with spatial concepts because they fit the objects and shapes they are creating into the format and limitations of the surface upon which they are working.

Through the ages, artists have found a number of ways to create the illusion of three-dimensional space on a flat two-dimensional surface. The easiest way to create this illusion of space is by overlapping. When one object covers part of a second object, the one in front seems closer. When artists make compositions with only a few overlapped objects to create depth, we say the composition has a shallow or flat space.

The size of various shapes is important in showing space. Larger shapes are seen as closer to us; smaller shapes seem farther away. Placement of shapes also contributes to the illusion of depth: Those objects closer to the bottom of the composition are seen as closer than those higher up. This works in reverse for objects in the sky: Those clouds or birds that are closer to the top of the picture seem closer to us than those nearer the horizon.

Details, colors, and textures of figures and objects that are close to us are more distinct, bright, and clear than those objects deeper in space. This is often called atmospheric or aerial perspective. During the Italian Renaissance, a period when artists were observing the world around them with freshness and clarity in an effort to draw and paint very realistically, painting distant objects in a hazy manner was called *sfumato*, meaning smoke.

Another way that artists are able to make objects look as if they exist in space rather than being flat shapes is through the use of directional lighting. This gives modeled form to three-dimensional objects in that the objects are shaded gradually from light to dark.

Converging lines also lead our eyes into the spatial depths of a picture. Renaissance artists learned that lines that we perceive in nature as being horizontal and parallel to each other tend to converge at a point on an eye-level line called the vanishing point.

The "Color Gallery" can help us to identify and describe some ways that artists have used space. There may be several different answers to the queries that follow. Discuss the reasons for your answers.

- 1. Describe the way that Mondrian has divided the surface space in his Composition, and then compare with Klee's use of space in Rolling Landscape.
- 2. In Yellow Cow, Marc used overlapping to show space. Which ways of showing depth did he not use?
- 3. Would you describe the space in Picasso's *Still Life* as shallow, flat, or deep? Compare Picasso's use of space with that in the mosaic *Empress Theodora* and Retinue.
- 4. Measure the closest, tallest figures in the foreground of Seurat's Sunday Afternoon on the Island of La Grande Jatte. Then measure a figure a little higher up in the middle ground; then a figure still higher up in the background.
- 5. In Mlle. Charlotte du Val d'Ognes, how did Charpentier treat the building and figures seen through the window to make them seem far away?
- 6. Vermeer and van Eyck used directional lighting to show modeled forms of figures. Can you find any other artworks in which this device was used to depict space?
- 7. Find the converging lines and vanishing point in van Gogh's *The Bedroom at Arles* and Derain's *London Bridge*.
- 8. In *Prades, the Village*, Miró did not choose to show space in a highly realistic manner. Describe the ways she depicted distance.
- 9. Describe Seurat's use of aerial perspective in Sunday Afternoon on the Island of La Grande Jatte, and compare it with Chagall's Green Violinist.

SPACE: IN THE CLASSROOM

These four art reproductions in the "Color Gallery" can help young children to identify and describe some ways that artists have used space: Marc Chagall: *Green Violinist;* Edgar Degas: *The Millinery Shop;* Vincent van Gogh: *The Bedroom at Arles;* and Henry Moore: *Reclining Figure*.

QUESTIONS ABOUT SPACE FOR PRESCHOOL-AGE CHILDREN

Find the picture that looks as if people are walking on air. (Chagall's) Why does it look that way?

Which person in Chagall's artwork looks closest to us? Why? (size)

Which artworks show an inside place? (Degas and van Gogh's) How do you know it is inside?

Which artwork looks as if it has holes in it? (Moore's)

How do you think the sculpture would look without the holes—heavier or lighter? More like a person or less like a person?

QUESTIONS ABOUT SPACE FOR EARLY SCHOOL-AGE CHILDREN

Look at the two chairs in van Gogh's bedroom. Which one looks closer? Why? (bigger)

Describe all the things that are in front of the girl in *The Millinery Shop*. (counter, hats)

Is your bedroom bigger or smaller than van Gogh's? What makes you think

Two of the paintings have people in them. Which of the people look furthest away? Why? (small figures in Chagall's painting because of size and placement higher in the picture)

What words would you use to describe Henry Moore's sculpture that would tell us about its size and weight? Can you point out some spaces inside the artwork?

QUESTIONS ABOUT SPACE FOR UPPER PRIMARY-AGE CHILDREN

Which artist has used space so that the painting looks like a dream? (Chagall) What is dreamlike about the space in the picture?

Which hat in *The Millinery Shop* looks furthest away? (the one with red trim) Why? (it is the smallest, highest, and dullest in color of the hats; it is also overlapped by others)

What has van Gogh done with the edges of the floor, bed, and other furniture to give the feeling of space? (the edges seem to come together as they approach the back wall of the bedroom)

Which artwork seems to have the most depth? Why?

Sculptors use space in their artwork, too. Find space around and inside Moore's *Reclining Figure*. How would you describe this space?

Before going on to the next section, look at other artworks in the "Color Gallery," and formulate questions about space that you might use with young children. Jan van Eyck's The Marriage of Giovanni(?) Arnolfini and Giovanna Cenami(?), Constance Marie Charpentier's Mlle. Charlotte du Val d'Ognes, and Seurat's Sunday Afternoon on the Island of La Grande Jatte are particularly suitable for dialogue focused on concepts about space.

Principles of Art

The principles of art are the ways that artists organize and arrange the elements of art to create a painting, sculpture, piece of architecture, or craft object. The artist strives for a harmonious use of the elements of art. The principles of art are: balance, emphasis, proportion, movement, rhythm/repetition/pattern, and variety and unity.

Balance Balance has to do with a visual feeling of weight that we see and feel when we look at an artwork. There are two kinds of balance: formal and informal. Formal or symmetrical balance is when one side of an artwork is exactly like the other side—a mirror image. If architects wish to design a building in which serious, dignified activities take place, one in which a feeling of formality and stability is to be achieved, they may choose this sort of balance. Many government buildings and churches show formal balance. Balance that is almost symmetrical is called approximate balance.

Informal (or asymmetrical) balance, on the other hand, creates a sense of equilibrium, even though both sides of the artwork are different. Artists usually use informal balance in making paintings, and they find many different ways of achieving it: They may balance one large shape against several small shapes, or a small, roughly textured, or patterned area with a large, smooth, or plain one. A dark value of a color seems heavier than a light color. Bright colors attract our attention more so than do low-intensity colors. Warm colors appear heavier than cool colors. More-complicated shapes catch our eye and thus appear heavier than those with simpler contours.

The "Color Gallery" can help us to analyze some ways that artists have used balance. There may be several different answers to the queries that follow. Discuss the reasons for your answers.

 What kind of feeling does the formal balance of Modigliani's Head of a Woman create?

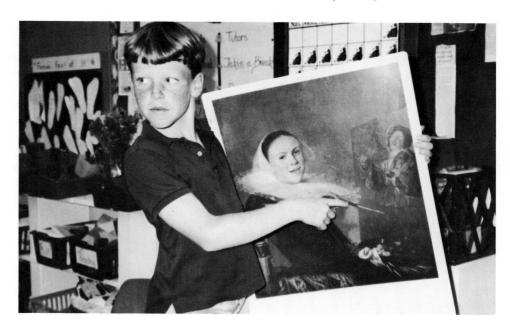

Students analyze Judith Leyster's *Self-Portrait* to determine several ways that the artist created main and secondary centers of interest.

- 2. Compare the ways in which balance was achieved in the mosaic *Empress Theodora and Retinue* and in van Eyck's *The Marriage of Giovanni(?) Arnolfini and Giovanna Cenami(?)*
- 3. Find the shapes in Marc's Yellow Cow that create a comfortable feeling of informal balance.
- 4. How did Matisse vary the shapes to achieve balance in The Wild Poppies?
- 5. Look at Kandinsky's *Painting No. 198* upside down and sideways, and discuss how he achieved balance.
- 6. In what way did Feininger achieve balance in *Zirchow VII?* Does this create a calm feeling?
- 7. Picasso's complicated *Still Life* is balanced in many ways. Find three of the ways.
- 8. Is the feeling of balance comfortable or uncomfortable in Picasso's Family of Saltimbanques? Why?
- 9. In Chagall's *Green Violinist*, the figure is in the center. What shapes and colors did Chagall use to achieve a feeling of balance?
- 10. What part do shapes and their repetition have to do with balance in Seurat's Sunday Afternoon on the Island of La Grande Jatte and Degas's The Millinery Shop?
- 11. Discuss how, in *Composition*, Mondrian balanced the larger white areas with the smaller areas of color.

Emphasis Artists have many ways to emphasize what they want us to see within an artwork. The center of interest, or focal point, is the main part of the composition and usually the part that we see first when we look at an artwork. This area dominates the other parts of the composition. Normally, we are drawn immediately to the center of a picture, but most artworks do not have the focal point in this position as it is a rather static and even humdrum arrangement. Most artists place the emphasis to the right or left of center and use various means to establish a feeling of balance.

The subject matter of an artwork is what usually catches our eye first. As human beings, we are drawn to images of other human beings, especially their faces, and most especially, their eyes. So this is often a focal point. If the subject matter is unusual or at least treated in an unusual, surprising, or even shocking manner, that area becomes dominant.

Contrasting elements can catch our eye, too. The lighting in the composition can create strong contrasts of lights and darks that arrest our attention. Likewise, an intricately textured or patterned area can create an emphasis. Many artworks use the color red to focus attention on a special area.

Many artworks use "pointers," such as someone's uplifted arm or lines that take our eye in a given direction. Even someone's eyes within the composition, if looking in a particular direction, make our eyes follow them in the same direction. Converging lines created by the illusion of perspective direct our path of vision to a focal point as well.

Isolated elements, perhaps a figure or object set apart from the other parts of the curriculum, also tend to attract our attention.

The "Color Gallery" can help us to analyze some ways that artists have used emphasis. There may be several different answers to the queries that follow. Discuss the reasons for your answers.

- 1. In Cassatt's *The Bath*, notice the heads of the woman and the child. They are the darkest areas, and they are looking down to the pan of water. What other devices direct your eyes to the secondary focal point?
- 2. Can you discover three ways in which Vermeer created a center of interest in *The Girl with a Red Hat?* Compare Vermeer's painting with Charpentier's *Mlle. Charlotte du Val d'Ognes*.
- 3. What do you perceive as the focal point in Kandinsky's *Painting No. 198?* What directs your attention to it?
- 4. Are there any directional pointers in Chagall's Green Violinist?
- 5. Analyze the use of value and color in Derain's London Bridge.
- 6. In Yellow Cow, what means did Marc use to emphasize the cow?
- 7. How do the shapes and negative spaces combine to create an emphasis in Moore's Reclining Figure?
- 8. What is the focal point in Degas's The Millinery Shop? How is it achieved?
- 9. Can you find any artworks that achieve emphasis through isolation?
- 10. Find two artworks that show emphasis through contrast.
- 11. Describe how Modigliani has attracted our attention through an unusual treatment of the facial features in *Head of a Woman*.
- 12. Can you find any artwork in which the center of attention is in the center of the composition?

Proportion Proportion involves the relationship of one part to another. Long ago, people in ancient Greece sought a perfect proportion that would establish a rule, a mathematical formula to compare sizes, that could be used for perfect results in whatever kinds of artworks they created. The ratio they developed was called the Golden Section. Artists today are free to use it or not, of course, but generally it results in a harmonious relationship of the various parts of an artwork.

A figure or face has realistic proportions when it closely resembles what we see. If artists wish to be expressive and communicate a feeling, mood, or emotion, they often distort, exaggerate, or elongate the proportions. Such deviations can sometimes be quite decorative.

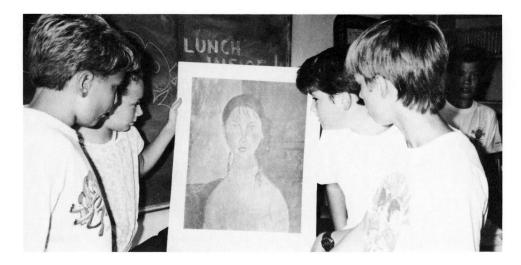

Students respond to Modigliani's painting by describing and analyzing the lines, shapes, and colors to determine what part they played in establishing the mood of the artwork.

The proportion of the average adult is about seven-and-a-half heads high. Children are about five or six heads tall, and a baby is three heads long. When artists depict the human figure, they may choose to use realistic proportions or to change them to suit their needs.

The proportions of the face likewise follow certain guidelines for a realistic portrayal: The eyes are halfway between the chin and top of the head. The eyes are an eye-width apart. The nose is about an eye-width long. If lines are extended downward from the middle of the eyes, they establish the corners of the mouth. The ears are on a line with the top and bottom of the nose. Once again, artists change, distort, elongate, and exaggerate the size and location of the features in many different ways.

The "Color Gallery" can help us to analyze some ways that artists have used proportion. There may be several different answers to the queries that follow. Discuss the reasons for your answers.

- 1. In the artworks, find some figures that seem to have realistic proportions. Check to see if the figures are about seven-and-a-half heads high.
- 2. If Modigliani had used realistic proportions in his *Head of a Woman*, where would he have placed the eyes in his sculpture? How would that have changed the feeling of his work?
- 3. Do the proportions of the figures in Picasso's Family of Saltimbanques appear to be realistic or elongated? Does this contribute to the mood?
- 4. Analyze the proportion of lights to darks in Feininger's Zirchow VII. Compare this kind of relationship in Warhol's A Set of Six Self-Portraits.
- 5. Which figure in the mosaic *Empress Theodora and Retinue* is the tallest? Why do you think the artist made this figure taller than the others?
- 6. In Composition, what kind of size relationship of parts did Mondrian use?

Movement When we speak of movement in an artwork, we generally refer either to the illusion of movement or to the ways our eyes move around the composition, since the only kinds of artworks that have actual movement are mobiles and motion pictures.

Simulated movement creates in the viewer the feeling of action and can be accomplished in a number of ways. Artists can create paintings or sculptures that show figures running or jumping, and the effect can be rather static and stiff, or quite realistic. Shapes and lines can be repeated in a flowing, sweeping, swinging manner. A

progressive arrangement of shapes moving from large to small can create a restful, relaxing feeling of movement or a jerking, mechanical one. Diagonal lines can contribute to a downward, upward, or powerful movement.

Even though the subject matter itself may not be one that suggests action, artists can combine different elements that cause our eyes to move or sweep over the composition, directing our eyes from one point to another.

The "Color Gallery" can help us to analyze some ways that artists have used movement. There may be several different answers to the queries that follow. Discuss the reasons for your answers.

- 1. Choose an artwork that suggests actual movement, and describe how the artist depicted it.
- 2. Analyze the way your eyes move around through Klee's *Rolling Landscape*. Compare the path your eyes take with a classmate's.
- 3. What contributes to the feeling of movement in Marc's Yellow Cow. Do you sense movement in Feininger's Zirchow VII?
- 4. Kandinsky's Painting No. 198 is far from static. Describe its movement.
- 5. Explain how the vertical lines and shapes give a quiet, static feeling in both Seurat's Sunday Afternoon on the Island of La Grande Jatte and the mosaic Empress Theodora and Retinue.
- 6. How do the round shapes and vertical lines move your eye around Degas's *The Millinery Shop?*
- 7. Let your eyes follow the curving shapes in Moore's *Reclining Figure*, and describe how the positive and negative shapes guide the ways your eyes move.
- 8. What makes the water seem to be moving in Derain's London Bridge?
- 9. How many words can you use to describe the feeling of movement in Kandinsky's *Painting No. 198?* What elements of art were used to create this feeling?

Rhythm/Repetition/Pattern Rhythm refers to a regular or harmonious pattern that is created by the repetition of a line, shape, or color. The unit that is repeated is called a motif, and it creates a decorative allover pattern. Patterns can be regular or irregular, even random, depending upon the manner in which the motif is repeated. They can also be gradated, going from a large motif to a small one. A pattern can consist of alternating motifs and colors. Patterns can flow and lead our eyes around a composition. Patterns provide decorative effects and surface enhancement. They attract our eyes. Some patterned areas simulate texture, and sometimes, surface patterns help to reveal the illusion of a form beneath them.

The "Color Gallery" can help us to analyze some ways that artists have used pattern. There may be several different answers to the queries that follow. Discuss the reasons for your answers.

- 1. Find three different areas of pattern in Miró's *Prades, the Village*. How are the patterns varied?
- 2. Look at Cassatt's *The Bath* and Chagall's *Green Violinist*. In which one does the pattern of the clothing reveal the form of the figure underneath?
- 3. In addition to the clothing pattern, Cassatt has shown three other patterned areas in her composition. Find them.
- 4. The mosaic *Empress Theodora and Retinue* is rich in patterned areas. Look for four different motifs that are repeated.
- 5. In van Eyck's *The Marriage of Giovanni(?) Arnolfini and Giovanna Cenami(?)*, what contributes to a feeling of rhythm?
- 6. Similar shapes are repeated in Matisse's *The Wild Poppies*. What kind of pattern do they create?

- 7. What effect do the repeated yellow brushstrokes in the water have in Derain's London Bridge? What about the repeated arch shapes of the bridge itself and the repetition of the buildings?
- 8. In Degas's *The Millinery Shop*, how does the point of view relate to the repetition of shapes? How is variety achieved?
- 9. What shapes are repeated in Feininger's Zirchow VII?
- 10. Describe how Warhol varied his motif and created a pattern in A Set of Six Self-Portraits.

Variety and Unity Variety is concerned with differences, such as differences in sizes of shapes, in shades and tints of a color, in contrasting textures, and so on. Lines can show variety by being thick or thin, straight or curving. An artwork is boring if it has too much sameness, yet too much variety creates a chaotic effect.

Unity is the feeling that the artwork gives us when we look at it and know that nothing should be added, taken away, or changed. All of the different parts seem to belong together. Colors do not jar us; they harmonize. Nothing seems out of place or superfluous. The technique or style of the artist is harmonious with the subject matter, theme, or mood. Sometimes, an artist repeats the same shape, color, line, or texture throughout the composition to achieve unity since our eyes like to move from one color or shape to a similar color or shape. Limiting the number of colors or the different kinds of shapes also helps an artist to achieve unity, as does grouping similar shapes closely together, letting them overlap and cluster.

The "Color Gallery" can help us to analyze some ways that artists have used variety and unity. There may be several different answers to the queries that follow. Discuss the reasons for your answers.

- 1. Find two artworks in which the artist limited the number of colors to three or four. Discuss how the unified effect would have changed had the artist used seven or eight different colors.
- 2. Similar shapes are repeated throughout Feininger's Zirchow VII. Find another painting in which similar shapes contribute to the feeling of unity.
- 3. Look closely at the figures in the mosaic *Empress Theodora and Retinue*. How is each one varied? With so much variety, how did the artist achieve unity?
- 4. What if Chagall had used the same bright colors for his background that he used for the violinist in *Green Violinist*? Would he have achieved more unity or less unity?
- 5. How do the brushstrokes contribute to the feeling of unity in van Gogh's *The Bedroom at Arles?*
- 6. Notice the variety in the shapes, colors, and positions of the hats in Degas's *The Millinery Shop*. What would the effect have been had he painted all the hats the same color and shape?
- 7. Do you think that Seurat's Sunday Afternoon on the Island of La Grande Jatte has a great deal of variety and unity? Explain your answer.
- 8. Do you think that Mondrian's *Composition* has more variety or more unity? Why?
- 9. Are the colors and shapes that Marc used in painting the Yellow Cow in harmony with his theme? Compare with the colors in Charpentier's Mlle. Charlotte de Val d'Ognes. What if Charpentier had used the bright colors that Marc used?
- 10. Picasso used a variety of different values of red and blue for his group portrait of a family. Does his choice seem in harmony with the mood of the subject matter? Compare it with Chagall's *The Green Violinist*.
- 11. Would you say that Warhol's A Set of Six Self-Portraits has too much variety or too much unity?

Getting Acquainted with Artworks: Strategies for Art Criticism and Art Heritage

Commentary and questioning strategies that involve both art criticism and art history should be fused and intermingled in helping children to respond to and understand artworks.

When we look at an artwork and think in terms of art criticism, all of the information is before us and contained within the painting, drawing, or piece of sculpture. However, we need to turn to outside sources, such as books or informed persons, to find information relative to art history. Both art criticism and art history commentary encompass:

- 1. Description
- 2. Analysis
- 3. Interpretation
- 4. Judgment

Description

Art history tells us when, where, and by whom the work was done. If we are looking at a small reproduction, it is helpful to know the actual size of the original and perhaps where it is located. We should know if the medium was oil, pastels, watercolor, encaustic, wood, stone, etc.

Art criticism asks us to look carefully and thoughtfully at the artwork and describe the subject matter. We note if the artwork is a landscape, portrait, still life, or abstraction and study its technical properties (broad sweeps of watercolor washes, thick application of brushstrokes, chisel marks in the wood, and so on). We also identify and describe the elements of art, using such words as:

Color: Primary, secondary, intermediate, complementary, analogous, tints, shades, neutrals, warm, cool, bright, intense, dull, dark, light, glowing, soft, harmonious, flat, modeled, monochromatic, decorative, clashing, representational, realistic, symbolic, imaginative

Value: Very dark, medium dark, light, gradated, dramatic, expressive, blended, hatched, crosshatched, stippled, modeled, distance, shadows

Line: Straight, horizontal, vertical, diagonal, curving, smooth, broken, fuzzy, blurred, spiraling, jagged, thick, wide, thin, sharp, graceful, contour, bold, long, short, thick to thin, continous, meandering, sketchy, hatched, angular, nervous, energetic, delicate, strong, gesture, implied, actual, zigzag, outline, sketchy, firm, smooth, tense, parallel, rough, branching, confusing, stable, stiff, calligraphic, perspective, realistic, abstract, distorted, decorative, gradated

Shape/Form: Angular, circular, geometric, free-form, soft-edged, hard-edged, large, small, gradated, repeated, outlined, natural, distorted, threatening, irregular, positive, negative, light, heavy, silhouette, decorative, symbolic, realistic

Texture: Rough, smooth, shiny, soft, fuzzy, feathery, bumpy, actual, real, simulated, illusion, slick, grainy, fluffy, matte, inviting

Space: Deep, flat, shallow, overlapping, distant/lighter, distant/smaller, distant/less detail, distant/higher, negative, perspective, realistic, distorted

Analysis

Art history tells us what is special about the artwork, compared to and contrasted with those features found in other artworks. This helps us to determine the work's artistic style.

Art criticism asks us to respond to the artwork by perceiving how it is organized and put together. Here, we focus on how the principles of art have been used to arrange the elements of art and use such words as:

Balance: Formal or symmetrical, informal or asymmetrical, approximate, radial, comfortable, uncomfortable, casual, calm

Emphasis: Focal point, center of interest, dominant, less important, location, convergence, isolation, contrast, triangular, center, off-center, eyes, face, shocking or surprising subject matter, directional lines, eye-leading lines, pointers

Proportion: Relationships, bright to dull, large to small, dark to light, rough to smooth, realistic, unrealistic, distortion, exaggeration, elongation

Movement: Actual, simulated, illusion, stiff, frozen, swinging, sweeping, optical, shifting, mechanical, flowing, random, progressive, linear, repeated shapes, circular, dizzy, diagonal, downward, upward, triangular, animated, realistic, powerful, rhythmical

Rhythm/Repetition/Pattern: Decorative, motif/module, lines, shapes, colors, gradated, monotonous, dull, lively, realistic, flowing, surface enhancement, structural, revealing form, regular, irregular, random, intriguing, optical, simulating texture

Variety: Of color, line, shape, texture, value, size; contrast; differences; placement; monotonous; dull; chaotic; too much; not enough

Unity: Complete and harmonious, too much or too little harmony among elements or between subject matter and style, simplicity

Interpretation

Art history tells us how artists were influenced by the world around them. When and where they lived and the events, values, and attitudes of their immediate culture influenced the direction of their artwork. Information about an artist's background, friends, personality, and outlook on life helps us to understand why the artist created in the manner he or she did. Art history tells us why the artwork was created and why the artist chose to work in a particular mode.

Art criticism asks us to react to the emotions, feelings, moods, and ideas communicated by the artwork. This is a highly personal reflection and is influenced by many factors. We endeavor to understand what it is within the artwork that elicits a particular response—the kinds of colors or lines, the brushwork, the sense of chaos or movement achieved, the subject matter itself, as well as our own background and previous experiences.

Some of the words that we may use in interpreting artworks include: humorous, vigorous, peaceful, joyous, sad, poetic, religious, restless, quiet, frightening, dreamlike, charming, mysterious, perplexing, hostile, warm, loving, playful, narrative, propaganda, energetic, angry, recording a likeness, and recording an event.

Judgment

Art history helps us to understand why an artwork is considered important. Factors affecting the significance of a particular artwork may include the artist being the first to create art in a particular manner and having many followers, or a particular artwork having a powerful effect on religion, political life, and so on. We learn from art history what influenced a particular artist and how that artist, in turn, influenced other artists.

Art criticism asks us not to merely express a personal preference for an artwork but to make a decision regarding the artwork's artistic merit. To make an appropriate judgment of an apple, we do not taste it and state that it is not a good apple because it does not taste like pumpkin pie; it is not pumpkin pie and must be judged instead on its "appleness" quality. The same thinking applies when judging an artwork in relation to artistic styles, and our final evaluation should be in the spirit of stating, "I like it (or don't like it) because . . . ," rather than "Because I like it (or don't like it). . . ."

Four styles of art are often referred to in this regard:

- 1. Representationalism or realism: Artists strive to achieve a literal imitation of the subject matter before them. An artwork is successful if it looks like and reminds us of what we see in the world around us.
- 2. Expressionism/emotionalism: Artists feel that their most important objective is to communicate moods, feelings, and ideas in vivid and powerful ways. To do this, they often distort and exaggerate shapes and use unrealistic colors.
- 3. Abstraction/formalism: Artists strive to effectively organize the elements of art through the use of the principles of art. Their compositions may or may not include any real people or objects.
- 4. Surrealism/fantasy and dreams: Artists endeavor to show us the world of the imagination, even the subconscious, often basing their images on realistic objects but presenting them in unlikely situations, combinations, and connections.

A Model for Art Criticism/Art Heritage

Let us use Marc Chagall's *Green Violinist* in the "Color Gallery" to model our strategies for art criticism and art heritage.

Description

"This oil painting, by Marc Chagall (1889–1985), is quite large: 78 by 42¾ inches. It is in the Guggenheim Museum in New York. It was painted in 1923–1924. I see a man sitting down and playing a violin. He takes up most of the space in the picture. His head is tipped to one side. There are some small houses behind his head, some clouds, and a floating figure. Beneath his feet are some more houses, a tree, ladder, bird, and a dog with its paws on the rooftop. There is another small figure at his side. The most important colors are purple, orange, and green—the secondary colors. The background and smaller figures are in light neutrals. The purple coat has dark and light values of purple in somewhat triangular shapes. The man's face and one hand are green. The violin is orange. There are no outlines around the shapes. Small, square shapes are repeated in his pant legs and in the windows of the house. I can't see any brushstrokes; the colors seem to be blended smoothly."

Analysis

"This artwork is quite different from a number of other artworks in that it relies on fantasy and imagination and has strange, unlikely, and unusual things happening that make me wonder what is going on—for example, the floating figure, the strange relationships of sizes, and the positions of figures, houses, the dog, and so on. The center of interest or emphasis is the violinist himself. My eyes go directly to him because of his central location and size. I especially see his face because it contrasts strongly with the other colors and is bright green instead of a realistic flesh color. The black lines on the violin lead my eyes to his face also. The repeated triangular shapes in his coat almost make my eyes dance upward in a rhythmical and undulating manner to his face and hand. The roundish shapes of the clouds are a pleasing contrast to the blocky shapes of the buildings. The houses and objects in the lower portion balance those at the top. The proportions are unrealistic but add to the feeling of fantasy and dreams. The strong, intense colors contrast with the lighter, neutral colors."

Interpretation

"Chagall was born to a rather poor Jewish family in a tiny village in Russia. He referred to his childhood as being both sad and happy. His family saw to it that he had art lessons. When he grew up, he always painted in a very personal style, using bright colors and taking his subject matter from his childhood memories of folk tales and fantasy. His paintings often tell of a dream world where delightful fairy tales come true and the laws of gravity are overturned. His art is a happy mixture of reality, dreams, nostalgia for his childhood, and fantasy. He delighted in nature and in music. I think that, if I could 'walk into this picture,' I would hear some happy, vibrant music. I would probably hear the dog barking to the beat of the tune. I might even try flying myself as the mood makes me feel lighthearted and free. I keep looking at it and wondering and dreaming. The colors are happy and strong."

Judgment

"Chagall has been called a magic surrealist, and his colors and use of fantasy influenced other artists considerably, especially postwar German artists. He had a genuine love of humanity and designed stained glass artworks also, giving them to the United Nations, the Jerusalem Synagogue, and opera houses in Paris and New York. This painting seems to be quite successful in its expressive content, and he also achieved a fine balance and harmonious relationship in his use of colors and shapes. I think he was concerned with fantasy and with the way he was organizing the colors and shapes that he used. The artwork communicates a lilting poetic feeling of fantasy by not being painted in a highly realistic manner. I keep looking at it again and again, pondering and delighting in its mood."

Motivational Strategies for Eliciting Student Responses to Artworks

When responding to artworks is the focus of the lesson (whether the artworks are originals being viewed in a museum or are reproductions), children need to be as close as possible to the artworks to see details and to prevent them from becoming distracted. Small children are often comfortable seated on the floor near the display.

The following tips and activities are very successful in helping children to respond to artworks during a class presentation:

- 1. With a "magic paintbrush" for a pointer, the teacher or the children can point to different details in an artwork, such as all the places the artist used red, all the roundish shapes, and so on. The magic paintbrush can also be used to show how technical properties were achieved—how the brush left a path called a brushstroke and how some brushstrokes overlap and swirl and how some are little daubs of paint. The magic paintbrush is also useful for tapping children's shoulders to let them take turns at having "magic artist eyes" and telling something that they see that no one else has yet mentioned. A "magic paintbrush" is made by covering the handle of the brush with glue and sprinkling it with glitter. Children who have the opportunity to use the "magic paintbrush" frequently notice that some of the "magic" is left on their hands after they have used the brush! A long "super brush" can also be used effectively as a pointer. It is made by attaching about 2 or 3 feet of dowel stick to the ferrule of a brush.
- 2. One aspect of reading readiness is developing the ability to sequence: what happened first, what happened next, and so on. The teacher can start a story about an artwork and have students add on to the story after they are tapped on the shoulder with the "magic paintbrush." Another aspect of reading deals with having students grasp the main idea of a paragraph or story. Thinking in terms of "the big idea" or important concept can also be visual when students are asked to name an artwork before they are told the actual name that the artist gave it. Or they can be encouraged to rename the artwork.
- 3. Students must use left-brain memorization a great deal, that is, memorizing spelling words and math combinations. Visual memory skills can be developed by asking the students to sit very quietly for fifteen or twenty seconds and memorize an artwork. Then the artwork can be turned around and the students asked to describe it, or they may enjoy making up questions about it to ask their friends.
- 4. The teacher can ask students to tell how two or more artworks are alike and how they are different. The students may find differences and similarities with regard to subject matter, the elements and principles of art, the mood or feeling of the paintings, the artist's technique and style, the degree of realism, and so on. Unusual responses and fluency should be encouraged.
- 5. The students can be asked to enter a painting with their "magic artist eyes" and "take a walk." They can use the "magic paintbrush" as a pointer. The path will be the direction their eyes follow, going from one shape, line, or color to another. and moving back and through the space of the composition. Different children will take different "walks." "Magic artist eyes" do not need to have legs to walk; they can climb trees and leap across clouds if that is the way the artist has related the lines and shapes in a composition.
- 6. Students can be asked to imitate a pose or a facial expression in an artwork. Several students can imitate a group pose. This involves the students kinesthetically and helps them to identify emotionally with the figures and scene.
- 7. After students have viewed a number of artworks and had sufficient time to understand and respond to them, they can take turns "selling" an artwork to the rest of the class, with a time limit of twenty or thirty seconds. Students should base their sales pitch on the way the artist was able to show movement, express a feeling of excitement or loneliness, show a great deal of fantasy or imagination, show realistic textures, and so on.

- 8. At the conclusion of a discussion about an artwork, the students can take turns using a word or short phrase to describe the artwork. The first child may say, "bright colors." The second child might say, "bright colors and black outlines." The third child repeats what the first and second children said and adds another word or phrase.
- 9. The teacher can cover an art reproduction with a piece of butcher paper in which several small openings that reveal details of the painting have been cut. If only an eye is showing, students should guess what the rest of the person looks like. The artwork should remain covered a day or two. Before the teacher removes the butcher paper, the students can use crayons and draw on the butcher paper what they think might be beneath it.
- 10. The teacher prepares small cards to serve as "awards" and, on each, writes one of the following terms (or similar ones): lonely feeling, lots of movement, strong vertical lines, cool colors, geometric shapes, and so on. When the students have finished looking at a thematic grouping of prints, the teacher holds up one award, and the class votes on which painting should receive that award.
- 11. Some artworks are fairly easy to "reconstruct." The students can guess as to what they think the artist did first in making the artwork, what the artist did next, and so on.
- 12. A sheet of clear mylar or acetate is placed over the reproduction to cover the reproduction entirely. Then, with a black, water-soluble marking pen, the teacher or the students can draw all the places where contour lines, diagonal lines, negative areas, oval heads, and so on are seen. Pen marks can be wiped off with a damp paper towel.

For Discussion

- 1. Using a large reproduction of an artwork, discuss the elements of art and how the artist used them.
- 2. What is the difference between shape and form? Study both two-dimensional and three-dimensional art reproductions, and discuss the characteristics of positive and negative space in each.
- 3. In each of the sections that list sample questions to ask young children about works of art, formulate at least one additional question of your own.
- 4. Use the "Color Gallery" to formulate questions for very young children that would concentrate on the principles of art.
- 5. What are the four components of commentary that emphasize both art criticism and art history? Using the art reproductions from questions 1 and 2, list possible vocabulary and questions that might be suitable for very young children.
- 6. What is the difference between art criticism and art preference?
- 7. Use the "Color Gallery" to find examples of the four styles of art.
- 8. Select one artwork from the "Color Gallery," and formulate questions that might be useful in guiding a discussion with young children. Concentrate on description, analysis, interpretation, and judgment.
- 9. Plan a new motivational strategy that would utilize sequencing.
- 10. Describe a concept that was introduced in this chapter that is completely new to you and that you perceive as being particularly useful as you interact with young children.

Reaching Out: Accessing Artworks

Art is like a border of flowers along the course of civilization.

LINCOLN STEFFENS

It is through early contact with art and artists that children's attitudes and concepts form. Young children are ready to find and enjoy art in their community. This discovery can be facilitated in several ways.

Museums and Galleries

Most of the larger cities and towns in the United States have small galleries and a museum or two that offer exciting viewing potentials for field trips. Some museums have specially designed rooms, or galleries, or exhibits for elementary schoolchildren. Visits to museums and galleries, when begun early, can become a lifelong habit and a source of enjoyment.

Teachers should obtain information from the museum before scheduling a field trip. The museum will probably send some written information or slides to use in preparing the children for the trip. When the children arrive at the museum, a volunteer docent who is trained in talking with children about the museum and about the artworks they will be seeing may be provided. Most museums are enormous places, and it is advisable to check ahead of time and request a short viewing of perhaps only one gallery so as not to lose the children's interest and attention before their energy is depleted.

Young children should be in small groups and briefed on "museum manners" before they go. They need to understand that they may only "touch" the artwork with their eyes, since the paintings and sculptures are very valuable and could be damaged by people's hands. The museum may have a special studio for children to visit after walking through the exhibit, where they can have a hands-on opportunity to make some art that has some relationship to the theme or perhaps the media of the exhibit they have just seen. Many museums provide simple printed materials, including pamphlets and gamelike "search sheets," to help children be specific in their viewing.

After the children have viewed the exhibit, a brief stop in the museum shop allows each student a chance to buy a postcard reproduction of a particularly favorite piece of art that they have just seen—an early start on becoming an art collector! Some museums have a rental room where students can browse and collectively vote on which artwork they would like to borrow for the classroom for a month or two.

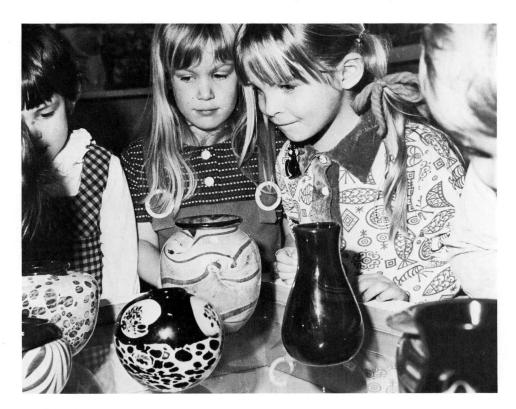

Preschoolers visit an art gallery and study the swirling, contrasting patterns that the ceramist created on these pots.

Artmobiles

In some parts of the country, museum-sponsored artmobiles travel to areas somewhat distant from a museum or to school districts whose budgets for field trips are inadequate. Proper planning ensures that both teachers and children are prepared for the sojourn of the traveling unit, that they are escorted through the exhibit in small groups with a guide who is well-versed in talking with young children, and that adequate follow-up activities are provided.

Art-in-a-Trunk

A similar concept to the artmobiles, but on a much smaller scale, is the "Art-in-a-Trunk" project. In Sacramento, California, community groups, clubs, leagues, and businesses cooperated with the Junior League in sponsoring the assembling of eleven art trunks. Footlockers were equipped with shelving, compartments, and wheels, and then the interiors were transformed into a multimedia milieu for teaching art in kindergarten through the sixth grade. On loan to elementary schools, the art trunks each have a theme. Some encompass multicultures, such as "Arte de Mexico," "African Art," "Native American Art," and "American Heritage." Other trunks are crosscultural and contain items related to weaving, puppetry, toys, art in music, design, birds and beasts in art, and jewelry.

The contents of each art trunk are structured around the following general categories:

1. **Mini-museum:** Replicas, originals, folk art—from many cultures, countries, and periods, and incorporating a variety of materials.

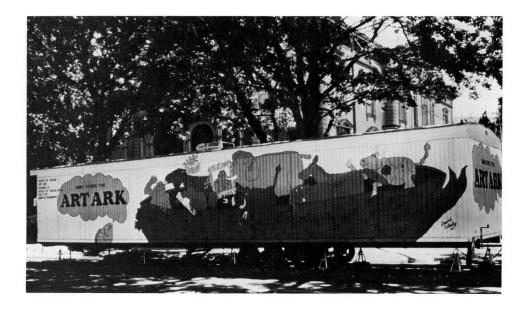

Crocker Art Museum, Sacramento, sends ART ARK for a week's visit to schools. The mobile unit is staffed with an artist who talks with small groups of children as they tour its interior and see original works of art. (Photograph by Chad Chadwick, © 1983)

- 2. **Bulletin board visuals:** Photographs from books, magazines, etc., mounted on colored poster board and laminated. Holes are prepunched for attaching with pins to a bulletin board.
- 3. Stand-up visuals: Zigzag fold-up display materials made of pages from books, magazines, calendars, etc., mounted on 9-by-12-inch colored poster board, laminated, and then taped at the sides. Also, plastic cubes with photos mounted on five sides.
- 4. Filmstrips with cassettes: Some were purchased from commercial sources, and others were created by local personnel from slides taken from private collections, local museums, and other sources.
- 5. **Books:** Both children's and teachers'—reference books, how-to books, related storybooks, descriptive books, historical books, detailed books, etc.
- 6. Games and puzzles: Crossword, matching, word-a-grams, acrostics, etc., for vocabulary and general concept development; manipulative puzzles and games, commercially purchased or created by committee members; postcard puzzles, mounted on colored poster board, cut, and placed in vinyl fold-up envelopes.
- 7. Project cards: Written and visualized descriptions, directions, how-to's, etc., on 8½-by-11-inch paper, mounted on colored poster board, and laminated. Originals are kept in files to guard against loss. Schools are encouraged to copy these so that they can make use of the ideas inspired by the visit of the trunk.
- 8. Examples to accompany the project cards: Mounted, laminated, and placed in a vinyl packet with the project card.
- 9. Tools for projects: Brayers, looms, magnifying glasses, baker's clay tools, and others.
- 10. Tape cassettes that introduce the child to the trunk: Descriptive, explanatory, motivating. Also, cassettes with stories, legends, and folk tales related to the theme of the trunk and made by members of the committee.
- 11. **Reproductions:** Sets of twenty of one print, 6 by 9 inches or in postcard form, laminated, and placed in colored vinyl packets.

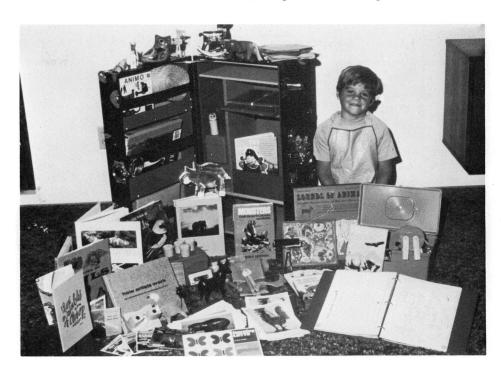

"Birds and Beasts" is the theme for this art trunk. The contents are geared for teaching art's four components using a multimedia milieu.

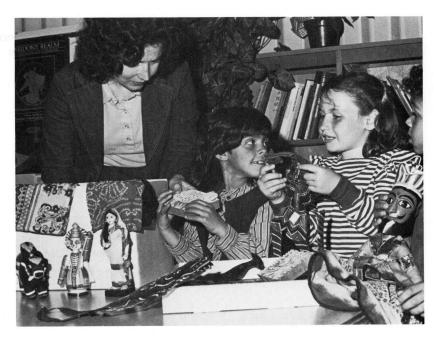

Items from India are examined from an art box that contains puppets, costumed dolls, fabrics, etc.

Smaller than the art trunks but highly concentrated and practical are art boxes. Filled with items related to such themes as Japanese art, masks around the world, and the art of India, the boxes are a stimulant to the development of a unit. The boxes may contain such hands-on items as folk art, a filmstrip and cassette, brayers, games, puzzle sheets, and sets of reproductions, and are an open-ended tool to establish, implement, and nourish art projects that are related to the four components. Art boxes are easy to store, an exciting challenge to compile and assemble, and a joy for the creative and inventive teacher to use. Any single idea or concept can be embodied in an art box and can be geared to any age level and used repeatedly in many different ways.

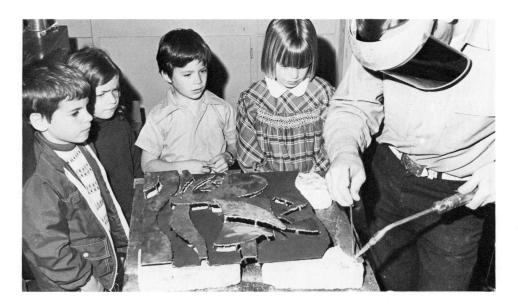

A trip to the studio of a metal sculptor introduces children to the beauty inherent in steel, copper, and brass when these materials are touched by the torch of a skilled and sensitive craftsperson.

Contacts with Artists in School and Community

A visit to the studio of a working artist has much to offer young children. They come into contact with an adult whose life is devoted to his or her art, and they see the artist at work—producing paintings, sculpture, prints, or crafts in an art studio. They observe the artist using fascinating equipment, and they listen and watch as the artist explains the sequence of steps it takes to complete an object. Most artists' studios abound in finished objects as well as works in the making, and they are intriguing places for students to visit. The students can come to know and identify art as a natural and vital part of adult endeavor and of a community's life. A unit on the "Community and Its Helpers" often includes visits to fire stations, post offices, and factories. What better time than this to arrange a visit to the studio of an artist? To see a potter throwing a pot on a fast-spinning wheel, to watch a sculptor chisel a block of stone or wood into a beautiful form, to see a craftsperson create jewelry with metal and heat, to watch a weaver make a shuttle fly back and forth on a loom, or to observe a printmaker work on a silk screen—all of these are inspiring experiences for the young child.

Many shopping centers hold art fairs with dozens of artists and craftspeople not only exhibiting their work but participating in an art-in-action performance. These occasions offer opportunities for children to see sculptors welding, jewelers setting stones, wood carvers polishing sculpture, and potters throwing on a wheel.

Not only is it feasible and stimulating to take children to art galleries and artists' studios, it is also highly recommended that artists be invited to come to the school. Teachers can enlist the help of guilds, leagues, museums, galleries, local arts councils, and artist-in-the-schools programs to recruit resource people to visit the classroom. In one case, a woman from the Weaver's Guild brought her spindle, fleece, and spinning wheel to a preschool and not only demonstrated her skill but let the children work at carding wool and try their hand at spinning. They watched with keen attention as she showed them how yarn can be spun on such a simple device as a stick inserted in an onion. She told them of the many sources of fleece and brought along samples from a number of animals for them to touch. In a similar manner, an enamelist, linoleum block printer, painter, jewelry maker, or any number of kinds of artists could touch the children's lives in a memorable way through a classroom visit.

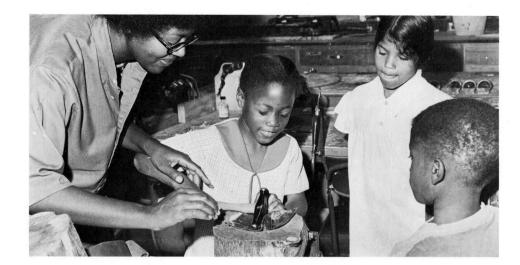

Visiting youngsters watch to see how jewelry can be made and then are given the opportunity to pound copper in a wooden mold.

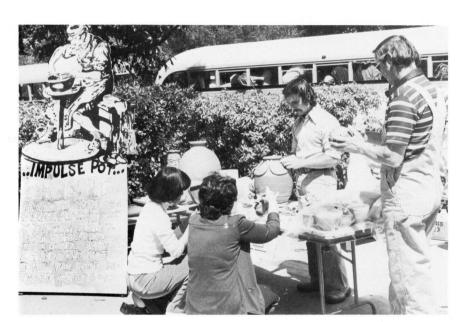

Art fairs and art-in-action events held in shopping centers and other locations are excellent places for children to view artists at work. Here, a potter throws and decorates a pot and invites audience participation.

Folk Art: An Ethnic and Multicultural Emphasis

Above the entrance to the International Museum of Folk Art in Santa Fe, New Mexico, are inscribed the words: "The art of the craftsman is a bond between the peoples of the world." Folk art comes to us from many ethnic and cultural groups. The people who have produced it were and are the common people of a nation or region. They modeled, constructed, carved, wove, stitched, and otherwise made objects for both utilitarian and nonutilitarian purposes. Folk art embodies the values and beliefs of different cultures. By examining folk art, children can begin to have a feeling of the past as well as of the present. They can learn something of their origins and of themselves. Folk art celebrates the creative spirit of a people and preserves cultural traditions.

Alexander Girard, in speaking about the Collection of Folk Art from the Girard Foundation, makes a plea for the present-day evolution of customs and the shaping, in our own way, of contemporary objects of equivalent value, using new methods and materials. Folk art, he believes, should not be sentimentally imitated, but its creative spirit should nourish the human productive attitude of the present.¹

A. Three-year-old girl gives the demonstrator an assist and actually sees fibers become spun yarn on a drop spindle.

B. The ancient task of carding wool is experienced firsthand by this young boy.

C. Preschoolers examine several kinds of fleece used for spinning yarn on the wheel.

Very young children can be introduced to the artistic heritage of many countries, peoples, and times by seeing a number of items that have their origins in ethnic and cultural groups. They can come to know that art has always been an important and beautiful aspect of life for young and old alike. Folk literature, folk music, folk dance, and folk costumes have long been meaningful areas of exploration in the educational program. Children respond readily to the directness and simplicity of folk art and to its sometimes humorous, whimsical notes. In the early childhood classroom, folk art can motivate an art production, be the focal point for a discussion of aesthetic considerations, or provide information about the way of life of another people.

Though the roots of various cultures differ widely, there is a pervasive similarity in most folk art, and at the same time, a good deal of relatedness to child art. The materials and subject matter of folk art are often familiar to children. Carved and modeled figures (both human and animal) masks, baskets, pots, dolls, toys, jewelry, textiles, and metal pieces usually portray an individual craftperson's response to a need.

A. Papier-mâché doll from Mexico and Kachina dolls from the Southwest use familiar materials and arouse the interest of children everywhere. Through respect is born the desire to handle fine things with care.

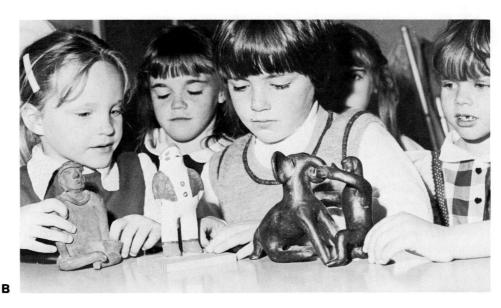

B. Mexican and Indian figures, both human and animal, are modeled from clay. Six-year-old children are fascinated with the figures' simplicity and tactile appeal. Folk art in the classroom inspires, stimulates, and conveys historical and cultural concepts.

Throughout time, cultures around the world have given a high priority to fine craftsmanship and good design in all sorts of objects—whether for everyday use, for religious or ceremonial purposes, or even for play.

Almost all art of ethnic origin makes use of a great deal of overall decoration, whether it is applied to a fabric, carved on an animal, painted on a clay pot, or hammered on a tin mask. While the motif is usually uncomplicated, it is often repeated over and over because the folk artist delights in rhythmic design rather than in natural appearance. Many folk groups use their own legends, stories, religions, and everyday

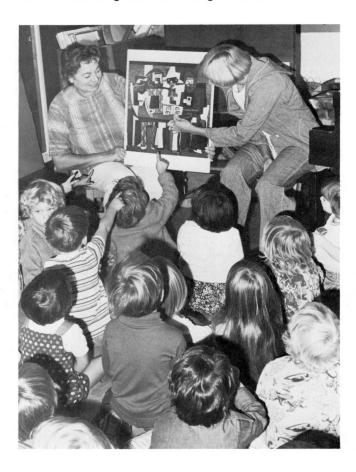

Parent docent discusses Picasso's *Three Musicians* with youngsters.

events as a basis for their craft work. In a similar manner, children model and construct characters from their favorite tales and from their immediate environment. Folk artists everywhere love to carve, model, and make small figures of both humans and animals, and children respond instinctively to this sort of sculpture with delight and interest.

While industrial growth and the emergence of city life have brought about a decline in folk art, recent years have witnessed new and revitalized interest. It appears from this trend that the need for being involved in craft and art production, as well as for owning handmade objects, is a very natural and human one. The need can be fostered and nourished by introducing folk art in the early childhood educational program.

Thematic Presentations: Portfolios

Regular presentations of thematic groups of artworks, either by classroom teachers or by trained parent volunteer docents, can enhance and supplement the classroom art program. A parent volunteer docent can bring a portfolio or mini-exhibit of great artworks into the classroom. Such a portfolio might contain a thematic group of three to six large reproductions. The usual length for a docent's visit is about thirty to forty-five minutes, during which time the children respond to the docent's comments and questions. Reproductions of many famous paintings and drawings are available at reasonable prices from several sources.²

A successful docent program in northern California features eight different portfolios for each grade level and covers a variety of themes. Each thematic presentation is followed by a hands-on art activity taught by the classroom teacher and involves one or more concepts emphasized in the presentation. The hands-on activities for the year's program for each grade level cover a wide variety of media and media skills.

Grade 1

Artists Paint People Doing Things.

Art Concepts and Skills: Artists show individual figures and several figures doing ordinary, everyday things in addition to showing figures engaged in those events that are special in our lives.

Students paste down small photographs of heads clipped from catalogs and then complete a drawing of themselves and their family or friends engaged in some activity that is important in their lives.

You'll need:

catalogs (or magazines) scissors and paste white or manila paper crayons

Motivation:

What do you and your mom, dad, brother, sister, or a friend like to do together? Perhaps you remember some favorite activity you have done with a grandparent. How about: fishing in a boat, playing ball, riding in a truck, going to the zoo, having a picnic, flying a kite, gardening, jogging, biking, shopping, having a story read to you, visiting an art museum. Maybe you remember a very special day, such as someone's wedding or birthday. How did you dress for the activity you choose to show? Where did it take place--indoors or out? What details will you need to include?

Parent docent program. (Sample hands-on lesson to follow a portfolio presentation.)

Here's how:

- Look through catalogs or magazines and find several heads: one that looks a little like yourself and others that look a little like the other people that took part in the activity you will show. Cut them out.
- 2. Paste the heads on a piece of drawing paper.
- 3. With crayons, draw a picture of yourself and either your family or friends and show what you are doing, what you are wearing, and where you are.

Vocabulary:

activity details

A sample set of subjects for thematic portfolios follows, as does a sample lesson for a presentation for grade 1.

KINDERGARTEN

Artists paint stories.

Artists paint animals.

Artists paint cowboys and Indians.

Artists have fun with sculpture: Calder and Moore.

GRADE 1

Artists paint flowers and plants.
Artists paint people doing things. (sample lesson follows)
Artists paint the circus.
Artists paint self-portraits.

GRADE 2

Artists paint birds. Artists paint kings and queens. Artists paint winter and summer. Artists use line.

GRADE 3

Artists paint still lifes. Artists paint trains. Artists paint portraits. Artists paint landscapes.

"Artists Paint People Doing Things": A Sample Lesson for a Thematic Portfolio

"Do you like to make pictures about things you do with your friends and family? Many artists have used this as a favorite theme. Perhaps more than any other subject, artists have chosen people to draw and paint, often showing us exactly how the people looked and dressed and what they were doing. When they do this, they usually include many details and textures that make their pictures look very real. Sometimes, they show us just one person, and sometimes they tell us about what two people are doing, and sometimes they show us whole groups of people. They show people at work and play, indoors and out. Often, they show us ordinary people doing everyday activities. Sometimes, artists try new ways to paint people and aren't concerned with making the figures look exactly like someone we may know. These artists enjoy working with shapes and lines and colors and expressing a certain feeling more than they do the subject matter itself. Sometimes, they like to explore new ways of painting. If you could be a person in one of these pictures, which would you choose?" (Note: The artworks discussed in the paragraphs that follow are found in the "Color Gallery.")

Sunday Afternoon on the Island of La Grande Jatte, by Georges

Seurat "What do you see? I see a large number of people near the water, enjoying the sun and shade. They are wearing clothing in a style that was popular a little over one hundred years ago when this picture was painted. How would you dress for a day at the lake? An artist named Georges Seurat made this oil painting about a place near where he lived. Do you think it is warm or cool here? Why? Choose a figure, and describe what that person is doing. Stand or sit in the same position. Which figures are painted the largest? They are in the foreground and appear closer to us. Which are somewhat smaller? They are farther away, in the middle ground and background. Our eyes are led to the background by the diagonal shoreline. What kinds of animals do you see? What are they doing? Can you find shadows? What colors do you see? Can you find some dark greens, light greens, yellow-greens? The artist used a red-orange to contrast with all the greens and blues. Our eyes seem to go from one red shape to another. There are many curving shapes in this picture. The arc shape of the umbrellas is repeated, and we see the same arc in the sailboat and even in the tails of the dog and monkey! Look at the many shapes of hats. What would you hear if you were in this picture? Would it be quiet or noisy? The many vertical

shapes of the trees and figures give us a feeling that nothing much is moving. If we could see the original of this painting, we would discover how large it is. It is 81 by 120% inches! Can you see the grainy texture over the entire surface? Seurat invented a new way to paint. He made many tiny dots of color placed very closely together. He wanted your eyes to mix the colors when you viewed his artwork. Instead of mixing a yellow-green, he would put tiny dots of yellow and green together. This is called **pointillism**. Do you think it took him a long time to make this picture? He was very skilled at this technique. He has shown us quite a realistic scene in which people seem to be posed stiffly and very formally, almost like statues. Can you find a painting in this group that shows people who are posed more naturally?"

The Bath, by Mary Cassatt "In this painting, we see a woman helping a little girl wash her feet in a bowl of water. Have you ever sat on your mom or dad's lap while they helped you wash your feet or put on a new pair of shoes? Perhaps the little girl has been outdoors playing and is getting ready for a nap. The little girl is seated on the woman's lap, and they are both looking downward. Their shapes take up most of the picture space. They are probably in a bedroom because we see the repeated pattern of the carpet on the floor and more patterns of furniture and wallpaper behind them. Can you find any other patterns? Their two heads are the darkest areas of the picture, and we tend to see them first. Where do your eyes go next? Perhaps down the long lines on the mother's sleeve to her hand, around the bowl, and back up, following the line along the little girl's leg and up to her bent arm and back to her head. Find all the roundish shapes in the picture. See how the pattern of lavender, gray, and white stripes on the mother's garment curves and shows the form of her body. Mary Cassatt painted this picture about one hundred years ago. She often painted women and children. She was an American but spent most of her life in Paris, painting with other artists. Can you find another picture that shows someone engaged in an ordinary everyday activity?"

The Millinery Shop, by Edgar Degas "This picture is called The Millinery Shop. This means that hats are sold here. Did you ever shop for a hat? Or go with someone who wanted to buy a hat? Stores sometimes specialize in just one product, and when this painting was made—about one hundred years ago—women wore large, colorful hats and could even have one made to order just for them. Perhaps the woman we see holding a rather plain hat is trying to decide just what she would like added to it to go with her new dress. See how the artist Edgar Degas has shown variety in the shapes of the hats. Each one is decorated differently. Describe them. The artist created a feeling of unity by repeating these roundish shapes and overlapping them. The hats are shown on stands, and one is on the table. They dominate the picture space. Find the diagonal lines of the edges of the table. Are there any other lines in diagonal directions? See how Degas balanced the diagonal with the vertical lines of the hat stands. This is a quiet picture, showing a woman as she shops for a hat."

The Marriage of Giovanni(?) Arnolfini and Giovanna Cenami(?), by Jan van Eyck "This picture shows a very special day—the wedding day of an Italian merchant and his bride in their home. It was painted over five hundred years ago. The couple had commissioned the artist Jan van Eyck to record exactly how they looked on their wedding day. He used oil paint on a wood panel, a technique that he perfected and that allowed him to show every little detail—the silky hair on the dog, the grain of the floorboards, and

the wooden shoes. Many of these objects have a symbolic meaning for marriage, such as the dog for fidelity. Look at the chandelier. How many candles do you see? The one candle probably symbolizes divine light because the ceremony is a holy one, or it may be a candle clock; we can't be sure. Find the circular convex mirror on the back wall. Convex means that it curves outward and gives a distorted view of the room. If you could see the original of this picture, you would see four people reflected in it. The artist signed his picture by writing the Latin words for 'Jan van Eyck was here' on the wall over the mirror. People got married in their homes quite often in those days, and they dressed quite differently than today's brides and grooms do. Look at their wedding clothes. The bride's dress is green, not white, and it is so long that she is holding part of it up. The red of the furniture behind them contrasts with all the green. The bride's sleeves have white fur on them. Notice her hair and headpiece. She is holding her hand out to her groom. Notice their slender, dainty hands. Perhaps it was winter, since his clothing also looks heavy and warm. Notice the shape of his hat and how his light face contrasts against it. Do you think that van Eyck was successful in his painting to celebrate an important occasion and to show exactly how these people and their house looked?"

Thematic Questions

- 1. Which pictures show people doing things in another time or place that people still do today?
- 2. Which pictures show us exactly how some people looked and dressed?
- 3. Arrange all of these pictures in order from most real to least real.
- 4. Which picture do you think shows the greatest use of the artist's imagination?
- 5. Which picture would you like to make up a story about?
- 6. Compare the mood in Cassatt's The Bath with Seurat's Sunday Afternoon on the Island of La Grande Jatte.
- 7. Which pictures give us a strong sense of light coming from one direction?
- 8. Which picture has the deepest space? Which has the shallowest?
- 9. Which picture gives you the calmest feeling? Why?
- 10. Act out a story with your classmates about Seurat's painting.
- 11. Write a short poem about Seurat's Sunday Afternoon on the Island of La Grande Jatte or about Degas's The Millinery Shop.
- 12. Which artwork would you describe as being a portrait?

Classroom Gallery of Art: Postcard Reproductions

A "Classroom Gallery of Art" can easily be assembled by the teacher and used by children for quiet and reflective enjoyment in the classroom. This little gallery is made of two pieces of mat board that are hinged with tape and placed in a convenient and comfortable spot, perhaps on a counter, tabletop, or bulletin board. Children can take a leisurely "walk" through the gallery and look at great artworks in miniature form—postcard reproductions. Different sets of theme-related postcards with adhesive-backed Velcro allow the exhibit to be changed easily.

The "Classroom Gallery of Art" shown in the photograph was based upon a set of thirty postcards called ARTPACK, produced by the Museum of Fine Arts, Boston.³ The thirty cards are divided into five theme-related sets, with six postcards in each set. The themes are: "Portraits," "Everyday Scenes," "Modern Art," "Landscapes and Seascapes," and "Still Lifes." All sorts of postcard reproductions are available in museum shops and could be grouped in a similar manner.

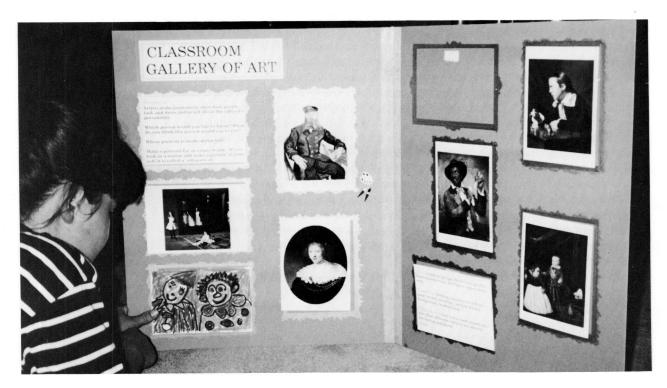

"Classroom Gallery of Art" brings a mini-museum with changeable theme exhibits to students. Comments and questions on cards provide a springboard for discussion. Spaces on panels allow students to make their own theme-related drawings and to attach them in the frames with Velcro.

A "Classroom Gallery of Art" requires two pieces of mat board, 16 by 20 inches each. A gold marking pen is used to draw ten frames, 4¼ by 6 inches, on the mat boards. Five of the frames should be horizontal and five vertical in format. Half-inch squares of adhesive-backed Velcro tape are attached to the back of each postcard and inside each frame. The two pieces of mat board are attached with filament tape so that the gallery stands up by itself and folds flat for storage. Six of the ten frames are used for the postcards, two are used for study questions, and two are used for the students' artwork.

Two study-question cards can be made to accompany each theme-related set of prints. The cards should be the same size as the postcards and have Velcro on the back so that they can be attached inside one of the frames. For example, for "Landscapes and Seascapes," one card might say: "Artists make paintings to show us how places look—fields, lakes, mountains, rivers, city streets, and the ocean. Which place would you like to visit? What sounds might you hear? What would you do there? Choose two pictures and compare them. Make a picture of a place you have been, and put it in an empty frame. Think about the weather and the skies."

The second card might say: "DESCRIBE: the weather, the light, the brush-strokes, figures, and animals. FIND: foreground, middle ground, background, horizons, different kinds of skies. THINK ABOUT: the path that your eyes follow, things that overlap, distant objects smaller and higher up, the mood of each picture, which picture is most realistic, which picture is least realistic."

Some blank tagboard cards of the same size and with Velcro on the back should be provided so that students can fit their own artwork in the two remaining empty frames.

Art Games

The games that follow are examples of play activities designed to sharpen children's perception, familiarize them with great works of art, and contribute to their visual/verbal knowledge about the elements and principles of art.

Games are not exactly new as a teaching device. Friedrich Froebel used the game technique in 1896 when he developed his gifts, which consisted of blocks, triangles, straws, and other materials. The game approach can be useful for teaching art concepts. The competitiveness factor is minimal in the games described here. These games can be an excellent activity for an individual child or for cooperative learning activities with small groups. They are easy enough so that most children can play them alone and independently, thereby minimizing the teacher's role.

The directions for the games described here are open-ended and flexible. It is hoped that the ideas presented will stimulate teachers to become involved in creating other art games, too. The teacher needs to collect a number of small postcard reproductions and other prints of great artworks, as well as photographs showing patterns, colors, textures, and close-ups of natural objects. Often, calendars, museum catalogs and flyers, advertisements, and magazines provide good visual materials for the game maker.

Game cards that are laminated or covered with clear contact paper wear better. Plastic file boxes are excellent for storage. Also, colored vinyl from yardage shops can be stitched into envelopes on a sewing machine and the flaps secured with an inch of Velcro.

"Artcentration" (Similar to "Concentration")

Twelve pairs (or more) of mounted reproductions are needed for the game. One pair consists of two prints by the same artist. Each pair may consist of the same painting or different paintings by the same artist. Or the pairs can be landscapes, still lifes, figures, abstractions, seascapes, architecture, ceramics, sculpture, or jewelry. Or the pairs can be matching textures, shapes, lines, or colors. To play the game, the children mix the cards and place them all facedown on the table. The first child turns one card over and tries to find its mate by turning over one more card. If he is successful, he keeps the pair and tries again. If unsuccessful, he places the cards back in the same position, facedown, and the next child turns one card over and then tries to find its mate in one more turn. (With very small children, the teacher should start with four pairs of cards and increase the number as the children become familiar with the artworks and the artists' names.)

"Art Squares"

The teacher cuts 5-inch squares of colored poster board. Then, small reproductions are cut in half diagonally so that there are two triangular pieces. All the blank squares are placed on a table, and a matching pair of triangles is arranged on each side and then glued in place. A number—1, 2, 3, or 4—is placed on one half of each matched pair of triangles. To play the game, children place all the cards in a stack, facedown. The first player draws the top card and places it in the middle of the table. She then draws again and places the second card alongside one of the sides of the first card. If she is able to match a pair, she scores the number printed on the matching set. If no triangles match up, she must play the card anyway, along a mismatched side. The second player continues, drawing the top card and adding it to the already-placed squares. Players are not allowed to move any squares after the squares have been put in place. Blank sides can be placed anywhere, but no score is given. Plays in which a player is forced to place a card in a nonmatching position do not score. When the last card is played,

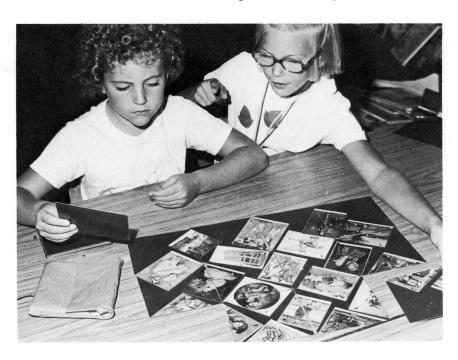

"Art Squares" can be played in several ways. Two triangles match to complete each picture.

players add up their scores. Variation: "Art Squares" can be played as a jigsaw puzzle, with one or more players putting all the squares together, matching all sides and timing themselves.

"Art Words"

From photographs of zoo, farm, or jungle animals, one child secretly chooses a photo and describes the animal to the group in terms of the animal's color, shape of its ears, size of its feet, placement of its nose, and so on. This causes the child to look carefully at the animal and to select its significant and characteristic details. He may then say, "I have four thick legs. My skin is wrinkled and rough. My ears are flat and roundish. Which animal am I?"

"Arty-Knows"

Small reproductions are cut in half and mounted, domino-style, on small rectangles of poster board. Two different colors of beads are used to keep score. Each child should have a notebook ring to hold the beads as he or she scores. Eighteen "half-dominoes," fifteen "double dominoes," and four blank dominoes are needed for the game. All the beads are placed on a large notebook ring to serve as the "bank." All the "Arty-Knows" cards are placed facedown on the table. Each player selects four of the cards. The first player chooses one card from the pile and places it faceup in the center of the table. She then tries to play one of her cards in a matching position. If she plays a double card, she takes a black bead from the bank; if she plays a half card, she takes an orange bead. She draws another card from the deck or "gallery." Play passes to the left. If a player cannot play at all, she passes to the second player and retains her four cards. Blank ends of half cards may be joined to other blank ends, but no beads are collected from the bank. A perpendicular joint may be made with a blank card where two blanks have joined. When the gallery is empty and no more plays can be made, the player with the highest score wins. Orange beads equal one point; black beads equal two points.

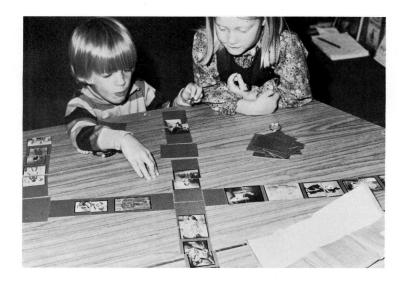

"Arty-Knows," a form of dominoes, is made with small reproductions cut in half and mounted on poster board.

"Bag of Textures"

Discs, two each of a variety of textures, such as leather, vinyl, sheet plastic, cork, corduroy, velvet, and sandpaper, are placed in a cloth bag. The child reaches into the cloth bag without looking and tries to find matching pairs by touch. The child may be asked to describe the texture. Or one disc of each texture can be placed on the table and the child asked to reach in the bag and find each disc's mate.

"Circle-in-a-Picture"

Close-up texture photos from a magazine or color photos that you have taken yourself of flowers, tree bark, seed pods, shells, tires, and pebbles are needed for the game. Each photo should be mounted on a piece of poster board and a round hole made in the center of each one. A small bead is glued to the cut-out circle for a "handle." The picture with the circle cut from its center is then glued to another piece of poster board. Children gently whirl the discs in the center holes to find the correct locations. (This game could also be done with fine art reproductions.)

"Color: Tint and Shade Cards"

With cards of paint samples from the paint store, the child arranges each color from light to dark.

"Match-It"

Two or three postcards or small reproductions of works of each of about five to ten artists are needed for the game. The reproductions should be mixed up and placed in a box or a fabric drawstring bag. The child takes the cards out and spreads them all out on a table. Then he is to pair or match up the two or three that are by the same artist. Two van Gogh's have similar characteristics, colors, and style, and the child should be able to separate and differentiate them from two Rembrandt's, two Gauguin's, and so on.

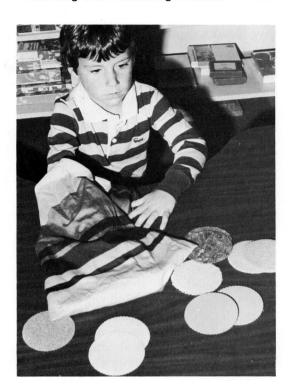

A bag of pairs of diverse textures challenges children to discriminate and select the disc inside the bag that matches the disc on the table beside them.

"Matching Halves"

Small reproductions or postcards are cut in half and mounted on small pieces of poster board to make a number of very simple puzzles. For the youngest child, about three or four prints can each be cut in half and all the cut halves mixed up and placed in a small box. The child takes out the pieces and puts them together, matching the top half with the bottom half.

"Match the Paintings"

For this game, the child needs a playboard with five or six rows and a single picture by a different artist on the left in each row, followed by four blank squares on the picture's right. Four additional pictures by each artist are then mounted on small squares of poster board. The child to play the game must perceive similarities and differences in various artists' styles and techniques by grouping all the paintings by one artist on the blank squares to the right of the example. A color dot on the reverse side of the cards matches a color dot by the picture to provide for a self-checking device.

"Multi-Game Cards"

Four works of art by one artist are mounted on four pieces of poster board. (Variation: Four different textures, landscapes, portraits, sculptures; or sets of four values of one color.) Twelve sets are made in this manner for a total of forty-eight cards.

Game 1: "Museum" The cards are shuffled, and seven cards are dealt to each of four players. The remaining cards are placed in a center pile, called the Museum. The first player asks another player to look for all the cards that he has by one artist (or all

landscapes or textures). If this player has any, he must give them to the first player, who then asks the same player for more cards of a set. If this player has none, the first player draws a card from the Museum. If the first player draws the card she asked for, she may ask a second player for cards. The next player repeats play as described. When a player collects a set of four cards, he places the set in front of him. The winner is the one who has the most sets of cards when play is over.

Game 2: "Old Master" This game requires one additional card, one that reads "Old Master." The cards are shuffled and dealt out to four players. The dealer then places on the table all the matching sets in her hand, if she has any. She then takes a card from the hand of the player to her right. If the card she chooses matches cards in her hand, she puts the set on the table. The player to her left then does the same, and the game proceeds until all the cards are matched, leaving the "Old Master" card in the winning player's hand.

Game 3: "Paintbrush" One set of four matching cards is needed per player and one paintbrush for each player, minus one. Four cards are dealt to each player. The object of the game is to collect four cards of one set. Each player selects one card he does not need and places it facedown next to the player to his left. When all of the players have done this, the players pick up the cards on their right. Play is repeated until one player has a set of four. That player quickly grabs a paintbrush from the center, and then each player grabs one. The player who does not get a brush loses.

"Perceptual Recall"

The child looks at a tray with a number of objects for a few minutes. Then the tray is covered. The child names the objects she can remember. The task is varied by asking the child to name all the brown objects, or all the hard objects, or all the round ones. Or one or two objects can be secretly removed to see if the child can remember which ones are missing. Just a few objects should be used at the beginning and the number increased as the child becomes more skilled.

"Postcard Puzzles"

Postcards that show fine art reproductions are mounted on lightweight poster board and then cut in four, six, eight, or nine pieces. For each puzzle, an identical postcard should be mounted on poster board, with some interesting information about the artwork and the artist on the back. A convenient storage pouch can be made from colored vinyl and a pocket stitched for each set of pieces.

"See, Touch, and Tell"

A natural object, such as a seed pod, flower, or shell, is passed from one child to another in a circle, with each child adding a word or phrase to describe it. A seashell, for instance, might be called "big" by the first child, "big and bumpy" by the second, "big, bumpy, and pink" by the third, "big, bumpy, pink, and curving" by the fourth, and so on. This causes the child to observe and feel the object carefully, to use a word to describe it, and to remember the other descriptive words that have been used.

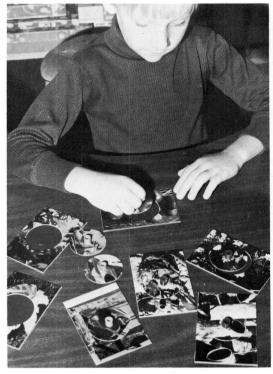

- A. Close-up photographs of cactus, leaves, flowers, metal, and such are made into puzzles by cutting a circle from the center of each and attaching a bead for a handle. The child must whirl the circle in the empty space until he or she matches the correct position.
- B. A set of five cards for each color goes from dark to light. The child may sort and match up sets in an appropriate arrangement or create other tint-and-shade games.
- C. "Old Master" and several other games can be played with a pack of cards made up of sets of four cards by each artist.

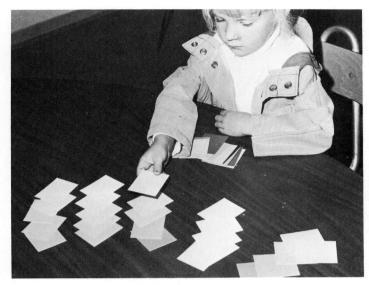

В

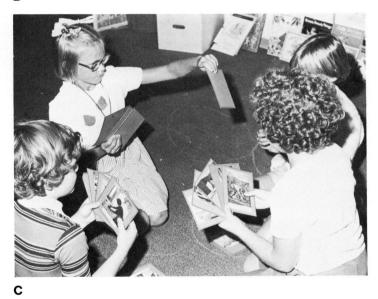

"Secret Guessing"

A small object is passed around a circle with everyone blindfolded, and each child, in turn, feels the object and silently guesses what it is. When all the children have examined the object, the teacher calls on the children to see how many guessed correctly.

"Tactile Dominoes"

Each half of a regular domino is covered with different bits of textured materials, such as: one = sandpaper; two = vinyl; three = cork; four = suede; five = felt; six = calico; blank = wood stripping. The dominoes are placed facedown on the table, and each child draws five of them and stands them up in front of him or her. The first player places one domino in the center of the table, and the second player matches one of the ends with one of his dominoes. If he does not have a domino that matches, he draws from the pile until he can play. After he has played, the third player has a turn. Play continues until a player has used all of his or her dominoes and becomes the winner.

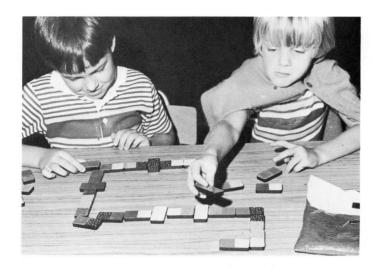

The game "Tactile Dominoes," with halves covered with sandpaper, suede, etc., enables children to see and feel differences and similarities in texture.

"Tell about It"

A number of reproductions of fine paintings, drawings, or pieces of sculpture are needed for the game. The teacher asks three children to leave the room. The first child to return is told which is the secret picture. She then must describe it to the second child, when he returns, using art words that do not refer to the picture's subject matter. The second child must remember what he has been told and repeat the description to the third child, who was waiting outside the room and who must try to guess which is the secret picture. This game can be modified in many ways, according to the number and kind of reproductions available, and the interest and maturity of the children.

"Three-Dimensional Jigsaw Puzzles"

All six sides of nine wood cubes are used for mounting six or nine different reproductions that have been cut into six or nine squares to fit the square sides of the cubes. The children then try to piece together these three-dimensional jigsaw puzzles.

"Touch and Guess"

Players sit in a circle, with one child blindfolded in the center. The other children take turns selecting an object from a tray for the child in the center to hold and guess what it is. Objects should include such things as a feather, a piece of sandpaper, a cube, a cylinder of wood, a nail, a bit of fur, a scrap of soft satin, a button, a paintbrush, a rock, and a wooden spoon. If the blindfolded child guesses correctly on the first attempt, the child who selected the item gets to become "it."

"Visual Perception Game"

Twelve 3-inch squares each for Cards 1 and 2 for Game A and twelve 3-inch squares each for Cards 1 and 2 for Game B are needed. (See the diagrams.) Two contrasting colors should be used. Cards are the same on the back and front sides. The children play at matching and making configurations and forms. This game helps with figure-ground differentiations, visual closure, positioning, synthesizing, and visual memory.

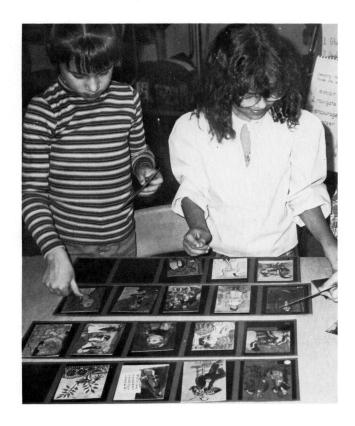

"Match the Paintings" game challenges children to find similar styles from a mixed assortment of small prints.

Set of "Visual Perception" cards requires children to match sides and make designs. Two contrasting colors should be used in constructing a set of these cards. (See the diagram.)

CARD 1

Game A

"Verbal/Visual Match-It"

A set of cards with small reproductions glued onto them is needed for the game. On another set of cards, short descriptions of these reproductions are written. Children may play at matching up the visual image with the written description. Or the cards can be distributed to the children to see how quickly they can find their verbal/visual mate. For children who have not yet learned to read, the teacher may distribute the visual cards and then read the written cards, with the children listening to see if the description matches the card they are holding.

For Discussion

- 1. How is it possible to provide opportunities for young children to see original works of art? List places in your community where that could happen.
- 2. What kind of items would you expect to find in an art trunk, and how are art trunks designed for classroom use?
- 3. How does folk art reflect the culture where it originated?
- 4. What are the similarities and differences to be found in folk art that originates in different times and places?
- How can a classroom teacher facilitate children's exploration of art in their community? List at least six specific resources that could be used in your local area.
- 6. Formulate at least one theme for art lessons at each of the following levels: preschool, kindergarten, grade 1, grade 2, and grade 3.
- 7. Select artworks from the "Color Gallery" that relate to a theme. Discuss thematic questions that might be appropriate to ask young children.
- 8. Which of the art games described: (a) are most likely to strengthen visual perception? (b) utilize reproductions of contemporary or historical art? (c) require verbal responses? (d) reinforce concepts discussed in chapter 2?
- 9. Collect postcards that show artwork related to a theme. Assemble the postcards in a minigallery (as described in the section "Classroom Gallery of Art: Postcard Reproductions", page 57).
- 10. Select a specific work of art that is in your community. What kind of background information is appropriate to provide for young children? What guiding questions can be formulated that will increase students' understanding and appreciation of the work when they see the original?

Notes

- 1. Alexander Girard, The Magic of a People (New York: Viking Press, 1968), "Introduction."
- Abrams Art Reproductions, Haddad's Fine Arts, P.O. Box 3016C, Anaheim, CA 92804. Art Education, Inc., 2 Erie St., Blauvelt, NY 10913.

Art Image Series, Art Image Publications, Inc., P.O. Box 568, Champlain, NY 12919-0568. Art in Action Enrichment Programs, I and II, Holt, Rinehart and Winston, 1627 Woodland Ave., Austin, TX 78741.

Austin Reproductions, Inc., 815 Grundy Ave., Holbrook, NY 11741 (sculpture replicas). Metropolitan Museum of Art, Box 255, Gracie Station, New York, NY 10028.

Museum of Fine Arts, Boston, Catalog Sales Dept., P.O. Box 1044, Boston, MA 02120.

Museum of Modern Art, 11 West 53d St., New York, NY 10019-5401.

National Gallery of Art, Publications Service, Washington, D.C. 20565.

New York Graphic Society, Ltd., P.O. Box 1469, Greenwich, CT 06836.

Shorewood Reproductions, 27 Glen Rd., Sandy Hook, CT 06482.

Starry Night Distributors, Inc., 19 North St., Rutland, VT 05701.

University Prints, 21 East St., Winchester, MA 02890.

- 3. Museum of Fine Arts, Boston, P.O. Box 74, Back Bay Annex, Boston, MA 02117.
- 4. Friedrich Froebel, Education of Man (New York: D. Appleton, 1896).

4 Artistic Development in the Early Years

There are children playing in the street who could solve some of my top problems in physics because they have modes of sensory perception that I lost long ago.

J. ROBERT OPPENHEIMER

General Developmental Characteristics

Very young children all over the world begin at an early age to reveal certain developmental characteristics in their art products. General stages of growth appear to be universal and identifiable so that an environment for maximum growth can be designed. The adult's task is to provide the means through which the child's motor, affective, perceptual, cognitive, and aesthetic development can reach its fullest potential.¹

Two points of view regarding artistic development in children have been prevalent. One holds that the child manifests changes in his or her artwork, with the teacher merely providing the materials. The other maintains that the unfolding of the child's artistic self can be aided and abetted by direction and training. Howard Gardner insists that a deeper understanding of both views can emerge and benefit from a developmental perspective.² He notes that, by age seven or eight, perhaps earlier, children have an initial grasp of the major symbolic media of our culture. They are incipient artists, since they now have the raw materials to become involved in the artistic process, ideas of how symbols work in an aggregation of symbolic media, and some knowledge of how to construct works themselves.

The school curriculum in early childhood should provide a qualitative developmental sequence of art lessons. The result should be that, when children later become much more self-critical, they will have developed skills at a sufficiently high level that they will not reject what they have done. In addition, they will have a store of ideas and feelings they wish to express. A developmental program in art is based on experiences the children have had at earlier levels and helps the children to recall visually and verbally, to perceive, organize, define, clarify, and reinforce their thoughts and feelings. It provides the foundation for the level that follows.

The early childhood years are marked by young children's eagerness to participate in art with enthusiasm and naturalness. They enjoy creating their own art. They like looking at pictures and reproductions of works of art and visiting galleries and museums. Their art expression progresses from scribbles into more organized forms

and symbols and is an important means of nonverbal communication. Art is a first language for all children, according to the National Art Education Association, which states that:

The first language of humans was the creation of images on cave walls, just as the first language of a child is drawing. Art is a universal and basic language. The inclination to express oneself visually begins early. Its subsequent development is fundamental for every person and essential for our society.³

In grades 1 to 3, children become even more responsive and curious in reacting to visual/tactile experiences than they were in earlier years. They are able to handle a greater variety of materials and tools—they can make prints, construct, model, paint, stitch, and weave. They can begin to talk about the art of others, make choices and express preferences, and understand the relationship of art to literature, social studies, and music. They learn about various cultures and times.

Children who have had paper, marking pens, crayons, scissors, paint, and modeling materials available at home come to preschool or kindergarten more advanced in their artistic development than those who have not. Mental, emotional, and physical handicaps, as well as social and cultural influences, also have a bearing upon a child's visual image development. Some children pass quickly through the stages of growth in art, but the characteristic pattern of their artistic behavior remains very similar.

It is of paramount importance that this early period of development be fostered to its fullest to set the stage for future growth and development. Without basic and supportive experiences with art materials, children tend to be hampered in their artistic expression. They do not acquire a language of nonverbal symbols that enables them to express their personalized images of the world in artistic forms. If at this time adults encourage children to do copy work and to use coloring books and if they forbid children's spontaneous scribbling, the child's development in learning, as well as in art, may be harmed.⁴

Children get pleasure not only from handling materials but from experiencing the thrill of discovery and the intense satisfaction of mastery. Through early manipulative and exploratory experiences, children develop concepts of searching, investigating, recording, selecting, building, and determining. From relatively simple, limited, and direct use of materials, young children advance to more complex, sophisticated involvement.

These manipulative experiences, which begin in preschool, may not seem of great significance as the adult views the final product. Yet, the children are establishing beginnings—in using the elements of art; in planning, executing, completing, and evaluating; in judging the wholeness or completeness of a composition; in correlating visual expression with other forms of expression; and in demonstrating originality, self-confidence, and competency. The adult's attitude when these early expressions begin has much to do with the children's later ability to communicate ideas, images, symbols, and feelings in their own unique and original way.

For children, as for the adult artist, art is more than a factual recording of an object. They are coming to grips with their thoughts, feelings, and perceptions, and these may involve fantasy, dreams, suspense, surprises, thrills, sorrow, fear, delight, wonder, anger, pleasure, joy, or hate.

The Scribbler

The development of art in the young child actually originates in the years prior to formal instruction. Difficult as it may be to believe, the origin of artistic expression for even the greatest of artists can be found in the earliest scribbling of childhood.

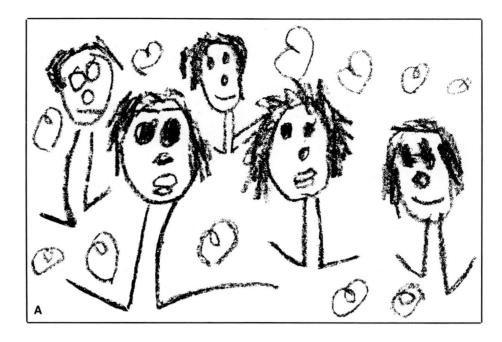

A and B. These two drawings, both done by children in the same kindergarten class, show differing stages of development. Although the faces in the first drawing are detailed, the legs and feet are the only parts of the body represented. A body, arms, and fingers appear in the second drawing; the child clearly has the concept of "many fingers," but an exact number has not been determined. Both drawings depict the children's families.

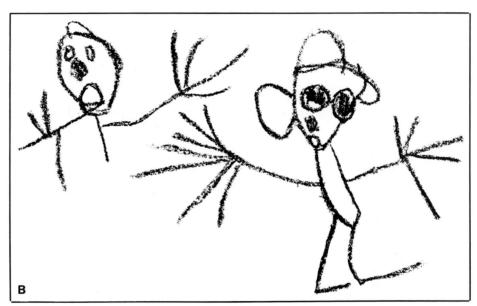

Irregular Scribbling

The first marks the child makes, usually between the first and second year, are random scribbles and are most likely derived from the kinesthetic enjoyment of moving the arm and hand. At this stage, children do not realize that they can make these marks do what they want. They show variation in these random marks in both length and direction. They may show some repetitive movements as they swing the arm back and forth, but the main principle involved is kinesthetic. Accidental results occur. The line quality varies. The crayon or drawing implements may be held in various ways, and the size of the marks and movements are in relation to the size of the child's arm.

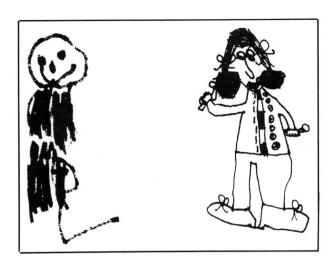

These two drawings of a girl, drawn by the same child, show the development that occurs between the ages of three and six. The development of a definite schema is evident in the later drawing.

There is no intent by children at this time to make representational symbols; rather, their work shows a somewhat random, haphazard grouping of marks. They enjoy scribbling, and they must have the opportunity, materials, and place to engage in it. Chalk and chalkboard, crayons, marking pens, pencils with strong, blunt points that do not break easily—all of these are vehicles for the child to use for this kinesthetic activity.

Controlled Scribbling

Usually about six months after children begin to scribble, they develop some control and discover that they can make the marks do what they want them to do. They become consciously aware of scribbling. While an adult may detect no difference between these scribbles and those of the previous disordered stage, this marks an important step in children's artistic growth. The children begin to vary their motions. They repeat some lines that give them particular satisfaction and spend a longer time at this activity. They make circular and longitudinal scribbles. They are mainly interested in the kinesthetic sensation and in mastering their movements.

Symbolic Scribbling

At about three-and-a-half years of age, most children begin to name their scribbles, which is a landmark in their development because the child's thought process has now changed from thinking kinesthetically to thinking imaginatively. Until now, the children were principally involved in motions; now, they have connected their motions to the world around them. While the actual drawings may appear much like those of the previous stage, the children's intent is different. They may start a drawing and say, "This is Daddy," or at least have some idea of what they are going to draw. They may call it something else when they are finished. They may talk the entire time that they are drawing, or they may announce what it is when they are finished. The next day, looking back at their drawing, they may possibly call it something else, but they have established a visual relationship to the world with their drawings. They may revert back to manipulation of the medium if they have a new tool. If given baker's clay, salt ceramic, or clay, their thought processes are the same as with drawing and painting in that they first manipulate it—pound it, roll it, pinch it. Their movements gradually become more controlled until the naming stage evolves and they begin squeezing little blobs of the modeling material and giving their creations names.

- A. The circle as a symbol for a face can be seen in Bradley's early drawing (age three). Although the scribbles representing the hair and one ear are detached from the circle, details have been added to form a recognizable symbol for the human face.
- B. Bradley's later drawing (age four) uses a rectangular shape for the body, with two lines extending from the rectangle to form legs. Notice how scribbled circles are repeated to form symbols for eyes, the nose, buttons, and knees. Radial lines have been added for hair.
- C. A third drawing shows a complex ensemble of figures—a clown, two trapeze artists, and a tightrope walker. Drawn when Bradley was five years old, the picture represents his experiences and interests.

Since scribbling mainly involves muscular activity, gaining control, and then establishing a relationship with the outside world, color does not play a very important role at this time. They begin learning the names of colors. The colors that children choose are those they happen to like and not those that are related to the visual world. What is most important is that children have an art medium that enables them to gain control of their lines. Therefore, crayon, chalk, marking pens, or paint should be of a contrasting color with the paper on which the children are working so that they can see clearly what they are doing.

Communicating with the Scribbler

Joseph and Marilyn Sparling focus on meaningful dialogues with scribblers, on positive approaches to increasing communication skills.⁵ They suggest that these beginners in art need (1) encouragement in the form of verbal approval and respect, (2) to be aware of their own creative process and product, and (3) to perceive their own thoughts and feelings. When children gain new names or labels for things, they have a way of reusing and recalling experiences. Skills in forming concepts have been shown to be linked to the acquisition of language, especially labeling.⁶

The Sparlings make specific suggestions as to what to say to the scribbling child. First, the communication should be geared to the child's developmental level, since a comment appropriate for a child who is scribbling in a disordered manner is not appropriate for a child who is controlling his or her crayon. Second, a comment should relate specifically to what the child has done. Generalized comments that show that the adult has not really looked at the child or at what he or she is doing are often stereotyped phrases that provide no rich language stimulation.

In talking with the beginning scribbler, the adult could mention the child's movements, since the child at this stage is more fascinated with the kinesthetic process than by the marks he or she is making. These comments make the child more aware of his or her own movements, and motor coordination is an important task. The adult might comment on how fast the child's hand is moving back and forth, or on how hard the child is pressing on the crayon, or on how big the child's movements are. If comments are directed toward how the child's work looks, the child becomes more aware of the things that he or she has created spontaneously. The adult could describe some of the child's marks—such as long, curving lines, or where the marks were placed on the page, or the colors used. The Sparlings also suggest that the adult touch or trace some of the lines with his or her finger to guarantee that the child knows what is being referred to.

If the adult provides a language model, the child can become more conscious of his or her feelings during and after scribbling. Such comments lead the child to verbalize feelings independently. The adult can find clues to the child's feelings in the child's facial and body expressions and preferences. Comments on what a long period of time a child has been working and how he or she must have enjoyed it help the child to know that the adult understands and values what the child is feeling.

In the controlled stage of scribbling, comments should be directed toward the child's increased motor control and ability to devise a variety of movements. Because the child at this time is better able to repeat certain movements, the adult might comment on how the child's hand is going around and around. Conversation directed at the way the scribble looks helps children to realize that they have made a particular mark many times or that they have made a number of closed shapes and lines. The adult might call their attention to how they drew a small circle inside a big one and how hard that is to do. The adult might also refer to contrasting colors and values, describe different lines or shapes, and note how these marks relate to each other. Since scribblers feel great satisfaction at being able to control their marks, talk about their feelings should focus on this new accomplishment and how exciting it is.

When children begin to name their scribbles, a much richer opportunity for communication exists. Since the actual marks may not differ much from those done earlier, and since children frequently change their ideas and meanings by the time they complete a scribble, it is unwise for the adult to try to guess or name an object in children's artwork. Instead, the adult should listen to the child's comments and build on the meaning to the child at that moment. When a child *does* name a work, the adult should pick up on the clue and ask questions relating to both the composition and to the child's personal ideas. A child's comment about "my big man" could be countered with questions about the shapes, colors, or repetition of lines, and also about the relationship of the child to the man, or the size or placement of the man. These comments concentrate the children's thinking in the direction they have begun and have more meaning for them.

If children are hesitant to talk about their work, the Sparlings suggest encouraging conversation by commenting on how much fun the children seem to be having and asking them whether they would like to tell about some of the things they have made. If the child does not respond, he or she may be at an earlier stage of scribbling or may just be unwilling to converse. A positive or reassuring comment could be made about the "nice lines going around the paper" or about how glad the adult is that the child is having fun. Children should not be forced to comment, but with continued support, they will gradually want to converse about their work.

The Sparlings suggest remedial techniques to use with children who are reluctant to scribble. The adult may sit down with the child, use a crayon along with the child, and comment on how he or she is letting the crayon move all around the paper and how good it feels to do so, even with his or her eyes closed. Then the adult can suggest

that they try doing it together. The smallest efforts should be praised and attempts made each day, since it takes a while for children's confidence to be built up if they have had an unhappy experience or are frightened of new experiences.

Some children enjoy humming and making other noises as they work. Other children stare into space while they are engaged in scribbling. It is best not to interrupt when the child is fully involved. But when the child puts the crayon or brush down, or takes a moment to stop work, the time is good for communicating. The adult should use the child's name and sit at the child's level. The child should not be asked what he or she is drawing or whether an object is a house or a dog, since these questions put the child "on the spot" and leave no room for creativity and further exploration. A comment might be directed at an especially bright color the child has used and the child asked if he or she would like to tell about something special in the drawing.

Sensitive and thoughtful comments directed to the scribbler help children to be more enthusiastic about expressing themselves through art. They become more motivated to continue and expand their artwork, while the general awareness that has been built up through language enables them to translate their art experiences into art concepts. This sort of awareness is needed when children reach later stages in their development and are required to use aesthetic concepts to evaluate their work and the works of others.

The Schema Emerges

At a specific point in the child's development, scribble lines evolve into rudimentary shapes. These early efforts contain both closed and open shapes, in combination with linear marks.

Circles and Simple Configurations

Many of the early scribbles are circular, and usually during the fourth or fifth year, children make the remarkable discovery that they can make a closed, round shape and repeat it at will and that, in this circle, they see a symbol that they can use to represent a number of objects that are of emotional significance to them in their world. They can add two lines, and the circle becomes "mother." This new configuration is usually referred to as the "head-feet" symbol. While different children arrive at this stage at various times in their development, most are using this symbol during their fourth and fifth years. They repeat it, often modifying it, making it more elaborate and detailed by adding eyes, mouth, ears. They may add a number of radial lines and call it the sun, or four legs and a tail and make it a dog. Eventually, many children draw a connecting line near the lower part of the two lines that are extending from the circle, making it into a body, from which they may extend two more lines for arms and two for legs. The body is sometimes in a triangular shape, or sometimes it is another circle or oval, with the legs and arms also drawn with ovals.

Children use this rudimentary "head-feet" figure repeatedly to suit their needs and to communicate with themselves and others about those experiences that have some important conceptual or emotional meaning to them. They use it with drawing tools, with paint, and with modeling materials.

Children at this time verbalize a lot with themselves or with an interested adult while they are drawing—recalling, reorganizing, fantasizing about some experience. In the end, the result may be named something entirely different than it was originally intended to be.

It is very interesting to collect the drawings from one child over a period of time, from initial scribbles through the development of a schema. The child's comments should be noted on the backside of each drawing, along with the date the drawing was made. It is also revealing to collect a group of drawings from a kindergarten class of children who are close in age, to see the wide range of artistic development.

74 Artistic Development in the Early Years

Recording comments made by the child on his or her drawing provides an introduction to reading and the written symbol. The two examples shown here are "Smiling people on PSA, getting ready to land," by a child who is 4½, and "A crane lifting an 'E' to a weather vane on a church" by a six-year-old child.

Accuracy isn't essential in this whimsical drawing of an "ice skater with thirty-five buttons." Notice the number "35" on the right side of the drawing. The young artist has allowed long, wandering lines to enclose the figure in a box.

A, B, C, and D. The developmental stages from symbolic scribbling to fully evolved schema are shown in these four drawings by Mia at ages three, four, five, and six. The looped fingers and outstretched arms were repeated without variation for some time during the later stage.

Responding to Early Drawings

An adult should never "correct" children's drawings, show children "how to draw," or ask them to copy another drawing. Such interference is meaningless and is damaging to the children's pursuit of self-discovery, to their artistic growth, and to their personality. It makes them dependent on an adult when they need to be building confidence in their own visual language and learning to reach out, explore, and communicate their own thoughts. A cliché of a boat or a stick figure "taught" to the child of this age usually results in a clinging to that form, a stereotyped repetition that is locked in and halts creative growth.

Bruner states that, by the age of three or so, and through the primary grades, children are probably functioning at the level of iconic representation; that is, they are primarily learning through actions, through visual and sensory experiences and organization. He also believes that the emotional attitudes concerning learning begin at this age and that a relaxed and playful attitude and approach on the part of the teacher is favorable. Bruner believes that children are more encouraged to attempt things and are less upset by failure if they understand that the results of such activities are not as extreme as they may have hoped or feared that they would be.

The crude symbols made by the four- or five-year-old give the adult tangible clues to the child's thinking process. The first head-feet representations may not be easily recognized without the child's naming of them. However, by kindergarten, most children are making objects that are easily recognized as houses, trees, animals, and people.

Visual depiction of relative sizes and proportion is not children's major concern at this time. Rather, they have an honest sense of logic that is naive and obvious and that is, perhaps, quite realistic in the true sense of the word: A long, strong arm is needed to pull a wagon; hence, that arm appears longer in the picture. To depict oneself with a newly lost tooth requires drawing a huge mouth. A stubbed toe feels larger than it looks and may be drawn that way.

As kindergartners mature, their schemas show more variations and details until, by age six, the children's drawings are fairly elaborate. The children draw things differently each time, depending upon the experience or feelings they may have at that moment. They are more interested in relating the drawing to the object than they are in relating the color to the object, and thus they may draw themselves with green hair or make a red tree. They like color and find painting with tempera, drawing with colored chalk, and cutting with brightly colored pieces of paper most exciting. The adult should not criticize or correct children's choices of colors as not "right" for an object; children discover the relationship themselves as their work merges into a later stage of development. The adult should find ample opportunity, however, to develop and encourage this awareness through art games (see chapter 3), in motivations (see chapter 6), and in impromptu informal chats: for example, "What a bright red skirt Kim is wearing today," or "Maria's dog is as brown as a chocolate bar."

When children first begin drawing the head-feet symbol, their concepts of space have not developed beyond that of representing objects in a random floating array. A symbol for "mother" may be placed high on the page, the child's kitten may be positioned lower, and perhaps a house may be placed off to the side. The objects are not related to one another in position or size; nor are they related to the ground. It is satisfaction enough for the children to be aware that they have created a symbol that is recognizable as a person, animal, or house.

Although this is a time of development of verbal skills, Lowenfeld feels that there is no substantial reason for attempting to teach children of this age to read, since they are not able to relate letters to form words and words to form sentences—skills learned later when they have established a base-line concept that is symptomatic of a higher level of seeing and understanding spatial relationships. Furthermore, if children begin their reading instruction later, they are better able to learn to read quickly and with less struggle, with the result that their attitude toward reading and learning in general is positive and eager.

One of the key factors operating in the child's drawings at this time is that the symbols for various objects change frequently. Children are quite flexible in their depictions of a "man" or a "dog" and make them with different forms and features each time they draw. The way objects are depicted may relate to the experiences the children have had with that person or object, the keenness of their perception and overall awareness, their intellictual capacity (since a large number of details indicates a higher intelligence), and, in general, more-developed personality characteristics.

Topics for Drawing

Children of four and five years of age are self-centered, and the names they give their drawings usually have in them the words *I*, *my*, and *me*. Motivations, therefore, should focus on extending the child's field of awareness and expression in this direction. Productive topics are those that have to do with the bodily self—"I have a new pair of dark glasses," "I have a stomachache," "I am jumping rope," "I am blowing soap bubbles."

A trip to a natural history museum motivated Jeff (age 5½) to make this detailed drawing of Indians, teepees, drums, campfires, and smoke. Experiences not only help the child's perceptual growth but stimulate memory and other cognitive powers as well.

Each motivation of this type emphasizes one bodily part, a part that at that particular moment is charged with emotional and/or kinesthetic impact. The adult can use these moments to ask such questions as: "How do your dark glasses feel? What holds them up? Did you look at yourself in the mirror with them on?" Or "Where is your stomach hurting? Or "Where are your arms when you jump rope? Do you bend your knees?" Or "Show me how you blow bubbles. Do you puff your cheeks out? How do you hold the pipe?"

Topics with more emotional significance can also be drawing topics: "when my kitten died," "saying goodbye to Grandma at the airport," "my new baby brother," "I am eating birthday cake." The adult may extend the child's idea by asking questions after the child has initiated an idea for drawing, or the adult may suggest drawing topics that are tuned into the child's experiences and recent happenings.

Reproductions of famous artworks whose subject matter is the same as or similar to the children's can assist the children in making relevant connections at this time. (See, for example, the works by Cassatt, Chagall, and Seurat in the "Color Gallery.")

Motivations can expand the child's perceptual growth, cognitive powers, and emotional relations, and all discussions relative to drawing, painting, and modeling should incorporate several questions or points related to these three areas of perceiving, thinking, and feeling. Motivations can help children to be more aware of things in their world; to develop flexible personalities; to think with imagination, originality, and fluency; to increase their ability to face new situations; and to recognize and express both pleasant and unpleasant feelings in an acceptable manner. Motivations can also include questions and comments that help the children to consider where they will place the objects on their paper, what shapes they will use, which colors will be best, and so on.

Schematic and Spatial Concepts

The objects in a child's early drawings may not appear very realistic to the adult eye. However, these symbols represent the child's understanding of the world as he or she experiences it.

Symbols Emerge

By the time children are six or seven years old, they usually have developed definite schemas—for example, symbols for a man, a house, a dog, a tree, and so on—that they repeat without variation unless some motivation or experience causes them to deviate from them. To prevent these symbols from becoming "locked" in and stereotyped, the teacher should endeavor to keep children flexible in their thinking and, thus, in their depictions. The schemas for children of this age are generally made up of circles, rectangles, triangles, ovals, and lines. By constantly structuring motivations and experiences, the teacher can help to make the child more aware of visual details related to the figure and to objects.

The motivations should incorporate the self and also should extend outward to include where and with whom the action took place. Concepts regarding space become obvious at this time, and a greater awareness of how to deal with spatial ideas is probably the most notable achievement at this stage of development. Children begin to include the *base line*, a line drawn across the paper and upon which objects are placed. This signifies that the child is now aware that there are other objects in the world and that they have a definite place on the ground and in relation to other people and objects. They often put a line across the top of the picture for the sky, with "air" in the middle.

Once again, it is very important to make sure that the spatial schema does not become a rigid concept, since many ideas and experiences will be unfolding that the child will want to draw but for which the base line will not suffice. Motivations that encourage base-line deviations, therefore, are appropriate. Such deviations and their topics might include:

- 1. Bent or curved base line: Climbing a mountain, going skiing
- Multiple base lines: Horses racing on tracks, booths at the carnival, an orchard

A second-grade class in Glendale, Calif., culminated a unit on "Our Neighborhood" with this tightly filled baker's clay mural. Included are stores, homes, churches, schools, cars, people, and a number of other important parts of the children's environment, organized on multiple base lines.

An imaginative kindergartner comments on this drawing:

"People are hanging in a dungeon. An elf is on top of the ladder, locking them up with a key. The girl doesn't know how to tie her shoes, and her dad (the big guy on the wall) won't do it for her. The elf's boss is at the bottom of the ladder."

- 3. Elevated base line (placed near the top of the paper): Inside an ant hill, under the sea, animals that burrow beneath the ground
- 4. Mixed plane and elevation (part of the objects are drawn as if we are looking down on them, and others are drawn as if we are looking at them at eye level): Floating down the river on rafts, a parade on a street with buildings on both sides

Exaggeration As an Expressive Quality

At this stage, when children want to express something that a person is doing or experiencing, they often exaggerate the bodily part involved in the activity or enrich it with many details. The picture "I am throwing a ball" may show a much longer arm than is usually drawn. Or children may change the shape they ordinarily give to a symbol for a bodily part. If a child who usually draws a circle to represent a hand is given a new ring or has fingernail polish applied, the circle often disappears, to be replaced by a much more elaborate and detailed drawing of a hand. This indicates that the child is maintaining a degree of flexibility and is able to change his or her schemas to meet the needs of what it is he or she wants to represent.

A rigid and inflexible child responds either by drawing the same schemas over and over again, regardless of the motivational topic, or by stating, "I can't." In this case, rather than "drawing for" the child to "show him or her how," it is much more advisable to have the child, for example, actually throw a ball while the adult endeavors to make the child more aware of how the child moved his or her arm, how it felt, and how far the ball went. Then the child might observe the stance and movement of another child throwing a ball.

Children often become so emotionally involved in depicting an experience/idea that they omit a bodily part that at that particular time is unimportant. Ears may be left off a figure who is throwing a ball. However, a subsequent motivation might emphasize the ear by asking the children to draw "when I had an earache," or "my new pierced ears," or "whispering a secret in my ear."

Occasionally, this student draws pictures looking down on people. Roasting marshmallows, sleeping, and playing chess seem to be the activities in this Boy Scout camp-out. Jeff, age nine, has a remarkable ability to manipulate space in his mind's eye. This ability appeared at the age of six, when he completed a picture of a baseball game, again looking from above.

Exaggerations, changes of shape, concentration of details, and omissions are all healthy and to be expected during the schematic period. If motivations are regular, consistent, and sensitively structured in themselves, children's awareness is gradually awakened and incorporated into their drawings. Their symbols become richer, more detailed, and more unified, and the children are able to use, change, and enrich the symbols to depict all manner of experiences and ideas. Art, indeed, is a first language for all children, one whose vocabulary depends upon perceptual awareness, cognitive development, and emotional feelings that can be developed by sound motivational practice in these early years.

Characteristics of the Schematic Years

Children in the schematic years are eager participants in group projects, such as assembled murals and large, boxy constructions. They like to explore new materials and processes, such as printmaking, stitchery, weaving, puppetry, and modeling techniques. Also during the schematic period, children discover and use colors that are related to objects. Hair is no longer purple and noses green. They are eager to classify and categorize things, to feel that they have a tangible hold on the world.

Children's attention can be directed to warm, happy colors in their environment, such as red, orange, yellow, and hot pink, and what things those colors make them think of. They can also be introduced to cool, calm colors and encouraged to think of

Taking a close look at one's features while drawing sharpens a child's perception while creating a self-portrait.

images that these tones of green, blue, and purple evoke. They should have ample opportunity to practice mixing different colors together, adding a bit of one color to white to make tints and a bit of black to a color to darken it and make a shade. As they become more deeply involved in picture making and see the manner in which red vibrates next to green or the effect that a great deal of a dull color has next to a single bright spot of orange, children acquire the skills needed to mix and blend their own colors to suit their needs.

By the end of the third grade, children should be able to express their own ideas creatively and confidently, using a wide variety of materials. Gradually, they learn to place the figures and objects in different positions in their pictures and reveal a growing awareness of the entire painting area. Through repeated drawing and painting experiences, they learn to vary the sizes and shapes of things and to use contrasting colors for emphasis, dark and light values for moods. By age eight, the schema for human figures has changed somewhat, from being totally geometric symbolic representations to ones that show more specific characterizations. The children use more details, including hair, buttons, eyebrows, and clothing patterns. Distant objects may sometimes be represented by making them smaller and by placing them higher on the page. Children are, by this time, using more visually realistic proportions and usually represent some spatial relations through the overlapping of forms. The base line may become the horizon line. Attempts are made to show figures-in-action poses.

Teachers are sometimes disturbed and puzzled by the child who paints over a picture that has just been completed. Such behavior is usually of an emotional nature; perhaps, the child just happens to like that particular color very much, or in painting over the picture, the child may be showing some normal aggressive behavior. Unless

A. The exaggerated legs of this running figure dominate this drawing by Max (age five). Children often become so involved with their experiences or ideas that they emphasize the parts that are involved in the activity and minimize or eliminate those parts that are not being used.

B. Four years later, Max's drawing of a robot indicates increased concern with detail and proportion.

these actions are part of a larger pattern of overtly abnormal behavior in other areas, they may be regarded as within the range of typical development and will probably soon be outgrown and left behind for more positive actions.

As some children reach seven and eight years of age, they may sometimes be critical of their own work and become dissatisfied when something does not look just as they want it to look. This is especially true if they have not had numerous perceptual encounters, have not participated in a variety of experiences with art materials, and if

Achievement Expectations -- Completion of Grade 3 Aesthetic perception enables individu-By the end of the third grade, a student should be able to: **Aesthetic Perception** als to recognize beauty, its character Perceive differences and similarities among groups of lines, shapes/forms, and conditions. Heightened perception textures, colors, values, and internal and external spaces. sensitizes students to the world about Classify lines, shapes/forms, textures, colors, and values into families or groups. them, enabling them to see, feel, and Verbalize an expanding awareness of the elements line, shape/form, react with greater responsiveness. texture, color, value, space. Manipulate space in two- and three-dimensional works to create personal art forms. Demonstrate understanding of the principles of design (balance, unity, Art develops aesthetic perception by emphasis, rhythm) by expressing simple concepts in his or her own words. providing sensory experiences and Demonstrate increased ability to arrange elements to achieve emphasis, heightening responsiveness to unity, and rhythm in both two- and three-dimensional works of art. aesthetic qualities in the environment. Describe ideas and feelings when observing works of art, nature, events, and objects. By the end of the third grade, a student should be able to: Visual expression results when the Express personal ideas and feelings through drawing, painting, printmaking, urge to communicate is linked with modeling, constructing, ceramics, filmmaking, graphics, textiles, and so on. originality and with knowledge of the Interpret a single subject or theme in a variety of ways, using a variety of skills structure and language of art. and materials. Expression Produce with confidence in several art media. Create varying types of art (portraits, self-portraits, landscape, still life, collage, Art enables students to express their rubbings and prints, torn and cut paper, sculpture and constructions, ceramics, own creativity through a nonverbal form of communication that embodies their Apply simple concepts learned about line, shape/form, texture, color, value, and personal symbols, images, feelings, space in personal artwork. ideas, and spirit. Involvement in quality Creative Create a balanced composition in both two- and three-dimensional works. art experiences enables students to Demonstrate originality in selection and arrangement of images in personal artwork. realize moments of satisfaction. Utilize varying sources of inspiration in own environment to create original works accomplishment, and joy. of art Utilize simple perspective techniques of overlapping, placement, size variation. Express both fantasy and perceptions of the real world through imaginative application of two- and three-dimensional media. By the end of the third grade, a student should be able to: Opportunities to see and study a rich variety of artworks develop understand-Recognize similarities and differences among works of art produced in varying ings of artists and works of art as well as Distinguish the ways that people (past and present) use art to express (ideas, their evolution and functions, both today emotions), celebrate (events), embellish (everyday items), enrich (personal life), and in the past. and intensify (spiritual beliefs) the human experience. Make associations with own artwork and the work of professional artists in the past Awareness of artistic accomplishments of various cultures of the world enables and present as well as artists working in other cultures. pupils to see the place of art in relation Verbalize in own words ways that people everywhere use art to record ideas, to those cultures and in their own lives. feelings, and events. Recognize the purpose of museums as places where artwork is cared for and Consequently, art serves to connect displayed (actual museum experience is recommended). students to their cultural heritage as well Point out ways that art has been used to decorate and enhance daily life. as to increase their appreciation of the artistic contributions of other cultures Identify at least three well-known artists from examples or reproductions of their work. As students learn to recognize, discuss, By the end of the third grade, a student should be able to: and work with art, they come to under-Select personal favorites of well-known works of art and briefly describe reasons stand it and to build a foundation for for choice. Identify broad categories of artworks by subject matter (for example, portrait, still life, making judgments about its form, content, **Aesthetic Valuing** technique, and purpose. Discussion, landscape, abstract, and so on) as well as form (for example, painting, print, critical analysis, reading, and observation sculpture, drawing, fiber, ceramic, construction, photography). Recognize the ways that artists organize the elements of design (line, shape/form, of both original art and reproductions are requisite to develop criteria for arriving at texture, color, value, space) by using principles (such as balance, unity, emphasis, personal preferences and opinions. and rhythm). Use appropriate new terms in discussing visual art forms. Recognize the role of professional artists (such as architects, industrial designers, Art develops and refines students' ceramists, illustrators, muralists, fabric and wallpaper designers) in our everyday sensibilities, providing bases for understanding, enjoying, and appreciating art

similar and different.

Achievement expectations—Completion of grade 3.

and its contributions to life.

Reprinted with permission of the California Art Education Association (from the "Scope of Sequence")

Compare and critique differences and similarities in works of art (their own, their

peers, professional artists living in the present and past, artists of other cultures). Compare environments and describe the qualities that make them aesthetically

their artistic growth has been interfered with by coloring books or highly directed projects. The teacher can help by having the children draw from direct observation—focusing their attention on shapes and outlines, sizes, colors, and details—and by encouraging them to look carefully.

The chart on page 83 summarizes certain expectations in the areas of aesthetic perception, production, art heritage, and aesthetic judgment that children can achieve by the completion of grade 3.

For Discussion

- 1. What are the characteristics of a developmental program in art?
- 2. What is the importance of manipulative experiences in the early years?
- 3. Describe each level of artistic development, from irregular scribbling through the schematic period.
- 4. At what stage does a child become an eager participant in group projects?
- 5. In what ways can an adult respond and communicate with children about their art so that the dialogue helps children to be more enthusiastic and confident?
- 6. At what point in the child's development does the "head-feet" figure emerge? What would be the implications of observing this big-head symbol in drawings by a seven-year-old child?
- 7. How might an adult encourage a child who either draws the same schemas over and over or just says, "I can't," during art experiences?
- 8. How would the use of art reproductions help the child's growth and development of schemas?
- 9. What are the characteristics of drawings of four- and five-year-old children? How can the children's interests be used to motivate expression and development?
- 10. Summarize the achievement expectations at the end of the early childhood stage. What are suitable educational goals for art learning for this period?

Notes

- National Art Education Association, Art for the Preprimary Child (Washington, D.C.: National Art Education Association, 1972), 59-73.
- Howard Gardner, "Unfolding or Teaching: On the Optimal Training of Artistic Skills," in The Arts, Human Development, and Education, ed. Elliot W. Eisner (Berkeley, Calif.: McCutchan, 1976).
- 3. National Art Education Association, poster, 1988.
- Rhoda Kellogg, Analyzing Children's Art (Palo Alto, Calif.: National Press Books, 1969), 100.
- Joseph Sparling and Marilyn Sparling, "How to Talk to a Scribbler," Young Children 28(Aug. 1973): 333–41.
- H. H. Kendler and T. S. Kendler, "Effect of Verbalization on Discrimination Reversal Shifts in Children," Science 134(1961): 1619-20.
- 7. Jerome S. Bruner, *Toward a Theory of Instruction* (Cambridge, Mass.: Belknap Press of Harvard University, 1966), 10-13.
- 8. Viktor Lowenfeld and Lambert W. Brittain, Creative and Mental Growth, 6th ed. (New York: Macmillan, 1975), 208.

5 Identifying Talent and Special Needs

When I examined myself and my methods of thought, I came to the conclusion that the gift of fantasy has meant more to me than my talent for absorbing positive knowledge.

ALBERT EINSTEIN

When young children reveal developmental characteristics in their art products either earlier or later than would be expected, or when physical or mental handicaps prevent artistic development, some adjustment in the art program is necessary. If the art curriculum for early childhood has been formulated to provide a qualitative developmental sequence of lessons, it is fairly easy to assure correct placement for those children who are progressing either more rapidly or more slowly through the general stages of growth. If art experiences are haphazard, of low quality, and not adequate to develop appropriate skills and knowledge at specific levels of development, then there is little to offer any child, let alone those with extraordinary talents, abilities, or special needs.

Very young children form mental images before words, enjoy capturing those images in art, and are enthusiastic about expressing their unique artworks. It is the adult's responsibility to challenge the child's motor, perceptual, affective, cognitive, and aesthetic abilities to assure each child's development to the fullest potential. In the case of high-ability or special-needs students, all too often the early spark of enthusiasm dies because meaningful experiences are limited. If adults encourage coloring books, copying, and rigid, manipulative activities, children are not able to explore, discover, select, and communicate the rich visual imagery that is uniquely their own. Without supportive and nurturing environments for artistic growth, young children are unable to experience the satisfaction of accomplishment and the joy of personal expression. This is of particular importance when children feel isolated or "different," as high-ability or handicapped students often do.

Quality art experiences can connect children to the real world as well as provide an opportunity for growth and communication through a personal language of non-verbal symbols. For the child of exceptional talents or of special needs, art becomes significantly important as a means of expression as well as an avenue to understanding the thoughts, feelings, and perceptions of others. Although each of us is unique, we are more alike than different; art provides a common language, a means of connecting individuals to a larger community.

Identifying the Artistically Talented

Perhaps the single characteristic that most typifies the artistically talented student is rapid progression through the various stages of art development. When compared to others of their age, artistically talented students consistently demonstrate abilities at

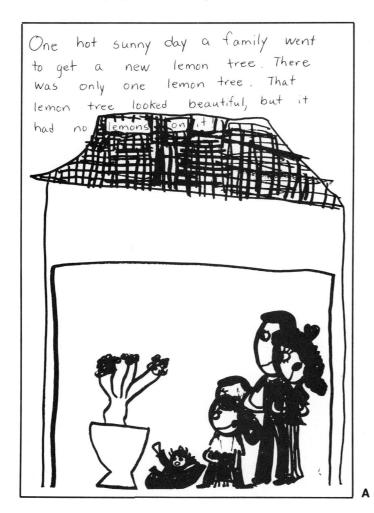

A and B. The child in the schematic years enjoys expressing his or her own ideas both in pictures and in words. These two samples from child-made books demonstrate verbal and visual creativity at grades 2 and 3.

The grandmother was in the kitchen cooking. Sheeba smelled the food and washingry. Sheeba pulled on the grand mothers dress to tell her she was hungry and ripped her dress.

The whole family got mad at Sheeba and threw her out of the house. Sheeba was very sad because she no longer had ahome.

extraordinary high levels. Adults familiar with the typical artwork of students at various grade levels frequently communicate on the "maturity" or "advanced ability" of the exceptionally talented child.

The classroom teacher is sometimes the first person to notice a student's unusual talents, although other students also are usually aware of the exceptional talent of one of their peers. As can be expected, however, finding the exceptional and uniquely talented student is not an easy task unless there exists a basal art program for all students. There are no standardized tests for art ability, and the most reliable means of identification is by looking at the accumulated body of work created by large groups of children. If one becomes familiar with what is "typical," the artwork of the exceptionally talented child becomes clearly evident.

In addition to advanced development in art production, highly talented students are very interested in art activities, take the activities seriously, and seem to find satisfaction in them. Frequently, talented students have accumulated a sizable amount of artwork, and they may spend a great deal of time and energy drawing (sometimes all over the pages of books, classwork, or any other available surface—much to the despair of teachers). Talented students display ease and dexterity in creating art products, and they frequently use visual representation to communicate their experiences, ideas, and deepest feelings.

Challenging the Exceptionally Talented

Just as the classroom teacher is often the first person to recognize the student with extraordinary artistic ability, the classroom teacher is also usually the first to acknowledge a sense of inadequacy in providing challenging art experiences for talented children. Often, the "solution" is to give the student paper and crayons and additional time to draw. While this is not harmful, neither is it stimulating; nor does it develop the child's potential. The talented child needs some instruction in the use of new materials and moves rapidly beyond the manipulation of tools.

A conceptual approach to art experiences originates with an idea and requires that the student use materials merely as a means to solve a problem. Given encouragement, the talented student shows unusual and unique ideas and is highly fluent in generating a variety of solutions. When provided with an open-ended art problem to solve, talented students frequently exhibit widely divergent solutions and art products.

The teacher's role is to encourage, support, and challenge the talented student. Although this may appear to be an overwhelming task to an adult who perceives the child as "already knowing more than I do," it is a similar situation to a coach who directs the training of and challenges the world-class athlete. Maturity, experience, knowledge, and interest are the primary ingredients necessary to guide and support children with exceptional abilities and talents.

The talented young child is eager to participate in "games" or activities that have many solutions. If is a powerful word; teachers should develop long lists of "what if" and "what would things look like if" questions, such as:

- 1. What if cars were made of bricks?
- 2. What if it snowed on your birthday?
- 3. What if the sun was blue?
- 4. What if you had a monster for a pet?
- 5. What if people could walk on ceilings?
- 6. What if you lived in a circus?
- 7. What if you had a butterfly for a pet?
- 8. What if puppies grew on trees?
- 9. What would things look like if you could fly?
- 10. What would things look like if we were on another planet?

A, B, and C. Series of drawings by Emily at age six, showing high degree of talent. Note complexity and variations in figure, overlapping, action, detail, composition, etc.

A, B, C, and D. Examples of drawings at ages seven, eight, nine, and ten show Victor Navone's exceptional talent at various stages of his early artistic growth. Victor is self-taught, and his work

reveals his interest in exploring techniques and images. In addition to exceptional talent in art, Victor is one of those rare children who is also highly gifted in intellectual and academic abilities.

This drawing by Joel Claunche, age eight, demonstrates the advanced artistic development of an exceptionally talented student. The work of art, entitled "Scoot Over," shows a variety of imaginative characters riding in an elevator.

- 11. What would things look like if you were bigger than an elephant?
- 12. What would things look like if you planted magic seeds in your garden?
- 13. What would things look like if everyone walked on their hands?
- 14. What would things look like if we lived in houses made of candy?
- 15. What would things look like if people were taller than buildings?

Exploring the world of fantasy offers opportunities for talented young children to create personalized images that are both original and imaginative.

At times, talented students may repeat schemas, but with variations, until they exhaust the "theme and variation" motif. No matter what the motivational topic, the talented student may express a desire to explore his or her current set of images—such as monsters, ballerinas, horses, cars, outer space. As long as the child continues to be highly original and is willing to try out new materials, techniques, and experiences, there is little reason for concern. As motivations help the talented child to become more aware of things in the world, diverse images flow from the highly creative mind into the art products.

Occasionally, talented students become locked into repeating certain images (their own or those of others). This usually occurs when, in the past, they have received praise and recognition for duplicated artwork. It takes a great deal of self-confidence to take risks, to create original artwork. With very young children, the teacher is a particularly strong influence and has the primary responsibility of providing a safe environment for originality. Just as there is an ideal environment for the growth and development of living things, there is an optimum environment in which children may best develop creatively.

Highly talented students need opportunities and recognition for their artwork. Kindergarten student Henry Li is shown here with his drawing of "people watching a parade" that was used by the California Art Education Association for a poster commemorating the state's Youth Art Month.

Exceptionally talented students are usually interested in other people's artwork—that of their peers and also of adults. Parents and teachers can enlarge the young child's experience by providing opportunities to see exhibitions of student art, to visit art galleries and museums, and to look at originals and art reproductions from a variety of cultures, past and present. The combination of rich visual experiences with a supportive environment for creative exploration results in fluency, variety, and increased sophistication of imagery in the talented child's artwork.

The Creative Environment for Exceptional Talent

Psychological safety and freedom are necessary if people are to behave creatively. All children, but especially those who exhibit high levels of artistic ability, have a need to experiment and seek out their own symbolic expression. According to E. Paul Torrance, one of the leading authors in the field of creativity, children reveal their intimate imagining only if they feel loved and respected. This is the essence of what Torrance calls the creative relationship between a teacher and child. For this reason, the classroom teacher is instrumental in developing the optimum environment for creative expression.

When the "significant adults" in a child's life are highly critical and judgmental, when uncertainty is reinforced by disapproval, creative and original artwork diminishes. All too often, limiting statements, such as "Dogs aren't green," or "Don't be so messy," are made. Students' self-confidence also can be undermined by constantly exposing them to art that utilizes patterns and prepared outlines. The message inherent in these activities is that the child is not able to create his or her own images, that the outcome must be predetermined by an adult.

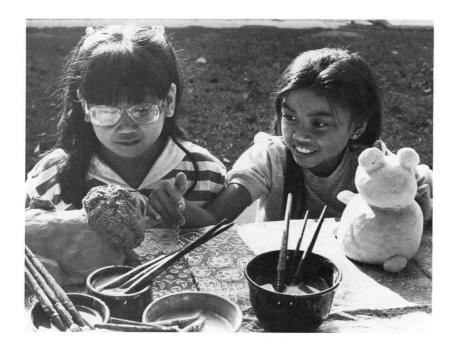

Two talented students discuss and compare their work as they experiment with clay, a new medium for them. Bringing students together so that they can interact and stimulate one another's creativity is one of the purposes of this program for highly talented students. Providing new materials also permits experimentation with techniques and ideas.

Anne Wiseman states that parents and teachers hold the success of children in their tone of voice and generosity of understanding.² To awaken children's creative potential, all artistic expression that shows sensitivity, uniqueness, and involvement needs to be acknowledged in positive and honest ways. Encouragement and motivation form the basis of the environment that stimulates individuals to their highest potential.

Exceptional Opportunities for Exceptional Talent

In addition to the creative environment so necessary for the artistic expression of all children, the highly talented student needs additional stimulation, opportunities that go beyond what is offered in the regular program. Partially, this can be provided by the classroom teacher. As a major influence in the child's life, the teacher need not be artistically talented but can provide the open-ended art activities necessary to develop the student's abilities and can encourage discussions about the artwork of great artists. Opportunities for students to interact with professional artists also provides, in part, for the needs of the exceptionally talented. Whether the artist is a visitor or the student visits the artist's studio, observing professionals functioning in the real world can have great impact.

Talented peers can also greatly influence a student who shows a high degree of art ability. Students who are highly skilled, who have a great deal of "natural talent," frequently feel alone. Interacting with peers of comparable talents not only alleviates the feeling of isolation but can stimulate ideas and a realistic sense of ability. For this reason, grouping students who are exceptionally talented can have positive results—in personal development as well as in artistic production.

In a program designed to meet the needs of talented children, there should be opportunities for students to work in one area in depth. Thus, a child who is interested in making pinch pots may be given the opportunity to create large ceramic animals or (with help from an adult) to experience the use of a potter's wheel. Another child might be given the opportunity to make a filmstrip by drawing a series of images on acetate,

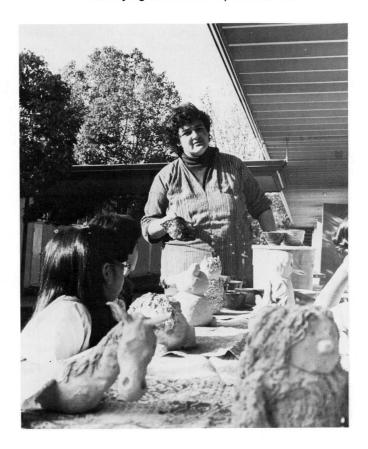

Artistically talented students are given the opportunity to work with professional artist Nancy Gordon in this Saturday morning class in Chula Vista, California. Providing opportunities to interact with professionals is one way to meet the needs of highly talented students.

to create a pinhole camera, and to participate in the development of his or her own contact prints. Since many of these activities are beyond the scope of the regular classroom program, after-school opportunities and Saturday morning classes can extend the range of the child's experience and compensate for the relatively limited challenge provided in the regular school program.

Acknowledging artwork that represents the highest degree of a child's potential is also a powerful influence on the child's development. When outlets and audiences are provided for the student's most creative work, when pieces of art are valued and exhibited, meaning is given in the real-life world. Even at a very young age, children are sensitive to the unspoken message communicated when their artwork is displayed for others to see. As value is given to their efforts, highly talented students respond with images that are richer and more elaborate and that consistently incorporate personal symbols depicting the enormous variety of experiences—both real and imagined—in these early years.

Gifted and Talented?

Several states have expanded their traditional programs for gifted students to include abilities other than intellectual/academic potential. One category appearing more and more often is one in which students show exceptional talent in one or more of the visual and performing arts. What confuses some is the erroneous supposition that a "talented" child is also "gifted" in areas identified with high scores on IQ tests. While this

may be the case, it need not be. Each individual is a blend of gifts and talents of varying degrees. A person with high mathematical aptitude is not necessarily someone with exceptional musical abilities. Students who demonstrate high creativity may or may not be successful academically. The child with extraordinary talent in art may or may not demonstrate equal levels of ability in other areas.

For a number of years, some states did not permit funds in gifted programs to be used for art books and materials. Art was not seen as being sufficiently "academic" to challenge the higher thinking skills of the intellectually gifted. Gradually, educators came to the realization that the development of intellectual skills is fostered not only by convergent thinking but also by divergent activities that "extend awareness, rationality, and one's grasp of reality." Quality experiences in the arts extend and expand the learning of the gifted student. In some cases, the divergence inherent in problemsolving art activities provides an exceptional challenge to students who have been highly successful in providing the "one right answer" required in academic areas concentrating on convergent solutions. Introduction of art activities at a young age assists the gifted learner in acquisition of sophisticated skills needed for decision making and creative problem solving. Through early exploratory and manipulative experiences, the gifted learner develops concepts of investigating, selecting, planning, and evaluating—essential ingredients for the development of both cognitive and affective processes.

Students with Special Needs

Unlike highly talented students who advance rapidly through the various developmental stages, children with mental or physical handicaps have barriers that impede progression. The handicapped child often has problems and encounters frustrations in everyday life that other children never experience. Art activities can ease the frustrations of the handicapped learner, provide a profoundly valuable form of emotional expression, and encourage improved muscular control, increased perceptual awareness, and a sense of personal achievement. The creative activities found in art are particularly important for children with physical or mental handicaps. As with all other children, the aesthetic experience for students with special needs should emphasize the development of the individual to his or her fullest potential. For this reason, if no other, the importance of art in the education of disadvantaged students cannot be overemphasized.

Federal legislation (Public Law 94–142) granted to the handicapped the right to education in the "least restrictive environment." Children who would previously have stayed at home or remained in private schools are now able to request public education. The law also states that handicapped children must be educated with nonhandicapped children to the extent possible. This means that some students with handicaps participate in the total school experience, while children with more severe handicaps may participate in limited mainstreaming—recess, lunch, assemblies, some physical education activities, and some classroom experiences, such as story time, music, and art. Only the most severely handicapped children are placed in separate environments designed and staffed to meet exceptional needs. The Individualized Education Program (IEP) requires that persons most familiar with the handicapped student's needs—as well as professionally qualified to select the most appropriate learning environment—meet to develop a plan for the individual child's education. The key element in the decision making focuses on where the child should be placed to most likely experience success.

In most situations, handicapped students are included in classrooms as much as possible so that they have the social interaction that is so much a part of a child's development. However, as art therapist Nancy Mayhew has pointed out, many children who are now integrated into regular classes—"mainstreamed"—for part of their day experience deep anxiety and are fearful of the reactions of others in their environment.

Creative activities found in art provide a means of expression while helping to improve muscular control and increased perception. Original drawings such as this one by Javier (age ten) demonstrate the potential that can be stimulated through the use of art in special education classes.

These physical and mental barriers decrease these children's ability to interact successfully with their environment and cause social and emotional isolation. In working with these children, Mayhew has found that the art process performs a psychological service in that it promotes emotional and social growth, which, in turn, aid the learning process. She sees art as also benefiting four general areas of special importance for the handicapped: language and communication skills, independent living skills, psychomotor development, and social-emotional growth.

Zaidee Lindsay, a specialist in art for handicapped children, agrees with Mayhew's views and states that art activities can be used for developing manual dexterity and patterns of movement as well as for encouraging social communicability and providing a means to restore confidence. In art experiences, the child is able to master his or her environment through control of tools and materials. In addition, art encourages observation and discrimination of color, shape, and texture. Last, but certainly not least, states Lindsay, art experiences stimulate imagination.⁵

Appropriate Art Activities for Special Education

A discussion of appropriate creative activities for both the physically and mentally handicapped is difficult, since numerous handicaps offer a wide variety of obstacles to learning. However, the single factor that seems to be common to all disabilities is that most of the children in special education programs were placed there because of difficulties in responding to outside stimuli. These difficulties often delay, distort, or limit development of the child's perceptual and expressive skills. Many handicapped students can overcome these obstacles when introduced to creative activities that stimulate physical and mental abilities, increase awareness of the environment, and offer alternate ways of communication.

Using a Toy

A simple art activity for young handicapped children, one that can be adapted for use with children of differing disabilities, utilizes a favorite toy or stuffed animal. A beloved teddy bear, a toy truck, a tricycle, or a doll can offer unlimited possibilities for motivating sensory exploration and for stimulating perceptual awareness.

Media selected for this activity need to be suited to the individual child's abilities and limitations. Crayons may be awkward for children with severe physical handicaps since downward pressure is required, but colorful felt markers or sponges dipped in paints can provide flowing lines.

Before the actual art activity, children are encouraged to write letters or make up pictorial invitations asking their favorite toys to visit the classroom. When the toys and stuffed animals arrive, a number of activities are possible: Toys and children can participate in a parade to music; toys can be weighed and measured; the children can make up a book of drawings, stories, and poems about their favorite toys. Some children might be willing to dictate stories to adults, to other children, or into tape recorders, and these stories can be a source of interest and entertainment for several days. After a drawing or painting experience in which the toys are used as models, the paintings and drawings, as well as the actual toys, can be exhibited. All of these activities extend the art experience and make it more meaningful.

A, B, C, and D. This series of drawings of a bird and eggs was motivated by a nesting bird on the playground. The students, ages nine and ten, show remarkable awareness of their environment, despite limitations caused by their disabilities. (Drawings from the Ann Daly Center, TMR class, Chula Vista, California)

Enriching activities and a safe environment enable students to produce original artwork. Jimmy's drawing captures the popcorn experience enjoyed by his TMR class in elementary school.

Using Themes

Thematic art activities are recommended for all students, but some subjects may be particularly suited to learners with special needs. While some themes, such as "Clowns," "Umbrellas," "Shoes and Stockings," "Pets," "Friends," "Playing," and "Families," might be appropriate for most children with mental or physical disabilities, other themes might not build upon the experiences of children who have been limited in some way. The table that follows indicates some appropriate themes for use with young children in special education programs. Because descriptions, program titles, and terminology in special education vary from state to state and even from school district to school district, a child who is mentally handicapped may be said to be "developmentally disabled," "learning handicapped," or "mentally retarded" (MR, EMR, and TMR usually stand for "mentally retarded," "educable mentally retarded," and "trainable mentally retarded"). To establish a common frame of reference in the table that follows, special needs groups are categorized as follows:

Learning handicapped (LH): Learning disabled and educable mentally handicapped

Specific physical handicaps: Orthopedically impaired (OI), visually impaired (VI), hearing impaired (HI)

Socially/emotionally disturbed (SED)

Severely handicapped: Physical and emotional (The "Severely handicapped" category is not included in the table, but teachers might be able to adapt some of the themes to meet the needs of their individual students.)

The use of themes for art activities is particularly appropriate for the first two categories and varies in usefulness for the latter two categories, depending on the severity and type of disability.

	L.H.	O.I.	V.I.	H.I.	S.E.D.
"A" is for "Apple" (letters)	Х	X	X	Χ	?
Animal babies	X	X	X	X	X
Big bird, little bird	X	X	X	?	
Birthday party	X	X	X	X	X
Blowing bubbles	X	X	X	X	X
Cars and buses	X	X	X	X	X
Clowns	X	X	X	X	X
Dinosaurs	X	X	?		
Dogs, cats, hamsters	X	X	X	X	X
Families	X	X	X	X	X
Friends	X	X	X	X	X
Funny, fantastic faces	?	X	X	?	
Gardens, flowers, bugs	X	X	X	X	X
Games/people at play	X	X	X	X	X
Happiness is	?	X	X	?	
Homes and houses	X	X	X	X	X
Jungle/Jungle Animals	X	?			
Kites in the wind	X	X	X	X	X
Monsters and beasts	X	X			
Parades	X	X	?	X	
Parks and playgrounds	X	X	X	X	X
Popcorn's-a-poppin'	X	X	X	X	X
Roots, stems, and leaves	X	X	X	X	?
Shadows	?	X	?		
Shoes and stockings	X	X	X	X	X
Things that fly	X	X	X	?	
Tools I've used	X	X	X		
Umbrellas in the rain	×	X	X	X	

Many other themes and topics, other than those presented in the table, will come to mind, especially as they relate to activities involving the disabled learner. Participating in a parade, making popcorn, flying a kite, growing plants, holding an animal, blowing bubbles, having a clown visit the classroom, flying paper airplanes, taking a walk in the rain—all of these experiences are enriching and both involve and intrigue children who vary widely in developmental levels.

Themes combined with looking and doing also provide opportunities to compare the many ways that artists have shown the same thing. Art reproductions that are particular favorites are Pieter Brueghel's Children's Games, Henri Matisse's The Snail, Marc Chagall's The Flying Horse, a jungle scene of Henri Rousseau's, and Wayne Thiebaud's still life of ice-cream sundaes (called Confections). The boys playing in Winslow Homer's Snap the Whip and all the people in the snow in Sugaring Off by Grandma Moses make these two artworks popular. Teachers can combine artwork, themes, and activities by having the children wear crowns, discuss Georges Rouault's The Old King, and paint pictures of kings and queens. Young children, especially those with special needs, require the stimulation and enrichment to be found in an art developmental program that builds on personal experiences.

"I am a Halloween ghost" was the theme for this shapedpaper lesson in a classroom for the visually impaired. The self-portrait drawing is revealed inside the foldedpaper shape.

Preshaped Paper

Many art activities found in special education classrooms utilize paper cut in the shape of an object. Since precut paper defines the boundaries for students, it may be helpful for the visually impaired as well as for some students with learning or physical handicaps. However, shaped or precut paper should be used as a portion of an art activity that stimulates creative responses. For example, paper can be folded and cut in the general shape of a person. Students can then use colored markers, crayons, paints, or pieces of colored paper to show a Halloween costume on the front. Inside, they could do a self-portrait—the person behind the costume.

Another possibility might be paper cut to make a "door" that folds open. A second piece of paper is placed underneath and provides a surface for students to draw what they visualize when they open the door. If there is a goldfish bowl in the room, the teacher could give students paper cut in the shape of the bowl. Crayons or oil pastels can be used to draw the goldfish, and a watercolor wash over the drawing results in a piece of artwork that not only records an actual experience but also has an expressive content. Preshaped paper can be used to enhance, rather than drain, an art activity of its potential for creative expression.

Chance Manipulation

Activities that enable the student to produce original work derived by chance manipulation of materials is another method frequently found in special education classes. Although these experiences fail to provide creative stimulation, they can be introduced periodically for variety and to promote increased awareness. For example, a string dipped in black tempera paint and dragged across a piece of white paper may provide the teacher with an opportunity to discuss such concepts as dark and light, lines and

shapes, curved and straight. Spots of red, yellow, and blue paint (primary colors) can be painted on a piece of paper that is then folded along a midline and rubbed on the outside so that the paint inside smears and mingles. When opened, the accidental design is symmetrical, and some of the colors have mixed to produce new ones (secondary colors).

These phenomena can be discussed and the mirror-image concept extended by holding a mirror up to an object so that half of it is mirrored or reflected in perfect symmetry.

Process Rather Than Product

Some teachers of the handicapped are tempted to provide activities that lead to more skillful-looking results. "Dictated art" presents little creative stimulation and does not provide the sense of fulfillment to be found in creating original art. Tracing, using patterns, and copying the work of others becomes manipulative busywork that fills the time but not the soul of the handicapped child. Teachers concerned with the fundamental learning process and the needs of their students do not find satisfaction in methods of instruction in which the focus is on the end product, rather than on developing a child's abilities.

Adaptive Tools and Aids

Myriads of adaptive tools are available for students with physical handicaps. Some, like double-handed scissors, are designed so that another child or adult can work the tool along with the disabled child. Many children with physical disabilities are able to squeeze objects, and spring scissors that automatically open (much like gardening shears) have been designed. Although not labeled specifically for persons with handicaps, some commercial art materials are particularly appropriate: liquid gluesticks with sponge applicators, tempera-markers that apply paint by means of a slight squeeze on the self-dispensing bottle, and extra large crayons (over a half inch in diameter) or chunk crayons.

In addition, teachers have become very creative in finding ways to solve problems that might frustrate or limit the child with a physical disability. Rough-surfaced "non-skid" tape (the type found in hardware stores and used in bathtubs or on stairs to prevent slipping) can be cut and applied to pencils, crayons, markers, and paintbrushes to assure a better grip. Velcro can be used in the same way and can be combined with gloves or mittens, if needed, to enable the child to grasp brushes and other art tools. Foam hair curlers can be slipped over brushes or pencils to help students with manual grasp difficulties. Stubby shaving brushes or sponge wedge brushes used for house painting also are worth trying as art tools.

Good organization is crucial in ensuring successful art projects for children with physical disabilities. Students who have difficulty picking crayons up from a flat surface appreciate having them in upright positions. The visually impaired child is often more secure using a large, shallow tray (often found in cafeterias) as a work surface. Water containers can be stabilized by setting them in the core of a roll of masking tape. Nonslip plastic sheeting is commercially available but is very expensive; nonskid tub strips may work just as well to stabilize materials on a slick surface.

In all cases, the adaptation of tools and materials to meet the needs of disabled children reduces frustration and increases the potential for success. With success comes a sense of accomplishment and heightened self-confidence.

The young child's awareness of his physical impairment is evident in this wire sculpture in which the handicapped left arm is shortened and bent. Art provides not only a creative outlet but also, sometimes, an emotional one for children with special needs.

Although Saul (age ten) is autistic and mentally handicapped, he enjoys drawing and is willing to spend time and energy in creating detailed pictures. This drawing of his classmates is a unique statement about the world as he perceives it.

Museum Visits for the Disabled Child

Young children with handicaps can enjoy a rich, visual world by viewing original art in galleries and museums. Many of the physical barriers that once existed to galleries and museums have been eliminated due to Section 504 of the Federal Rehabilitation Act. This legislation states that handicapped persons cannot be excluded from participation on the basis of their disability. Institutions like museums that receive federal funds must comply with regulations that assure safe and convenient access. Wheelchair ramps have been installed, doors widened, and many other architectural features altered so that people with physical disabilities are able to move easily through public spaces. In addition, many museums have extended and adapted their programs so that children who are hearing or learning impaired can understand and interact with art. Some museums have a coordinator and docents whose primary responsibilities are assisting disabled visitors.

A bouquet of irises inspired a printmaking activity. After touching the leaves, stems, and flowers, visually impaired students used the edges of their hands and of cardboard strips to print irises. The use of tangible objects to motivate art activities is particularly successful in working with disabled students.

In preparing for a trip to the museum, teachers should use previsit activities in the classroom to inform young children about what they are to experience. Art reproductions and improvisational techniques help students to experience an imaginary trip that introduces them to the purpose and function of a museum and also gives them a greater understanding of the art they will see.

Preparation for a museum visit also requires that the adult supervisors are thoroughly familiar with the physical accessibility of the building, the type of adaptive materials and equipment available, and the portions of the exhibitions that are most suitable for the young children participating in the visit. Some museums have lists of touchable art objects for the visually impaired. Special exhibitions or areas may be designated as "touchable," and these are often of great interest to young children. If possible, a few postcards or small reproductions of artwork that the students see during their visit should be purchased. These can be used to motivate discussions about the art and the museum experience once the students have returned to the classroom. The postcards also can be attached to large pieces of paper and used as "starters" for a painting that shows the children viewing art during their museum visit. Pre- and post- activities reinforce the experience, increasing awareness and perceptual skills and forming a basis for appreciation.

Abilities of the Handicapped Child

Antusa Bryant and Leroy Schwann conducted a study to see if the design sense of retarded children could be improved. They developed and administered a test to assess sensitivities to five art elements: line, shape, color, value, and texture. The researchers discovered that, after fifteen half-hour lessons, children with substandard IQs (23–80) were able to learn art terminology by direct exposure to concrete objects that they were able to observe, examine, manipulate, verbalize about, react to, and put together in some artistic way. The study also indicates that retarded children can get involved in producing original art that they understand and enjoy.⁶

In a paper presented at an international conference, speaker Gay Chapman described many similar art activities that develop specific skills. As Chapman points out, one of the great strengths of the art process is that the child with disabilities is able to set the learning pace and manipulate his or her own environment. This not only builds self-confidence but also leads to self-discovery. Art is one means of helping children with disabilities to confront and adjust to their handicaps.

As with children in the regular school programs, it is essential that the abilities of the handicapped child not be underestimated. In working with children with disabilities, the teacher must look beyond labels and categories to provide the program best

suited to the needs and abilities of the individual child. The methods and activities used in the regular art program are, to a large extent, also practical and effective when used with handicapped children. Teachers introducing art activities to handicapped children, however, may need to adapt some of the art experiences. They may need to simplify, repeat directions, demonstrate, and divide the learning activity into manageable stages. Most of all, they need to have the patience to step back and allow each student to experience his or her creative potential. The results, while possibly not highly representational, are the tangible products of a process that has involved decision making, problem solving, and the manipulation of the physical world so as to create unique and personal visual statements.

For Discussion

- 1. How may an art program be "adjusted" for children of exceptional talents or special needs? In what ways would meaningful experiences in art assist these children?
- 2. What are the characteristics of artistically talented children? What are some of the ways of identifying these children?
- 3. What type of program and experiences are best suited for talented students? What type of environment and what kind of opportunities are appropriate for children who are identifed as "gifted"?
- 4. What are the benefits of appropriate art activities for children who are physically or mentally handicapped? What would be the primary focus of these "appropriate art activities"?
- 5. Develop an additional set of ten themes for art activities that could be added to the table for use with young children in special education programs.
- Locate and list sets of art reproductions that you think would be of particular interest to a group of young students with special needs. Develop appropriate questions to focus their attention and that would relate to their personal experiences.
- 7. What type of environment and what kind of art opportunities are appropriate for young children in special education programs?
- 8. What problem is there in focusing on the end product rather than on the process in an art activity planned for children with special needs?
- 9. How have museums and other public places provided access to their programs so that children with physical handicaps can interact with art?
- 10. In your own words, describe a research project that indicates that handicapped children benefit from art experiences.

Notes

- 1. E. Paul Torrance, Creativity (San Rafael, Calif.: Dimensions Publishers, 1969), 43.
- 2. Ann Wiseman, Making Things: The Handbook of Creative Discovering (Boston: Little, Brown, 1973), 3.
- 3. California State Department of Education, Arts for the Gifted and Talented: Grades 1 through 6 (Sacramento, Calif.: California State Department of Education, 1981), vii.
- Nancy Mayhew, "Expanding Horizons: The Practice of Art Therapy in a Special Education Setting" (Paper presented at the American Art Therapy Association's Ninth Annual Conference, Los Angeles, Calif., 1978), 5.
- Zaidee Lindsay, Art and the Handicapped Child (New York: Van Nostrand Reinhold, 1972),
 9.
- 6. Antusa P. Bryant and Leroy B. Schwann, "Art and Mentally Retarded Children," Studies in Art Education 12(Spring 1971): 56.
- 7. Gay Chapman, "Learning in a Friendly Environment: Art As an Instructor" (Paper presented at the Fifty-Fifth Annual International Convention of the Council for Exceptional Children, Atlanta, Ga., 1977), 3-4.

Art Production: 6 Motivating and Evaluating

Every child is an artist. The problem is how to remain an artist once he grows up.

PABLO PICASSO

Innate Awareness

Art education practices are firmly founded on the fundamental philosophy that children have the innate capacity to transform their primary means of knowing—the experiences of feeling, thinking, and perceiving—into their own unique art forms. In attempting to retain and foster the precious human gift of discovery through art, leading art education authorities have emphasized the importance and basic value of motivations as the primary method of evoking art responses in the child.

Motivation that precedes an art production experience should engage the children in a visual analysis that includes emotions and cognitive functions so that they become skilled in looking. They should come to know that every object, whether it is natural or of human origin, has a form and characteristics that distinguish it from other objects. For example, the overall shape of a lion is different from that of a peacock, and the parts of the lion can be analyzed as to their thickness, thinness, angularity, and relative sizes and positions.

The children's attention can be directed toward distinguishing lines in the object—such as smooth, flowing tail feathers or sharp, jutting antlers. Appropriate terminology can be used to describe the object's visual and tactile qualities—rough, shaggy, shiny, bumpy, and so on. The gesture or bearing of the object can be noted—it may be restful, tense, ready to jump, or running. The position of the object should be perceived. Are the arms stretched to catch a ball? Is the cowboy seated on a horse? Is the beak of the toucan higher or lower than its body when it sits on the branch? The brightness or dullness of colors can be noted, along with which color is predominant. Pattern involves repeated shapes, and children can become aware of bricks in a building and stripes on a zebra. They can note contrasts between dark and light, large and small, and plain versus patterned.

Observed is a key word here. Frequently, children are directed to draw or paint pictures without any observation. When this happens, children draw upon their memory, and the result is as good, or as poor, as the stored images in their minds. If the child is told to draw an elephant, for example, the child's memory may include a long trunk, but all of the other visual characteristics—the large ears, wrinkled skin, thick legs—may be lost in the finished work of art. Direct observation of objects in the real world (or carefully looking at photographs of real-world objects) provides experiences that can be stored and later used. Drawing or painting observed objects is also a way to

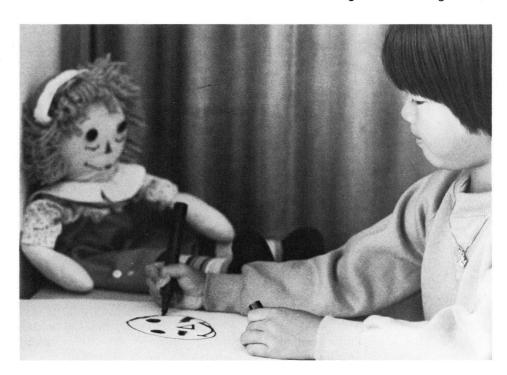

Students use dolls, stuffed toys, and other everyday objects in this draw-from-the-real-world lesson.

Students asked to draw what they remember must call upon a large bank of stored visual images.

increase perception and to store visual experiences that can be recalled for use at a later time. The development of fantasy objects, creatures, and environments is based upon observation and recall. In this case, the imaginary creatures and objects are combinations, variations, and distortions of those observed in the real world. Providing many visual/tactile experiences and directing the child's observation is necessary to attain the high levels of perception required for creative and imaginative art production.

Providing Options

As children become established in the base-line stage of their art development, at about age six, they can think more about the placement or environment necessary to deal with the theme or idea they are portraying. Second and third graders are ready to preplan their pictures—that is, think of a point of view and where the objects will be placed on the paper ("Will I draw it from the front, side, or back? From below or above? From close up or far away?"). Children should verbally describe the object they are going to draw or paint, striving to note as many of the aforementioned factors as possible. With practice and perseverance, the child's skill in learning to look and looking to learn substantially increases.

It has been said that from impressions come expression. Motivations can help children to select the subjects for their art and to make a complete statement of their thoughts, feelings, and perceptions. Regular experiences in painting and drawing help the children to sort out pertinent details, eliminate unnecessary elements, establish harmonious relationships within the work, and correlate contrast and balance. Through verbal interchanges, children are made more aware and critical of why or why not their pictures have conveyed what they wanted them to.

Six- and seven-year-old children are ready to widen the range of their experiences with art materials and to explore more-challenging and intricate processes. They are eager to develop their skills in manipulating all sorts of materials, and the teacher should not underestimate their capabilities. They tend to be less spontaneous and fluent, and hence, the teacher should use many motivational channels to stimulate their art production.

A variety of motivational techniques provides opportunities for the adult to ask leading questions that stimulate the child to look, feel, remember, and engage in art production. The child's artwork subsequently may be evaluated for evidence of behavioral change and artistic growth. Motivations set up by the teacher provide artistic problems for children to solve. During the production period that follows, children need to develop a critical eye and conscious judgment. The aesthetic choices and decisions made during the work process ultimately result in a higher level of visual literacy, and the teacher/child verbal interchange can better bring this about.

Photographic Materials for Visual Information

Visual materials (such as photographs, videos, slides, films, and filmstrips) on a variety of subjects provide precise observations as preparation for drawing, painting, and modeling. "Field trips" to places all over the world can thus be brought directly into the classroom. Such visual aids not only provide visual stimulation and input, but also present opportunities for language development as the children look, question, discuss, compare, contrast, and note specific shapes, colors, lines, patterns, and size relationships.

Photographs can be collected from such sources as Junior World, National Geographic's Ranger Rick, photographic magazines, calendars, and books that deal with a single theme or subject. After trimming the photos, the teacher should mount them on railroad board, using spray adhesive. This method of adhesion, in addition to being quick and easy, keeps the photos flat and neat on the boards and avoids the wrinkles and stains that sometimes occur when paste or rubber cement is used. One large piece of railroad board can be cut into several small panels. Photographs can be grouped thematically and stored in envelopes. The following themes are suggested: birds, horses, animals and their young, butterflies, buildings, trains, cars, faces, trees, people in action, fish, flowers, insects, dogs, cats, portraits, cities, landscapes, seascapes, and skies.

В

A. A visit by a clown can provide strong motivation for subsequent drawing and painting activities.

B. Bold, black lines characterize this painting of a clown by a first-grade student. Studying photographs that deal with birds prior to an art activity about birds, for example, can increase children's perceptual skills through directed observation. The discussion helps the children to note the different shapes of beaks and how different birds make use of their beaks, the lengths of different legs and necks, different sizes and shapes of bodies, the relative size of a bird's head to the size of its body, details that relate to the placement of the eyes and to the position of the wings at rest and in flight, the different kinds of claws and tails, and so on. The children should pretend that they are birds, swooping, feeding, pecking, roosting, and nesting, thereby ensuring that different modes of sensory awareness—visual, auditory, and kinesthetic—are open to them.

The importance of this approach, which ensures that all of children's strongest modes of learning are addressed, has been demonstrated by a study that found that 33 percent of individuals learn primarily in the visual mode, 24 percent are auditory learners, 14 percent are kinesthetic learners, and 29 percent learn in mixed modes. In other words, some individuals learn best when the input is mostly taken in through the eyes. Others tend to listen and take in more information through their ears. The small but significant minority are those who need to move and go through the motions to take in data. Almost one-third of us learn best through a mixture of these modes of sensory awareness.

In initiating a drawing or painting activity, if the teacher only tells the child to "draw a bird" and uses no visual input devices, no directed observational opportunities, and no kinesthetic activity, the expression that is produced is usually symbolic, generalized, and lacking in any degree of emotion or self-identification. The left hemisphere is content to present a symbol to stand for "bird," using only small bits of

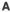

В

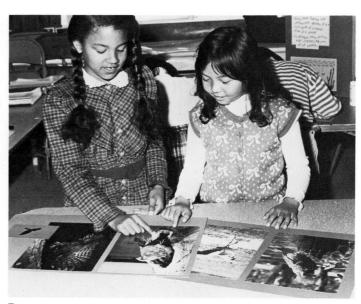

A, B, and C. Careful observation of photographs of birds, noting different sizes and shapes of their bodies, beaks, wings, legs, and tails, results in the emergence of differentiated concepts when

children undertake painting

activities.

Photo files organized by subject are useful to motivate drawing lessons and to refresh mental images. After looking at many photographs from the "jungle animals" file, children made drawings to be used on notecards and to illustrate calendars.

A and B. A student sits in a real saddle, wears oversized boots, and rides a makebelieve horse while the class observes and draws or paints. Live models with simple costumes and props assist in schema development by providing visual clues and emotional identification with real-life experience.

В

information to represent the whole thing. By alternating hemispheric involvement during a motivation, a teachers calls upon the left hemisphere's ability to analyze birds in a logical manner, to use words to name, define, and describe birds step-by-step and part-by-part. On the other hand, the characteristic modes of the right hemisphere increase students' nonverbal awareness of birds. Students are challenged to synthesize or put a bird together as they draw and paint, focusing on the likenesses between things, seeing where the different parts are in relation to other parts, and how different parts go together. If the motivation is open-ended and encourages fluency of response, children are free to make metaphorical relationships, arriving at divergent conclusions based upon intuitive leaps of insight, hunches, feelings, and visual images.²

Such observational skills involving the child's thoughts, feelings, and perceptions can be increased through frequent, short encounters with visual materials. These input skills establish a perceptual learning pattern or base that can be transferred to other media and other occasions—for example, when the students look at photographs on a variety of subjects and when they observe real-life objects that are either brought into the classroom or seen on field trips. These encounters build up within children's minds visual image "banks" in which their imagination may find rich resources for expression. Subsequent art production can call upon the students to review, recall, and visualize ideas, feelings, and experiences in their drawing, painting, and modeling.

Actual Objects As a Motivational Strategy

Using actual objects that intrigue and interest the children is a motivational strategy that is challenging and open-ended. A bugle, a drum, a bicycle, a toy truck, a favorite doll, or a pet rabbit brought into the classroom can all trigger immediate enthusiasm and responses. For example, through handling a saddle during a motivation, children could:

- 1. Enjoy sitting on the saddle
- 2. Act out or pretend to ride horseback

- 3. Observe other children's body positions when they are sitting on the saddle and verbalize as to the placement of arms, legs, and so on
- 4. Discuss various situations and environments where people ride horses
- 5. Think of items of clothing they might be wearing when they ride and what sort of hat and boots they might have
- 6. Observe the shape of the saddle and the length of the stirrups
- 7. Imagine their drawings on paper, thinking of where they would place the different parts and what background and which details they would use
- 8. Draw or paint themselves or another person horseback riding

These considerations do not restrict the individual's creativity in that they do not preordain or control the child's response; nor do they specify how the child must draw or paint. The motivation or stimulus is provided, with the main focus being on perception, motor and cognitive awareness, and affective involvement, along with some preproduction planning.

Thematic Groups of Artworks

A group of related artworks can motivate students to make art that has the same or similar subject matter. By viewing several artworks by different artists, students begin to understand art's diversity, even when it deals with the same theme. The motivation should encourage students to deal with the theme in their own unique ways. Children should first be actively engaged in describing, analyzing, and interpreting the artworks and then presented with a similar topic and appropriate materials. Themes could include: portraits, animals, sports and games, flowers, the sea, families, and so on.

Three artworks to be discussed shortly focus on a favorite theme of great American artists: "Artists Paint Cowboys and Indians." A motivation can show how some of these artists have chronicled the adventures and lives of cowboys and Indians and have told us through their pictures how these individuals dressed and what they did. The reproductions discussed in the paragraphs that follow are from the Art in Action Enrichment Program³ and can be presented to the children, using art criticism, art history commentary, and questioning strategies, while relating the theme of "Cowboys and Indians" to the children's own art productions. (Allowing the children to copy or imitate any of the paintings is to be vigorously avoided.)

White Cloud, Head Chief of the Iowas, by George Catlin "This proud leader of the Iowa tribe of Native Americans is depicted by artist George Catlin as being strong, confident, and brave. Catlin said that White Cloud was humane and noble and was well worthy of being chief. The picture was painted over 150 years ago. Describe what White Cloud is wearing (eagle quill headdress of war and special paint on his face; grizzly bear claws strung around his neck; skin of a white wolf hangs from shoulders). Catlin was very skilled in painting a variety of textures; we can almost feel the soft, white fur and the sharply pointed feathers. The repeated curves of his necklace make a pattern. Can you find any other patterns? We see White Cloud in three-quarter view. His face is oval shaped. Catlin was a lawyer who decided to spend the rest of his life observing and painting American Indians, making a visual record of how they looked, dressed, and lived. He collected Indian relics, and today his artworks and collections can be seen in the Smithsonian Institution in Washington, D.C."

The Fall of the Cowboy, by Frederic Remington "This painting was made almost one hundred years ago and, like Catlin's painting, is a visual record. Frederic Remington loved the Old American West and knew that times were changing fast, with more and more people settling there. He thought that the 'wild riders and vacant lands' were about to vanish and wanted to capture the

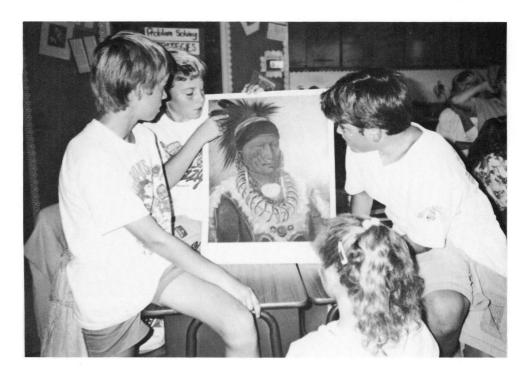

Students find visual textures and details of clothing and costume in George Catlin's painting of *White Cloud, Head Chief of the lowas.* They come to sense the noble dignity of the character of this Indian, who lived in the early part of the nineteenth century, and to appreciate the contribution made by Catlin, who recorded countless numbers of native Americans.

Remington's painting *The Fall of the Cowboy* tells children about an important change in the western frontier. Students describe colors and other compositional components to determine the mood.

spirit and vigor of life on the frontier. He named this painting the *The Fall of the Cowboy* because he sensed an end to the time when cowboys could roam freely, herding cattle and camping out with the chuck wagons. Farmers were moving in and building fences. Describe what you see in this painting (one cowboy at the gate, his horse waiting for him; another cowboy on a horse; fence going way back into the distance). Notice how cold it looks, how there are no trees or bushes, just a lot of snow and gray skies. We get a lonely feeling when we look at this picture; even the horses hang their heads sadly, almost as if they know that their time to gallop across the open plains is nearing an end. Notice how the cowboys are dressed and what they have on

Students respond to a contemporary artwork—Indian Portrait with Tomahawk by Fritz Scholder—and describe the full figure with feathered headdress. They look for similarities and differences with regard to color, texture, and proportion in Catlin's portrait of an Indian chief. They decide which portrait is more realistic and which tends to symbolize Indians and then give reasons for their choices.

their heads. Remington worked as a ranch cook, shepherd, and cowpuncher. He painted many pictures of the West so that people would know what life in this part of America was like in the 1800s."

Indian Portrait with Tomahawk, by Fritz Scholder "Fritz Scholder is the artist who made this lithographic print (a print made from the flat surface of a stone), and he is still living today. Scholder has shown us a full figure of an Indian in profile. The many, many feathers cascading down his back make a strong, repeated pattern. His head seems very small in proportion to his body; perhaps the artist did this to make him look very strong and powerful, like a statue of a hero. Can you see details on his face, as you did in Catlin's painting? Scholder was painting the idea of many Indians, rather than a specific one, as Catlin did. His Indian is a symbol of stature and dignity. The colors we see are mostly red, white, and blue and a little of a soft, mustard yellow. The spots and splashes of red over much of the artwork make our eyes continually move over the surface. We see a yellow stripe going up the Indian's trouser leg, and this leads our eyes to his tomahawk, a horizontal element in the composition. The background is a warm, neutral color."

After a discussion of this group of paintings on "Cowboys and Indians," the children are ready to make visual statements of their own ideas about how these individuals lived and how they dressed. A follow-up lesson could involve discussions of the following:

- "What kinds of work did cowboys do, and what kinds of adventures did they have?" (herded cattle, lassoed strays, branded cattle, rode horses, made camp fires, shot rifles)
- "What did Indians do?" (rode horses, hunted animals such as buffalo, herded sheep, shot bows and arrows, carried babies, gathered food, acted as scouts)
- "Describe the clothing of cowboys and Indians in detail. Describe their headgear, footware. What did they carry?"

As preparation for the children making their own pictures about cowboys and Indians, the teacher can cut a potato in half and drain the flat, cut side on paper toweling to absorb moisture. The potato half is an oval shape and can serve as the face(s) for the children's drawings of cowboys and/or Indians. The children should brush the potato half with watercolor paint or diluted tempera on the surface and then make one

A and B. Potato-print face shapes were made by first graders. Then a student wearing a blanket and feather headdress modeled for the class and students completed their drawings with oil pastels.

A

В

or several prints on pieces of manila paper. After the prints are dry, two or three students, perhaps from an upper-grade classroom, should dress up in cowboy or Indian costumes and model for the children. With two or three models, all of the students can be close enough for good observation. Costumes might include a cowboy hat, kerchief, boots, lasso, and saddle for the cowboy and feather headdress, necklace, blanket, tomahawk, and moccasins for the Indian. The children can then use crayons or oil pastels to draw the facial features and rest of the picture—the body and clothing of the cowboy and/or Indians. The teacher should encourage the children to include clothing and facial details and to show what their cowboys/Indians are doing and where they are.

"Take 5!"

The children might want to include a horse, buffalo, wagon, trees, rocks, and so on. The pictures may show upper bodies only, as Catlin did in his portrait of White Cloud,

or they may show full figures, as Scholder and Remington did.

Many school districts have sets of art reproductions that are stored on shelves and seldom used. How to make these conveniently accessible to classroom teachers is a problem. One solution, developed about ten years ago in Palo Alto, California, is a program called "Take 5!" Sets of five theme-related reproductions are packaged in portfolios and circulated in the schools. On the back of each reproduction is a brief statement about the artist and the artwork. Included are questions, statements, and information to enable the teacher to lead classroom discussions.

The set of five reproductions is used over a two-week period for about five minutes a day. During the first week, in which one reproduction is looked at each day, the focus is on recognizing and describing the subject matter, media, and elements of art. During the second week, the emphasis is on looking at the ways that the various artists have used the principles of art in composing the artwork. The expressive content—the mood—is also discussed. As each day's discussion ends, the teacher places the print on a display board or chalk rail, accumulating a small gallery for continued viewing.

Originally, in the Palo Alto program, there were only a few portfolios grouped around such themes as "People at Work," "Circus," "Art and Music," "People at Play," and "Portraits." With increased teacher requests, the number of thematic portfolios

increased to sixty. Some of the new themes include "Seasons," "Villages," "Beasts," "Children at Play," "Celebrations," "Flags," "Reading," "Rooms," and a portfolio each on "Night" and "Day."

The five reproductions selected for each portfolio show great diversity to demonstrate that artists create in many different ways—even when they have the same subject matter. For example, the portfolio with the theme "Rooms" contains: Vincent van Gogh's *The Bedroom at Arles*, Andrew Wyeth's *Master Bedroom*, Horace Pippin's *Victorian Interior*, Henri Matisse's *Interior with Phonograph*, and Pieter de Hooch's *The Pantry*. Although all of the works show rooms, the styles vary widely, and the artists are each unique in their use of the elements, in arranging and organizing their composition, and in establishing mood or expressing ideas.

During the first week of viewing the five artworks in the "Rooms" portfolio, the major task is to recognize and describe the subject matter, media, techniques, and art elements of the artworks. Sample questions could include: "What do you see in this painting?" (subject matter) "What shapes, lines, colors, textures, values, space do you see?" (the elements of art) "What did the artist use to make the artwork?" (medium—oil, watercolor, pastel, ink)

During the second week, discussion goes beyond mere recognition of subject matter and the art elements to the perception and description of how the elements are combined and organized and how feelings and ideas are communicated. Sample questions might include: "How did the artist arrange (colors, line, shapes) in this work?" (Where are they repeated? What is emphasized? How is the artwork balanced?) "What mood does the artist express?" (What feeling does the artwork give you?)

On the last day, students are invited to make critical value judgments: "That is my favorite because . . . ," "I don't like that one because . . . ," and so on. The important component of this last day of discussion is that the students justify their choices by relying on the perceptive, technical, formal, and expressive learning of the previous two weeks.

Because the program is arranged in manageable, "bite-sized" portions, even the teacher who feels inadequate in art heritage and criticism is able to become involved. The Palo Alto portfolios are on continuous rotation—each being inventoried and sent to the next teacher on the list after they are returned to the center. Teachers on the waiting list look forward to their chance to "Take 5!"

Evoking Images with Words

Children produce highly imaginative artistic responses when they are presented with humorous songs and image-evoking poems. These devices may call upon the child to include several sequential events within one picture. The students can be asked to close their eyes while listening to the song or poem and to pretend that they have a television set "inside their heads" upon which to "see" what the words are describing.

The song "The Big Black Hat" by Rolf Harris (EPIC 45 rpm, 5–9596) describes a man who is dressed in a very strange way. The rhythm and melody are lively and easy to remember. After listening to the song, the children are asked to call upon their visual memory and to tell whether they would be frightened, curious, or amused to meet a man dressed in the manner described. Questions that the teacher might ask the students include: "Can you remember how the man was dressed, starting with what he wore on his head? What sort of brim did the hat have? What kind of band? How do you imagine the man's moustache was shaped? What sort of glasses were on his nose? What was around his neck, and what was attached to it and dragging on the ground? What is a 'sunshade'? What color was the man's sunshade, and where did he hold it? What sort of coat and shirt and trousers do you suppose he might have worn? Do you imagine that this strange man was tall or short, fat or thin? Do you think he had large feet or small? Do you think he wore boots, shoes, or sandals?"

Edward Lear, who lived during the nineteenth century in England, was a master of limericks—five-lined, often humorous poems that are always highly rich in evoking visual images. The people and other creatures in the limericks are often connected in odd and unexpected ways. Children who hear the following limericks generally visualize completely different responses in illustrating what they see while listening to the words:

There was an old man in a tree, Whose whiskers were lovely to see: But the birds of the air, Pluk'd them perfectly bare, To make themselves nests in that tree.

There was a young lady whose bonnet, Came untied when the birds sat upon it; But she said, "I don't care! All the birds in the air Are welcome to sit on my bonnet."

There was an old man of Dunrose, A parrot seized hold of his nose. When he grew melancholy, They said, "His name's Polly," Which soothed that old man of Dunrose.

There was an old man with a beard, Who said, "It is just as I feared! Two owls and a hen, Four larks and a wren, Have all built their nests in my beard!"

Mother Goose rhymes, Aesop's fables, and numerous books of poems for children contain descriptive accounts of people, real and imaginary animals, places, and events. The teacher should avoid showing the children any illustrations that may accompany a poem until after the children have completed their drawings.

"Acting It Out" Motivations

Some motivations can emphasize requiring the child to identify with another person or object, with questions prefaced with "If you were a helicopter pilot (or a scarecrow, or a balloon seller, or a robot). . . ." These motivations call for children to project their thoughts, feelings, and perceptions into another being or object, placing themselves in that being or object's position and imagining how they would feel, what they would see, and what they would think and do. For example, students can be asked where they have seen balloon sellers and if they themselves have ever let go of the string on a balloon and watched the balloon vanish in the distant sky. Other questions could include: "Would you like to sell balloons? What colors would the balloons be? How many shapes of balloons have you seen? How many balloons could you hold if you were selling them at a fair? Would your balloons be on sticks or strings? Would you need one hand or two to hold all of them? Where would you put the money you are collecting? What kind of clothing would you wear? Would you get tired? How would you like to look up and see about twenty balloons over your head?" Children might then cut out a large number of circles from colored paper, paste them onto a piece of drawing paper, and finish the drawing with their crayons.

Becoming a grasshopper for a few minutes before drawing these insects calls upon the children to think about how it would feel to be on a leaf hiding from a big, hungry bird. Questions to ask the children could include: "What shape is your body? What do you like to eat? Where do you hide from your enemies? Do you know that grasshoppers are musicians and that they rub their legs and wings together to make music? How would it feel to have three pairs of legs and to have to tie shoestrings on six shoes? What position are your legs in when you hop? (The children should crouch down, elbows bent upward, to simulate grasshopper legs.) Hop! Hop! Now crawl along a juicy leaf and take a bite of it."

Fantasy and Humor for Motivation

Fantasy and humor are also appealing focus points for a motivation that charges children's mental batteries and aids them in pushing forward in their artistic production. Fantasy themes can be fanciful, unreal, absurd, and dreamlike. Humorous topics deal with whimsy, wit, jests, jokes, and just plain funny situations. Examples might include: "The Mixed-Up Animal I Saw in My Backyard," "What I Think I Look Like Inside," "Inside Our TV set," "Magic Flowers," "Underground Tunnels for Alligators," "What If Cars Could Walk?" "What If Elephants Could Fly?" "What If Insects Became Giants?" "What If Fish Had Legs and Animals Had Wheels?" and "What If Cities Were Built in Jungles?" Pretend and make-believe, weird visual connections, old ideas placed in fresh surroundings, and silly, absurd situations help children to grow creatively and to explore new tasks in individual, visualized ways.

Evaluating Student Development in Art Production

As children become involved in regular and sequential lessons in art, their artistic production is expected to change. Looking at the outcomes of a series of motivations and having some criteria for evaluating both the process and product become a significant area of concern for the classroom teacher.

Four aspects of art production can be evaluated. The first of these is the child's degree of skill in handling materials, both during the time the child is working and within the finished artwork. This relates to the extent to which the child shows motor control in using materials because, without constantly improving material-handling skills, expression is held back. In a child's early years, highly developed motor control is not expected. However, an increasing capacity to master materials and a desire to develop skills are evidences suitable for evaluation.

The second aspect for evaluation deals with the manner in which the child has organized his or her artwork and made the different parts function—how the child has used colors, lines, shapes, and the other elements of art. It also refers to how the child has used repetition, balance, variety, and the other principles of art. When a child achieves unity in an artwork, he or she has made it look whole, harmonious, and complete.

The third aspect for evaluation involves expressive or emotional content in the child's artwork. This has to do with feelings and moods, as seen in choices of subject matter as well as in the selection of colors, use of lines and shapes, and so on.

The fourth focus for evaluation in the productive realm involves assessing the degree of creative imagination, independent thinking, and ingenuity used in making the artwork. This has to do with original ideas, making unusual connections (relating two or more usually unrelated ideas), humorous or insightful approaches, or fresh new ways to express an idea, solve a visual problem, or use a material. Technical skill and an aesthetically pleasing form may be present, yet imaginative aspects and fresh insight may be at a minimum. Ideally, all four aspects work together and support each other and should be taken into account in evaluating student development in making art.

For the preschool and kindergarten child, an impromptu and informal discussion as the completed art products are being hung about the room is probably critique enough: "John's painting makes me feel like a sunshiny day—happy and warm. Louise's drawing tells us how strong and furry her black dog is. Jim loves red and orange, and he has arranged them well. Lisa has repeated this yellow shape over and over, and it makes an interesting pattern."

The teacher's supportive and encouraging remarks bring out the best in all children. The three occasions during which such encouragement can take place are during the initial motivation period, during the working process, and then later, while discussing the finished work. Specific comments are more meaningful and offer more opportunity for the child's growth: "Louise, I am delighted how you repeated curving lines in your picture," or "I am very pleased to see how much you enjoy painting with red and yellow," are more specific than "That's nice." Precise statements during the working period may refer to product as well as process: "José, it makes me happy to see how much you enjoy making purple circles. I am glad to see how hard you are concentrating on applying that blue paint." Instead of a vapid, "That's nice, Liz," or "Good work, Sue," the teacher should first look carefully at the work. The comments then can be directed to several content points:

- 1. The elements of art that the child has used: "You have used red in several places, Diane." Or, "I like the blue and green colors that contrast with the big, orange sun, Larry."
- 2. The art principles involved, such as rhythm, balance, proportion, and the overall composition: "You did a good job of repeating this shape, Jim. It gives your picture a sense of rhythm." Or, "These two small, bright spots of red on this side of your picture help to balance the large, dull blue spot on the other side."
- 3. The expressive quality: "I feel happy when I see the warm colors in your painting, and I remember going to the circus last summer." Or, "Your picture makes me remember a stormy night last October."
- 4. The inventiveness, ingenuity, and imagination shown in the child's work: "Bob drew his horse different from anyone else's. It's almost running off the page."

 Or, "Mary found two new ways to show people jumping rope."
- 5. The length of time and effort the child has put into a work: "Dean has worked for a whole hour on his picture. He is trying very hard to show us his tree house."
- 6. The child's improved skill and control of the medium: "Laura painted her background color up very close to the house." Or, "Jean really is doing a good job of making her crayon drawing dark and waxy."

Artwork in which the child has placed much sincere effort should be attractively displayed since this tells the child that he or she, as a person, is important, and that his or her individual and unique achievements are respected and valued. All of the children's artwork should be on display at different times during the year and should be accompanied by appropriate reinforcing comments and definitive discussion.

As children produce art at a more conscious, critical level, usually during the first grade, they may talk with the teacher in small groups or individually, verbalizing about their work and becoming more aware of the art elements and how to integrate them in their artistic configurations. Periodic discussions after art production periods aid the children in dealing more effectively and expressively with color, shape, line, contrast, rhythm, and allover composition. In this way, future discouragement and frustration may be prevented. If teachers neglect to talk about the child's art in art terminology, the child does not automatically develop an art language and awareness.

A positive and constructive approach that does not single out one child's work as "better" than others can be achieved by asking such directed questions as: "What is the best part of this painting?" "What shapes in Dan's picture tell us about his boat ride?" "How did Joe make us feel the coldness of a snowy day in his picture?" "What shapes are repeated in Helen's work, and how does this make us feel?"

Art educators have frequently made statements as to the inadvisability of comparing one child's work to another's or of using one child's work as an example for others to copy. This does not mean, however, that a teacher should never choose one child's work for positive and directed comments. These comments may refer to: the child's ingenuity; unique approaches and solutions; imaginative use of materials; sensitive observations of things and events; enrichment of drawings and paintings with fine, textural qualities and details; selection and expressive combination of colors; taking the initiative in suggesting ideas; manner of showing feeling in his or her work; and so on. Such evaluative considerations are specific guideposts for young minds, giving the child added insight and understanding.

Process and Product: Reviewing and Reflecting

The questions that follow are helpful for small-group or class discussion following the completion of an art activity. The questions review the working process to assist the children in remembering how they worked with materials and how they responded to the motivation as they worked. The questions also concern the product itself so that students do not reflect only on how they arranged their compositions and used the elements and principles of art, but also on how they portrayed emotions and feelings and how they showed their imaginations.

Process

- 1. Can you use some new art words to tell about how you made your art?
- 2. Did you think about how you were going to draw or paint your idea before you started?
- 3. Did you try to imagine your idea on your paper before you started?
- 4. Did you take some careful looks at the real object (the horse, tree, person) that you were drawing and observe its edges, colors, textures, big and little shapes, and so on?
- 5. Did you act out any poses or movements so you understood them better?
- 6. Did you enjoy working with this medium?
- 7. Did you experiment and discover any new ways to work with your art material or tools?
- 8. Did you try to improve your skills in handling this medium?
- 9. Did you work hard and "stick with it" longer than you usually do?
- 10. Did you stop working on your picture before you were finished and look at it to think about what you should do next?
- 11. Did you follow any step-by-step directions that were given?
- 12. Did you try to think of a new and different way to draw something that you have drawn before?
- 13. Did you try not to bother other students?
- 14. Did you cooperate in a give-and-take of ideas? (murals and group projects)
- 15. Did you clean up your work space and return materials to their storage places?
- 16. Would you like to repeat this art project?
- 17. Can you think of a different way you would draw this theme next time?
- 18. Do you know about a great artist who painted this same subject?

Product

- 1. Did you fill the paper with your picture, keeping in mind the size and shape of the paper, and let some objects touch the sides of the paper?
- 2. Did you make the figures (or important shapes) large enough for your idea?
- 3. Did you show the necessary action for the idea you were drawing?
- 4. Do you need to look more carefully or act out the motions or the pose your-self?
- 5. Is the idea you wanted to show clear and easy to see? Would this picture fit better on tall paper, larger paper, smaller paper?
- 6. Could you make the ground or sky more interesting in any way?
- 7. Did you show enough details to tell about your idea?
- 8. Did you include overlapping if it was necessary?
- 9. Did you make a focus or center of interest? How did you do this?
- 10. Did you use a variety of colors to give your picture the feeling you wanted?
- 11. Would you use the same colors next time?
- 12. Would using lighter or darker colors tell your idea better?
- 13. Did you use some large and some small shapes?
- 14. Does your composition seem balanced?
- 15. Did you use several patterns for variety or decorative purposes?
- 16. Did you show any contrasting things: colors, shapes, lines, sizes, textures?
- 17. Did you make several different kinds of lines: thick/thin, long/short, straight/curved, broken/continuous?
- 18. Did you make your negative spaces interesting?
- 19. Did you place distant objects higher up and make them smaller if you wanted to show deep space?
- 20. Do all the parts harmonize and give you a feeling of unity?
- 21. Did you make any of the parts of your picture (clay animal, puppet) in a new or different way?
- 22. If you could make this picture over again, what would you change?
- 23. Is the feeling or emotion that you were thinking about easy to see?
- 24. Would your idea have worked better if you had used a different medium?

Art has a body of knowledge, concepts, and skills. Art requires thoughtful effort, hard work, practice, and decision making. Art requires the child's best performance in the realms of understanding, thinking, feeling, perceiving, and expressing with precision and beauty. These do not happen by chance. Only through skillful teaching over the years can the very best performance in both art process and production be elicited from children.

For Discussion

- 1. What are the purposes of a motivation that precedes an art production?
- 2. What is the purpose of observation as it relates to the art experience?
- 3. How does the child's verbal description assist perceptual awareness?
- 4. Find reproductions of five works of art by *different* artists. The five works should all reflect a common theme. Using the format described in "Take Five," create sample questions.
- 5. Explore and list poems, stories, and objects that might be used as motivation for imaginative artwork.
- 6. List the four aspects for evaluation. Use a child's artwork or an item from the "Color Gallery" to discuss these aspects.

- 7. Bring an art reproduction to share with the group, and discuss it in terms of the four aspects for evaluation.
- 8. At what point(s) of the art activity would encouraging remarks from the teacher be most appropriate and beneficial? Develop a list of possible encouraging remarks for each of these stages.
- 9. Discuss the ways in which positive and directed comments about student artwork can eliminate feelings of competition.
- 10. What are the characteristics of "process" and "product"? For each, develop additional questions for discussing a completed art activity.

Notes

- 1. Swassing-Barbe Learning Modality Index (Columbus, Ohio: Zaner-Bioser Company, 612 North Park Street, 43215).
- 2. Betty Edwards, Drawing on the Right Side of the Brain (Los Angeles: J.P. Tarcher, 1979), 40.
- 3. Barbara Herberholz, Art in Action Enrichment Program, Levels I and II (Austin, Tex.: Holt, Rinehart & Winston, 1987).

7 The Teacher As Motivator and Facilitator

The impoverishment of the imagination is more often the cause of difficulty in school learning than failure to master the mechanics of the three R's or the factual content of textbooks.

HARRY BROUDY
The Arts As Basic Education

Although teachers vary in styles and techniques, each is responsible for involving a large number of children in a wide variety of learning activities. Teachers of all levels, including those in early childhood classrooms, are concerned with classroom management—organizing students and materials, planning the daily program, and establishing an environment conducive to learning. Meeting the needs of individual students while orchestrating the many strands of an educational program presents a challenge to all teachers—new and experienced, and at all levels, including those who work with children with exceptional talents or special needs. One of the teacher's primary goals is to motivate and encourage, to nurture the curiosity and enthusiasm that is characteristic of early childhood. Experiences in art provide motivation for the young learner, while challenging each to develop creative thought processes. Teachers must pay particular attention to the development of strategies and the organization of time, space, and materials needed to provide an enriching environment.

The Teacher: A Key Person

The teacher is in charge of arranging and structuring children's experiences with regard to producing and responding to artworks. As motivator and facilitator, the teacher must provide many avenues for the development of student skills and for the refinement of the senses that lead to concept formation and greater emotional awareness. Such arrangement and structure ensure the fullest development of each child's inherent and unique potential.

Research by Torrance indicates that a child's creativity peaks at the second-grade level and then tends to be stifled by demands and pressure "to conform" from curriculum, peers, and teachers. Thus, a creative thinker is forced to adjust to the norm. Torrance also found that teachers tend to favor a child with a high IQ but with low creativity. His study describes the creative child as one who seems to "play around" in school, who is engaged in manipulative and exploratory activities, who enjoys learning and fantasy, who is intuitive, imaginative, flexible, inventive, original, perceptive, and sensitive to problems. The creative student, Torrance believes, is often not identified as intellectually gifted.

Further evidence for the need for a supportive and stimulating early learning environment comes from research by the Goertzels.² They studied the lives of four hundred eminent people of this century and found that the childhood homes of almost all of these persons emphasized a love of learning and that a strong drive toward intellectual or creative achievement was present in one or both parents. The family attitude of being "neutral" and "nondirective" was practically nonexistent. Three out of five of these people had disliked school, but the teachers they liked the most had let them progress at their own pace, allowed them to work in one area of special interest, and had challenged them to think.

The teacher as motivator and facilitator is responsible for including in the plan for the year's art program ample opportunities for children to make art—to use observation, memory, and imagination. The teacher is an important role model: If the teacher values children's originality and treasures the unique and sensitive responses that children make during encounters with art, the children will likewise place importance on these things and are more likely to resist stereotypes, to demonstrate flexibility, and to attain some measure of self-direction in producing art images with a variety of materials.

If, in a discussion of artworks, children know that their comments and responses are accepted and valued, they are more likely to continue to engage in describing, analyzing, and interpreting strategies and to enjoy exploring their feelings and trusting their perceptions and judgments. The teacher must also arrange and plan for situations where children can reflect on, respond to, and discuss their own own artworks as well as those of adult artists.

As motivator and facilitator, the teacher "sets the stage" for the learning that takes place in the classroom, as well as for the attitudes and tastes that the children are forming. The physical ambience of the room, with its exhibits, bulletin boards, and display corners, has an important visual impact. Items should be well chosen and displayed in such a way as to create an orderly, uncluttered, and warm and inviting atmosphere. The displayed items may be two- and three-dimensional objects from the natural world, as well as artifacts of all kinds that are being used for art experiences and other areas of the curriculum. The extra time it takes to keep the room visually enhanced and appealing tells the children that the teacher cares.

A teacher's enthusiasm for learning can be contagious. By having a pleasant and positive attitude, the teacher can help to make the children feel relaxed and comfortable in the classroom situation. If a teacher shows excitement and curiosity about learning new things, the children follow suit. If the teacher encourages the children to work hard and to take pride in a job well done, the children begin forming work habits that will sustain them in later years. If teachers treasure and display beautiful things from the world of nature and art, children develop similar aesthetic attitudes.

Teacher Contact with Parents

At the beginning of the school year, the teacher should find occasion to send a letter home to the parents or to meet with them in conference and explain the goals and behaviors to be expected in the child's artistic growth. Visits to the school enable the parents to be informed of the goals of the art program and how they can help the child in achieving them. Parents may be invited to serve as art aides. Children's drawings and paintings should be received by understanding and appreciative parents at home if the child's artistic development at school is to be reinforced. Children will be acquiring an art vocabulary that they will be using in discussing their own art and those

of adult artists, and it is helpful and enriching if the home environment fosters and parallels a continuing dialogue. Suggestions and reminders to parents include:

- 1. Art stimulates the imagination and makes the child think more inventively. Art provides a healthy, natural, and satisfying activity for the child now, and the habits thus begun in early childhood can last and flourish throughout life. Children's artwork is an indication of their personality. Parents should respect their children's artwork and endeavor to see their children's point of view.
- 2. Originality and independence in art, rather than copying and imitative activities, should be praised. Encouraging children to be resourceful with materials develops the children's capacity to be inventive. The unique, the original, the novel solution to a problem, the unexpected, the humorous approach in expression—these qualities should be cherished and nourished. A parent's specific comments (rather than general ones) show the child that the parent has taken time to really look at the artwork and that it is valued. Coloring books and patterns tend to destroy children's ability to think for themselves and to foster stereotyped and dependent responses. Comparing a child's work with that of a brother or sister also makes for negative feelings and attitudes.
- 3. A place to draw, model, construct, cut, and paint encourages children's ongoing and spontaneous flow of art production. A place to keep their collection of interesting objects sharpens children's visual and tactile sensitivities and nourishes their curiosity. Displaying children's artwork shows the family's interest and support.
- 4. Trips to galleries and museums establish a cultural habit that will endure throughout life. Small reproductions of favorite artworks are available in museum shops and can be hung in children's bedrooms. Trips to interesting places of all sorts in the community give children experiences that will be reflected in their artwork.
- 5. Sharing books with children that have color reproductions of paintings and sculpture and the like can be a rewarding experience for both parents and children. Children's books on artists make good birthday gifts.
- 6. Special after-school and Saturday art classes are offered by universities, museums, and youth programs. Children's participation should be encouraged.

Time for Art: Regular and Frequent

State departments of education throughout the United States tend to recommend about one hundred minutes of time for art per week in the elementary classroom.³ Preschool and kindergarten children need time for art every day. Often, five or ten minutes is all the time required for these children to engage in drawing, modeling, cutting, or looking at and talking about a reproduction. As they grow older, children can work for longer periods of time. First graders should be expected to work twenty or thirty minutes on simple art tasks and longer periods on more-complicated tasks that involve several steps. Kindergartners and first graders are ready to spend extended time periods working together on such art tasks as mural making and construction activities. In so doing, they learn to respect another's point of view and see their own production contribute to the whole. They also can begin to engage in longer discussions in which they compare several reproductions of artworks.

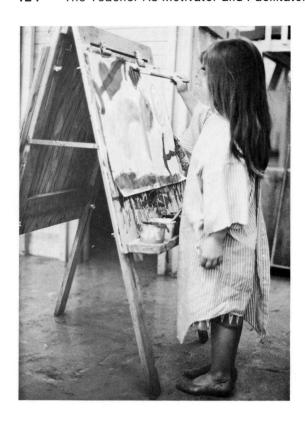

Time, materials, and space are all necessary ingredients in stimulating young learners to fulfill their creative potential. The traditional painting easel in the classroom (usually near a sink) is still one of the best ways to promote large paintings in the early years.

Art experiences with different media should be repeated to be educationally valuable since children gain more skills and insight with each experience. Teachers should keep a "portfolio" of each child's work, putting in dated drawings and paintings, cutpaper work, and such that show progress, deviations, or regressions in the child's development. If the child has verbalized about or named an artwork, a notation can be attached to the drawing. Art is language for children, and much can be learned about children's personalities and ways of perceiving and feeling about the world through this cataloging technique.

Since art production and art responding both involve alert and vigorous minds, teachers would do well to schedule art periods early in the day, when children's ability to attend and to remain "on task" is at a high level. Aesthetic sensitivity and media skills develop in the same way that skills in reading and mathematics progress—through frequent and regular scheduling.

Art Materials: Suitable, Safe, and Varied

Small muscles in early childhood are developing motor control rapidly, and art materials that provide the child with experiences in cutting, joining, applying, brushing, twisting, forming, adding, squeezing, rolling, pressing, printing, taping, and drawing are basic. Materials and processes introduced and used in early childhood should require minimal assistance from the adult, while enabling children to gain feelings of confidence and competency on their own. Small children can learn to cut both paper and fabric if they are supplied with good scissors. Ballpoint pens; soft-lead pencils; small-size crayons; marking pens; oil pastels; small, medium, and large stiff-bristle brushes; tempera paint; glue and paste; tape; clay; salt ceramics; staples; needles and yarn—all provide fertile soil in which the seeds of the young child's imagination can grow.

Young children's lack of mastery in handling materials may sometimes be due to the introduction of new materials each week, which does not allow children time to gain skills and competency with any one material. This is not to say that variety in materials is not needed. After the initial exploratory and experimental period, children may find that a new material enables them to give form to a latent image. Through working with materials a number of times, children learn which materials suit them best and what limitations and possibilities are characteristic of each.

A considerable amount of attention has been given recently to toxicity and the potential hazards of using art materials incorrectly. Many states have enacted legislation that requires more thorough examination and certification of art materials used with children. During the child's period of maximum growth, when body metabolism is high, division and addition of cells in the body cause young children to be particularly susceptible to substances that may have little or no adverse effects on adults. For this reason, government and health agencies have conducted laboratory tests and developed standards to ensure that products are safe for classroom use.

Two nonprofit organizations that have a long history of testing and certifying products are the Art and Craft Materials Institute (ACMI) and the American Society for Testing Materials (ASTM). Manufacturers who meet the stringent requirements for certification developed by these two organizations are permitted to print safety seals on their product labels. These seals certify that the materials are not toxic and that they do not cause acute or chronic health problems. The first step in selecting art supplies and using them safely is to scan the product's label, looking for one of the safety seals shown.

CL CERTIFICATION

HEALTH LABELING
CONFORMS TO ASTM D4236
CERTIFIED BY
ART & CRAFT MATERIALS INSTITUTE
BOSTON 02116

Nontoxic seals

If the product is not labeled or if additional information seems necessary, the consumer can request a "material safety data sheet" from the manufacturer or supplier. Local chapters of such national health organizations as the American Lung Association are often able to provide additional information and resources.

Certain art products are prohibited for use with very young children but are acceptable if used by older students or adults. These materials are potentially hazardous unless precautions are taken to assure safe handling. High on the list of unsafe materials are products that contain certain solvents. A few solvents pose a particularly high risk and should be used with caution or not at all. According to Dr. David H. Garabrant from the University of Southern California School of Medicine, benzene and n-hexane, both solvents commonly used in rubber or paper cement, are particularly hazardous and should not be used in any art class under any circumstances. Other products, such as spray fixative, contain solvents that are less harmful but that must be used only when there is adequate ventilation and then only by adults. Dry products, such as powdered tempera or instant papier-mâché mix, should also be handled by adults only since the particles may become airborne; once in liquid form, these products are safe for student use.

Adults who work with young children in art activities must be informed about health and safety. While there is no need to overreact, a few precautions and a sense of safety awareness will maintain a hazard-free environment for the young artists in their care.⁵

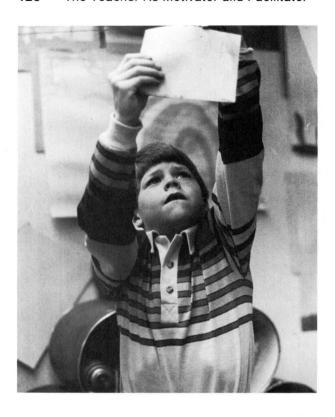

A classroom "art line" allows students to hang wet paintings or prints so that they will be out of the way as they dry.

Space: The Classroom As Studio and Gallery

The self-contained classroom is one in which all children are in the same grade and the teacher is responsible for all of the children's experiences. The school district is responsible for providing textbooks in art or other packaged, sequential programs for the classroom teacher and for making available the services of an art consultant or resource person. Some districts provide a visiting art teacher. The open or nongraded classroom consists of a large number of children of several age groups, working at their own levels of accomplishment and regrouping for various subjects. Some schools have a special art room to which the children go at specified times during the week for art activities.

In preschool and kindergarten rooms, children may choose during activity periods to work in one of several spaces—one of which may be an art learning station. At other times, art tasks may be structured with small groups or perhaps the entire class working together.

Easy access to and immediate availability of art materials are imperative to a good art program. When art supplies and work spaces are convenient and neatly organized, the teacher feels more relaxed and eager to provide a maximum number of art activities, and the children are more stimulated to innovate, experiment, and participate. Four kinds of space within the classroom should be considered:

- 1. Storage space for materials, tools, and supplies
- 2. Space for projects not completed
- Space for displaying the children's finished work, both two- and threedimensional
- 4. Space for displaying interesting art-related objects

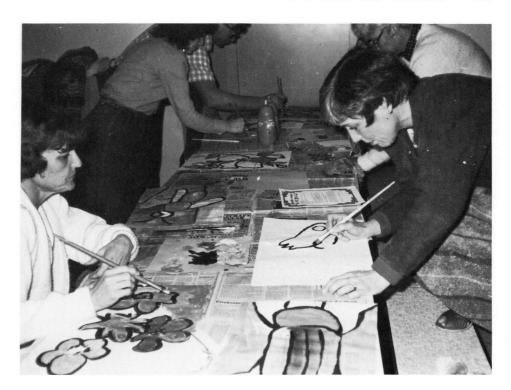

Teachers update teaching skills at in-service workshops. Ease of setting up tabletop painting activities is facilitated through the use of disposable palettes for mixing small amounts of tempera.

Paints and brushes should be stored in cabinets or on shelves near the sink. Several large cans should be kept handy for storing brushes of various sizes. Brushes should be cleaned before being put away and should be stored with bristles up. Different sizes, colors, and kinds of paper should be on shelves or in drawers within reach of the small child. Shallow, plastic trays or dishpans with labels attached can be used to store marking pens, chalk, oil pastels, crayons, colored pencils, scissors, glue, and tape. Cardboard boxes, ice-cream cartons, or plastic dishpans can be labeled and filled with such materials as felt, fabric, yarn, feathers, and scrap materials.

In displaying the children's artwork in a classroom "gallery," teachers should display the work of the entire class or the work of small groups of children on a rotating basis that is understood by all. If teachers only put up pictures they consider "the best," this can signify a preference that might cause children to copy others or to become locked into repeating certain "successful" images to receive recognition. Children who are eager to please could easily become repetitious in their art expression. For children whose work is never selected, the message is clear, and they can become easily discouraged. At some time during the year, after collecting artwork in student portfolios, each child should select his or her favorite for an exhibit to be called "Portfolio Favorites" or "Artists' Choice."

There usually are opportunities for exhibiting student artwork outside the class-room. Prints, paintings, and drawings can be displayed in the principal's office or in the school office. Large art pieces show off best in such spaces as the auditorium or cafeteria. Public libraries, airports, stores, and other public buildings frequently are interested in displaying children's art. Museums and galleries sometimes sponsor shows of student artwork, especially in March, which is National Youth Art Month. Classrooms, schools, or districts sometimes compile a collection of student drawings and creative writing for publication. All efforts to feature a child's work communicate value and respect.

School stages and multipurpose rooms can provide large spaces needed for group art projects. Students here are making kites that will be flown and then displayed on the curtains backing the stage.

Art Learning Stations

An art learning station is a small space that provides one or two students with a minienvironment for independent or semi-independent activity. With materials set up and visual and/or verbal instruction provided, children are able to work with minimal supervision, thereby gaining confidence in their ability to do things "all by myself." Some children feel more comfortable and free to experiment, fantasize, and develop ideas and images in the quiet, private atmosphere that an art learning station provides. Learning stations also make it possible to organize and use materials that are too small, too few, or too awkward for an entire class of children to use at one time.

As in any art activity, the focus in an art learning station is on divergent and creative responses. At the same time, the child is learning to follow simple directions in producing a final product. The learning station is basically designed to reinforce or extend a skill or concept that has been introduced by the teacher. To function productively, an art learning station needs to meet the following requirements:

- 1. Be attractive and enticing, offering the child ways to explore, investigate, and manipulate
- 2. Have well-defined rules for its use, such as a limit on the number of students at the center at one time
- 3. Provide the supplies needed
- 4. Require few written directions for the primary child
- 5. Provide several directions in which the student may work to develop, reinforce, or extend learning
- 6. Contain a wide variety of multi-level activities that can be adjusted to the needs and abilities of individual children
- 7. Have several ways of doing the activities, such as listening, reading, observing, and/or manipulating
- 8. Include some self-correcting devices, such as color coding, matching numbers or shapes, or puzzle matching
- 9. Provide a place for finished and unfinished activities
- Be changed at regular intervals to coincide with curriculum changes and/or student interests

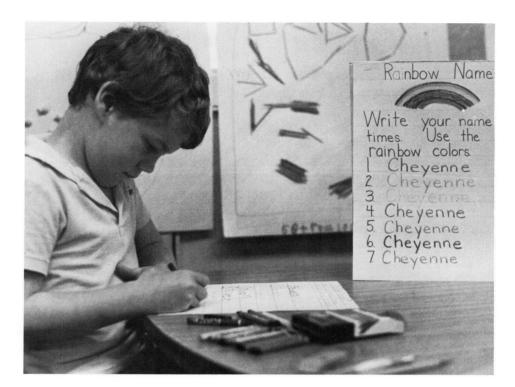

This portable center is placed on desk tops or tables for an art learning station session and is then stored easily when the teacher has scheduled activities that require a more traditional classroom arrangement.

Teachers must instruct students in the most effective use of an art learning station. As each new station is developed, the teacher should explain the new concept. Stations should be part of the daily program; they become an integral and effective part of curriculum planning as teachers recognize and utilize the variety of ways that learning can be reinforced.

Art Learning Station Activities

A "See and Touch" art station may have natural objects and art objects for the children to investigate. The teacher can make up a game sheet on which numbered objects, such as a mounted owl, dried weeds, pressed flowers, the dried skull of an animal, feathers, butterflies, colored Indian corn, shells, or a bird's nest are described in such terms as rough and scratchy, crumbly, swirling, white, pointed, smooth, and so on, and the child must match the term with the object. This tactile station should sometimes have an arrangement of folk-art items, such as a pottery bird from Mexico, a puppet or mask, a carved wooden lion from Africa, a piece of Eskimo soapstone sculpture, a Hopi Kachina, carded wool, brass bells, or stone beads. A magnifying glass provides an intriguing stimulus for visual perception.

Some particularly appropriate art activities for learning centers include mixing colors and a series of activities that reinforce basic clay techniques, progressing from making simple shapes in modeling clay to making pinch pots and clay animals and figures. Sample activities dealing with great works of art include making a collage after seeing some of those created by Picasso or Braque, or making a painting of dots (using daubers found in shoe-repair shops) after viewing some of the works of the Impressionists. After the entire class has looked at portraits and self-portraits of great artists, students can draw a portrait of a classmate; drawing a self-portrait at a learning center further reinforces the concepts introduced in the classroom setting.

Color mixing using watercolor markers is the activity at this art learning station. Students are allowed to select one of two art experiences (the other one in this particular center deals with paper sculpture).

The following are specific examples of art learning stations that lend themselves to self-contained areas of instruction and that assist the child in making an individualized response to an art motivation:

String Starters

Materials: String or yarn, scissors, glue, crayons, 9-by-12-inch paper

- 1. Glue a short piece of string to the paper.
- 2. What does the string make you think of? A jump rope? A fishing line? A clothesline? The tail of a fish? The back of a camel? The shoe of a giant?
- 3. Complete your picture with crayons.

Crayon Melter

Materials: Crayon melter (see chapter 8), unwrapped wax crayons, cotton swabs, heavy paper, watercolors and brush, masking tape

- 1. Dip cotton swab in melted crayon.
- 2. Daub on paper.
- 3. Cover all of the paper with crayon, or brush a watercolor wash over the uncovered paper.

Warming Tray

Materials: Warming tray, unwrapped wax crayons (soak in warm water to remove paper), paper, masking tape, mitt

- 1. Tape the paper to the edges of the tray.
- 2. Move the crayon slowly on the paper, letting the crayon melt as it moves.
- 3. Add more colors to cover the paper completely.
- 4. White, gold, or another color can be blended on top of another color.

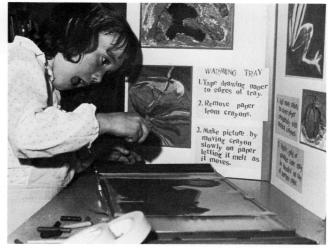

В

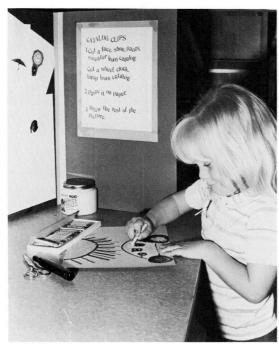

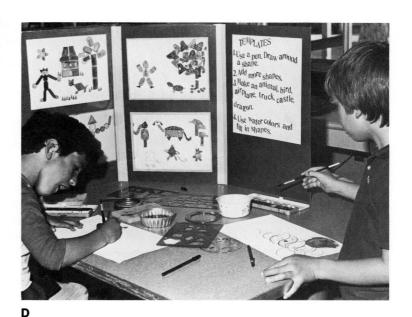

C

Set-ups for art learning stations provide space for intense, uninterrupted efforts for one or two children at a time.

- A. "String Starters" aids divergent thinking.
- B. Warming tray and crayons require student concentration while she searches for image formation.
- C. "Catalog Clips" sparks individual ideas for expression.
- D. Templates, pens, and watercolors add up to animal shapes, trees, houses, monsters, and designs.

Grade-level art lessons are sequenced and color coded in this kit called "Creative Expressions." The art activities introduce vocabulary and concepts and can be used with an entire class or at learning stations.

Catalog Clips

Materials: Old catalog, scissors, paste, 9-by-12-inch paper, crayons or felt pens

- 1. Cut out a face, shoe, pants, sweater, wheel, clock, or lamp from the catalog.
- 2. Paste it on the paper.
- 3. Draw the rest of your picture.

Instructional Materials for Art Learning Stations

Teacher convenience is a primary consideration for the sequential art lessons presented in *Creative Expressions*. Twenty art activities for each grade level are presented in color-coded folders. The standard-size folders easily fit in classroom file cabinets or portable file boxes. A blank on the front of each folder is for a student art example. The list of materials needed and simple directions are printed inside. Many illustrations make the directions easy to follow. Objectives, teacher hints and information, and evaluation questions are printed on the back of the folder, along with the art components to be emphasized in the lesson. Each grade level has sequential lessons in drawing, painting, printmaking, the elements of art, and three-dimensional experiences. Since "extensions" or additional activities are often listed in the teacher's section on the back of the folder, *Creative Expressions* is an excellent resource for setting up art learning stations to reinforce concepts, knowledge, and skills.

As Ralph Voight points out, the art learning station implies certain teacher characteristics or behaviors, an enlarged learning environment, greater learner independence, and revised physical arrangements in the classroom. He goes on to state that the learning center embodies the implementation of an idea that enables children to grow at their own rates, in their own styles, and to their uniquely personal potentials.⁷

For Discussion

- 1. Review the work conducted by the Goertzels and Paul Torrance. Describe the type of home and school environment that is most likely to encourage the creative student.
- 2. What are the advantages of maintaining an art portfolio for each child? How can these portfolios be used in conferences with parents? In evaluating student development as discussed in chapter 6?

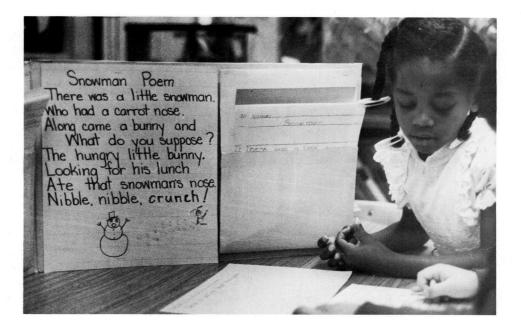

Simple directions, ample supplies, and a limit on the number of students using this learning station make it a comfortable space for independent activity.

- 3. What "hidden" messages are communicated to children when their artwork is attractively displayed at school and/or at home? How might a teacher display small groups of pictures so that all students feel involved?
- 4. What is the "ideal" length and frequency of art activities for young schoolage children? How do you think this would vary from art schedules for preschool children?
- 5. Discuss "variety" versus "mastery" in the use of art materials. What would you consider a "happy medium," and how would you determine this?
- 6. What are the advantages of learning stations? What would be a few of the reasons for having an art learning station in the classroom?
- 7. If you visited a classroom with many learning stations, what might you assume about the teacher and his or her expectations about learning?
- 8. How might thematic art activities be used in learning stations? Briefly outline the materials and processes that would need to be planned for a theme that would interest a young child.
- 9. The "See and Touch" station described in the chapter would reinforce concepts about one of the elements of art—texture. Plan a learning station that would reinforce learning about two of the other elements.
- 10. If possible, interview a teacher who uses learning stations consistently, and discuss the advantages/disadvantages of learning stations, as well as the scheduling and organization required for effective use.

Notes

- 1. Robert F. Biehler, Psychology Applied to Teaching (Boston: Houghton Mifflin, 1971), 248.
- Victor Goertzel and Mildred Goertzel, Cradles of Eminence (Boston: Little, Brown, 1962), 3-9.
- 3. Guy Hubbard, Art in Action, Teacher's Manual (Austin, Tex.: Holt, Rinehart & Winston, 1987), vii.
- 4. David H. Garabrant, "Art Hazards" (Paper prepared for a workshop co-sponsored by the American Lung Assocation of Los Angeles County and the Santa Monica Unified School District, 1984).
- 5. Charles A. Qualley, Safety in the Artroom (Worcester, Mass.: Davis Publications, 1986).
- 6. Lee Hanson, Creative Expressions (Palo Alto, Calif.: Dale Seymour Publications, 1990).
- Ralph Claude Voight, Invitation to Learning: The Learning Center Handbook (Washington, D.C.: Acropolis Books, 1973), 2.

Drawing and Painting 8

Learning to draw is really a matter of learning to see—to see correctly—and that means a good deal more than merely looking with the eye. The sort of "seeing" I mean is an observation that utilizes as many of the five senses as can reach through the eye at one time. Although you use your eyes, you do not close up the other senses—rather, the reverse, because all the senses have a part in the sort of observation you are to make.

KIMON NICOLAIDES The Natural Way to Draw

Drawing: External Thinking

Human beings have engaged in drawing activities since the first rock pictographs were made many thousands of years ago. Early people drew on cave walls and on clay pots. Egyptians used limestone tablets and sheets of papyrus. Artists in the Middle Ages drew on parchment made from goatskin or sheepskin.

Drawing is basic to art. Drawings can be valid works of art in themselves or can be used in planning other works of art. Drawings by the old masters are treasured in museum collections, and many contemporary artists express themselves with sketches, figure and contour drawings, modeled renderings, and cartoons, using charcoal, chalk, pastels, Conte crayons (an exceptionally hard crayon, usually black, rust, or brown in color), pencils, and pens and ink.

Throughout history, painting has been a mirror for feelings and ideas about the world. Artists, by recording the development of civilization all over the world, have left paintings that tell about religion, national life, historic events, geography, and famous people.

Many activities call upon us to clarify and develop an idea with a sketch. Drawing and thinking are often an all-at-once phenomenon, making a graphic image an extension of the mental process and helping to bring an idea into focus. Engineers, chemists, city planners, carpenters, surgeons, mechanics, and football coaches are but a few of the individuals who find a need to make useful and practical application of external thinking—that is, drawing.

Like other learned skills, drawing improves with practice. Many children and most adults believe that people are born knowing how to draw and that those who cannot draw "instinctively" never will learn. Like any other ability, some people may show a little more drawing aptitude in the beginning, and practice increases drawing skills. Ten minutes of drawing every day results in improved drawing skills, and focusing on specific objects in the environment increases perception as well. People who do sit-ups every day get better at them; people who draw every day also improve.

Very young children approach drawing with great enthusiasm and spontaneity. Their marks are exciting to them. Directed observations can heighten their awareness.

Drawing improves with practice. By providing time, topics, and materials, the teacher can help students to increase their skills.

Even very young children are able to display their understanding of the components of various types of paintings. After discussing and looking at reproductions of landscapes, this kindergarten child clearly shows his understanding of the concept in his watercolor painting.

Opportunities for students to draw from direct observation should be numerous and frequent. Contour drawing, with model or object close to student-artist, emphasizes keeping one's eyes on the model or object while the pen is moving. Students may glance at the paper to reposition their pen. Students make a slow, continuous line, with their eyes on the model or object, and pretend that a sleepy ant is crawling along the edge they are drawing and that their pen is pushing it along.

Sometimes, children (and adults) look without seeing. Examination is fleeting and cursory. By carefully examining lines, shapes, colors, dark and light areas, and textures of objects, as well as relative proportions and sizes of figures and objects, children can develop their perceptions. The more details they perceive, the more details they are likely to draw, and the more differentiated their visual configurations become.

Exploring Images

There are three ways to develop an image in drawing—from memory, from looking at objects in the real world, and from the imagination. Frequently, children are asked to draw or paint objects of which they have only dim memories, and the results are disappointing. When asked to draw a person or object that has greatly influenced a child's life, the results are usually more detailed and may show exaggeration that reveals some emotional significance to the young artist. A neighbor who is very frightening may appear large and menacing in the drawing, while the child's self-image is small and practically hidden. A friendly dog may appear to be all tongue, and a piano player may have dozens of fingers on each hand.

Drawing objects in the real world is one of the best ways to increase visual perception and discrimination. Without making children feel inadequate, an adult can reinforce and direct children's observations of details. For example, a teacher may ask students to draw a leaf. Once the drawings are completed, the teacher can give each child several leaves and ask the children to rub each leaf between their fingers. Some leaves have smooth edges, while others have serrated "sawtooth" edges. Many leaves are different shades of green, and some are yellow, gold, or red. The children should

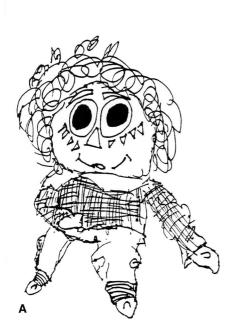

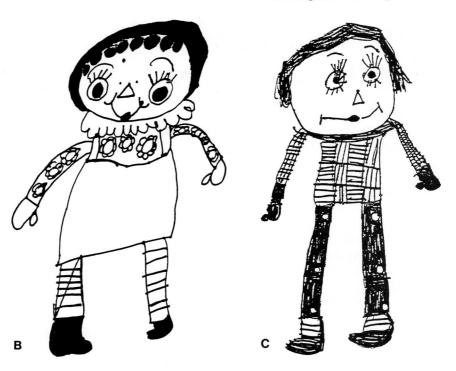

"Pablos," a cardboard assembled toy, helps students to learn about still-life drawing as they identify different shapes—triangles, rectangles, diamonds, half-circles, and such—and the shapes' proportions and relationships. Pattern and color play an important role as third graders use black marking pens and oil pastels.

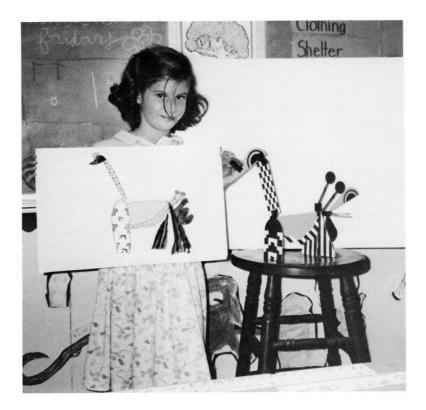

look at each leaf's shape, veins, and stem. If asked to draw a leaf again, the children, because of their increased sensory interaction with their environment, will have greater awareness and be able to depict a leaf more realistically.

As children mature in the schematic stage of development, they need frequent opportunities to draw from direct observation. Visually interesting objects set close to small groups of students catch their interest and imagination. Interesting objects that have simple shapes and parts—toys of all sorts, fruits and vegetables, live pets, mounted birds and animals, costumed models (perhaps dressed as a character in a favorite story)—all lend themselves to developing the habit of observing carefully while drawing. Teachers can call the students' attention to the contour lines and edges in the still life or figure and help the students to compare relative sizes and proportions. Students can note the different textures, dark and light places, and colors before they begin to draw. More-mature students can learn to use small, paper viewfinders (square of paper with a small rectangle cut from the center) to help them focus on the part of the object, figure, or landscape they are going to draw.

While drawing real objects increases perception and eye-hand coordination, sometimes an artist may want to go beyond reality to create images that do not exist in the real world. Artists may choose to exaggerate and distort and use unreal colors to create a mood or feeling (for example, the bright yellow cow in Marc's painting in the "Color Gallery"). Children frequently follow the same course, either consciously or intuitively. Drawing from the imagination can result in delightful and highly original scenes that exist only in the child's mind.

When Children Draw

Children begin drawing very early in life, when they first trace a finger through spilled oatmeal, move a stick on the surface of sand, or make a few crayon or chalk marks on a piece of paper. It is indeed exciting to discover that the kinetic activity of moving one's hand when it is holding a crayon can leave a mark on a paper!

To draw is to depict forms with lines; it is to pull or move a drawing instrument in a direction that causes the instrument to make marks. The best tools for children to use are marking pens, crayons, oil pastels, ballpoint pens, chalk, and soft-lead pencils. Most drawing instruments have small tips, and these almost always require a small piece of paper; conversely, thick chalk is an excellent medium for drawing large figures, animals, and houses on the sidewalk or on a large piece of paper.

Drawing plays an especially vital role in young children's artistic development because, during early childhood, children need to see very clearly the images and symbols that they are making and not have them drip or run together, as they do when children work only with paint. They can use drawing tools to make outlines and details; it is at this time that their perceptual explorations lead them toward finding and recording all sorts of things that are of fundamental importance in their development of concepts. The more details they perceive, the more details they are likely to draw, and the more highly differentiated their visual configurations become.

Thick, round-topped crayons are frustrating for small children to use. At a time when they are perceiving and refining visual forms and details, small crayons better

A and B. Self-portraits by two six-year-olds using felt markers.

"Clowns" and "circus" are always popular themes for art projects in the early school years. Discussion of the elements of line and shape can precede the lesson and is evident in the amount of detail in the finished work.

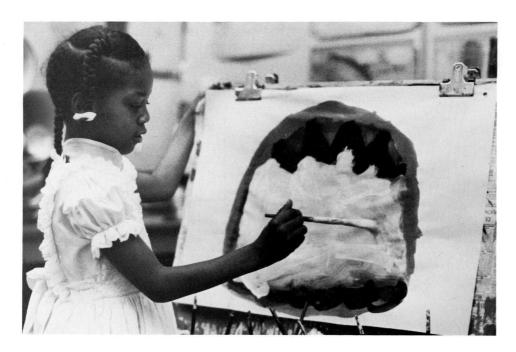

This student feels comfortable and enjoys working on large paintings at an easel. The important thing in a classroom is to set up a variety of painting experiences for children so that they are able to experiment with many approaches and techniques.

suit their needs. A thick crayon in the hands of a five-year-old child is equivalent, in proportion, to a broomstick-size crayon in an adult's hand, making it difficult for the child to grasp and to control its direction. Children find it much easier to draw small details, such as fingernails, shoelaces, and teeth, with slender crayons. Slender crayons tend to break more easily than thick ones, but children should never be so cautioned about the use of crayons as to cause them to become intimidated and fearful of using them. If young children are going to become more perceptive in relation to visual details and better able to make distinctions and differentiations, they must have the kind of art materials that encourage definitive drawing activities, such as pencils, marking pens, and small-size crayons.

When Children Paint

In early childhood art programs, painting should play a constant and integral part. Tempera is the most functional and popular paint for young children to use. It should be purchased in liquid form, in plastic containers with squeeze tops that make for easy dispensing. The squeeze top is convenient and also economical in that only the amount to be used needs to be squeezed out at one time—usually about a spoonful of each color into egg cartons or onto paper plates.

If the paints are too thick, they can be thinned by stirring in a little water; however, tempera should be a creamy, opaque consistency, as too much water makes it transparent and runny. Paper for painting activities should be heavy enough so that it does not tear when it becomes wet with paint. Flat and round stiff-bristle brushes in small, medium, and large sizes should be plentiful, since the exclusive use of big, wide brushes encourages the smearing and stroking of paint, rather than the making of images and the painting of sensitive forms and details.

At Easels

Most preschools and kindergartens have several easels available for ongoing painting activities. Easels are convenient for children. However, since the paper is attached to the easel at the top and hangs vertically, paint tends to drip and run down if it is at all

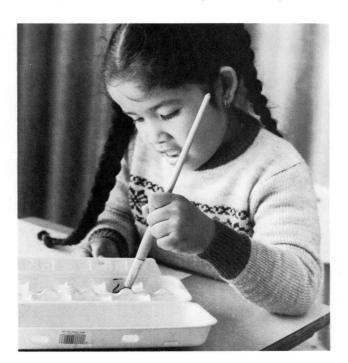

A styrofoam egg carton provides places to mix paint. If necessary, the lid can be closed and the paints stored overnight (the students can write their names on the lids in pencil). When finished, all cartons can be discarded in a large plastic bag.

thin and watery. Children need to learn to put the brush back in the same color to avoid getting the brush or the paint supply muddy and also to wipe each side of the brush on the inside edge of the paint container to avoid dripping and having excess paint on the brush.

Tabletop Painting

In addition to ongoing easel-painting opportunities, tabletop painting activities that focus more definitively on skill building can be set up and structured by making use of newspaper-covered desks and tables (or even floor space). Small groups of children, perhaps two or three, should have a disposable palette (egg carton or paper plate) for holding several spoonfuls of thick tempera paint. They also need another paper plate or perhaps the lid of the egg carton to use for mixing two or more colors together. By avoiding the use of tin cans, small milk cartons, or muffin tins, which are often used for tempera containers, clean-up time is shortened, and less paint is wasted. Children should each have a clean, moist sponge or paper towel for wiping their brushes clean between colors. This eliminates the necessity of providing children with cans of water that might spill and that need changing when dirty. Also, if a water-soaked brush is dipped into tempera, the water dilutes the tempera and makes it too thin and transparent. An old shirt worn backwards or a vinyl apron should be worn to protect clothing. A large-sized plastic garbage bag with a hole cut for the child's head and two holes cut for the arms makes an excellent slip-on protective smock. Brushes should be washed in warm, sudsy water and rinsed at the end of the painting period and then stored, bristles up, in a large can or laid flat in a plastic container.

Bold, black lines and bright colors characterize paintings based on the style of the artist Rouault. "Give your heart to art" was the theme of this kindergarten art project, which was completed in two stages: Black lines were painted first and color added later.

Size, Design, Color in Painting Experiences

Children should have opportunities to paint on both large and small paper. All sizes of brushes should be available so that the children can select those that best suit their needs. Some children, however, may feel threatened and overpowered by large, blank sheets of paper or find themselves unable to manage, delineate, and control the wide strokes that a large brush forces them to make.

The teacher's guidance in setting up many painting experiences greatly enhances the variety of approaches that the children may take. For instance, giving the children colored paper to paint on enables them to see new relationships between colors and the unifying effect of the background. Premixing colors occasionally for the children encourages them to try mixing colors themselves. Pastels, blended tones, grayed colors, gold, silver, magenta, peach, and lime are not frequently used colors, and their introduction arouses children's interest and causes them to think of new subject matter for picture making.

Older children profit from having a piece of scrap paper handy to try out brushstrokes, brush sizes, and color mixing. They can also work together in planning, sketching, and executing a mural on a large piece of paper, with each child painting several items individually.

The painting tools of the child artist include the working elements of design, one of the most important of which is color, since it incorporates and reflects both the cognitive and affective domains in the child's growth and attitudes. Children live in a world of color. They see it in flowers, in clothing, in cars, in rain puddles on oil-slick streets,

At age six, Jessica's paintings are colorful, bold, and detailed. This self-portrait was completed at the classroom easel after discussing and looking at reproductions of self-portraits by master artists.

in animals' fur and birds' feathers, in sunsets, in paintings, and in people's eyes and hair. Color can make us feel happy or sad, warm or cool, and the colors children use in their paintings and drawings often reflect this quality.

We usually associate a color with familiar things, and as very young children begin to paint and draw, they slowly develop this color-object relationship. Since fire is red and yellow, these colors are thought of as warm. Sky and water are green, violet, and blue, and these are usually thought of as cool colors. Children like to have favorite colors, and they usually choose bright, intense hues.

If children compare the green leaves of the budding willow tree with the green leaves of the oak, if they look at the blue summer sky mirrored in a lake and the blue-gray sky above city buildings, they develop a more refined awareness of color's delicate or intense tonal differences.

Color wheels can be purchased, or the children can make them. Children can draw around a paper plate and then use the curved edge of the plate as a guide to draw six sections in the circle. They then apply the primary colors (red, yellow, and blue) to three of the sections and mix two primary colors at a time to make the three secondary colors (orange, green, purple) for painting the three remaining sections. These "beach balls" or "balloons" can then be cut out and mounted in a bright display on the bulletin board.

A serious look at a commercially produced color wheel can help children to understand primary and secondary colors.

Children may choose two opposite colors for a painting, adding black or white to each color for tints and shades, or mixing the two colors in varying amounts to achieve dulled colors. Analogous colors, or those adjacent to each other on the color wheel, may be selected for a warm or a cool picture. An entire painting based on a monochromatic color scheme can be made by using only one color and black and white.

Children can also mix equal amounts of colored baker's clay, choosing colors that are opposite on the wheel or two primary colors, to see what happens. Clear, plastic cups or glasses can be filled with water and food colors dropped in to see the colors mix. Students can also respond to reproductions of paintings by identifying and describing the colors they see in them.

Painting Skills to Be Expected of Young Children

After very young children have had a number of initial exploratory experiences with one or two colors of paint, they can learn how to handle brushes and paint. They should begin to know and demonstrate proficiency in:

- 1. Using fingers and not the fist to hold the brush and holding the brush close to the ferrule
- 2. Using the tip and side of the brush, making thick and thin lines and strokes, and avoiding scrubbing with the brush
- 3. Using a large, flat brush for large areas and smaller, narrow brushes for details and for painting close to another painted area
- 4. Using chalk, occasionally, for preliminary sketching before applying paint
- 5. Painting large areas first and letting a color dry on the paper before applying details either on top of the painted area or close to it in order to prevent smearing

Pouring spouts on commercial paints and a cardboard container (which once held bottles of tonic water) form a unit that is easily carried and distributed to students.

A and B. Preliminary drawings with chalk or crayon enable children to plan and develop paintings that include overlapping and details.

В

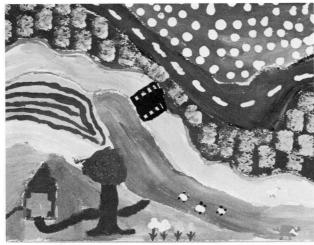

- 6. Learning to mix colors on their disposable palettes: adding a little bit of a color to white to make a tint; adding a little bit of black to a color to make a shade; mixing a little of the color's complement to a color to dull it (blue-orange, red-green, yellow-violet); mixing any two primary colors to obtain a secondary color (red + yellow = orange; blue + yellow = green; blue + red = purple) (It is recommended that one use magenta, turquoise, and yellow to mix secondary colors as these colors, in tempera, create truer secondary colors.)
- 7. Wiping the brush clean on moist sponges or paper towels before using it for another color
- 8. Completing a painting by covering the entire surface of the paper with paint, giving consideration to composition, adding patterns, small details, and so on
- 9. Washing brushes in warm, sudsy water when finished and storing them in a designated container; cleaning up work area

Crayons and Oil Pastels

Probably the most familiar medium for childhood art is the wax crayon, with its glowing, vibrant colors. However, the waxy effect is not often realized when children only use it as a medium for line drawing. They should be encouraged to bear down on the crayon, applying sufficient pressure to achieve the rich, waxy look typical of this medium. The large-assortment crayon boxes can prove exciting due to the many shades, tints, and dulled colors available.

First graders can be shown some of the rich possibilities and encouraged to explore using crayons. They can draw their ideas lightly on white or manila paper with a yellow crayon, making changes and corrections as they desire, and then color in the areas solidly. They should not use a pencil for preliminary drawing when using crayons because the sharp point of the pencil is suitable for small details that cannot be covered or colored with the blunter, softer tips of the wax crayons. Older children should be encouraged to imagine their entire drawing on the paper before they begin, to think of background areas and spaces around the objects and to plan for their utilizations. Having a thick pad of newspapers under the drawing paper is helpful since this surface is more conducive to crayon work than the hard desktop or tabletop.

A and B. "From above" theme stimulates children to imagine themselves looking down from a hot air balloon and to paint the landscape, mixing colors for fields, rivers, trees, houses, and fences.

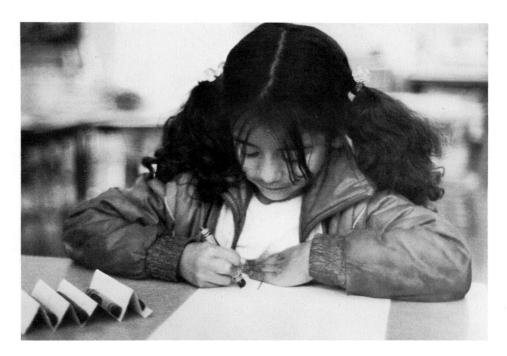

Accordion-pleated cardboard forms a holder for crayons so that they will not roll off the desk.

A first grader drew this clown with a black marking pen and added color with oil pastels.

The children should be reminded that repeating the same color or shape or texture several places in their drawing will give their drawing unity and that dark colors used next to light hues give the drawing contrast. Watercolor washes or diluted food color washes can be applied to white spaces left uncolored. This is called "crayon resist."

Oil pastels offer a type of drawing/painting combination experience for young children. Oil pastels are available in rich, glowing colors and are softer than wax crayons. They should be applied boldly, and the children should press down hard enough to achieve the brilliant effect typical of this medium. Once again, a newspaper pad underneath the drawing paper provides a helpful cushion and makes it easier to apply

the oil pastel strokes. Oil pastels are especially vibrant when applied to colored paper. They are somewhat akin to oil paint in that a lighter or darker color or white oil pastel can be applied on top of another color. Oil pastels are especially successful when used as a resist technique in which the child makes a drawing and then applies watercolors, a diluted food color wash, or India ink to the background areas.

Resist Techniques

The basis for resist techniques is the incompatibility of two materials. Many substances can be used to resist other materials and preserve a design or picture. Wax or oil- and water-based paints are frequently used, although tempera and ink are also possible.

Wax Resist

An introductory experience in wax resist can utilize paraffin or white or yellow crayons to make a "secret drawing" for a classmate. Clear or white marks on white paper (or yellow marks on yellow paper) are like a coded message. Once the drawings are completed, students can exchange them and brush on a coat of watercolor or thinned tempera paint. The drawing appears magically, as contrasting colors of paint are applied.

Subsequent wax-resist activities can involve the students in drawing with many colors of crayon and applying thin paint over the entire surface. Holiday themes lend themselves to this technique, and a drawing of Santa on the roof or a haunted house becomes even more effective when a coat of black or dark blue paint is applied. Blue and green washes of paint over an underwater scene reinforce the illusion of water, and heavily patterned crayon designs increase in boldness and impact when paint is applied afterward. Children need to apply the crayon heavily; otherwise, the paint will cover the drawing. The teacher must be sure to point out that it is the wax from the crayon that keeps the water and paint from coloring the paper. If there is not enough crayon, if the waxy surface is too thin and sparse, the paint soaks into the paper and hides the crayon marks. Several layers of newspaper or a piece of window screening beneath the paper helps with the heavy application of crayon or wax. Oil pastels are more easily applied, and tempera, watercolors, or India ink applied as a last step make a particularly effective background for the finished artwork.

Paint Resist

With the paint-resist technique, thick, creamy, tempera paint is used to make a picture on colored construction paper. When the paint is thoroughly dry, a coating of india ink is brushed over the entire surface of the picture. The ink blackens the area where the paper is exposed. The painted lines and spaces prevent the ink from soaking into the paper in those particular spots. Temporarily, the ink blackens the outer "skin" or surface of dried paint, and the original painting seems to disappear.

After the india ink is thoroughly dry, the entire artwork is gently washed with water. Depending on the quality of the paper, it is usually a good idea to place a cookie sheet or some other flat surface under the paper to act as a support and to prevent tearing. As the water soaks into the dried tempera, the paint partially dissolves, lifting away much of the pigment, as well as most of the ink that dried on the painted surfaces. The result is an interesting, textured design, with the colors of the paper and paints combined in an antiqued effect against solid black.

The simplified version of this process is to use only white paint on colored construction paper. The effect is bold and striking and is particularly suited for portraits of people. Introducing several colors allows a more complex subject; tropical fish and

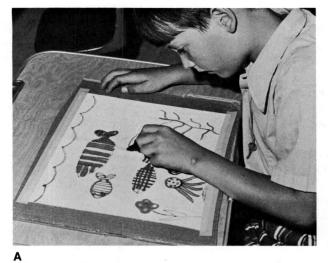

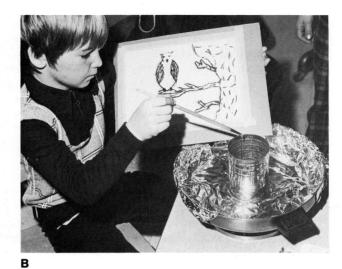

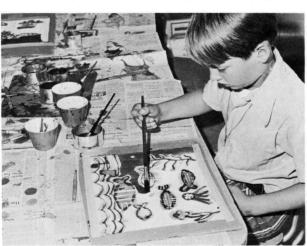

A. A child draws on fabric or Dippity Dye paper with watersoluble felt pens before applying wax.

C

- B. Wax melts in a can that stands in a foil-covered electric pan. Here, a boy covers his felt-pen drawing with wax before he brushes the dye on the unwaxed portions of the fabric.
- C. Diluted food coloring is brushed over the entire picture.
- D. When the wax is removed by ironing, the drawn batik is finished.

birds are very colorful and are excellent subject matter. Children can use tints (colors with white added to them), either mixing them or using preblended paints, for their artwork. Tints create a greater contrast with the ink.

A second resist technique involving tempera begins with the students painting colorful pictures. Contrasting colors of crayon are applied over each area of the dried painting. A wet sponge is then applied to the surface until the underlying tempera paints begin to flake off. The result is a mottled, textural picture in which the residual crayon accents the seemingly weathered tempera tones that remain.

Batik

Just how the batik process began is not known, but it probably originated in Indonesia and spread to Europe and other countries before finally achieving a high degree of development as an art form in India. Basically, batik is a process whereby wax or paste is applied to fabric in a decorative manner for the purpose of resisting the dye that is applied later. One of the main characteristics of batik is the spiderweb effect achieved

when the wax hardens and cracks and the dye penetrates into the fibers in thin lines. In more-complicated batiks, the fabric is waxed and dyed several times, creating fantastic color and design patterns due to overlapping and color blending.

In adapting the rather complex batik process for use with young children, teachers will find the techniques described here to be replete with artistic possibilities, yet simple and safe enough to be used in the classroom. All of the materials can be purchased in local stores.

Paste Batik

The "paste" method of batik does not involve using wax or dipping the fabric in a dye bath. It is somewhat related to a Japanese dye process called Sarasa. It is also akin to an African resist technique called adire eleko, in which the design is painted on the cloth with a starch called lafun, which is made from cassava flour. In this African process, when the fabric is dry, the starch is flaked off the cloth and the fabric is dipped in the dye again to reduce the contrast.

These Japanese and African techniques can be greatly simplified for use with young children by using a paste mixture made of ordinary store ingredients. Paste is used instead of melted wax to protect the fabric from the dye, which is applied later. Wherever the paste is squeezed onto the cloth, the fabric will be white when the piece is finished. The paste should be mixed until there are no lumps. A blender does the job efficiently and quickly. Double or triple the following recipe may be needed for large groups of children:

- 1/2 cup of flour
- 1/2 cup of water
- 2 teaspoons of alum (spice rack in grocery store)

Each child needs a small (8-by-10-inch) piece of 100 percent cotton muslin, bleached or unbleached, that has not been laundered or treated with permanent press. The material should be taped down to a piece of corrugated cardboard.

The paste is placed in several plastic squeeze bottles, such as those used for dispensing mustard and ketchup, and the children take turns drawing their pictures. Children make their designs by holding the bottle perpendicularly and squeezing it to create and maintain a smooth flow of the paste onto the fabric. They draw the entire picture in this manner, making lines, dots, and solid masses, and then leave it to dry overnight. The next day, food-color washes are brushed over the entire picture, and the dried paste resists the color and leaves the fabric underneath white.

Paste food colors, available from cake-decorating supply stores, or watercolors should be mixed with water in clean, shallow, tin cans, such as empty tuna and catfood cans. These do not tip over as easily as taller cans do. A small amount of this very intense dye should be stirred into the water to make a rich hue because the colors, once on the fabric, dry lighter than they appear to be when they are wet. Several colors can be brushed into separate areas of the same picture, as in applying red for a roof, brown for a tree trunk, yellow for a flower, and blue for the background. The fabric is left to dry thoroughly, and then the paste is chipped and rubbed off with the fingers, revealing the white picture underneath.

The fabric can be trimmed neatly, ironed to press out the wrinkles, and mounted. Batik pictures also make attractive greeting cards when they are glued to a folded piece of colored paper.

For a group project, a length of muslin can be taped to a large piece of corrugated cardboard, perhaps 3 by 5 feet. Each child can squeeze on a figure or animal, placing them on several base lines that have been applied beforehand.

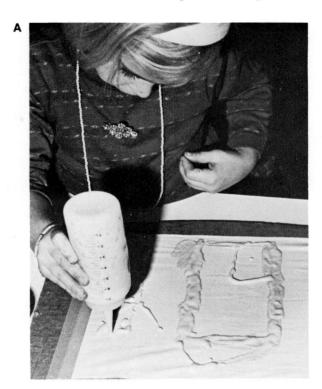

A. Paste flows smoothly from a squeeze bottle as the child makes a drawing on a tapeddown piece of cotton muslin.

B. Food dye contrasts sharply with the white areas that were protected by the paste. Intense watercolor washes can be used in place of the food colors.

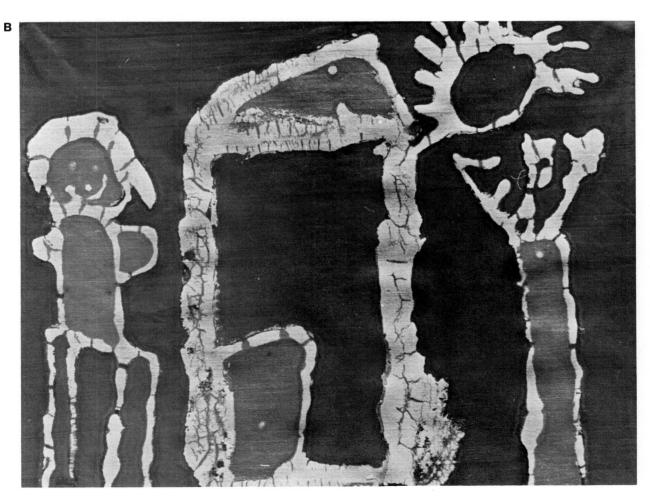

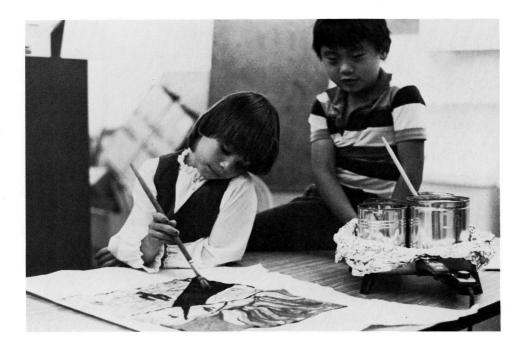

An electric frying pan with several layers of heavy aluminum foil can be safely used to melt paraffin for batiking. The thermostat on the pan maintains the wax at an even temperature, well below the burning point, and the foil protects the pan's surface and also provides insulation between the heat source and the cans of wax.

Drawn Batik

In a batik variation, the child draws a picture or design with a thick, black, water-soluble felt pen on Dippity Dye paper (available from art-supply catalogs). Colored pens can also be used. The Dippity Dye paper should be placed on a piece of white butcher paper. Then melted wax is applied with a small, natural-bristle brush to cover all the lines in the drawing. For safety's sake, the wax should be melted and kept at 250 degrees in a deep-fat fryer or in a can standing in a foil-lined electric pan. The wax should *not* be melted over an open flame or electric element or in a pan of hot water. Children should dip the brush into the melted wax and quickly apply it to the lines on the Dippity Dye paper, working rapidly to prevent the wax from cooling on the brush and not penetrating the Dippity Dye paper. The wax will cover a broader space than the black lines, making a white outline on either side of the lines.

After the children have completely covered all of the felt-pen lines in their pictures with wax, washes made of diluted paste food colors should be brushed onto the unwaxed areas of the paper. The wax protects the lines made with the marking pen.

After the paper is thoroughly dry, it should be placed on newspapers, ironed to remove the wax, and lifted up quickly from the white butcher paper upon which it was originally placed.

Simplified Batik

After children have completed a drawing on butcher paper with many colorful crayons, the paper is soaked in water and crumpled into a ball. After uncrumpling the paper, the students flatten it and blot off excess water. With a wet brush, each child applies watercolors or diluted tempera over the surface. Because the color is more intense in the creased areas of the paper where the fibers have been broken down, the finished drawing has the cracked effect of a wax batik.

Glue-It-On Drawings

Most young children produce drawings frequently and with fluency, but a few children show little interest in drawing, probably due to a lack of confidence in their ability. Both types of youngsters respond with enthusiasm to the "idea starter" type of drawing motivation. This art task suggests to children a specific focal point and directs their thinking to the innovative possibilities, upon which they may elaborate, enrich, and even deviate from their schemas.

In glue-it-on drawings, the basic concept is that of attaching one item to a piece of drawing paper and using that object as a visual point of departure to begin making a picture.

Clothing and Faces

Cutout faces or one item of clothing, such as a sweater, pants, shoes, or hat, that has been clipped from a magazine or catalog are especially conducive to developing the child's concept of the human figure. The teacher or the child should glue the cutout face or item of clothing to a piece of drawing paper. The subsequent discussion should deal with what the person whose face is on the paper or who is wearing that particular article of clothing might be doing—running down a hill, walking a dog, playing ball, skiing, pulling a wagon, sweeping a floor, jumping rope, painting a building. The motivation should then lead the child's thinking to the environment that would be appropriate, that is, where the figure might be—on the street, in a garden, at the zoo, on a mountain—and who else might be with the person. Next, the child uses crayons, pencils, marking pens, or oil pastels to complete the drawing.

Yarn

Each child is given a short length of yarn to place on a piece of paper in a curve, circle, zigzag, line, angle, and so on. The motivational discussion should cause children to wonder what the yarn suggests to them. Could it be the string of a kite? A fishing pole held by a man in a boat? The outline of an elephant's back? The top of a building? A clown's head? The peak of a mountain? A jump rope? The antennae of a butterfly? Then the children glue the yarn to the paper and complete the picture with drawing materials.

Seeds

The children should each have a paper with four or five flat beans or large seeds glued on it. The motivation should focus on the roots, stems, and parts of plants. For example, the teacher can bring in a flower or weed that has been pulled up so that the children can examine it closely and touch its roots, stem, leaves, flowers, and seed pods. The class can then talk about how the shapes of leaves and plants differ and about all the different colors of flowers. The children are then ready to design their own imaginary plants, drawing the roots below the ground, growing down from the glued-on seeds, and the stems, leaves, flowers, and seed pods growing upward above the ground from the seeds.

Flags

Very small paper flags mounted on short, wooden sticks can be purchased in variety stores. They are brightly colored and come in assorted designs. Each flag should be glued to a piece of drawing paper. Class discussion should focus on where the children

G

Н

J

- A. Photographs of heads clipped from a catalog were glued to 12-inch strips of lightweight poster board, and shorter strips were added for arms. The children drew the bodies and clothing with felt pens.
- B and C. Five-year-old children showed great diversity of form concept when they drew witches, using precut hats as visual starters. Felt pens, yarn, and fabric scraps were used to complete the drawings.
- D. A pair of pants was the glued-on starter for a five-year-old boy's drawing of himself walking his dog.
- E. Each child in the first grade had a photograph of his or her own face and was highly motivated to draw himself or herself in this assembled mural.
- F. Four seeds glued to the drawing paper motivated this drawing of roots and flowers by a five-year-old child.

- G and H. Flags glued to drawing paper suggested soldiers to one kindergarten child and racing cars to another.
- I, J, K, and L. Short pieces of yarn were shaped by one five-year-old child into a monster. Another child used shorter pieces for swings for a group of performers. Others used the pieces for the roof of a house and for ocean waves near a lighthouse.

have seen flags flying and who carries flags. One child should demonstrate how a real flag is held—how the elbow is bent—and how the flag flies high above the child's head. The children can discuss where they have seen flags—on buildings, on boats, on flagpoles, at fairs, and carried by horseback riders in parades. Then they will be eager to draw a picture with a flag in it, adding appropriate figures and environmental details.

Murals

In the mural "There Was an Old Woman" shown here, first-grade children were given actual photographs, about 4 inches high, of their own faces. These photographs were cut out and glued to a 12-by-18-inch piece of drawing paper. Then, using marking pens and scraps of colored paper and fabric, the children drew and cut out the rest of their bodies and clothing. The completed figures were then cut out of the drawing paper and assembled on a bulletin board, which in this case was covered with a piece of yellow felt. Several children painted and cut out a shoe house, a few flowers, and the title.

Not only did the figure concepts become more detailed and elaborate, but the children also experienced an intense awareness of drawing a person, since their own faces were serving as the focal points. By grouping the finished figures around a central item and using a unifying theme, the whole group of children enjoyed working together on a class art project.

Related mural topics for a group of children to create, using either their own portraits or photos of heads clipped from catalogs and magazines as glue-it-on starters, include:

- 1. A castle filled with kings and queens
- 2. An office building where many people work
- 3. A super rocket with space travelers in compartments
- 4. An ocean liner with many tourists in the cabins
- 5. People walking through the jungle on trails
- 6. Children getting on the school bus
- 7. Children playing games on the playground

In all of these motivational topics, each child draws a figure and some of the environment that is needed for the completed mural. Each item is individually drawn and cut out, and then all of the parts are assembled on the background. For a permanent mural, the parts can be glued in place. Pins should be used if the children wish to disassemble the mural later and retain their individual work.

Tall, Wide, Round, and Square Formats

How to provide situations that help children to break through stereotyped expression and move on to less rigid and more sensitive realms is a challenge for teachers. Appropriate and stimulating motivations keep children's thinking dynamic, their schemas enriched, and their imagery varied and flexible. Many artworks in the "Color Gallery" have different formats, where artists have made the shapes work harmoniously within their composition.

Paper for drawing and painting that departs from the usual 12-by-18-inch size challenges the child to make new visual configurations. If crayons, marking pens, or pencils are used instead of paint, the paper should be fairly small—6 by 9 inches, 6 by 6 inches, 9 by 3 inches. Tall and wide pieces of paper, as well as round and square sheets, encourage children to adapt their form concepts to that shape of paper, adding details and configurations that fit the new proportions and shapes.

The teacher may suggest to children suitable topics that are adaptable to a particular shape of paper. The following are some subjects that match unusual paper shapes:

Tall Paper

- 1. High-rise building with people looking out the windows
- 2. Church with steeple
- 3. Clowns on a ladder
- 4. Tree full of squirrels
- 5. Girl on a tree swing
- 6. Castle tower and a princess
- 7. Jake, the giant
- 8. Spaceship with an astronaut
- 9. Very tall man/woman with boots, umbrella, and hat
- 10. Giraffe or ostrich
- 11. Acrobats on a unicycle
- 12. Raccoons climbing a tree
- 13. Person on stilts
- 14. Tall bird

Long, Wide Paper

- 1. Submarine and its interior
- 2. Long train
- 3. Bus full of people
- 4. People waiting in line for tickets
- 5. Racehorses
- 6. Dancers on a stage
- 7. Chickens on a fence
- 8. Alligator
- 9. The most beautiful caterpillar in the world
- 10. Candy-making machine
- 11. Floating on water
- 12. Things that crawl
- 13. Camel caravan
- 14. Storefronts
- 15. Playing tug-of-war

Α

В

Round Paper

- 1. Children playing "The Farmer in the Dell"
- 2. Swimming in a pool
- 3. Fishing in a round lake
- 4. Children playing jacks or marbles
- 5. Butterfly
- 6. Flying carpet
- 7. Magic wheel
- 8. Clown's face
- 9. Mother cat nursing kittens
- 10. My friend the sun
- 11. Coiled snake
- 12. Circus ring
- 13. Pond full of ducks

A, B, and C. Drawing tall giants requires children to stretch their concept of the human figure to fit a long, narrow piece of paper.

D, E, F, and G. Round paper from a dentist's office was used for these circular representations by kindergarten children.

H and I. Vigorous drawings of a truck and a train by fiveyear-old children are aesthetically adapted to long, narrow paper.

J and K. Tall rockets and tall apartment buildings were painted by kindergartners.

Square Paper

160

- 1. Eating at a picnic table
- 2. Inside a magic box or radio
- 3. Mechanical snail
- 4. Face of a growling lion
- 5. Grasshopper or ant
- 6. Sitting in a chair
- 7. Bird in a cage
- 8. Bug on a big flower
- 9. Comet or shooting star
- 10. Very fat clown
- 11. Looking down on a city block
- 12. Baseball game

Drawing with Glue

A thick line oozing from a spout and flowing onto paper has great appeal to children and provides an interesting medium for them. In this activity, children draw with pencils first, until their pictures or designs are pleasing to them, and then trace over their work with glue. A large, thick, primary pencil is probably best for the initial drawing, since it discourages little details that are difficult to make with glue. A child making a free-form design with glue directly on the paper is also an acceptable approach to this lesson.

When dry, the glue lines are transparent and raised above the surface of the paper. The children can use tempera or watercolors to paint the areas within the lines. The glue protects the paper beneath it, and the lines appear to be white.

A variation of this is to draw with glue on black paper. When the glue is dry, colored chalk can be applied to the areas within the transparent glue lines. The chalk should be pushed with a fingertip into the spaces next to the lines. The transparent glue causes the black paper to show through as black lines. The chalk has a muted quality since the black paper dulls the colors. The teacher may choose to use a spray fixative over the finished drawing to keep the chalk from rubbing off.

Still another variation is to add black india ink to the glue (two parts glue to one part ink is a good combination). When used to make lines on white paper, the glue stands out, dark and bold. Watercolors or brightly colored tempera paints can be used to complete the work, and the permanency of the india ink allows the glue to dry waterproof. If watercolors are used, the intense black line against the transparent color gives the work a stained glass effect. Art reproductions of works by Rouault, Pollock, Klee, Calder, or Miró help to develop appreciation for the use of the black lines in art while introducing students to the styles of great artists.

Sand Drawings

After drawing with glue, children can add colored sand while the glue is wet. Sand can be easily colored by adding water to dampen the sand, putting in a few drops of food coloring, shaking or stirring to blend the color, and then putting the sand on a flat surface to dry (the drying procedure can be speeded up by placing the sand in a warm oven).

Once sand has been sprinkled over the wet glue lines, the design should be set aside until the glue has dried. Excess sand can be removed by tipping and shaking the design over newspaper. The excess sand can be returned to the container for later use. Soap powder, salt, or rice also can be used in place of sand.

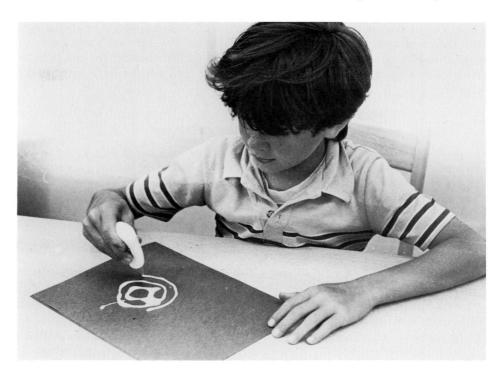

Designs created in glue provide a foundation for a multimedia work of art. Once dry, the white glue becomes transparent and forms a raised surface that adds interest to the drawing.

Drawing with glue on colored paper provides variety in materials. Once the glue has dried, it becomes a clear line. Chalk and oil pastels are then added in the spaces. Follow-up discussion can focus on open and closed shapes, as well as the other elements and principles of art.

This activity introduces texture to an artwork. Students should be encouraged to rub their fingers gently over their drawings and feel the lines and shapes with their eyes closed. A comparison of the sand drawings (actual texture that can be felt) to pictures in magazines (visual texture that can be seen but not felt) can extend the concept.

Painting with Melted Crayons

Encaustic painting, which involves painting with melted colored wax, was common in ancient times and in the early Christian world. This medium has even been used in a modern form by some twentieth-century artists; for example, Jasper Johns used melted wax on crinkled newspapers stuck to canvas.

This brightly colored medium can be adapted for early childhood classrooms in two ways. The first involves making a special crayon melter.

Crayon Melter

The materials needed for a crayon melter include an empty ditto fluid can, a muffin tin with small cups, an electric cord with a light socket on one end, a 150- or 200-watt light bulb, and a piece of lumber to attach to the bottom to prevent the tabletop from being scorched. An opening should be cut in the broad side of the can, the cord inserted through the pour-top opening, the wooden piece nailed to the bottom, and the light bulb attached to the socket. Then the muffin tin should be placed in the cut-out opening and screwed in place. Broken pieces of wax crayons should be soaked in warm water to remove the paper and then a different color of crayon should be placed in each cup, along with a small piece of paraffin. The paraffin makes for easier application and also lessens the possibility of crayons flaking off the finished pictures. The heat from the bulb melts the crayons.

The child can use cotton swabs or small, stiff, bristle brushes for painting. A small (5-by-8-inch) piece of heavy paper or card stock, such as old manila folders, makes an excellent surface for this form of encaustic. The size of paper should be small since it takes time to complete this sort of painting. A color can be applied to an area, and in a few seconds, it cools and hardens; then another color can be applied on top of it for details or a color can be placed next to it. The entire background can be filled with the melted crayons, or watercolor or food-color washes or india ink can be brushed on the uncovered areas. The wax hardens rather quickly on the cotton swab so the child will need to stand close to the crayon melter and keep dipping the swab or brush into the melted wax to achieve a waxy, luminous, encaustic effect. The wax should be applied in dabs and daubs, rather than strokes.

Though children will have their own ideas for encaustic paintings, they may be stimulated by seeing a butterfly collection, listening to a visual image-provoking record, such as "Puff, the Magic Dragon," or hearing a motivation having to do with nursery rhymes or fairy tales.

Warming Trays

A warming tray used for serving food also can be used for making crayon drawings. Garage sales and flea markets usually offer excellent buys on warming trays. A piece of paper should be taped to the top and bottom edge of the tray so that the child need not hold onto the paper while drawing. Warming trays do not usually get hot enough to cause any burned fingers; however, the child may want to use a kitchen mitt to hold the paper in place. Two children can be at the warming tray at a time—one to observe and wait for the next turn and the other to work.

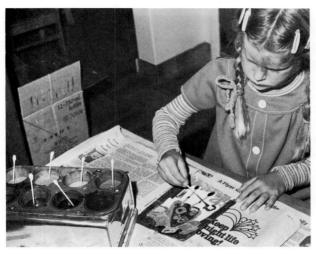

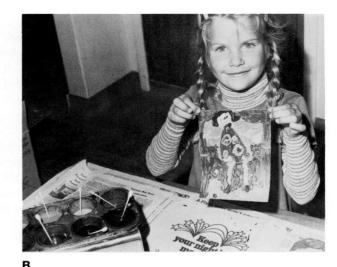

A

A. Shiny colors can be spread easily on card stock when applied with a cotton swab from cups holding melted crayons.

B. Small encaustic painting done with melted crayons was completed by a seven-yearold who concentrated on schematic theme and background design.

A small piece of paper is taped to a warming tray, and a child creates a melted-crayon drawing by moving crayons slowly over the surface. The entire paper can be covered with crayons, or background areas can be brushed with india ink or watercolors.

Paper wrappings should be removed from crayons by soaking the crayons in warm water. Children can choose to draw directly on the paper, or they can make a drawing with a thick, black, marking pen and then add the color by pressing down firmly and moving the crayons slowly enough to allow for the flow-melting action that the heat causes. The results are rich and waxy. Colors can be placed next to each other and the entire surface of the paper covered. Two colors can be blended one on top of another. The use of white on top of a color makes the color lighter. Gold and silver crayons add exciting touches. If the entire surface of the white paper is not covered, watercolor or food-color washes can be applied to the white areas.

Peepface Figures

Appeal to children's sense of humor, and you have a ready-to-go motivation for painting the human figure. Cardboard panels with cutout peepholes stimulate children's sense of the dramatic and illusory. Not only do the children delight in this comical art task, but they expand and enrich their cognitive awareness of the human form.

Large pieces of corrugated cardboard are discarded after mattresses and refrigerators have been shipped in them. A single, narrow panel is sufficient for one figure, while a longer panel works well for a "living mural." Small ovals just the size of a child's face should be cut very close to the top so that children can peep through them. Two smaller holes cut on both sides, either halfway up or near the top, can serve as openings for the children's hands. Placing hand holes up high requires children to extend the figure's arm up or bend its elbow to reach the opening. Children may wish to place a flower or some object near the opening for the hand to pretend to "hold" as it projects through the opening.

The panels should be placed flat on the floor or on several desks or tabletops while the children sketch their figures. Chalk, rather than pencil, enables children to draw freely, without fear of making a mistake, since they may quickly rub off any area they wish to change. Chalk is closely related to brushstrokes, and children are able to use it to draw details and decorative elements that are easily transposed to paint.

A supply of tempera in both pure and blended colors enables the children to predetermine which parts of their figures will be which colors. The children should be reminded to paint the large areas first, using a large, flat brush. Smaller areas, edges, and details should be painted with a small, stiff, flat, bristle brush. Paint should be dry before a color is placed next to it or a detail painted on top of it. The children enjoy painting the background on the panel and adding suitable environmental details.

For an imaginative extension of peepface figures, the children can use horizontal and vertical panels with cutout holes for animal paintings. The silly appeal of having one's face growling from a lion's body or perched atop a giraffe's neck irresistibly invites even the most timid young painter to become involved.

Colored Chalk

Large areas of paper can be covered easily with colored chalk. Young children respond readily to chalk's bright, vibrant tones. Chalk tends to be dusty and smudgy and can sometimes be frustrating for very young children to handle, so the options that follow are suggested to facilitate and enhance its use. Both of the methods described dry quickly, and the colors do not readily dust or rub off the finished pictures. Children should be provided with colored chalk that is designated for use on paper, not chalk-boards.

Starch Dip for Chalk

Colored chalk should be dipped quickly in and out of water and then drained on a paper towel. Then the tip of a piece of chalk should be dipped in some liquid starch in a jar lid or small container and rubbed firmly on white or colored paper. The tip of the chalk should be dipped in the starch as needed to keep the chalk marking and flowing in a smooth, velvety manner that almost looks like tempera paint. The colors lighten as they dry and will not rub or smudge as they do when dry chalk is used. The youngest children may want to draw directly onto the paper with the starch-dipped chalk, but first and second graders and older children may prefer drawing their ideas first with a piece of dry chalk or perhaps a thick, black, felt pen and then applying the colors.

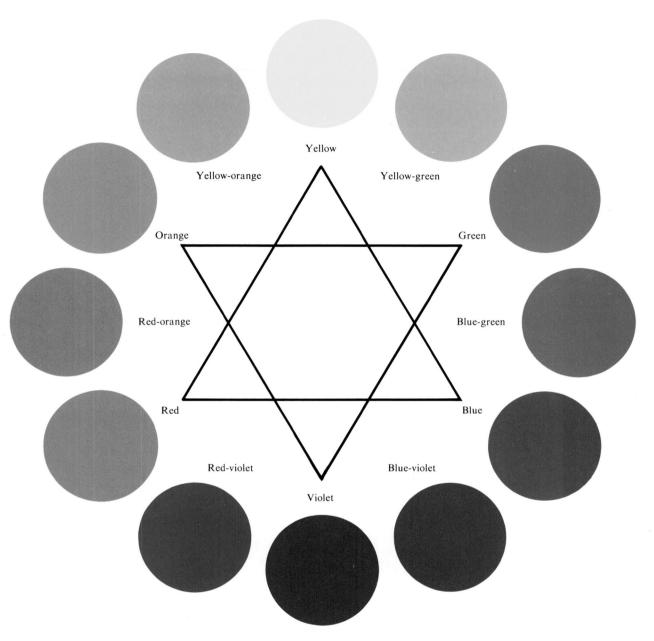

Plate 1 The color wheel. (From Ocvirk, Otto G., et. al., Art Fundamentals: Theory and Practice, 5th ed. Copyright © 1985 by Otto Ocvirk, Robert Bone, Robert Stinson, and Philip Wigg. All rights reserved. Reprinted by permission.)

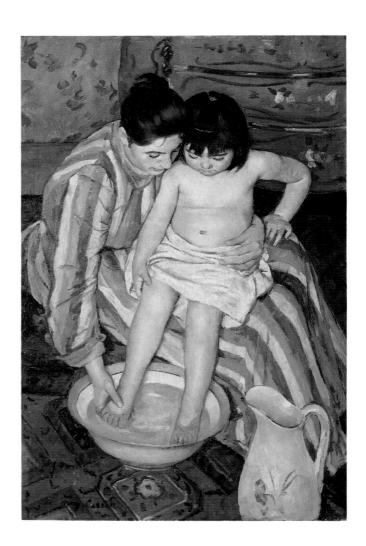

Plate 2 The Bath, Mary Cassatt. 1891–1892. Oil on canvas, 39 × 26 in. (99 × 66 cm.). The Art Institute of Chicago, Robert A. Waller Fund.

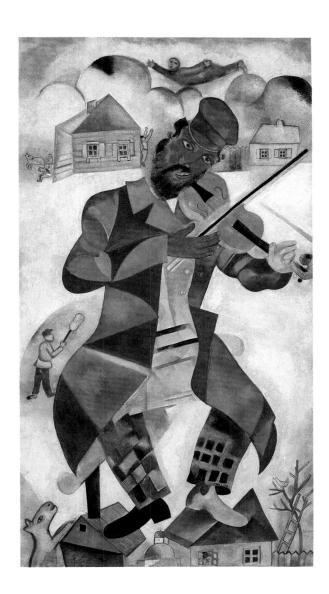

Plate 3 Green Violinist, Marc Chagall. 1923–1924. Oil on canvas, 78 × 42¾ in. (198 × 108.6 cm.). Solomon R. Guggenheim Museum, New York, Gift of Solomon R. Guggenheim, 1937. Photo: David Heald.

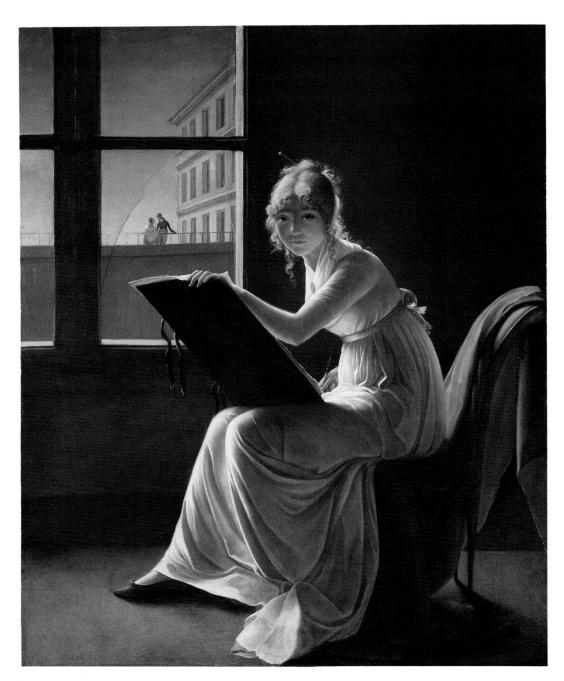

Plate 4 Mlle. Charlotte du Val d'Ognes, Constance Marie Charpentier. 1785. Oil on canvas, 63½ × 50% in. Formerly attributed to David, The Metropolitan Museum of Art, The Mr. and Mrs. Isaac D. Fletcher Collection, Bequest of Isaac D. Fletcher, 1917.

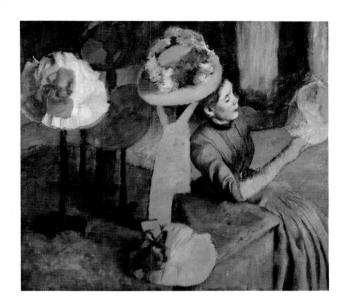

Plate 5 The Millinery Shop, Edgar Degas. 1882. Oil on canvas, 39% × 43% in. (99.4 × 110.2 cm.). The Art Institute of Chicago, Mr. and Mrs. Lewis L. Coburn Memorial Collection.

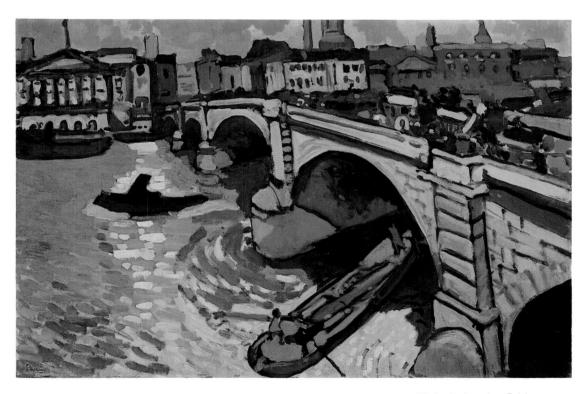

Plate 6 London Bridge, André Derain. 1906. Oil on canvas, 26 × 39 in. (66 × 99.1 cm.). Collection, The Museum of Modern Art, New York, Gift of Mr. and Mrs. Charles Zadok.

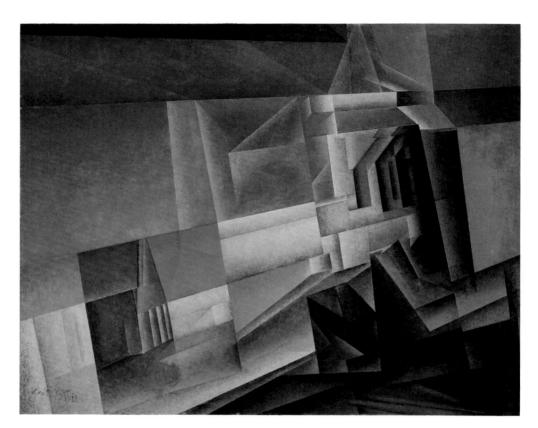

Plate 7 Zirchow VII, Lyonel Feininger. 1918. Canvas, 31¾ × 39½ in. (0.807 × 1.006 m.). National Gallery of Art, Washington, Gift of Julia Feininger.

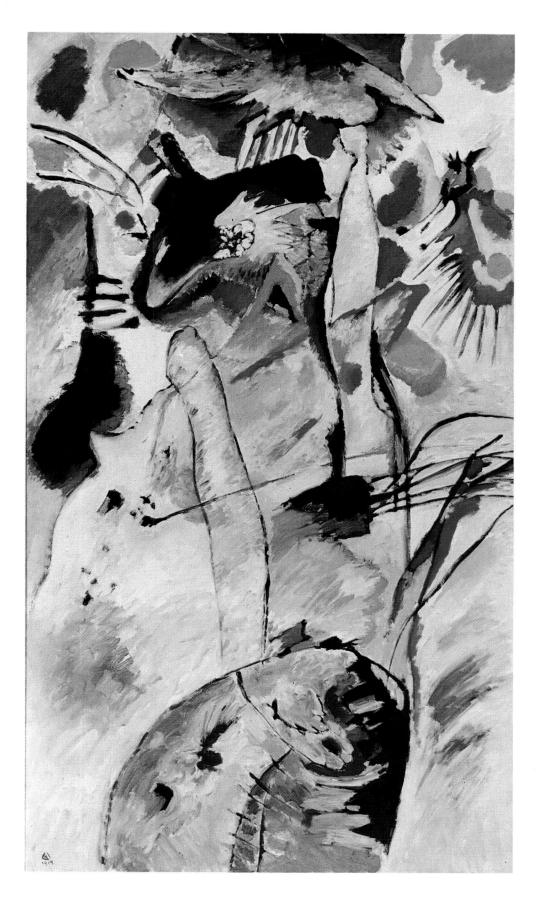

Plate 8 Painting No. 198, Vasily Kandinsky. 1914. Oil on canvas, 64 × 36¼ in. (162.6 × 92.1 cm.). Collection, The Museum of Modern Art, New York, Mrs. Simon Guggenheim Fund.

Plate 9 Rolling Landscape,
Paul Klee. 1938. Gouache on
chalk- and glue-primed
sailcloth mounted on temperapainted board, sailcloth
support: 15% × 21½ in.
(40.3 × 54 cm.); board mount:
18½ × 24¾ in. (47 × 62.9
cm.). Solomon R. Guggenheim
Museum, New York. Photo:
David Heald.

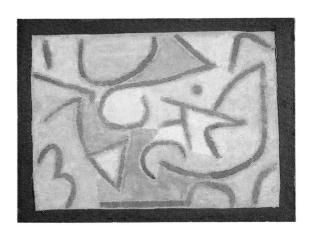

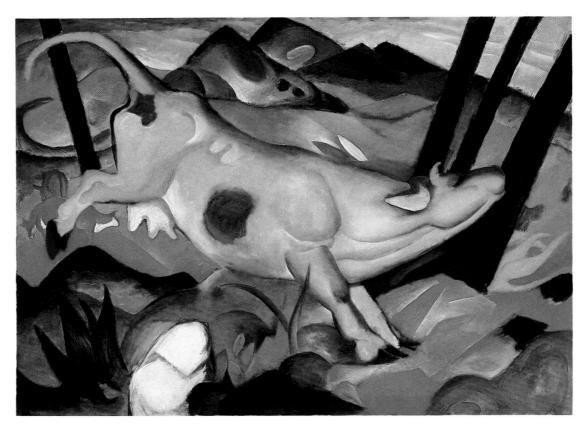

Plate 10 Yellow Cow, Franz Marc. 1911. Oil on canvas, 55% × 74½ in. (140.5 × 189.2 cm.). Solomon R. Guggenheim Museum, New York. Photo: Carmelo Guadagno.

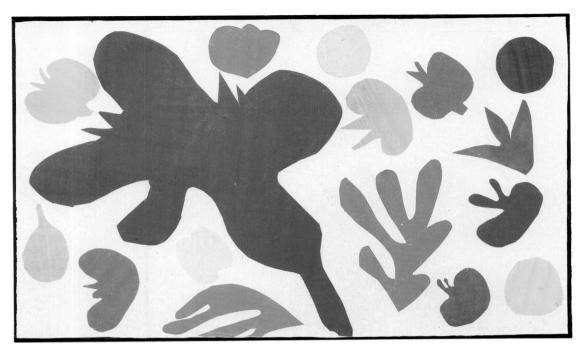

Plate 11 The Wild Poppies (center panel), Henri Matisse. 1953. Charcoal and gouache on paper, 31½ × 134½ in. (80 × 342 cm.). The Detroit Institute of Arts, Founders Society Purchase, Robert H. Tannahill Foundation Fund.

Plate 12 Prades, the Village, Joan Miró. Summer 1917. Oil on canvas, 25% × 28% in. (65 × 72.6 cm.). Solomon R. Guggenheim Museum, New York. Photo: David Heald.

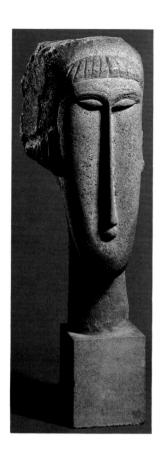

Plate 13 Head of a Woman, Amedeo Modigliani. 1909– 1915. Limestone, 25¾ × 7½ × 9¾ in. (.652 × .190 × .248 m.). National Gallery of Art, Washington, Chester Dale Collection.

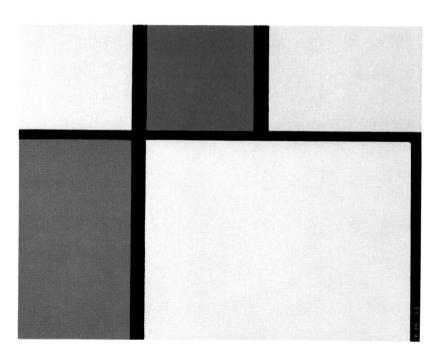

Plate 14 Composition, Piet Mondrian. 1925. Oil on canvas, 15% × 125% in. (40.3 × 32.1 cm.). Collection, The Museum of Modern Art, New York, Gift of Phillip Johnson.

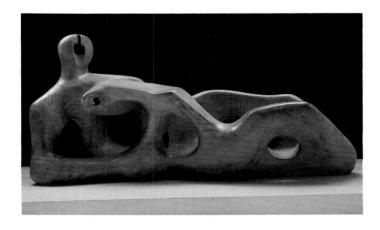

Plate 15 Reclining Figure, Henry Moore. 1939. Carved elm. $37 \times 79 \times 30$ in. $(94 \times 200.7 \times 76.2$ cm.). The Detroit Institute of Arts, Gift of the Dexter M. Ferry, Jr., Trustee Corporation.

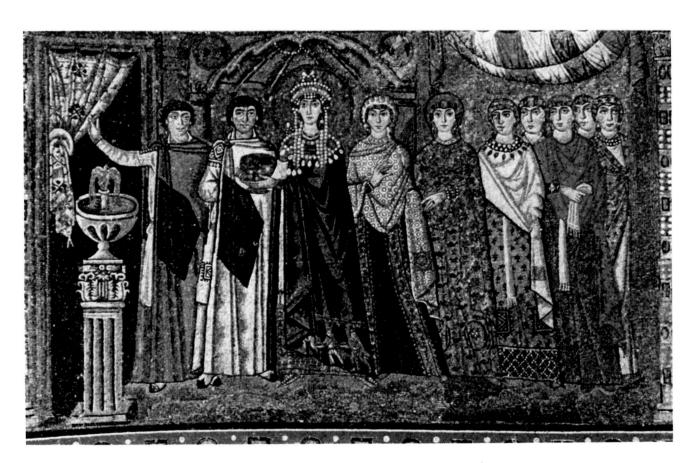

Plate 16 Empress Theodora and Retinue. Circa 547. Mosaic, San Vitale, Ravenna. Photo © American Archives of World Art, Inc.

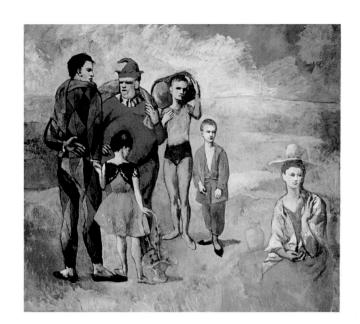

Plate 17 Family of Saltimbanques, Pablo Picasso. 1905. Canvas, 83% × 90% in. National Gallery of Art, Washington, Chester Dale Collection.

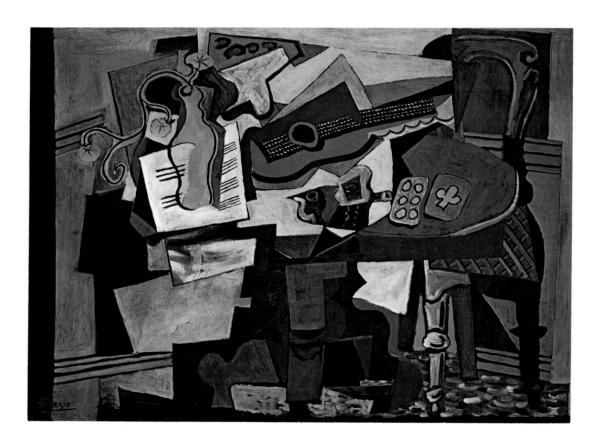

Plate 18 Still Life, Pablo Picasso. 1918. Oil on canvas, 54¼ × 38¼ in. Chester Dale Collection, 1962, National Gallery of Art, Washington, D.C.

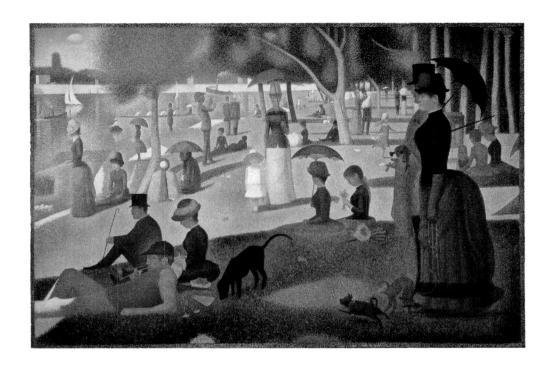

Plate 19 Sunday Afternoon on the Island of La Grande Jatte, George Seurat. 1884–1886. Oil on canvas, 81 × 1203/4 in. (205.7 × 305.7 cm.). The Art Institute of Chicago, Helen Birch Bartlett Memorial Collection.

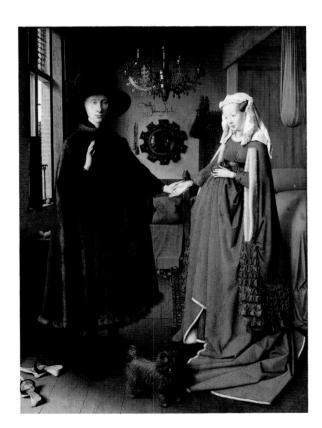

Plate 20 The Marriage of Giovanni(?) Arnolfini and Giovanna Cenamit(?), Jan van Eyck. 1434. Wood, 32¼ × 23½ in. (81.9 × 59.7 cm.). The National Gallery, London.

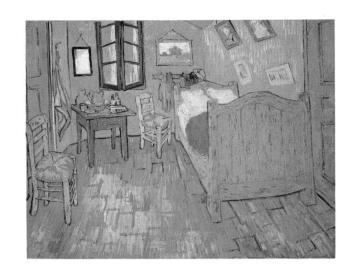

Plate 21 The Bedroom at Arles, Vincent van Gogh. 1888–1889. Oil on canvas, 29 × 36 in. (73.7 × 91.4 cm.). The Art Institute of Chicago, Helen Birch Bartlett Memorial Collection.

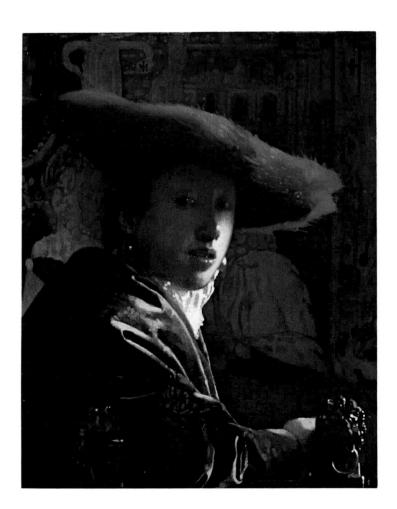

Plate 22 The Girl with a Red Hat, Jan Vermeer. Circa 1660. Oil on wood, 91/8 × 71/8 in. Andrew W. Mellon Collection, National Gallery of Art, Washington, D.C.

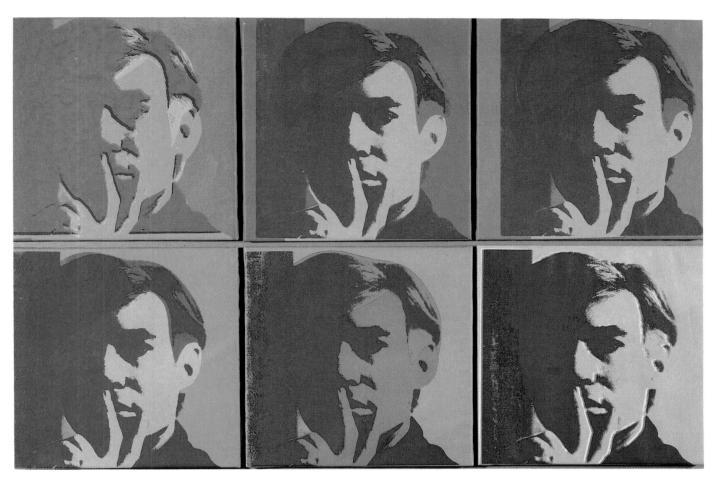

Plate 23 A Set of Six Self-Portraits, Andy Warhol. 1967.
Oil and silk screen on canvas, each 22½ × 22½ in.
(57.2 × 57.2 cm.). San
Francisco Museum of Modern
Art, Gift of Michael D. Abrams.

- A. Three chalk-drawn figures are being painted by these eight-year-old children. The long arm on the middle figure is reaching up to catch a bird painted close to the hand hole.
- B. Two boys are using tempera tubes rather than brushes to paint their peepface figure. Note the whimsical muscles on the figure's arms.
- C. A girl uses a small brush to paint background near her figure's hair.
- D. Some panels may have a half circle cut along the top edge, where the child may place his or her chin instead of looking through the oval-shaped hole.
- E. When the peepface figures are finished, the children enjoy taking pictures of each other looking through the openings.

A second grader, inspired by a visit to a California mission church, drew a bride and groom in front of one on black paper, using colored chalk dipped in starch.

White Tempera Dip for Chalk

The tip of the colored chalk should be dipped in about a tablespoon of thick, white tempera paint in a jar lid or small container. The children can practice making a variety of short marks—short, straight strokes; short, curving strokes; zigzags; little spirals and circles; up and down strokes; and such—on a small piece of black or dark-colored paper. The marks they make should show the distinct color of the chalk, edged with white tempera, against the dark paper. The children should not "scrub" with the tempera-dipped chalk unless they want to create a mixed, blurry tint.

A. Kindergarten girl enjoys seeing vibrant tones of starch-dipped chalk on her house/figure picture.

B. Kindergarten boy uses bright yellow and warm orange tones for his butterfly/ sun picture.

A

A and B. City buildings were drawn and colored with chalk/ starch colors after much visual analysis of real and photographed city scenes.

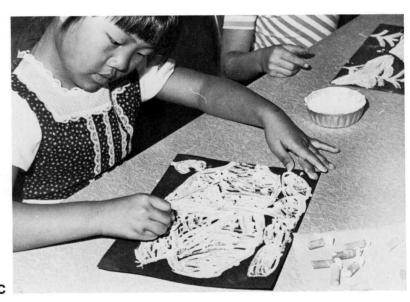

C. Colored chalk dipped in white tempera makes dramatically toned marks on black paper.

Themes for Drawing and Painting

As mentioned previously, art production in drawing and painting can be stimulated by the introduction of topics or themes. Themes that appeal to young children include:

- 1. The animal I want for a pet
- 2. The circus parade
- 3. Playing at the park
- 4. Trucks, trains, and planes
- 5. Forest friends; jungle beasts
- 6. Carousels and roller coasters
- 7. Walking in the rain: boots and umbrellas
- 8. My family, my home
- 9. Dressed up for Halloween
- 10. A trip to . . .
- 11. Birds, butterflies, fish
- 12. Clowns

Introducing topics that call upon actual or imagined experiences encourages language development, as well as enlivens the art lesson.

A limited palette of one color plus black and white encouraged this kindergartner to mix colors to complete a tempera self-portrait.

A live animal or a classmate dressed in an improvised costume and using a few props can ignite children's imagination and increase visual awareness. A vest, hat, umbrella, cane, cape, fan, bouquet of flowers, basket, doll, beads and jewelry, cardboard crown, or box of old clothes are all possible props. After experiencing painting or drawing lessons based on themes, children can better appreciate the various ways in which great artists depict such subject matter as kings, cowboys, and clowns. In this way, there is a natural flow from actual art production to art heritage and the valuing of art.

Assignment Interpretations

A truly "successful" art lesson can be identified by the number of different interpretations of the assignment. Each child should have his or her unique set of mental images and experiences to bring to the activity, and this should be reflected in the diversity of the artwork. Another criteria in establishing the value of a drawing or painting lesson is how each child feels about his or her work of art and about himself or herself as a creative person.

While enjoying the physical sensations of painting or drawing, a very young child may not make an effort to create an image that looks realistic. Even when children have started to develop pictures of objects in their environment, they do not necessarily draw objects the way the objects look to adults; nor are the colors realistic or imitative. The art of young children has a distinct character and is dominated by the vision of the world as they feel it and understand it to be. Many adults who are not familiar with young children's art frequently ask, upon seeing a child's work, "What is it?" This question implies that art must "look like" something and that the child has failed in some way, when it is quite possible that the child was happily experimenting with lines or color. Pictures reflect children's perceptions of important things in their world. In either case, the question "What is it?" creates a barrier between the child/artist and the adult/critic.

For Discussion

- 1. What changes might be expected in drawings and paintings that would indicate a child's heightened awareness of the environment?
- 2. Review the three sources of image development, and use them in discussing possible sources of images in the "Color Gallery."
- 3. Examine the children's drawings throughout the book. List and compare adjectives that you would apply to this sampling of artwork by young children.
- 4. Review the elements of art in chapter 2. Plan and discuss thematic art experiences for young children that would utilize premixed paints to reinforce a specific color concept.
- 5. Make small samples that show the differences in drawing materials. Also make samples that illustrate techniques described in this chapter. Discuss and list vocabulary terms that should be defined as each technique and activity is introduced to young children.

Tearing, Cutting, and Pasting

"Painting is a nail to which I fasten my ideas."

GEORGES BRAQUE

Why and How to Tear

For very young children, torn-paper activities help to develop motor skills in conjunction with visual perception. As they learn to control finger muscles, they become aware of shapes, sizes, and proportion.

Children should practice tearing paper before starting art activities that require paper tearing. Directions might include having the children use old magazines, phone books, and newspapers, and tearing the paper in half, tearing a strip from one edge, tearing a big shape, tearing a little shape out of the middle of the big shape, tearing tiny bits, and tearing thick and thin strips. Children can learn to control the torn edge by using the "pinch-and-tear" technique—that is, holding the forefingers and thumbs from both hands close together in a pinching position and moving inch by inch as they tear. Another technique is to place the forefinger on the paper and tear the paper by pulling it up and against the finger.

"Two People in Action" is the theme of this lesson, which uses torn construction paper pieces.

Torn-Paper People

Art can motivate and reinforce learning in other subject matter. For example, in studying the human body in science, very young children are able to understand that the body bends in certain places, with names like "elbow," "waist," "wrist," "knee," and "ankle." There are sixteen body parts and fourteen major places where the body bends. The teacher can point out the head, neck, upper torso, lower torso, upper arms, lower arms, hands, thighs, calves, and feet, using student volunteers. The children should then tear pieces of paper to represent the body parts, starting with the head, an oval shape about one or two inches high. The piece that represents the head determines the proportion of the other rounded rectangles that make up the remainder of the human figure.

Once all the pieces have been torn, the students can arrange the pieces on another paper to show a person in action—for example, engaged in various sports, games, or work activities. The children should arrange the pieces several times to show a lot of action before pasting the pieces down and adding some details with marking pens or crayons. Older children are able to add a second person in another color of paper. The torn-paper people can be made in different sizes and placed higher or lower on the paper or so that they overlap and show depth. The students can all paste their torn-paper people on a large background paper to form a mural about playground sports and games.

As a follow-up activity, the children can tell what the torn-paper person or people are saying. For older children, this extension of the art lesson can go into creative writing activities or the introduction to dialogue and quotation marks.

Cutting and Pasting

Children who develop cutting and pasting skills early in their lives continue to enjoy creating with paper and scissors. Children who are still scribbling probably will not cut recognizable objects; rather, they are content to experiment and cut for the sake of cutting. This is good practice and should be encouraged. As children explore cut paper for making artworks, they enjoy viewing cut-paper artworks by Matisse.

A and B. Body parts of figures were assembled in an action position pasted down, and then dressed in colored paper clothing.

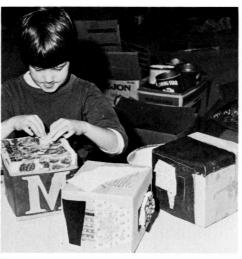

В

A. Very young children can begin to learn scissors skills if they are provided with a good pair that readily cuts both paper and fabric.

B. Cutting and taping colored paper into sculptural forms involves skills in forming, joining, and relating three-dimensional shapes.

Children will probably need some practice in learning to use and control scissors. The children can exercise cutting skills by blowing a puff of air and pretending that they are cutting the air into little pieces or by cutting clay or small foam pieces. The children can cut out favorite things—foods, clothes, animals—from old magazines and sales catalogs. The children can also cut teacher-drawn spirals on very thin paper plates so that they end up with a coil. When colored and patterned, the coil can make an interesting mobile.

Some skill-building exercises in handling scissors require giving children small pieces of paper, about 6 by 9 inches, and having them make straight cuts in the first piece by turning the paper as they go, rather than turning the scissors. They should enter one side of the paper with their scissors and "take a walk," making straight cuts as they go until they exit from their "walk" on another side of the paper. With a second piece of paper, they should practice making only curving cuts, again turning the paper rather than the scissors, and take a "walk" in which they twist and turn with curves until they exit from another side of the paper. In a third exercise-building skill, the children fold a small piece of paper in half, hold the folded side in their left hand (if they are right-handed), and cut out a simple shape that unfolds to be symmetrical. They should also learn that two or three lightweight pieces of paper can be cut at the same time to produce like shapes. Cutting out an interior hole or shape after folding the paper over is another basic cutting skill. Children who have mastered basic cutting skills can be introduced to simple paper-sculpture techniques, such as fringing, scoring, and curling paper. They can also learn to make slits and small tabs for joining two pieces of paper together.

The children should have good-quality scissors to prevent initial cutting experiences from being frustrating and failure-oriented. Without good scissors and appropriate paper, children's artistic growth is impeded, and later, when they reach the symbol stage and are eager to depict the human figure, animals, plants, buildings, and such, a lack of cutting and pasting experiences impedes their ability to communicate visual images in cut paper.

Goals and behaviors to be achieved in cutting and pasting with paper should be specific. Preschool and kindergarten children should have time, space, and supplies available daily for them to cut and paste. They should know not to run with scissors in their hands and that they should walk holding the scissors tips down.

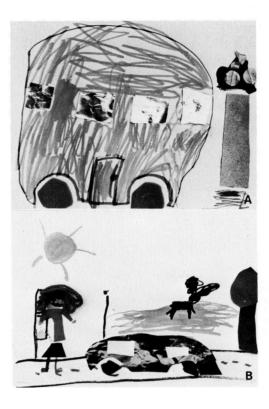

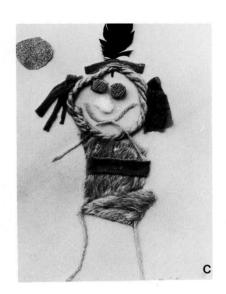

A and B. The children may choose to cut out only some parts of a touch picture. They complete the picture with felt pens or crayons.

C. All the parts of a touch picture can be cut from textured materials. Children enjoy closing their eyes when they examine each other's pictures.

The teacher should stress the importance of not using too much paste. Many times, paste is applied in globs, and the result is a piece of paper that is curled and lumpy. Students should apply paste evenly with their fingers to the backside of the paper shape that they have cut out. When the paste is applied to the paper, it should be a thin, shiny coat that covers the entire surface of small bits and pieces of paper and only the edges of large shapes. Old magazines or phone books are useful paste-applying surfaces: When a clean surface is needed, the child simply turns a page. A damp sponge or paper towel nearby to wipe sticky fingers eliminates some of the frustration of handling small pieces of paper. When the children begin to cut realistic symbols, the teacher can introduce more advanced skills—for example, how to paste details and smaller pieces of paper on top of other shapes.

An alternative to paste is a mixture of equal parts of white glue and liquid starch. The mixture is brushed on the reverse side of the piece of paper to be attached.

Children should be encouraged to cut freely into paper, without drawing the shapes with pencil ahead of time, as this makes for tiny, cramped details that are difficult to cut out. The teacher should discuss the kinds of shapes the children are cutting, referring to them as straight, curved, thin, jagged, or smooth. Children should be given the opportunity to use shiny paper, dull paper, and textured paper, as well as fabric and felt.

When children have developed sufficient skills with scissors and paste, the teacher should provide motivational topics for picture making. Children often enjoy combining their efforts to make cut-paper murals, with each child making several figures, flowers, insects, and buildings and then the cutouts being assembled with pins on a background until a final arrangement is decided upon. Making stand-up figures from oak tag for dioramas is a skill-building task for young children, as is decorating boxes and wood constructions with cut-paper decorations.

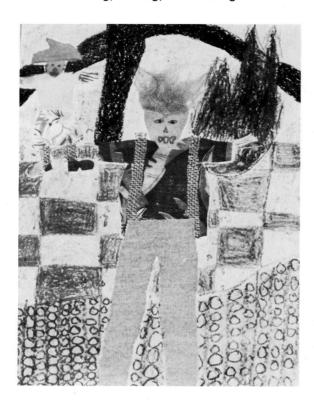

Collage scarecrows made of fabric scraps were adhered to a background by a third-grade student before adding the environment with oil pastels.

Collage Pictures

"Hands off" and "Do not touch" are frequently heard admonitions that run counter to the natural human inclination to explore the world around us through our sense of touch. Smoothly polished wood, shining brass, bumpy fabric, soft fur, gritty sand—all invite the hands to feel, to sense differences, and to enjoy a multitude of tactile qualities. Children need to develop their capacity to differentiate between textures and to enjoy the sensory experiences of associating different textures and surfaces with different objects.

When children draw, paint, model, and cut out pictures, they are usually more involved with shapes, colors, and lines than they are with texture. When making touch pictures, the young child is called upon to think primarily of the world in terms of its physical "feel" or surface quality.

In making collages, children should have the opportunity to handle and compare a number of materials and to talk about whether the materials are soft, rough, smooth, spongy, shiny, slick, furry, and so on. Once they have thought of things that the materials remind them of, they are ready to make collages— "touch pictures."

Velour-surfaced paper may suggest kittens to children. Sheet sponge may suggest undersea plants; shiny foil paper may suggest flashing, colored fish. Sandpaper and felt may remind the children of camping in a tent or a pleasant day on a sandy beach. Yarn and fabric may become clothing or hair. Corduroy could be the walls of a house. Leather scraps could be a horse or a cow.

Before children paste down the parts of their pictures, they should try moving the various parts around to possibly discover a more pleasing arrangement. Or they may decide to repeat some shapes to give their pictures more unity or to add other textures to enrich the overall quality of the concepts they are trying to convey. They may want to use marking pens or crayons to draw some finishing details.

A

A and B. Children who begin cutting and pasting from their earliest school days and who continue to have frequent opportunities to practice arrive at third grade with highly developed skills, as demonstrated by these renditions of trains.

Zigzag Books

The pages of a zigzag book flow in a continuous progression from front to back and tell a sequential story, or they become a focus for a cluster of connected concepts. The children should choose a topic and make up their story line together, with each child cutting out one picture for the series of episodes that are needed to tell the tale.

The book that the children are holding in the photograph tells the story of Silly Dilly the Clown, who had a dog named Billy. Each page of the book describes how Billy went searching at the circus for his lost master, asking first the balloon seller, then the thin man, the popcorn seller, the bareback rider, and so on, if they had seen Silly Dilly. The dog, made of felt, "traveled" from page to page with the aid of the storyteller, creating the necessary suspense leading to a happy ending on the last page.

A blank zigzag book should be made of sturdy cardboard so that it can be folded and unfolded a number of times, since the children enjoy looking at the pictures over and over and giving a visual and oral presentation to another class. Mat board should be cut into 8-by-10- or 9-by-12-inch pieces for the pages. These pieces can be fastened at the sides with masking tape or plastic tape on both front and back so that the pages will fold up in an accordion-like manner from either end.

After the children have decided on a title and a story line, each child chooses an episode that he or she would like to depict. Fabric, felt, yarn, and various kinds of colored and textured paper can be cut and combined for individual pictures. If the children arrange their cutouts on a piece of background paper the same size and shape as the pages in the zigzag book, they will find that the arrangement fits the dimensions of the page when they transfer the pieces to the book.

After arranging their pictures, the children can use paste or glue to fasten down the cutout pieces. Several children may cut out letters to spell out the title.

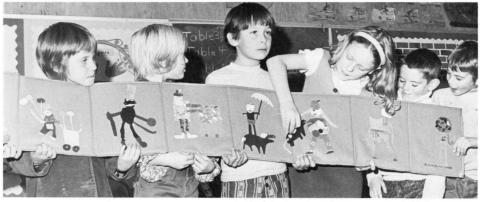

A

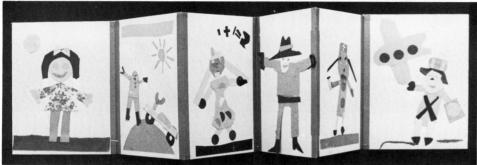

В

made a "When with the art

Oral communication and creative writing skills can be integrated with the art task of making a zigzag book. The children will be proud of their individual contributions and enjoy taking turns telling and retelling the stories and looking at the illustrations.

Topics that suggest story lines for zigzag books include:

- 1. The street where Tom lives
- 2. Things that are round
- 3. The crocodile who couldn't find his dinner
- 4. Rainbows and colors
- 5. Rockets and space people
- 6. Our families
- 7. Birds
- 8. An airplane named Harry
- 9. The adventures of a unicorn
- 10. Favorite nursery rhymes
- 11. Dinosaurs
- 12. Textures to touch

Corrugated Paper Crowns

Very young children can be kings or queens for a number of days when they proudly wear a brightly colored and ornamented crown of their own making. Corrugated paper serves as a sturdy base for these headpieces, and upon them the children can glue, tape, and staple all sorts of decorative materials. Corrugated paper comes in rolls in a variety of colors and is available from office and school supply houses. A strip about 21 inches long can be stapled to a longer piece of colored paper of the same length and then

- A. Zigzag books are sturdy receptacles for composite group ideas. They promote sequential thinking about events, or they may unify many concepts having to do with a single theme.
- B. Six-year-old children thought about what their life ambitions were and how they would look as adults and then made a zigzag book called "When We Grow Up."

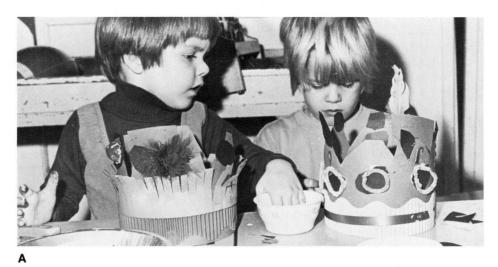

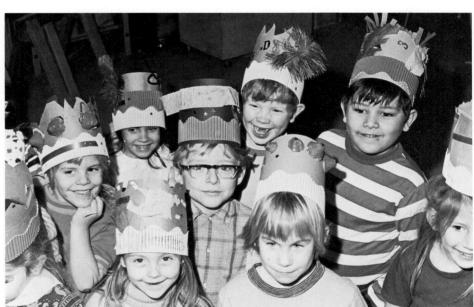

A. These preschool children are developing their cutting and gluing skills when they add both two- and three-dimensional decorations to their crowns.

B. Young children love to wear headpieces, and when they can make bright crowns all by themselves, they treasure them highly and wear them for all sorts of pretend play.

В

overlapped at the back and stapled to fit the individual child's head. The added piece of construction paper elevates the height of the crown, giving the child more space to decorate. Children may cut the tops of their crowns in points, curves, fringe, or whatever manner they choose.

With a rich supply of such things as discarded gift-wrap ribbons, colored paper, and yarn, the children are ready to begin using scissors, glue, tape, and staplers. The children can create projecting decorations by adding feathers, soda straws, and pipe cleaners. They can make moving parts with fringed paper and crepe-paper streamers. Foil paper, gold and silver stars, and alphabet stick-ons add sparkle and shine. Folding colored paper and cutting several shapes at the same time encourages the child to make a repeated motif. Buttons and beads with one side flat enough to hold a bit of glue add interesting design accents and serve as "jewels." A pile of egg carton bumps may be painted with tempera and glued on for fake diamonds, emeralds, and rubies.

When they have finished, the new kings and queens may parade in a grand procession or rule their kingdoms seated on thrones. They may happily act out stories and imagine themselves in their new roles as grand monarchs.

Paper Medals for Heroes/Heroines

Students may choose to honor a hero or heroine or some very special person who has shown great courage and strength and is celebrated for what he or she has done. Such a person has usually persisted against great odds to reach a goal in any field of endeavor.

To honor such a hero or heroine, students can design medals by folding and cutting three different pieces of colored paper. Each student needs a 6-inch square, a 4 ½-inch square, and a 6-by-3-inch rectangle. First, the students should fold the 6-inch square in half and then in half again. Then, curving and straight edges can be cut on the open sides, eliminating the corners, so that, when the paper is unfolded, it is a circular design. The students should then fold the 4½-inch square in half and then in half again and vary the cut edges. The smaller circular design is pasted in the center of the larger circular design. Decorations can be cut from the paper scraps and pasted on. The students can use a black pen to write the hero/heroine's name on the medal, endeavoring to make the lettering fit the design of the medal. The third piece of paper—the rectangle—should be attached to the bottom of the round shapes as a "ribbon." The bottom of it can be cut in a pointed or an inverted pointed design.

Pass-It-On Pictures

Gamelike in approach, pass-it-on pictures require children to be adaptable and quick in their thinking with respect to cutting out images freely from colored paper.

The children should each have a piece of white or black construction paper, 9 by 12 inches in size, and an assortment of colored paper and paste or gummed colored paper. The rules of the game are that the children must each cut out one shape from the collection of small pieces of colored paper in front of them, paste it anywhere they choose on their background, and at a given signal (two minutes is usually sufficient), pass their background to the student on their right. Also at this signal, the children each receive a background paper from the neighbor on their left, and they must quickly decide what the shape reminds them of and how they can add to it to make the picture progress. This passing-on continues for about fifteen or so turns, with each child adding a part to each picture for a composite finished arrangement.

A and B. Pipe-smoking funny man and a motorboat grew piece by piece as children each added to the arrangements in these "passit-on" pictures.

arranged on a paper background as preparation for crayon rubbing.

B. A piece of typing paper is

A. Cut paper shapes are

B. A piece of typing paper is placed on the top and corners are taped to prevent sliding. The flat side of a black crayon is rubbed over the surface to bring out the impression of paper shapes beneath.

В

The children are quick to find humor and suspense in observing what happens to the picture that each of them started and how their friends changed and enriched the picture as the game progressed. They may want to play the game several times and will find that practice increases their skill and ability to see novel configurations in shapes. They should let their imaginations dictate directions for unexpected and whimsical results. The children can conclude the activity by titling the finished pictures.

Crayon Rubbings

For many years, a number of people have enjoyed making brass rubbings on tombs in England and India, while children have amused themselves watching magical pictures appear when they place a piece of paper over a coin and rub it with a pencil. Crayon rubbings are made in somewhat the same manner, except that the children make the original cutout designs or pictures prior to making the rubbing.

Necessary materials include several sheets of ditto or typing paper, scissors, masking tape, and a black wax crayon, preferably thick and with the paper removed. Tagboard, index cards, or manila folders—all slightly stiff and heavier than typing paper—are best for the cut shapes. The teacher should demonstrate the overall process so that the children understand that the rubbing and not the actual cut picture is the finished product. First, the children cut out simple shapes for their pictures or designs. They may choose to make their own portraits, cutting a large, oval shape for the face and then cutting the features separately and pasting them in place. Or they may make animals, birds, fish, cars, airplanes, or any other objects, cutting all the parts separately; that is, the body of the dog is cut out, and the legs, neck, tail, and head are cut and placed in proper positions. Paste should be used very sparingly, applying a tiny dot in a strategic position and smearing it thinly, because paste blobs are highly visible on the finished rubbing. Cutout shapes may overlap. Making short snips in a shape and then folding the snips over—for instance, to create the tail feathers of a bird—produces an interesting result. Stripes may be placed on a tiger and polka dots on a clown. Children will enjoy using a hole punch for a few accents and details.

When the children have finished their cutout pictures, a piece of typing or ditto paper should be placed on top of each cutout picture, making a "sandwich" of the bottom sheet, the cutout work, and the top sheet. Masking tape should be used to hold the corners in place and to avoid any slipping. A thick, folded section of newspaper used as a pad under the "sandwich" results in a better rubbing than if the rubbing is done on the hard surface of a desk or table.

Children should stand up while making the rubbing. Using the black crayon on its side, the children should rub softly at first, making short strokes on the surface of the paper until they find the cut picture. When the edges of the cutout picture are ascertained, the children should begin rubbing harder and harder in the same short strokes, moving the crayon in one direction, rather than rubbing back and forth. The finished rubbing should emphasize the edges and make the images stand out in contrast with the background.

Sometimes, it is interesting to make the first rubbing of the cutout picture and then lift the top paper, move it over an inch or so, and make another rubbing that overlaps the first one. The second rubbing should be made lighter than the first one because it will appear to be behind the first rubbing. The image can be repeated several times to create a school of fish, flock of birds, fleet of ships, herd of cows, and so on. A wash made of diluted food colors can be applied over the rubbed shapes for added interest.

The class may decide to work together on a group project to create a mural on a long piece of butcher paper. For example, each child could cut and assemble a house for "Houses on Our Street." Other topics could be: "Circus Time," "Our Pets," "Our Trip to the Zoo," "Sea Full of Fish and Mermaids," "Our Faces," and "Cars and Trucks." The children might enjoy discussing Seurat's Sunday Afternoon on the Island of La Grande Jatte in the "Color Gallery" and then making a combined rubbed mural of themselves and their friends at the beach or park.

Tissue-Paper Collages

Making collages with colored tissue paper provides young children with a good opportunity to improve their skills in cutting freely and boldly with their scissors. The many bright colors of tissue paper, along with the wide range of tints and shades of one color, are visually stimulating.

Instruction should begin with the children having six small pieces of tissue for reviewing specific cutting skills. The first challenge should be to take a piece of paper and try making large, curving cuts. The second piece of paper should be used to make straight and jagged cuts. The third piece of tissue should be folded in half with a large shape cut from it, thereby making two of the same shape. Another piece of paper should be folded in half and then in fourths and four shapes made all at once. These multiple cuts are useful later for making such things as wheels for a train, petals on flowers, or windows for a castle. The fifth piece of paper should be folded and a symmetrical cut made. The last piece of paper should be used to try tearing a shape. This is best accomplished by holding the fingertips close together and remembering to "pinch and tear."

After the children gain confidence in "free-cutting," they are ready to start making a collage. They should look through their practice cuts and see what images might emerge from the scraps. They may suddenly discover an alligator's head, part of a rocket, or an elephant's trunk and then be eager to complete the picture with some more cut shapes.

To assemble their collage, students should dip a small, clean brush into a small amount of liquid starch in a jar lid or other small container and apply a small amount of the starch onto a piece of white drawing paper. They then place a piece of tissue paper on the starch-brushed area and brush a little more starch on top of it. Most of

A brush is used with liquid starch to adhere colored tissue to white paper. Black lines can be added to the collage before or after for details.

the colors of tissue paper do not "bleed" with liquid starch, but if they do, keeping the brushing to a minimum reduces this effect. More pieces of paper are applied to the collage, overlapping shapes to achieve interesting patterns and differences in light and dark. The entire background areas can be quickly covered by cutting or tearing a number of small pieces of tissue and using them to fill in around the objects in the collage in a mosaic-like manner. If the brush is wet with starch, it can be used to pick up each small piece and position it on the paper. Wrinkles in the tissue paper enhance the collage effect and provide textural interest.

When the collage is dry, the children may want to add some details with black pens. Collages can be ironed when they are dry to flatten the paper.

A variation of collage making involves having the children draw the picture first with a few strong, black, crayon lines and then covering the paper with pieces of tissue in the approximate shapes that were made with the crayon. No attempt should be made to cut the tissue shapes exactly the same as the crayon drawing. The essence of collage making is a cut-and-torn-paper appearance, along with the visual enhancement created by the overlapping of shapes.

Cut-Paper Assembled Murals

Mural making with cut paper, using an assembled technique, is highly appropriate for early childhood. Large pieces of colored banner paper or butcher paper are background material. These papers come in rolls in a number of brilliant colors. They can be cut to assemble the background areas, or they can be torn. For instance, the ground area will be lowest and may have a torn edge along the top for a horizon and be placed against a contrasting color for the sky. The space set aside for the ocean might have torn edges where it meets the sand. The jagged mountain peaks could be cut and all the pieces of paper pasted together or attached on the backside with masking tape.

The background composition should be in keeping with the children's spatial concept development. That is, if children are beginning to draw on a base line in their individual drawings, they will understand a mural background composed of a long piece

- A. Fun in final assembly of cut-paper mural is shared after children complete work on individual parts.
- B. Assembled mural from Glendale, California, utilizes kindergarten class's ideas expressed with cut paper and tempera paint and is arranged on three baselines.
- C. Bilingual mural from a Glendale, California, kindergarten class is arranged on a curved baseline, with thought given to the design of surrounding areas.

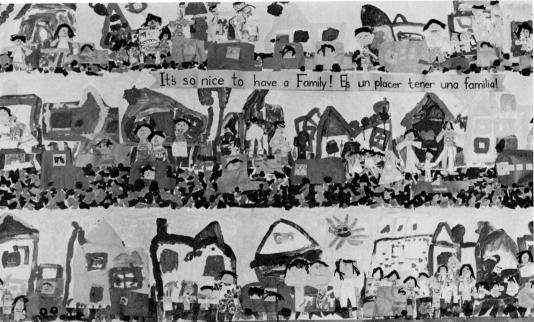

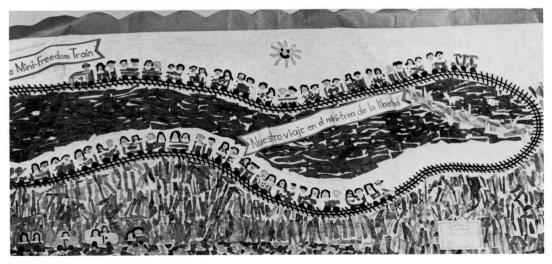

C

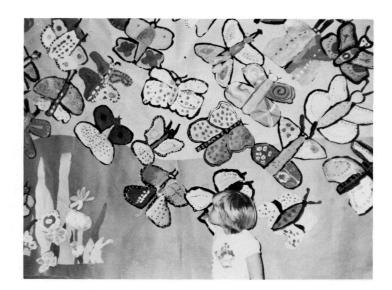

"Butterflies on the Wing" swoop upward together in this assembled mural created by first-grade children. Each butterfly was painted with tempera, cut out, and adhered to the background in the area above the painted flower garden.

of yellow paper with a strip of green paper attached to the bottom portion. The baseline concept can be expanded to form a multiple-base-line arrangement, and several colors of the banner paper can be cut or torn to serve as layers for these base lines. Base lines can be curved or bent. If the subject matter theme calls for a street, river, or road, the mixed plane and elevation concept will be understood as a spatial arrangement. That is, the street, river, or road can be depicted as if one is looking down on it, while the houses, trees, cars, and people may be perpendicular to it and seen as if viewed at eye level. A small committee of children may help the teacher in preparing the background ahead of time, deciding which areas will be sky, which will be ground, where the lake, ocean, streets, and mountains will be, and cutting and tearing the paper accordingly.

The background for the mural is then placed on a large table or on the floor so that, as the children finish items, they can place them on the mural and rearrange them until the final pasting-down occurs. For example, if the topic selected is "Our Neighborhood," children can name items that should be included, such as a grocery store, school, church, barbershop, fire station, motel, trailer park, apartment house, police officer, fire truck, radio station, trucks, cars, bicyclists, stop signs, park and play equipment, lamppost, airplane, sun, helicopter, and so on. Children then choose which items they will make, and there should be a discussion of scale. Generally speaking, the average cut-paper mural requires that the children make items about the size of their own hands. A very large building or elephant may be two hands high, and a dog may be only as large as the palm of the child's hand.

The children each make their chosen item from cut paper, preparing all details and decorations with cut paper, not pencils. They should have a choice of colors and kinds of paper. Usually, the teacher finds it useful to cut a number of small pieces of colored paper, say 6 by 9 inches and 4 by 5 inches or smaller, so that the children can conveniently make their selections. Scrap boxes of paper come in handy, too.

When the children finish, they bring their items to the prepared background and begin the assembly. The largest items are placed first, and efforts are made to have a center of interest, objects that overlap eye-leading lines, and unifying positions, with colors and shapes repeated to create a cohesive and related arrangement. Items can be moved and shifted and additional shapes made, until the class agrees on a final composition. Then the items should be adhered to the background with paste. White glue diluted with equal parts of starch creates a smooth, flat finish. Too much glue or paste applied in untily blobs makes for a messy finished mural.

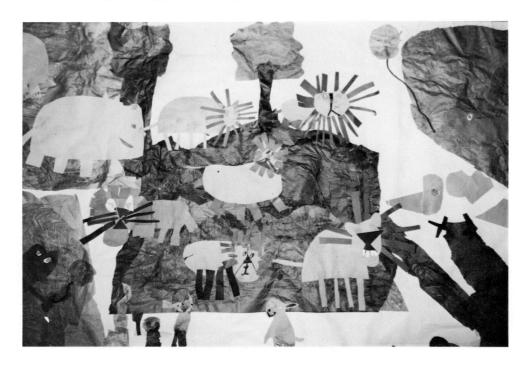

First-grade students used cut paper—construction and tissue—in creating this enormous jungle mural on a long length of white butcher paper. Different sections of the mural show groups of families of animals (lions are seen here), which lent a feeling of unity and order to the composition. Students learned about the effects of overlapping and repeating shapes.

Topics that are especially successful with cut-paper murals are those that include a large number of people, animals, plants, and objects, such as: "The Zoo," "The Circus," "Noah's Ark," "The Farm," "The Pied Piper," "Nursery Rhymes," "Fairy Tales," "On the Playground," "At the Seashore," "Dinosaurs and Dragons," "Paul Bunyan," and "The Parade."

A set of rubber alphabet stamps offers opportunities to foster language development along with the child's cut-paper skills. A cut-paper mural can be made and the rubber stamps used to print words or sentences about the objects featured.

Members of a second-grade class made cut-paper persons of themselves or a best friend doing what that person did best and then fastened them to the mural background and applied two or three stamped words. "Pat jumps rope," "Sue rides horses," "Bob hits balls," and "Jim runs," were some of the phrases that were stamped in a pleasing arrangement around the figures. The words became a part of the design, since they were combined to create an interesting arrangement.

Paper Sculpture

American sculptor Alexander Calder formed large stabiles and mobiles from flat sheets of metal. He even made an entire miniature circus of whimsical creatures. In a similar manner, sheets of paper can be cut and pasted to form three-dimensional artworks in early childhood classrooms.

While most cut-paper activities are two-dimensional and thus flat, a few basic skills can expand children's experiences into the area of making three-dimensional artworks called paper sculpture. For example: Colored construction paper can be folded, fringed, or curled by rolling it around a pencil. Small tabs can be cut onto the edge of a piece of paper, paste applied, and then the piece attached to another piece. Slots can be made and inserted into a slit in another piece of paper. A generous pie-shaped piece cut from a circle can be formed into a cone. A rectangle of paper can be rolled and taped to form a cylinder.

Fold-Over, Stand-Up Animals

A discovery-look at a number of photographs of different animals can lead into a discussion in which children describe what makes each animal look the way it does. Does a bull have a thick, powerful neck and a small head? How long are the legs of a hippo? What makes a pig look different from a lion? How many ways is a rabbit's shape different from a giraffe's? By comparing and contrasting distinguishing characteristics, students become more aware of shapes and comparative sizes and proportions. Each animal's important characteristics—the strength of a bull, the ferociousness of a lion, the graceful curves of a cat—can be exaggerated.

Students should be provided with 4½-by-6-inch colored construction paper to fold in half and lightly draw with a piece of chalk or crayon the important outside edges of the animal of their choice, with the fold serving as the animal's back. They then cut the animal out and let it stand up on its feet. They may turn the paper inside out so that the chalk or crayon lines are inside and do not show. They may then use interlocking slits to add parts and details, such as the neck and head, horns, ears, tail, and such. They can also paste on parts using the tab technique or cellophane tape. They may wish to use crayons, oil pastels, or marking pens for some of the finishing details. When students are finished, all of the animals can be placed on a tabletop for a jungle, parade, zoo, or farm scene.

Bird Masks

After students have looked at photographs of birds and examined the different shapes and sizes of heads and the different kinds of beaks, colors of feathers, sizes of eyes, topknots, crests, and so on, they will have developed some cognition of what makes one bird different from another. To make bird masks, they need to fold a 9-by-12-inch piece of colored paper in half so that they have the fold on the 9-inch side. To locate the eyes, the children should use chalk to draw a small circle near the upper portion, about an inch in from the fold, on each side. The circles should be about as large as their own eyes. They should then use a piece of chalk or crayon to draw the beak, with its point at the bottom of the fold and continuing upward toward the eye and then outward to the edges of the paper. On the unfolded side, opposite the fold, they should leave an inch or two for tabs to attach yarn to with tape. This leaves about 8 or 9 inches for the mask across the eyeline when the mask is unfolded. Now, leaving the paper folded, the children should cut out the mask, unfold it, and then cut out the eye shapes. They can then make decorations by overlapping pieces of colored paper cut in feather shapes, curling strips to project and dangle, making fringe, and so on. They can also use crayons, oil pastels, or marking pens to add patterns and details. When the masks are finished, yarn is attached to the sides with tape. The students can wear the masks for creative movement activities—swooping, flying, gliding—as birds would do.

Cylinder Sculpture

By rolling a 9-by-4½-inch piece of colored construction paper into a short cylinder and securing it with cellophane tape, children can make all sorts of three-dimensional faces of people or animals. They can also use the cylinder as a base for a figure. They can attach noses that project, fringed eyelashes, ears that stand up or out, hats, curled hair, moustaches, beards, and so on.

Hidden Homes

After discussing with the children how some animals make their homes inside hollow trees and how some sleep inside caves, the teacher can show the children a variety of photographs of these creatures. This activity integrates science with art. The children become more aware of hibernating animals and how they sleep for long periods in safe, warm places. They come to know that some birds and small animals build their nests and homes and find security and safety inside knotholes and hollow trees.

Homes in Caves

An 8-by-12-inch piece of colored construction paper can be used horizontally for the cave front. The children should tear out an opening and then, on the sides of the opening, draw rocks, vines, shrubs, flowers, and trees. This paper should be centered over the backing (a 9-by-12-inch piece of colored paper) and the cave opening traced on the backing with a pencil. The front piece can now be set aside. Cave dwellers, such as bears, lions, and wolves, can be cut from small pieces of paper. It is easier if the students cut out the individual parts of an animal separately (head, body, legs, tail) and then paste the parts together. Paper tabs folded on the back of the animal make the animal stand out from the background. More animals, rocks, trees, and so on can be added to the backing. Details can be drawn with marking pens. To complete the stand-up cave sculpture, the cave front should be stapled to the backing on the right and left sides, making the backing slightly bowed so that it stands up on its own.

Homes in Tree Trunks

The children should hold an 8-by-12-inch piece of manila paper over a rough surface and rub the side of a crayon over it to create a bark-like texture. Now the paper is folded in half, and a knothole is made by tearing out a semicircle on the folded edge. If the shape isn't torn out entirely, there can be a flap that can be opened and closed at will. The knothole opening should then be lightly traced onto the backing paper (a 9-by-12-inch piece of construction paper). Inside the marked space, the children can draw a nest of birds, an owl, a squirrel eating acorns, or chipmunks. With crayons, oil pastels, or marking pens, they can add insects and dangling spiders. Then the right and left sides of both papers are stapled together, with the front piece serving as the simulated tree bark and the backing piece bowed slightly. All of the children's sections of tree trunks can be stood up for a show of "Hidden Homes in Tree Trunks."

For Discussion

- 1. Create your own torn-paper still life. Make notations of appropriate terms to be introduced and questions to reinforce concepts about the elements and principles of art.
- 2. Compare your torn-paper still life to the painted still life by Picasso and the cut-paper design by Matisse in the "Color Gallery" to find similarities and differences.
- 3. Display and discuss several torn-paper still-life compositions. Consider the model for art criticism in chapter 2 and formulate appropriate questions.
- 4. What motivational topics are particularly suited for cut- and torn-paper art activities that incorporate texture and/or three-dimensional elements?
- 5. In addition to motor skills, what are two other skills that would be developed by involving young learners in mural making? What are possible connections to other subject areas in a mural-making project?

Printmaking 10

"Great art picks up where nature ends."

MARC CHAGALL

The first printmakers probably were early cave dwellers who found that the shape of a hand could be made on the stone walls of their domiciles. One of these ancient human beings placed his or her hand on the cave wall and then blew around it through a hollow reed with dry, powdered pigment that had been ground from earth. When the hand was removed, its shape remained, and so began the art of making stencils, a simple form of printmaking. Most children have had the pleasure of pressing a finger on a stamp pad, making a fingerprint, and if given a magnifying glass, examining the curving and swirling lines that they saw in the print.

Woodcuts or woodblock printing is one of the oldest ways of making prints, the first ones probably being made by the Chinese in the eighth century. The craft spread from China to Korea and Japan, where woodcut prints became a very important art form, with prints showing people engaged in many of life's activities. Although no woodcut prints dated earlier than the beginning of the fifteenth century exist today, it is believed that the technique was used before then for royal stamps and textile printing.

Intaglio—a type of printmaking that includes etching, engravings, and dry-point—originated in the Middle Ages, when rubbings and prints were made from incised designs on shields and armor. Medieval artisans recorded their designs in a process that later evolved into an art form. Today, the object used to transfer an image is called a "block" or "plate," even in cases when neither wood nor metal are being used. This carryover of terminology reflects the history and traditions of printmaking, which has existed in many cultures both as a means of producing fine art and as a way to embellish clothing and objects in the environment.

After the modern printing press with its movable type was invented in the fifteenth century, woodcuts became the method used to reproduce drawings for printed books. Such artists as Albrecht Dürer (1471–1528) designed many woodcut prints and left the actual cutting of them to a craftsman. Then, in the sixteenth century, metal engraving and etching became the important printmaking techniques in Europe, and for the next several hundred years, woodcut prints were not very popular. In the middle of the nineteenth century, printers of beautiful books began to use woodcut prints again for illustrations. During this time, Japanese prints found their way to Europe and influenced the art production of a number of artists—Degas, van Gogh, Cassatt, and others. In the twentieth century, there has been a great deal of interest in woodcut prints. Prints made of several colors require that a different wood block be carved for each one.

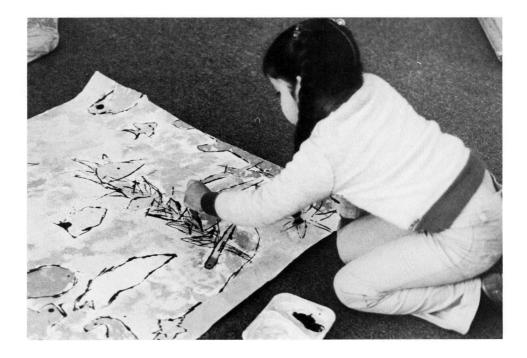

A student puts the finishing touches on a group mural. After studying fish, students cut fish shapes out of tagboard, painted them, and printed the fish on a large piece of butcher paper. "Sand" and "water" were printed with pieces of sponge dipped in tempera. Detail lines were added with pieces of cardboard, whose edges were dipped in dark-colored paint.

A brayer is used to roll ink evenly over the block or plate as the student prepares to pull a print.

Other printing processes used by artists today include: engraving and etchings, which involve the scratching of fine lines into a sheet of metal, usually copper; lithography, by which images are made with wax or a greasy material on a flat piece of limestone and then processed before being covered with ink and a print made; lino prints, which are similar to woodcuts but softer and easier to carve; silk-screen prints, whereby a stenciled image on a stretched sheet of silk impedes ink from going through the silk when a squeegee rubs ink across it.

Printmaking is filled with surprises and suspense. One is never quite sure what the finished product will look like until the magic moment when the block is pressed or stamped on the paper. Children are intrigued with the step-by-step process leading up to the moment when their prints are completed. Equally fascinating is the rhythmical element inherent in repeating a single design many times to make allover patterns, as is sometimes done with gadget printing, potato printing, and other small relief prints.

A relief print is the result of applying ink or paint to a raised surface and then pressing that surface onto paper. Relief printmaking involves three steps, the first of which is the making of the relief image, whether it is cut on a potato, made from insulation tape, or pressed onto a meat tray. Second, this block or plate is inked with a brayer, pressed on a pad saturated with paint or ink, or brushed with paint. Third, the image is pressed onto a piece of paper.

Relief prints can be printed on all sorts of paper, white or colored. If printing ink is used, it is best to use paper other than construction paper, due to construction paper's high absorbency. Such papers as Fadeless paper (available from art-supply sources) or Astrobright or Brighthue papers (available from printing-supply sources) are recommended. Using colored, water-soluble ink, as well as black ink, opens the door to a variety of printed effects. A white print on dark paper creates a very different effect than does one printed in black on light paper.

A print can be made singly and mounted or matted for display, or it can be repeated a number of times to create a patterned effect. Children can each make a print of an insect, car, or house, for instance, from their own blocks, and then all the children can print theirs as a group on a large piece of butcher paper to create a mural. Suitable topics for mural-making themes include:

- 1. Insects and flowers in a garden
- 2. Cars and trucks on a highway
- 3. Groups of animals in a jungle, zoo, or farm
- 4. Mermaids and sea life
- 5. Astronauts and spaceships
- 6. Rows of houses and stores

Other group projects involving printmaking include printing calendar illustrations, notepaper, greeting cards, and program covers. Allover patterns resulting from printmaking can be used for covering boxes and tin cans and for notebook covers, bookbinding, and wrapping paper.

Throughout the year, children should make all kinds of prints. Each time, they will be intrigued with the surprise that awaits them in the viewing of the final product and will discover that the design possibilities in printmaking are unlimited.

Potato Prints

Potato prints provide several ways to begin exploring printmaking. The oval or round shape created when a potato is cut in half can be used "as is" by the youngest child. Teachers should use a large, sharp knife when halving the potatoes to obtain a very flat, evenly cut surface. After the cut half has been placed on paper toweling for a few minutes to absorb moisture, it is pressed onto a paint-saturated pad. Then a potato print is made by pressing the cut half onto paper.

A suitable pad can be made with six layers of paper towels, which are moistened with water and placed on a paper plate. Then about a teaspoon of liquid tempera is poured on the center of the pad and brushed evenly over an area about the size of the potato. Each time students make a print, they need to press the potato onto the pad. More paint will need to be added occasionally. Children may either repeat the potato

A and B. The oval shape of a potato print was impetus for these family portrait drawings, done with oil pastels. The final step was brushing thinned tempera wash on the background.

shape a number of times randomly to create an irregular pattern or in rows to make an orderly, regular, overall pattern. When the paint is dry, the children may use another color of paint and stamp additional shapes on top of the first ones.

R

Instead of using a paint-saturated stamp pad, students can apply tempera to the cut surface of the potato with a brush. They will need to apply more paint with the brush each time they make a print.

An alternative medium for potato prints is watercolors. A few drops of water on each color in the watercolor tray softens the pigments and makes them easier to use. Then the surface of the potato is brushed with the watercolors before making the print. Since watercolors are transparent, as opposed to the opaqueness of tempera, stamping several different colors of watercolors on top of each other (after the color underneath is dry) creates an interesting overlapping effect.

The children can also print several potato shapes and, after the shapes dry, let their shapes suggest forms for them to use in drawing the rest of the picture; for example, the shapes may be heads of people. The children then draw the bodies with crayons, oil pastels, or marking pens. Or the shapes might be wheels on a car, centers for flowers, or the bodies of birds or insects.

After students have mastered the printing process with potatoes, they can use a paper clip to carve out a design from the flat, cut surface of the potato half. A few gouges, lines, and simple shapes can result in a pleasing design. Design possibilities are further extended by trimming the sides of the potato half to create a square, triangle, rectangle, or other geometric shape. A few gouges with the paper clip can transform the shape into a design motif or a more realistic form, such as a little house, boat, or spaceship.

Felt Prints

Scraps of felt also can be used in creating the relief block for printing. Older children will want to plan their design first by making sketches. Younger children who are still having problems controlling their scissors can use precut felt shapes or scraps left from other projects.

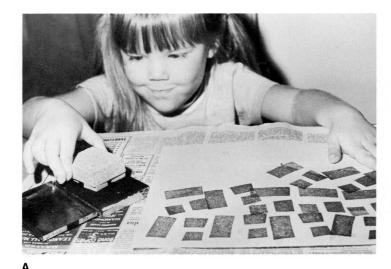

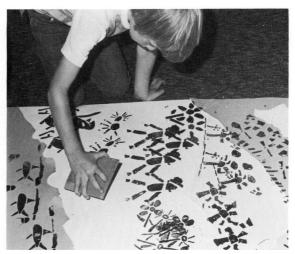

R

The felt pieces are arranged and glued to a piece of cardboard. The design could also be made from pieces of inner tube, although this material may not be readily available. Sturdy, sharp scissors are necessary for cutting either material.

Once the glued pieces have dried, ink can be rolled on the surface with a brayer, paper placed on top, and the back of the paper rubbed gently with the fingertips.

Clay Prints

Either plasticine or water-based clay can be used to make a print. A chunk of moist clay is flattened on one side by hitting it against a flat desktop. A design is then carved out, using a pencil point, plastic forks and knives, large nails, or the edge of a piece of cardboard. The decorated side can either be painted or pressed into a paint pad (as described earlier) and then printed.

Insulation Tape Prints

Rolls of dense insulation tape with peel-off paper on the adhesive side are available at hardware stores. This product is about a quarter of an inch thick and is easily cut with a scissors. Small design motifs can be created by adhering small, cut pieces to a small block of wood or a piece of corrugated cardboard. The interest span of the very youngest child can be maintained since the entire process takes but a few minutes.

Office stamp pads should be liberally covered with stamp-pad ink. A stamp pad in each color—black, red, blue, green, and purple—provides children with a wider range of design possibilities. Children press their block with the design on it onto the stamp pad and then onto their piece of paper. They can relate the process to the prints their fingers make when they press them on a stamp pad and to the prints their shoes make in the snow or the pattern a car tire leaves in the mud. By repeating their motif over and over, they begin to understand the meaning of the terms repeat print, rhythm, and allover pattern. A very simple design made with only a few bits of tape takes on a new importance and assumes interesting relationships when it is repeated very close together a number of times, especially if a second design on another block is used alternately with a second color of ink.

- A. A child presses a block onto a well-inked office stamp pad each time before printing on paper.
- B. Flocks of birds, schools of fish, crowds of people, and herds of animals are achieved by each child printing his or her design a number of times on a multicolored paper background. Each child attaches pieces of insulation tape to a piece of corrugated cardboard to make his or her design.

Scratchfoam Prints

Making a print with Scratchfoam (available from art-supply catalogs) or a clean meat tray is an easy task for young children, and one that they will want to repeat a number of times, trying out new images and forms as their concepts expand.

Scratchfoam comes in 9-by-12-inch sheets, twelve to a package, and each sheet should be cut in quarters. If meat trays are used instead, their curved sides should be trimmed on a paper cutter beforehand.

Children should first be given a pencil and a piece of paper the same size as the Scratchfoam to work out their ideas for their prints. Then the paper should be taped to the Scratchfoam and the lines of the drawing gone over again with the pencil. Students need to press down rather firmly with the pencil so that an imprint is made in the Scratchfoam. They can then remove the paper and go over the lines again on the Scratchfoam. If the lines are not deep enough, they will fill with ink and not print properly. All areas left standing print the color of the ink used. All the lines and shapes that are pushed down show up as the color of the paper upon which the plate is printed.

Children should be encouraged to achieve a balance of light and dark areas and to be innovative with their pencils in creating dots, close-together lines, and patterned areas, as well as thin lines, wide lines, and large and small shapes. The inclusion of letters and words should be discouraged unless the student understands that it is necessary to draw them on the Scratchfoam in reverse since they print backwards.

After the students have completed their Scratchfoam drawings, the drawings are ready to be inked and printed. Black or colored water-soluble inks can be rolled with a brayer onto a baking sheet or plastic tray. Then the child should use the brayer to cover the Scratchfoam with ink. A piece of typing paper, Fadeless paper, or colored Astrobright paper cut a little larger than the Scratchfoam should be placed carefully on top of it and gentle pressure applied with the fingers to assure an even printing. The paper is then pulled off the Scratchfoam, and the finished print is left to dry before being matted for display. Construction paper is too absorbent for use with printing ink.

Any number of prints can be made from the Scratchfoam; however, the Scratchfoam will need to be re-inked each time it is printed. Children are interested in seeing the different effects they can create by changing the color of the ink as well as the color of the paper upon which their prints are made. An unusual effect is created if a piece of paper of another color is cut and pasted onto the background paper before making the print. For instance, a strip of green paper could be pasted onto the lower portion of a print in which grass is important, or a circle of yellow could be placed in the area where the sun will appear in the print.

Carbon-Paper Prints

Used or inexpensive carbon paper can be used for a printmaking experience for young children. The print that results is black and silhouette-like. To begin, the children cut out shapes from the carbon paper and arrange the shapes, carbon side down, to make a simple picture on top of a piece of typing paper. Shapes may overlap. Then another piece of paper is placed on top of the carbon paper and ironed. When the carbon paper is removed, the shapes from the cutout carbon paper will have transferred to the bottom paper. (Hint: School districts often throw away large quantities of computer carbon paper used for making multiple copies of attendance sheets.)

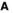

C

В

E

- A. A kindergarten child rolls water-base ink on his meat tray with a brayer. The paper is carefully placed on top of the tray and rubbed with the fingers to assure an even printing.
- B. The paper is pulled off the meat tray, and the print appears.
- C, D, and E. Since they are mostly linear, these prints strongly appeal to the very young child. They offer avenues for the development of his or her conceptual symbols.

Card Prints

If young children have had enough experience in cutting paper, they will have developed the skills needed to put together a card print. The children should use a 5-by-8-inch file card for the background and another file card, piece of tagboard, or discarded manila folder from which to cut their designs. Parts of an animal, such as the ears, wings, legs, and such, can be cut separately and glued down on top of other pieces. The edges of the cutout shapes create a white outline on the finished print. When all the parts of the picture have been cut, the child may wish to rearrange them a bit, add other shapes, or alter some of them. The printing ink is rolled onto the brayer from the inked tray or sheet, and the image is given a good coating of ink before printing it on white paper or colored Astrobright paper.

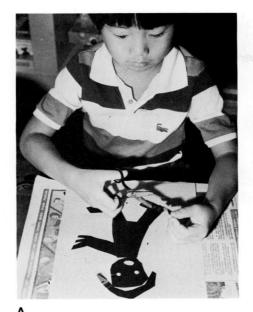

and placed, carbon side down, on a piece of plain paper. A second piece of paper is placed on top and quickly ironed to make the carbon-paper design transfer to the bottom sheet. Carbonpaper shapes are then lifted off and discarded.

A and B. Carbon paper is cut

В

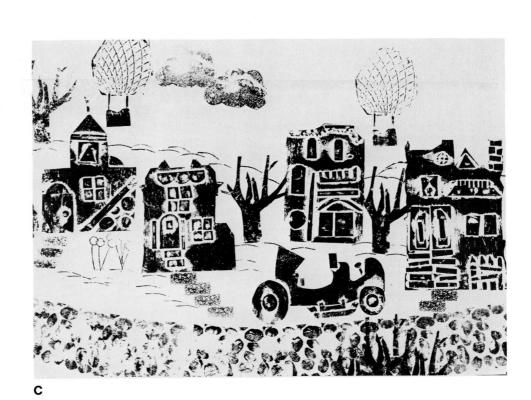

C. Each child made a house, tree, or car for this "card print" mural. Pieces are printed separately, several times, on a long piece of butcher paper. A piece of waxed paper covers the inked card to keep the background and fingers clean while the print is being pressed and carefully rubbed on its backside.

Printing with Cardboard Strips

A variety of short lengths of cardboard strips (2, 3, and 4 inches) should be cut on the paper cutter beforehand from thick mat board and corrugated cardboard. A moist piece of sheet sponge (or several thicknesses of paper towels) should be placed in a paper plate and tempera poured down its middle length. Then the edge of a cardboard strip is first pressed into the paint and then onto a piece of construction paper to make a printed line. The student can repeatedly press the strip into the paint and then onto the paper to make lines to form figures, objects, and designs. Black paint on white or colored paper is suitable, as is white or light-colored paint on black or colored paper. When the paint dries, the student can add some color with oil pastels.

A variation on this printing technique is to cut some simple shapes—circles, squares, and such—from colored paper. One or two of these can be pasted onto the background paper before the printing is done with the cardboard strips.

Eraser Prints

Small erasers are suitable for children to use in making repeated patterns. They can be pressed repeatedly onto office stamp pads of several colors and pressed onto paper. Art gum erasers are so soft that children can carve a design easily with an unbent paper clip or their fingernails. The art gum eraser can then be pressed onto the stamp pad and printed on the paper in a random or regular, repeated manner. If two or three such erasers and colored stamp pads are available, students can put math patterning strategies to work by making simple patterning configurations, such as two red prints and then one black print in row after row of motifs.

Gadget Prints and Paper Shapes

As a starting point and focus for this art task, the children need an assortment of circles, squares, rectangles, and long strips of colored paper. From these, they may choose one or more to glue down to a piece of paper.

A long strip of paper may suggest the stem of a flower to one child or a tree trunk to another. A rectangular piece might connote the shape of a car, airplane, or wagon, the torso of a person, or the body of an animal or bird. A circle might help the children

- A. Cutting and designing skills, as well as the know-how of printing, are involved when young children make card prints.
- B. Dark and light contrast sharply in card prints. The elephant and lion print was made by a five-year-old child.

Printing with the edges of cardboard strips provides opportunities for students to experiment with line. In this lesson, gray paper forms the background for black and white lines

to focus on a plant design, a ladybug, a wheel, a clown's head, a turtle, or a beaming sun face. Whatever the precut geometric shapes suggest is then ready to be enhanced and embellished and made more complete with simple gadget prints.

Small blocks and sticks of wood, corks, erasers, jar lids, and edges of cardboard strips are easy-to-handle shapes that offer endless possibilities in design. The children should gently press them on a paper-towel pad that is soaked with tempera each time before making a neat print on their paper. Children are eager to repeat and combine these in all sorts of configurations relative to the colored paper shapes.

Monoprints

When artists enter their original prints for a show, many times the rules indicate that they cannot enter a monoprint (a print that can only be made one time). Some people, therefore, do not consider a monoprint a "true" print. Actually, most monoprint techniques are closer to drawing or painting than printmaking, but the ability to pass pigment from one surface to another is a major element of printmaking, and in this respect, the monoprint qualifies.

Transfer Print

A simple monoprint can be made by painting a picture or design on a piece of paper and pressing another piece of paper on top while the paint is still wet. A design made in finger paints can be transferred by pressing another piece of paper on top of the wet original. Sometimes, the picture or design is made in finger paints that have been applied evenly to a cookie sheet. After using fists, fingers, and palms to create a design so that the shiny surface of the pan shows through, the student lays a sheet of newsprint paper on the surface of the paint and smooths the back of the paper with clean palms. The design is transferred to the paper, and the finger paints can be smoothed out to make another design.

Carbon-Paper Print

Another procedure for creating a monoprint requires carbon paper. After a picture or design has been drawn on paper with colored chalk, carbon paper is placed facedown on the chalked surface. Rubbing a hand over the back of the carbon paper results in the chalk being transferred to the dark, shiny surface. Spraying with fixative or clear spray is necessary to keep the print from smearing. (Carbon paper can be obtained from most computer services departments of school districts, since multiple copies are printed using computer paper with carbons. It is, of course, advisable to try a sample piece of carbon to be sure the carbon releases before doing either this activity or the carbon-paper prints described earlier in the chapter with the children.)

Tempera Print

A similar technique can be used to make a tempera print. Once a chalk design or drawing has been completed (the chalk must be applied heavily), another piece of paper is coated evenly with white tempera paint. While the tempera is still wet, the chalk drawing is placed facedown in the paint. The child rubs the back of the paper with fingers and hand and separates the two papers before they dry. Two pictures result—the chalk will have merged with the paint on one paper and some chalk will be left on the original drawing. Although there are two pictures, only one is a print. As in other printing processes, the design on the print is reversed or backwards from the original. For this reason, as mentioned earlier, children should be discouraged from using letters or numbers in their artwork.

For Discussion

- 1. How are the tools and techniques of printmaking different from other art forms? What skills are developed in young learners through exploration of printmaking?
- 2. Printmaking provides a means for making multiple images. Discuss Andy Warhol's set of self-portraits in the "Color Gallery." How do they reflect theme and variation through the serigraphs (silk-screen prints)?
- 3. What are "relief prints," and how are they appropriate as an art form for the young learner? How do relief prints differ from monoprints?
- 4. Develop themes for art projects involving printmaking. Share and compile lists with others.
- 5. Discuss printmaking from the viewpoint of repetition, pattern, and rhythm. How can these concepts be introduced into lessons for the young learner?

11 Modeling, Shaping, and Constructing

"I paint with shapes."

ALEXANDER CALDER

On suspended sculpture that move with air—"mobiles" as Marcel Ducamp called them in 1932 (Saturday Evening Post 28 Mar 85)

Sculpture and architecture have mass and volume and take up three-dimensional space. They have both played important parts in people's lives for thousands of years.

Prehistoric people believed that a carved object that looked like a person or animal must have special powers, and the earliest pieces of sculpture were probably made to help hunters. Later sculptures were made to represent gods. Ancient kings had their likenesses carved, probably in the hopes of making themselves immortal. Early Christians had sculptures of saints as well as demons and devils in their churches to remind the people of the presence of good and evil, since may churchgoers could not read or write.

Enormous fountains with sculptures are found in many modern cities. Sculpture monuments are crafted to pay tribute to heroes and famous people and to commemorate events. Many pieces of sculpture exist to be enjoyed for themselves, for the beauty of their forms, and for the colors and textures on their surfaces. Modigliani carved limestone to create his elongated, expressive *Head of a Woman* (see the "Color Gallery"). Henry Moore's *Reclining Figure* (also in the "Color Gallery") is carved from elm and by its curves and undulating forms creates an interplay of positive and negative shapes.

In relief sculpture, images are set against a flat background. Coins and friezes on buildings are examples of low relief or bas-relief. Freestanding sculpture in the round may be large or small. Sculptors work in many different media. Sculpture modeled with clay, wax, or other soft, pliable material is called additive sculpture. Clay pieces can be fired in a kiln later, or modeled pieces can be cast in metal or plaster. Carved sculpture, usually made from a block of wood or stone, is called subtractive sculpture. In carved sculpture, the artist removes pieces from the block with a knife or chisel until the desired form is achieved. With assembled, joined, and constructed sculpture, the artist joins pieces of metal, wood, plastic, or even stuffed fabric forms to make a configuration. This type of sculpture was not widely practiced until the twentieth century.

Architecture has to do with buildings, and unlike sculpture, it is an art form that has a practical, functional basis: Each building serves as a place where we find shelter or where we work, play, study, meet, or worship. Different periods in history are marked by different architectural styles that were suited for the way of life of the people who

used the buildings. Architects designing buildings have always been challenged and limited by the materials and engineering techniques available. To be a successful work of art, a building must fulfill practical requirements and be satisfying to look at.

A Child's Three-Dimensional World

The child's world of living, moving, and playing is largely in space; that is, it is three-dimensional. Consequently, the task of modeling, shaping, and constructing visual images is a natural channel through which the child's concepts of form become richer, more detailed, and interrelated. If only painting and drawing activities are experienced, the child learns only to deal with the illusion of three-dimensional space on a two-dimensional surface, translating roundness, depth, spatial relations, and texture into the limitations a flat plane. This is a complicated and advanced task. Children's conceptual base of information related to three-dimensional forms can effectively be developed and dealt with by actually using three-dimensional materials.

Students in a second/thirdgrade combination class had a robot parade after constructing unique robots from objects found at home.

A. Ceramic animals and people from folk cultures demonstrate construction techniques of slab, coil, pinch pot, and texturing.

B. Replica of 4,000-year-old Egyptian ceramic hippo gives children tactile as well as visual experiences in their first step on the road to aesthetic awareness.

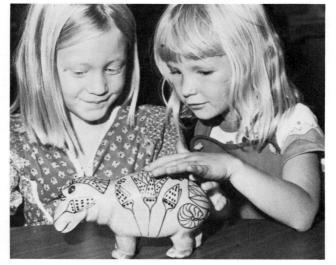

All children, and especially those who do not as readily express their ideas with paint or crayons, can derive pleasure and valuable experience from manipulation of three-dimensional materials. With an emphasis on inventive use of materials, the teacher can develop children's skills in making puppets, masks, animals, and sculpture. By alternating experiences between two- and three-dimensional materials, the teacher enriches children's experiences in each, and related concepts are made evident.

To construct means to combine materials in a three-dimensional way. The objects structured may or may not be realistic, but they should be joined in such a way that they are stable and hold together. The pieces can stand on the floor or hang from the ceiling or on the wall.

Children can work with many construction materials and find them challenging and interesting. They can learn to tape and glue. Preschoolers and kindergartners can learn to pound nails and saw small pieces of wood. Children can discover for themselves that such familiar objects as newspapers, boxes, tape, paste, wood scraps, and paint can be manipulated and combined to create all manner of three-dimensional objects. They need only a minimum of assistance in their work and often enjoy collaborating in pairs so that one child can hold while the other child tapes or glues.

Young children need to review their three-dimensional concepts many times, as their perceptions and knowledge increase and unfold with repeated experiences. The ease and appeal of modeling and constructing activities route their discoveries toward success-bound avenues.

When children manipulate a pliable modeling medium, they are able to feel the roundness, the depth, the overall wholeness of a figure, head, or animal, and through this tactile intake, they can refine, better understand, and communicate their knowledge of physical forms. Their continually increasing knowledge of three-dimensional forms intermingles with their two-dimensional drawing skills to prevent rigid fixations of stereotyped schemas.

Preschool and kindergarten children spend a good deal of time manipulating any modeling material they are given. They enjoy pounding, rolling, squeezing, making coils and balls, and imprinting objects into soft modeling materials. They should not be pushed into making recognizable objects until they are ready to do so naturally. However, if they have many opportunities to play with the clay and other modeling materials, their growth will proceed rapidly, and representative symbols will begin to emerge. When children are ready to make use of some actual techniques, the teacher can show them, for instance, how to moisten two bits of clay to make them stick together, how to roll out and cut pieces with a dull, plastic knife or tongue depressor, and how to make textures.

First graders and older children enjoy the challenge of a specific motivation or topic after they have passed through the earlier experimental stage of manipulating a modeling material. They can work creatively within a given framework and benefit from new areas of exploration and expanded ideas.

Constructing with Clay

Two kinds of clay are commonly used in schools—the water-base kind that hardens and is usually fired in a kiln and the oil-base variety that is reusable and never dries out. The oil-base type is called plasticine and can be used over and over again. The objects made with plasticine are generally tossed back into a container and are not kept by the children. However, plasticine's even consistency makes it a good material for manipulation, for children to learn some basic skills in modeling and forming.

Large, brown, paper bags or pieces of canvas or denim make excellent reusable work surfaces for clay. Newspapers should not be used since the oil from the ink may be worked into the surface of the clay, and the moisture of the clay makes the paper tear and get mixed into the clay body.

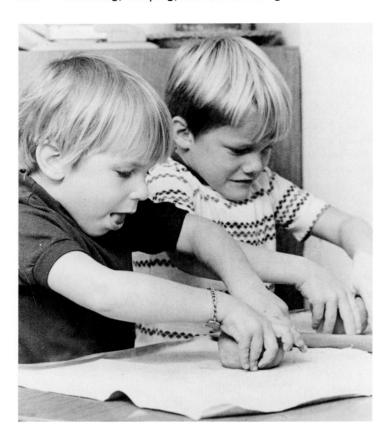

Students concentrate on forming clay into pinch pots, which will then be shaped into animals. Appendages will be attached in this additive sculpture lesson.

Very small children spend some time pounding, pinching, mashing, and rolling clay. The teacher should demonstrate the two ways of rolling a small ball of clay about the size of a lemon: One is by rolling a lump of clay between the palms, and the other is by rolling the clay between one palm and a tabletop.

Another introductory activity in manipulating clay is making a coil. Like the ball, it can be formed by rolling a lump of clay on a surface with the palm. Once the coil starts to lengthen, the palms of both hands can be used. Young children are often quite content to roll coils of clay for no particular purpose other than gaining the confident feeling of mastery.

The third technique to learn is rolling clay out to make a slab. Doweling that is 1½ to 2 inches in diameter and cut into 1-foot lengths can be used as rolling pins. Again, the flat of the hand is used to roll the doweling over the clay until it is the desired thickness. Once children can make a slab, it is easy for them to use a tongue depressor or plastic knife to cut the slab into pieces to make wind chimes, to fold the slab over and press the edges to make a pocket for dried flowers, or to square the slab off to make a tile.

To add texture, the clay can be rolled between pieces of burlap, a weed or pieces of rice can be rolled into the surface, or objects like wire whisks or forks can be stamped into the clay while it is soft.

Once a child has progressed to this stage of clay manipulation, the pinch pot is the next technique to be learned since it forms the basis of other techniques and activities. The teacher can demonstrate how to make a small pinch pot by holding a

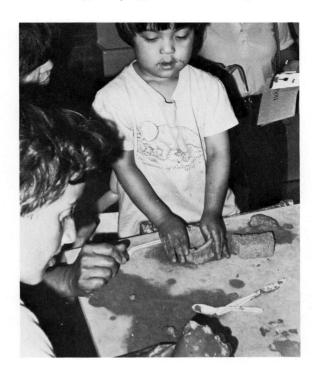

Squeezing, pinching, manipulating clay—young children need frequent opportunities for coordinating muscular activities and perception.

rounded ball of clay in one hand and inserting the thumb of the other hand into the center. As the ball is pinched and rotated, it slowly becomes rounded and hollow like a small pot. Care needs to be taken to make the sides an even thickness. The pinch pot can actually be left as a small pot or vase, or additional parts can be added, such as a handle or little legs.

When pieces of clay are joined, problems may occur. Frequently, children merely press pieces together, and this results in the parts separating. Although many ceramics books recommend scoring and brushing with "slip" (a solution of water and clay about the consistency of very thick cream), this is not always necessary when young children are learning how to work with clay. An old toothbrush dipped into water and rubbed on an area of the clay provides moisture and a roughened surface; when two surfaces are treated in this way and joined together firmly, the resulting juncture keeps the pieces together through handling and firing.

Two pinch pots, with edges roughened and joined, form a hollow ball. The round shape can be preserved by placing a piece of crumpled newspaper inside before the two halves are put together. Anything combustible added to the clay, such as newspaper, rice, or dried weeds, will end up as a few ashes after the firing. A word of caution: A pencil or some other object must be used to make a hole in the side of the hollow ball created by two pinch pots. The air pressure both inside and outside the ball must be the same, or the clay will explode in the kiln. A good "rule of thumb" is that anything bigger in diameter than an adult thumb should be hollowed out (a pencil can be inserted to make a hole in an extraordinarily thick coil, for example); anything hollowed out must have an escape path to allow for the free flow of air.

A hollow ball created by the joining of two pinch pots can be made into a person, an animal, a monster, or an imaginary creature. Legs, beaks, tentacles, wings, horns, heads, and other appendages can be added, using the toothbrush technique. "Hair"

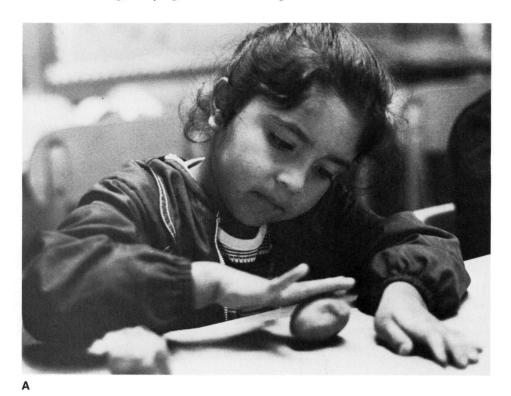

A, B, and C. Two pieces of clay are rolled into balls, flattened, and stamped with fired clay stamps. A weed or flower holder is formed when the two pieces are joined.

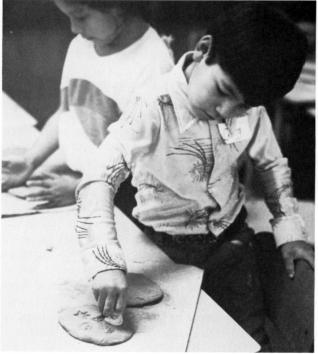

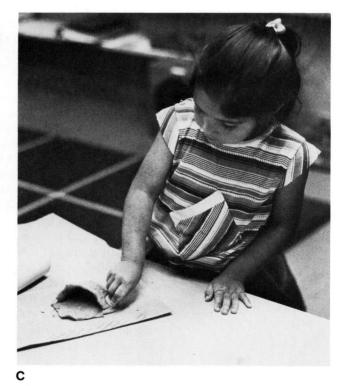

В

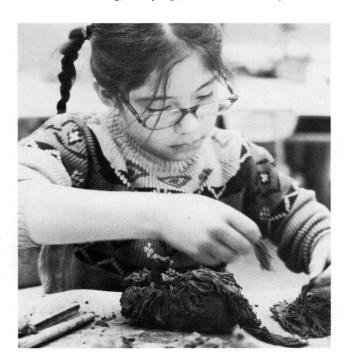

This second-grade student is adding "fur" or "hair" that has been made with a garlic press. A toothbrush dipped in water roughens the surface so that the clay pieces can be securely attached.

can be made by forcing bits of clay through a garlic press; texture can be added by imprinting with a variety of tools, such as old combs, forks, nails, scissors, patches of burlap, or wire screening.

Clay construction also includes making objects by a combination of techniques—joining slabs, winding coils into shapes, and adding coils to slabs or to pinch pots. The possibilities are limited only by the child's imagination and skills.

To explore the possibilities of modeling a figure, children can look at photographs of sculpture by the British artist Henry Moore (see the "Color Gallery"). He was famous for making seated and reclining figures that remind us both of ancient Aztec sculptures and smoothly weathered wood and stones.

To make a figure, children should roll out a thick cylinder of clay that is about 6 or 7 inches long. Then, using a plastic knife or tongue depressor, they should make a vertical cut about 2 inches or so on one end to separate the legs. A neck and head can be squeezed from the other end. Two smaller cylinders are then rolled out to serve as arms and are attached to the shoulders. A tongue depressor or finger can be used to make a smooth join. The figure can now be bent and shaped into the position of choice: kneeling, sitting, bending, reclining. The elbows, knees, and waist can be bent as needed. The head can be bent to one side and some feet and arms pinched out. When the pose of the figure is satisfactory, the surface of the clay should be smoothed evenly with a finger or the tip of a tongue depressor and allowed to dry.

Clay pieces should be allowed to dry slowly. If the atmosphere is too hot and dry, they may crack. Plastic bags or milk cartons with one end removed can be placed over drying clay pieces to slow down the process. Dampened paper towels are sometimes needed in very dry conditions.

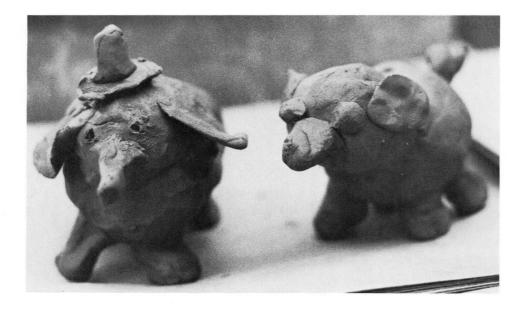

Two clay animals made from pinch pots by kindergarten students are ready to be fired. Holes have been poked into the hollow balls to let the steam escape and to prevent the pieces from exploding in the kiln.

Dry clay pieces are called greenware. As greenware, the pieces are very fragile. Once the pieces have been fired in a kiln, they are referred to as bisque and are much sturdier. After the bisque firing, a ceramic glaze can be applied. Glaze is a solution that looks drab; it is usually difficult to convince children that the glaze will turn into a bright, interesting color once the piece is fired again. Sample disks that have been painted with glaze and fired are useful in demonstrating what colors are available. Once the glaze has been painted on, the bisqueware needs to be fired again. Alternate finishes that do not require a second firing include:

- 1. Staining the bisque piece with thinned-down tempera—white or a color—and quickly rinsing off the excess paint until the desired "stained" effect is achieved. The colors are seen in the lower parts of the surface and create a pleasing effect.
- 2. Painting the bisque piece with acrylics or tempera.
- 3. Leaving the bisque piece its natural color but covering it with a clear matte or shiny acrylic spray.
- 4. Brushing a clear glaze called Joli (available from art stores) over the stained, painted, or natural bisque surface. This "glaze" does not require another firing and is similar in appearance to clear nail polish. It dries very quickly.

Recipes for Additional Modeling Media

Three additional types of media for modeling and construction activities all make satisfying finished projects:

- 1. Salt ceramic
- 2. Baker's clay
- 3. Food forms—candy clay, bread, and fruit and vegetables

All are easy to use in the classroom and only require materials purchased from the grocery store.

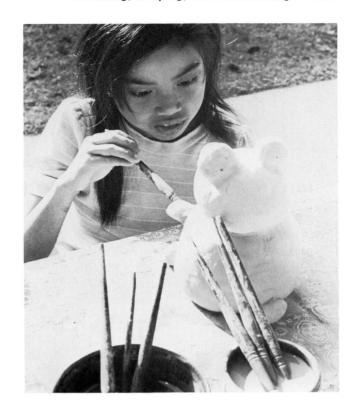

Glaze is being brushed on this bisque-fired animal. The bowls in the foreground have been glazed and fired to show the actual color of the glazes they each contain.

Α

A. Bread-dough doll from Ecuador is delicate, with much colorful detailing. Such examples are made with materials similar to those children use, and children are fascinated when they see work from a faraway land.

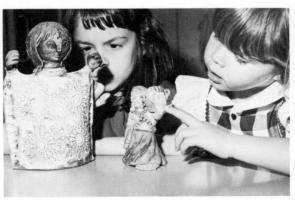

В

B. Clay figures by contemporary artists show much of the decoration and exaggerated forms that young children find easy to relate to and understand.

С

C. Clay wolf shows sevenyear-old child's highly developed skill in handling the material. Teachers need to demonstrate techniques for adhering arms, legs, feet, and ears.

Salt Ceramic

One batch of the recipe that follows makes a ball about the size of a large orange. Food color (preferably the highly concentrated paste food colors) or liquid tempera can be mixed into the water, or the batch can be left white. Salt is less expensive if it is purchased in 5-pound boxes rather than in 1-pound boxes.

1 cup of salt

½ cup of cornstarch

3/4 cup of water

These three ingredients are cooked over medium heat and stirred constantly with a wooden spoon until the mixture thickens into a big blob. Then the mixture is removed from the heat and placed on a piece of foil. After it cools a bit, it should be kneaded thoroughly. It should be stored in a plastic bag. If it must be kept a short while before using, it should be kneaded again just before being used to make it soft and pliable. Salt ceramic dries to a rock hardness without being baked. Finished objects are inedible and can be brushed with Joli or sprayed with a clear glaze. Toothpicks, cloves, feathers, and such can be embedded in salt ceramic while it is soft.

Baker's Clay

An optional ¼ cup of liquid tempera can be added to the following recipe for baker's clay:

1 cup of salt

4 cups of flour

11/2 cups of water

These ingredients should be mixed thoroughly by hand, adding a little more water if necessary. The dough should be kneaded about five minutes until it is soft and pliable. This clay should not be mixed ahead of time since it loses its springiness and resiliency if stored and often becomes too sticky to use. Items made with colored dough are best left to air dry. Items made from uncolored plain dough can be baked an hour or two on foil-covered baking sheets in a 300-degree oven till nicely browned and hard all the way through. Thick, large pieces require a longer baking time than small, flat objects. A browner color can be achieved by increasing the oven temperature.

Beads and Pendants

Children begin very early to roll bits of any modeling material in the palms of their hands to make small balls. They also learn to coordinate hand and eye in stringing all sorts of beads. By combining these two manipulative skills, very young children can make necklaces.

Children need blunt needles with large eyes and a length of yarn about 18 inches long. The children pinch off pieces of colored salt ceramic or baker's clay, roll the pieces in balls, and push the needle and yarn gently through the centers. Some children are interested in the more-advanced skill and challenge of alternating colors or sizes of beads—one red bead and then one yellow bead, or one large bead and then two small beads. Whatever planned or random combination is made, the necklaces are easy to make and attractive to wear. Making them holds the attention of very young children for quite some time.

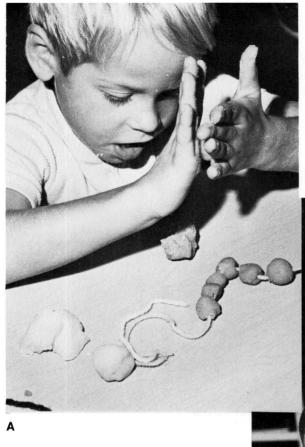

- A. Preschool children develop manipulative dexterity in rolling balls of salt ceramic.
- B. Beads are strung on soft yarn with a large-eyed needle.

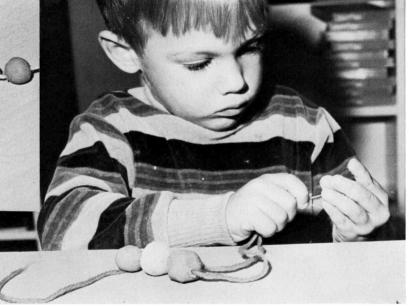

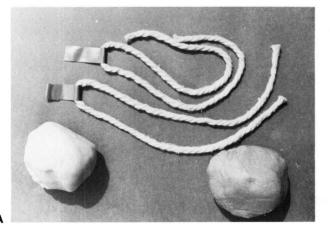

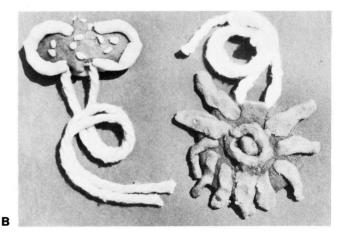

A. Tabs of folded-over tape form the base for attaching modeled salt-ceramic pendants.

B. Kindergarten children enjoyed creating these butterfly and flower pendants.

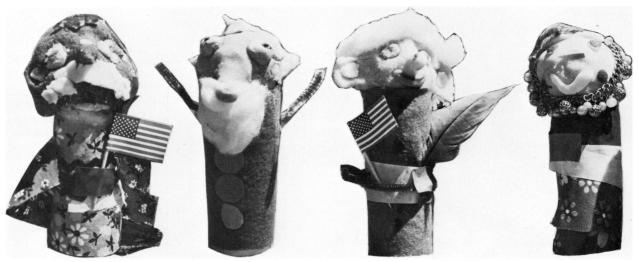

Α

A. Six-year-old children showed much originality and diversity of form when they made these salt-head figures. Colored salt ceramic made it possible for the children to model contrasting facial features.

B and C. Young children enjoy the challenge of finding appropriate scraps of materials for adorning their figures after the salt heads are hardened. Glue and tape are suitable adhesives.

The finished strings of beads should be placed on foil and dried thoroughly for several days. Periodically, they should be turned over gently to ensure that they dry evenly on all sides. When completely hard, they are ready for the children to wear.

Young children enjoy modeling salt ceramic or baker's clay to create handsome yarn-hung pendants, regardless of whether they themselves wear the pendants or share them with friends. To make a yarn-hung pendant, each child needs a 30-inch length of thick yarn, with a 2-inch strip of felt folded over in the center of the yarn. The felt forms the base upon which the children later glue their pendants. Four or five batches of salt ceramic or baker's clay in strongly contrasting colors are sufficient for an average class. If white salt ceramic or baker's clay is used, the pieces can be brush-painted with watercolor or tempera when they are dry.

The children can roll coils and small balls and make pinched and formed shapes to place upon the basic flat shape that they have pressed down on the felt tab. These small, decorative bits of salt ceramic or baker's clay may need to be lightly moistened to make them stay in place. If they fall off in drying, they can be glued back in place later. Pencils, toothpicks, tongue depressors, and other small tools are useful in creating small dots and pressed-in textures. Such simple forms as flowers, butterflies, turtles, elephants, airplanes, and faces make good motifs, or abstract designs can be created.

The pendants dry hard in a few days. They should be turned frequently so that they dry thoroughly and evenly. A clear acrylic finish or Joli glaze adds shine to the finished pieces.

Salt-Sculpture Figures

A cardboard tube or an empty frozen-juice can and a large lump of salt ceramic are the basic materials for salt-sculpture figures. To keep the figure from being top-heavy, the tube itself should be filled with salt ceramic and the head modeled right on top of it. The children each need a large lump of salt ceramic and several small pieces of other colors for adding facial features, unless they wish to paint the head when it is dry.

If the children have used salt ceramic before, they probably need only be reminded of the necessity for kneading it before they begin work and of how to moisten rolls and balls of the material to make them adhere as facial details. Toothpicks may be helpful in making added parts stick to the base. The teacher should point out that exaggerated or oversized features project well from a distance.

After several days, when the salt heads and the salt ceramic inside the tubes are dry, the figures are ready to be finished. Yarn, rope, or cotton can be glued on for hair and beards; felt, colored paper, and fabric for garments; pipe cleaners or sheet sponge for arms; and braid, feathers, and other scrap materials for other details.

Children should be encouraged to make a definite character, perhaps one from a favorite story or from a television show. The character can be real or make-believe, human or animal. Figures can also be used in dioramas.

Baker's Clay Murals

Baker's clay murals provide for a rich experience and a pleasing product in the early childhood classroom. These murals are a group project, with each child in the class contributing at least one item to the composition. Many topics related to areas of the curriculum, such as science, social studies, and literature, are suitable for these large panels or murals. Any theme in which there are a number of items for the children to form and shape individually and then assemble on the prepared background is appropriate. The photograph shows a large mural made by kindergartners in Glendale, California. The kindergartners modeled themselves, and the small schemas—each about the height of a child's hand—were arranged on a multiple-base-line background.

More than one thousand children participated in making a mural for the Department of Motor Vehicles building in Sacramento, California. Each of the twelve panels was 10 feet high and 2 feet wide. The general theme was "Highways and Byways of Sacramento," with each panel focusing on a specific scene, such as "Sutter's Fort," "Lake Folsom," "Airports," "Farm Life," "State Fair," "Gold Discovery Days," or "Fairy Tale Town." As each panel developed, the children came up with fresh, innovative ideas for additional items, until at the end of each day, the panel glowed with spontaneous bursts of people, cars, buildings, hawks, sunbathers, fireworks, bikes, and blimps. (Part of the "Farm Life" panel is shown in a photograph here.)

Kindergarten classes in a Glendale, California, school modeled themselves and placed the schemas in a joined-hands position on four baselines for this large baker's clay mural.

A baker's clay mural requires a ¾- or %-inch-thick piece of particle board or plywood, covered with chicken wire and with some thin, flat boards painted and nailed on the sides for the frame. Finished murals are heavy; two sturdy screw eyes and a wire across the back enable the panel to be hung later.

Baker's clay should be mixed in the desired colors for the background—yellow, for instance, for the ground area and turquoise for the sky. If a river, street, lake, or mountains are to be included, they should be arranged at this time. The background clay should be slightly softer than the clay that will be used for modeling so that it can be rolled out with ease. The background is formed by breaking off small amounts of the clay and "knuckling" it onto the board. When a large area is covered, it should be rolled smooth with a rolling pin. One full batch of dough generally covers about 1 square foot of background. The clay should be rolled to a thickness of about ½ inch—enough to cover the chicken wire. If the dough on the background is too thin, many cracks will form as it dries. After the background is finished, the board should be covered with a large sheet of plastic (from the dry cleaner's, or a large garbage bag) to keep the mural from becoming too dry before all of the children's creations are put in place.

Usually, the clay to be used by the children for forming the mural items can be mixed in half-batches to avoid wasteful leftovers. Plenty of liquid tempera must be put into the water when mixing the dough so that colors are bright and intense in the finished piece.

After a general discussion about the theme of the mural, what objects are to be made, and what sizes they should be, the children may select what they wish to make. After choosing small lumps of the baker's clay in as many colors as they need from the supply table, the children should work on a paper towel at their tables or desks. The finished form can be easily lifted from the paper towel and later put in place on the background. An assortment of plastic and wooden gadgets and tools for cutting, imprinting, and rolling the clay is useful.

The children who finish first should keep their items on the paper towel and cover them with a sheet of plastic to prevent their drying out before they are placed on the background. It is best not to begin assembly until all the children have finished, to determine how many large objects there are, how many small, and so on. Generally speaking, the largest items should be placed first, with thought given to making a

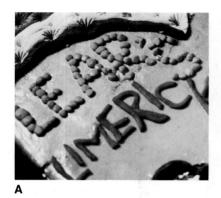

- B. This baker's clay tool is pressed into a rainbow on a mural to add starlike imprints for textural accents.
- C. Green baker's clay was pushed through a garlic press, and a toothpick was used to implant the "grass" to the mural background for a baseline effect.
- D. "Farm Life" is the theme for this 10-foot tall baker's clay panel. Orchards, barns, scarecrows, farmers, fields, and trucks are arranged on a textured, multicolored background.

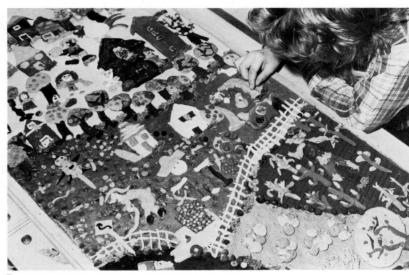

pleasing and cohesive composition that has one or more focal points and shapes that direct the viewers' eyes toward objects of interest. Sometimes, a street or path can be added to provide a baseline and unify scattered objects. A garlic press with very small holes helps considerably at this point, since green clay of various shades can be pressed through and a toothpick used to cut off small clumps of "grass." Placing the grass under the feet of each figure or at the bases of houses tends to relate these items in a unifying way and at the same time keeps the objects from having a "floating in air" appearance. A water-filled spray bottle should be used when assembly begins, with the background receiving a light spray of water before each item is placed on it. This serves as "glue."

When the mural is finished, it should be left to dry, preferably in a dry, warm room. It may take several weeks for it to become thoroughly dry, and during this time, the colors appear to fade and look very flat and unattractive. However, when the mural is absolutely hard and dry, any of several finishes can be applied, and the colors will recover their previous brilliance. The best finish to use is a brush-on resin. Envirotex (or any of several brands on the market) works well. This resin comes in a two-bottle package, the liquid in one of the bottles serving as a catalyst for the other. A small, equal amount of each liquid, about 1 or 2 ounces, should be poured into a clean can and stirred about a minute, according to directions on the bottles. Then it should be quickly brushed on the mural. One coat is sufficient, not only to bring back the colors, but also to give the mural a high-gloss coat that is glasslike in appearance. Other finishes, such as spray-on clear acrylics, clear varnish, and lacquer, bring back the color, but they require a number of coats to achieve sufficient shine or glaze.

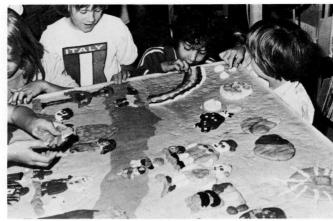

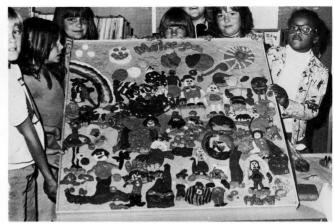

A B

Topics that work especially well for baker's clay murals are similar to those for cut-paper murals—"Nursery Rhymes," "Fairy Tales," "Aesop's Fables," "Seasons," "Birds and Butterflies," "Our Town," "The Zoo," "Scarecrows and Farms," "The Factory We Visited," "Boat Harbor," "The Circus Parade," "Flower Garden," and "All about Us." A study of *Noah's Ark* or *The Peaceable Kingdom* by primitive artist Edward Hicks can be a springboard for the children's own interpretation and version of these themes.

The children also enjoy making small, individual panels, covering little pieces of thin plywood with the clay and then adding their own designs. Chicken wire is not needed for these small panels, but four or five short nails should be hammered in to help hold the clay on as it dries.

Edible Art

Bread dough and candy clay as modeling materials probably find their happiest and most appropriate uses at holiday times—those special occasions when children need outlets for expressing creatively the happiness of the season. (Chapter 14, "Celebrations," lists a number of exemplary topics that would be suitable for stimulating the children's thinking when they begin modeling with these food forms.)

Bread Sculpture

Bread made from various grains and shaped in a variety of forms has long been a basic element in our diet. Who knows what adult (or child) first thought of shaping decorative forms while kneading, squeezing, or playing with soft, pliable, bread dough? Bread has often been a part of symbolic rituals, and many a baker with an artist's sense of three-dimensional form and design has used the unbaked dough to express aspects of the human spirit. Small children respond immediately when handed small lumps of soft bread dough. They sense its plasticity, and their hands respond to its tactile appeal.

It is debatable whether the Chinese or Egyptians were the first to make bread. Long, long ago, the Chinese knew about fermentation and steaming. Yet, it is believed that, about five thousand years ago, a king's baker in Egypt made dough and forgot about it. Wild yeast cells settled on the dough, and when the dough was baked, it rose high and light. By luck, the baker saved part of the dough and used it to make more. Loaves of Egyptian bread baked thousands of years ago are now in museums.

A and B. Assembly begins on a baker's clay covered panel as children complete small animals, human figures, and other objects needed for the theme. The complete panel is displayed proudly. Each child contributed one or more figures related to "Mother Goose."

Bread dough should be kneaded until it is smooth and elastic. It should bounce back when a finger is pressed into it.

People used to believe that bread rose by magic until Louis Pasteur found in 1859 that yeast was a live plant. Scientists tell us that four hundred tiny yeast cells can be placed on the head of a pin.

The Romans had their apprentices wear gloves and gauze masks to prevent sweat and bad breath from affecting the dough. They often baked bread in artistic shapes: If a poet was the guest of honor, the bread was baked in the shape of a lyre, while weddings called for bread shaped like joined rings.

Children can derive some multicultural understandings by modeling bread-dough forms around Halloween time, since parallels exist in several cultures. Every year in Mexico, November 2d is celebrated as the Day of the Dead, and it is an occasion for making different kinds of food in the shapes of skulls, skeletons, and masks. A special bread called "pan de muertos" ("bread of the dead") is made in the belief that the souls of dead people return and enjoy eating it. The cemeteries at this time are for families and friends to meet and decorate the graves.

The ever-popular jack-o'-lantern is Irish and Scottish in origin. One legend tells that it was named after a man named Jack who was condemned to roam the earth with his lantern after he was barred from heaven for his stinginess and from hell for playing too many practical jokes on the devil. In the 1600s, the Irish peasants decided that October 31 would be a good date to celebrate the good works of St. Columba, a missionary who converted Scotland. So they made the rounds, seeking donations to buy meat for a feast, prosperity being assured for generous donors, and threats being made against stingy persons. Thus, trick-or-treating was born!

This type of historical and cultural information helps to make bread sculpture near the Halloween season an appropriate activity. Children can choose to model cats, skulls, bones, skeletons, mummies, jack-o'-lanterns, spiders, witches, broomsticks, pots of magic brew, ghosts, goblins, or bats from the soft dough.

Of course, bread sculpture need not be limited to Halloween. At other times of the year, children can make faces, suns, animals, birds, and people of various kinds from the soft, pliable dough. Edible puppets can also be made with bread dough. The form should be about the size of a child's hand, with all the features and decorations attached. A length of dowel stick or a sturdy meat skewer is inserted in the finished puppet before it goes into the oven. The child may choose to make just the head or face of a puppet, and a show can be staged when the bread puppets have cooled—before the children gobble them up!

One batch of the recipe that follows makes one large bread sculpture about the size of a baking sheet, or it can be divided into five or six pieces for smaller sculptures. Children should make their pieces directly on a lightly sprayed or greased baking sheet because trying to lift and move the forms after they are completed is difficult. The dough can be formed into sculpture by cutting, rolling coils, pinching, and squeezing.

A

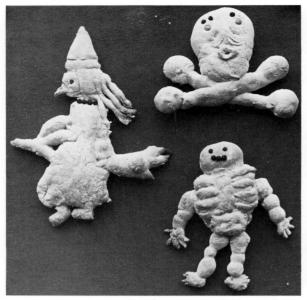

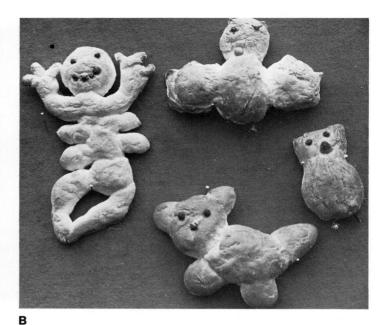

Bodies can be made in several separate parts and a tiny bit of water applied as "glue" if the child has used so much flour that the pieces of dough will not stick together. Children enjoy using almonds, pumpkin seeds, and sunflower seeds for eyes, noses, and other small decorative details. A shiny, golden glaze can be obtained by beating an egg with two teaspoons of water and using a pastry brush to coat the modeled forms before placing them in a 400-degree oven. A scissors can be used to make a number of little snips after the glaze has been applied. This creates a texture that can be used for fish scales, sheep's wool, alligator skin, and similar surfaces. Poppy seeds and sesame seeds can be sprinkled over the egg glaze for accent areas.

The odor of fresh bread baking, either in a classroom oven or one in the school kitchen, is truly memorable!

BREAD RECIPE

1 cup of water

1 teaspoon of sugar or honey

1 tablespoon or 1 package of dry yeast

Let these three ingredients stand in a bowl until the yeast softens—two or three minutes. Then add 1 cup of flour and stir vigorously with a large spoon. Beat until smooth and then add 1 tablespoon of oil and 1 teaspoon of salt and 1 more cup of flour. For a dark dough to contrast with white dough, whole wheat flour, wheat germ, or bran can be substituted for a portion of the white flour. Beating the batter thoroughly makes for a lighter and tastier loaf of bread. Pour the thick batter onto a floured board, and add more flour slowly as you knead the dough, keeping a coating of flour on the dough. To knead, fold the dough into a lump and push it firmly away from you with the heels of your hands. Knead for about five minutes, until the dough is smooth and elastic and no longer sticks to your hands. The kneading process is finished when the dough is smooth and satiny and when it bounces back if a finger is poked into it. Adding too much flour results in a stiff, heavy dough. Place the dough in an oiled bowl, cover the bowl with a clean towel, and set the bowl in a warm place to let the dough rise for about forty-five minutes. Then punch the dough down and work it into a smooth ball. Divide the dough into portions for use in various parts of the bread sculpture or for

A and B. Bread dough is soft, pliable, and fun to form into skeletons, bats, cats, owls, and witches at Halloween. Any holiday would be an appropriate time to let children make their own interpretations of characteristic symbols in bread dough. The dough bakes quickly to a golden crust.

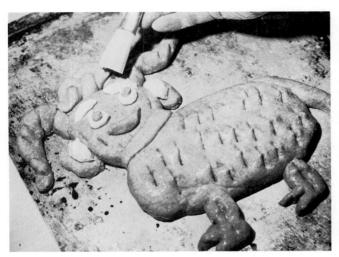

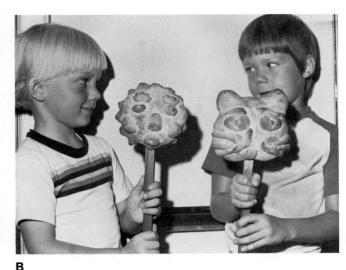

A

A. An egg-and-water glaze is brushed over a bread sculpture before baking to create a shiny glaze.

B. These youngsters can have their puppets and eat them, too. Made of edible bread dough, the puppets are brushed with an egg glaze and baked on a wooden stick.

different children to use. When sculptures are completed, let them rise in a warm place for about thirty minutes. Then bake them for fifteen to twenty minutes in the lower third of a preheated 400-degree oven. Large forms may take longer. The bread should be golden brown and baked through. Let the bread cool on a rack.

Candy Clay

The happy art task of modeling and shaping in a bas-relief manner with candy clay enriches the child's form concept. Animals, people, or plants that stand upright should not be made with candy clay. Paste food colors dye the candy clay to bright and irresistible hues, and each child should have marble-sized balls of several colors. The children should work with clean hands on freshly scoured desks on a piece of paper towel. Candy clay designs can be placed on a plain graham cracker or one that has been covered with buttercream frosting. Children also enjoy decorating frosted cupcakes with candy clay for special occasions or working together to decorate a large sheet cake. The approach to decorating such a cake with candy clay is that of making an assembled mural, with each child making one item about as tall as his or her finger and placing it on the frosted cake. Themes for cake murals might be: "Mary, Mary, How Does Your Garden Grow?" "Nursery Rhymes," "At the Circus," "Butterfly Land," "All of Us Standing in Rows," "A Favorite Story," "Silly Pets," or "Robots and Astronauts."

Candy clay can be mixed in the classroom by several of the students, or an adult or older child can mix it ahead of time and store it in plastic bags. Once mixed, it is not sticky to the hands. One batch is enough for a class of thirty students to each decorate a graham cracker or a cupcake. It is best not to choose a hot day to work with candy clay, as the butter tends to melt and make the clay too soft and sticky.

CANDY CLAY RECIPE

1/3 cup of butter or margarine
 1/3 cup of light corn syrup
 1/2 teaspoon of salt
 1 teaspoon of vanilla
 1-pound box of powdered sugar
 Food coloring

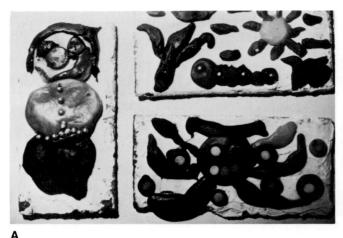

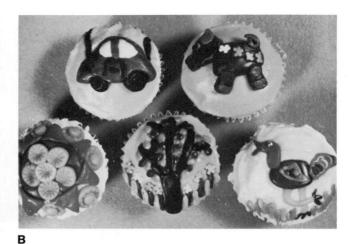

Blend the first four ingredients, and then mix in the powdered sugar. Knead till smooth. Add more powdered sugar, if necessary, to make a nonsticky, pliable clay. Divide into small portions, and mix in food colors.

BUTTERCREAM FROSTING RECIPE

- 1-pound box of powdered sugar
- 1/4 teaspoon of salt
- 1/4 cup of milk
- 1 teaspoon of vanilla
- 1/3 cup of butter or margarine

Combine the ingredients, and beat with an electric mixer until smooth and creamy. The mixture should spread very smoothly to make a neat surface on which to decorate with candy clay. If it is too stiff, beat in a few more spoonfuls of milk.

Edible Jewelry

Very young children can not only make necklaces, but they can eat them, too. Stringing the various items is good training in manipulative skills, and deciding the order for large/small, dark/light, and rough/smooth items calls for counting and decision making. A large-eyed needle and some lightweight crochet thread are needed for each child. Then food items, such as any dry cereal that has a hole in the center, raisins, prunes, dried apricots or any dried fruit, beef jerky, and gum drops, are placed in bowls for the children to make their selections.

- A. Frosted graham crackers are decorated with candy clay.
- B. Colored candy clay can be modeled in any number of decorative shapes and placed on top of frosted cupcakes.

- A. "Lollipops" are made from dark cookie dough and light dough that has been tinted with food colors. Sticks are added before baking.
- B. Colored cookie dough in the form of an angel has silver decors added before baking.
- C. Dark and light cookie dough become a dancing Santa and an elegant reindeer. Beard, hair, and eyebrows are formed from threads of cookie dough that have been pushed through a garlic press.

B. Preschoolers prepare for a nature walk by making a wearable snack of dried fruit and cereal.

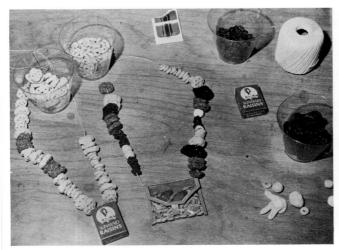

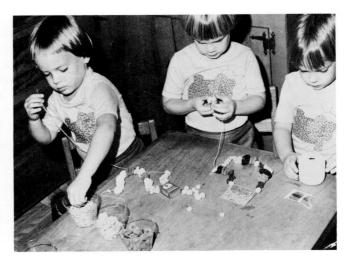

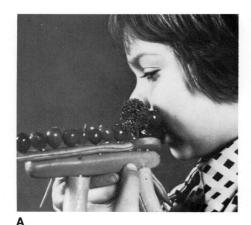

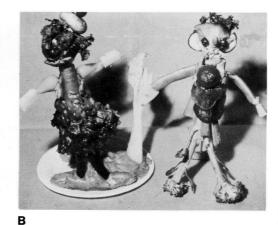

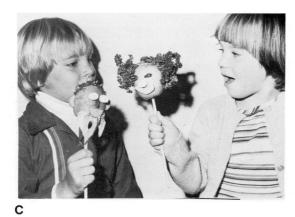

A. Olives, parsley, carrot slices, a wiener, and green beans are put together with toothpicks in an animal-like form for a vegetable assemblage treat.

- B. Stand-up characters are made from fruit, vegetables, and toothpicks.
- C. Wooden chopsticks are inserted in a potato (left) and orange (right) to hold edible puppets. Toothpicks are used to secure raisins, slices of carrots, tiny marshmallows, parsley hair, and dried fruit.

In the middle of the necklace, the children can place a pendant, such as a tiny box of raisins, or they can make a "survival" pouch from a clear piece of vinyl purchased by the yard from variety stores. Masking tape is used to seal the sides of this little envelope, and then it is then filled with sunflower seeds, nuts, raisins, and so on.

Fruit and Vegetable Assemblage

Materials for this nutritious art project can include such items as the following, plus any others that are in season or readily available: apples, oranges, potatoes, celery, carrots, lemons, lettuce, radishes, mushrooms, parsley, small squash, jicama, green beans, pumpkin seeds, nuts, lunch meat, cheese, grapes, cucumbers, pretzels, pickles, alfalfa sprouts, cloves, and tiny marshmallows. Some toothpicks and waxed paper or paper towels for each child's desk or table area are also necessary. The teacher should cut and slice the carrots, celery, or other items so that they are ready for the children to select from and use. Small hors d'oeuvre or aspic cutters can be used to cut interesting shapes from slices of carrots, celery, turnips, and the like.

Puppets and Other Edibles

An edible puppet is fun for young children to make. The "head" is selected from the assembled items—potato, apple, lemon, carrot, and so on—and a wooden chopstick inserted inside it for the handle. Then toothpicks can be used to adhere the features (slices of carrots, raisins, and so on) to the puppet's head.

For another edible, the teacher can give each of the children a wooden meat skewer and let the children select and arrange cutup edibles on their skewers. The filled sticks are then placed into half a cabbage head for an attractive edible "floral" arrangement.

Another assemblage project calls for the children to each have a small paper plate for creating a special arrangement. Using lettuce of various sorts for a background, they can choose to make a face, perhaps with a halved pear serving as the foundation. Or they may want to make an attractive design of cheese cubes, halved grapes, and pretzel rings.

Another delectable edible is the "stand-up construction." Animals can be made with a carrot section body, toothpick and grape legs, and a radish head. A racing car can be made from a zucchini with stuffed-olive headlights and carrot-slice wheels.

Whatever the assemblage, children can learn a great deal about delicious nutrition and even more about structure, good design, and adhering separate parts. . .and at the same time have a tasty treat.

Wadded Paper Creatures

A stack of newspapers, a roll of masking tape, some corks, cut-up dowel sticks, card-board tubes, and wheat paste are all that are needed to start young imaginations working. The lumpy, bumpy creatures shown in the photographs were all brought into being by six-year-old children. The materials are common and inexpensive, and the process provides channels for a wide range of responses by each child.

To make a mammal, bird, fish, or reptile, a large sheet of newspaper is wadded up by the child into an oblong, round, or egg shape. A few strips of masking tape are then used to hold the wad firmly together. Corks, a short piece of wood, and cut-up pieces of cardboard tubes are taped in place for legs, ears, tails, heads, and horns.

Wheat paste should be mixed with water to a smooth, thick consistency. To do this, the teacher should pour 3 or 4 cups of water into a large bowl and use an eggbeater while gradually adding dry wheat paste. The final mixture should be smooth and creamy.

Several children can share a paper plate of paste into which they dip short paper strips. Strips of paper towels, newspapers, or brown paper bags can be cut quickly beforehand on the paper cutter (by the teacher) into approximately 1-inch widths. The short strips should be thoroughly soaked and covered on both sides with the paste. Excess paste should then be wiped off before the strip is applied to cover the animal. A number of strips are needed to cover up the wadded form completely. The children should smooth out the strips with their fingers until the animal is neat and even on the surface. The animal is then left to dry thoroughly, usually for several days.

While the animal is drying, the children can think about how they are going to decorate their new friends—what colors of paint they will use and what they will choose to glue on, such as cotton, wool, or feathers. Then, using tempera that is smooth and opaque, the children should paint their animals with a base color. After this coat is dry, they can add features and decorative stripes, dots, and so on, with small, stiff brushes and cotton-tipped swabs. They can glue on a rope tail, button or thumbtack eyes, a yarn mane or hair, felt or sponge ears. If a shiny glaze is desired, the entire creature can be coated with a clear acrylic spray when it is dry.

Boxy Constructions

Instead of wadded-up newspapers as a base, small boxes and cardboard tubes can be fastened together with masking tape. These adapt themselves well to forming cars, fire engines, streetcars, trains, trucks, planes, boats, spaceships, submarines, and the like. Cardboard tubes and thick dowel sticks can be cut up for wheels and smokestacks. Short sticks can be taped on for sailboat masts, propellers, and airplane wings.

A. Children use masking tape to fasten corks and cardboard tubes to wadded-up newspapers before covering the entire form with strips of paper towels or brown paper bags that have been soaked in a wheat-paste mixture.

B. Contrasting colors are added for decoration when the base coat of paint is dry.

C. Cotton swabs dipped in paint are handy for making small dots.

D. Yarn, pipe cleaners, felt, feathers, and all sorts of scrap materials can be glued on the animal for final embellishment.

E. By cutting cardboard tubes in half lengthwise, a six-year-old girl fashioned tall ears for her wadded-up rabbit.

D

E

A few small boxes, cardboard containers, and tubes are stacked, combined, and taped together by children to become cars, gliders, boats, and moon ships.

When all the parts are securely taped in place, the entire form is covered with a layer of paper strips that have been dipped in wheat paste. This holds all the parts together and provides a smooth surface for the child to paint upon.

When the vehicle dries, the children are ready to paint it with tempera. After a base coat of color has been applied and has dried, the children can add windows, doors, wheels, and contrasting trim of all sorts, using small, stiff-bristled brushes. Boats need portholes, cabins, and flags. Planes can have emblems and numbers painted or glued on, and photographs of faces clipped from magazines can be glued onto the windows.

These small, boxlike conveyances appeal to young children because their forms are familiar and their size is such that children can cope with them. The concept is three-dimensional design, yet two-dimensional decorative elements also are involved.

A group project using large cardboard cartons, carpet tubes, and round ice-cream cartons can result in large animals for the classroom. With these larger creations, the boxes are assembled and held together with wide strips of butcher tape. Wads of newspapers can be attached with strips of paper dipped in wheat paste. In this manner, rounded forms can be built up and the general contours of the animal formed. All of the children can participate in this phase of the project. It takes quite a bit of time and quite a few pieces of newspaper to develop a lion, bear, giraffe, or fat hippo. When the animal is completely dry, the children can paint it with tempera, or it can be spray painted outside. A coat of clear varnish or shellac gives it a finished look. Usually, these animals, especially if a few pieces of lumber are included in their framework, are strong enough to hold a child on their backs. One teacher made a number of "saddlebags" for the hippo her class made and then filled them with task cards and books for the children's convenience. No matter how the boxy beings are used in the classroom, making them and having them for friends later are exciting experiences for young children.

A and B. Kindergarten boy contemplates how he will paint his cars and plane after they have been covered with paste-soaked strips of paper towels.

- C. Creamy smooth wheat paste is used to coat newspaper strips before covering the boxy conveyances with them.
- D. Popsicle stick is taped on top of this boat to hold a cardboard flag.
- E. Several colors of tempera and both large and small stiff brushes are needed to paint the boxy conveyances after the wheat paste has dried.

Cardboard Stabiles

A famous American sculptor of this century—Alexander Calder—is known for inventing a new kind of sculpture called mobiles. To do this, he cut large pieces of sheet metal into shapes and so balanced them on rods that they gently moved in the breeze. He also made many stabiles of flat sheets of metal and painted them in bright colors. Sometimes, his stabiles remind us of real objects; other times, they are to be enjoyed for their shapes alone.

To make a cardboard stabile, the teacher should cut out a number of small geometric shapes (about 3 to 5 inches or so in size) from corrugated cardboard on the paper cutter. Then the children can use scissors and cut a small notch in one of the

Early childhood teachers participate in an in-service class and learn how to cover boxes and cartons with wheat paste and newspapers to create life-sized animal forms.

Stabiles made of corrugated cardboard that is precut in a variety of geometric shapes are notched and glued together by students. Pieces may be added in an informally balanced manner as the glue dries. Students enjoy seeing pictures of both stabiles and mobiles by Alexander Calder and then painting their own sculptures with bright colors.

sides of each of two pieces. They then push the two pieces together, notch to notch, and add a drop of white glue to make them stay together. The children then join another pair of cardboard pieces in this manner, and when the glue on both pairs of notched cardboard pieces has dried, join the pairs to each other in the same notching-gluing manner. They can add on to their stabiles with more pieces of cardboard until they have created a rather large piece of sculpture. The children must be careful to keep their sculptures balanced or they will fall over. The sculptures can be painted later if desired. Students may also enjoy working in small groups and making large, free-standing, stabile sculptures in this manner.

Fold as shown in the diagram. Then cut on the dotted lines and fold to make a building.

Miniature Houses and Buildings

Children can use square pieces of white and colored construction paper and follow a basic folding process to create the base form for all sorts of small houses and buildings. Once the paper is folded, the building's back, front, and sides are determined, and the paper can then be unfolded to lay flat on the tabletop or desk while the child adds doors, windows, shingles, bricks, and so on with marking pens, crayons, and oil pastels, or by using scissors and paste and colored paper. Then the house is refolded and pasted together for its final form. Another piece of paper pasted on the top forms an overhanging roof. Students can make a false front for one end of the building by cutting a storefront or whatever from another piece of paper, decorating it, and pasting it onto the folded house.

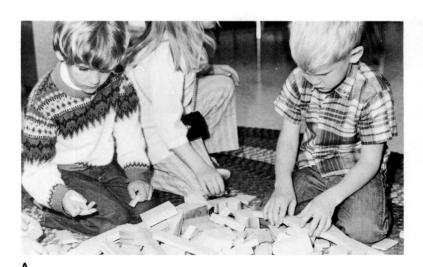

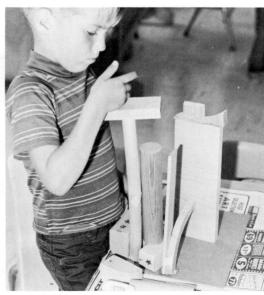

В

A. Children should see, feel, and study wood shapes carefully as they make selections for their glued-together constructions.

B. A piece of masking tape is helpful in holding several wood scraps in place until the glue dries. All of the children's little buildings can be assembled on a tabletop covered with butcher paper on which streets and sidewalks are drawn. Tree trunks can be made by rolling a 3-by-4-inch piece of paper into a cylinder and securing it with glue or tape. Half of a 6-inch circle rolls into a cone to glue on as a top to the tree-trunk cylinder. Students find it challenging to invent other ways to make stand-up trees, people, cars, dogs, signs, and so on.

The basic form for the house or building is made by using a square piece of paper, 9 by 9 inches or so, and folding the paper in half in one direction. The paper is then unfolded, and each of the two sides that are parallel to the fold are folded in to the center fold. Then the paper is folded in half from the other direction, unfolded, and the other two sides folded in to the center fold. The square has now been divided into sixteen small squares. Then the dotted lines, as indicated in the diagram, are cut. This forms the four sides and roof of a house or other small building.

Wood Scraps and Glue

If spread on the floor where small hands can poke, pick up, and handle them, wood scraps in a multitude of shapes and sizes cause young children to conjure and imagine, to relate and design, to think in terms of height, width, depth, and weight. Construction projects involving wood scraps offer children excellent three-dimensional experiences. Through handling and becoming sensitive to form, children find in the wood scraps shapes that may suggest to them the body of a bird; the basic shape for a truck, boat, or plane; the legs or arms for a figure; the trunks for a grove of trees; or the parts for a building or an abstract composition.

Cabinet shops and construction companies discard odds and ends of wood scraps. If these pieces are too large for the children to handle easily, they should be cut into smaller, odd shapes—triangles, squares, and rectangles. A few flat boards and Masonite sheets are helpful to use as bases upon which some of the children can glue their constructions.

The teacher should advise the children that, in adhering wood pieces, a small amount of glue will dry and hold two wood pieces together rather quickly, whereas a large puddle of glue will require a long time to dry. Masking tape holds the wood pieces in position while they are drying.

В

When the objects are completed and the glue is dry, the children may wish to paint them and add various kinds of decorations. Bits of fabric, feathers, pipe cleaners, and photographs of faces clipped from magazines can be glued onto the constructions.

Bas-reliefs can be made with wood scraps, too. For this art task, a flat piece of Masonite or thin plywood is used for the background, and the wood pieces are glued down flat in an arrangement. The children could be presented with the problem of designing a "Funny Machine" or a "Mechanical Animal." Thick yarn might be used along with the wood pieces if a linear element is needed, and the finished work can be painted with watercolors or tempera or sprayed all one color.

Masks and Mask Making

Children today most commonly associate the making and wearing of masks with Halloween. The tradition of wearing masks on the last day of October began long ago in ancient Gaul and Britain. The druids and priests thought that witches, demons, and the spirits of dead people came back to earth for this one night of the year. The druids lit bonfires to drive the bad spirits away, and they protected themselves by offering the bad spirits good things to eat and by disguising themselves with masks that made them look like evil spirits.

Protection is one reason for wearing masks, but other cultures have also used them to scare away intruders, to appease their gods, or for momentarily being another personality. In some cultures, masks are worn in rituals and in ceremonial dances. Indians in the Southwest and Mexico still use masks today as a part of their dances, celebrations, and religious rituals. In Japan, Kabuki theater uses masks as an integral part of the drama.

Many ceremonial masks have exaggerated features, repetitive design elements, and such decorative materials as paint or dyes, feathers, beads, bones, shells, hair, and fur. Tribal masks are usually symmetrical and often emphasize a mood or capture the personality of a spiritual creature through exaggerated and distorted parts. Mask makers often heighten the allover effect by using repeated lines and shapes to make dominant features stand out. Authentic folk-art masks of other cultures are frequently found in museums and are particularly interesting to young children. Photographs, reference books, films, and filmstrips are useful ways to bring masks into the classroom if real masks are not available.

Although we most frequently think of masks as dramatic and part of some celebration, modern-day masks are frequently utilitarian and are most often used for protection. Examples of useful masks include those of the deep-sea diver, the baseball catcher, the beekeeper, the surgeon, the astronaut, the welder, the goalie, the fire fighter, and the skier.

A. A bird assembled by a kindergarten child is embellished with paint and feathers. The structure is glued to a Masonite base.

B. A boat by a kindergarten child has basic form and structure.

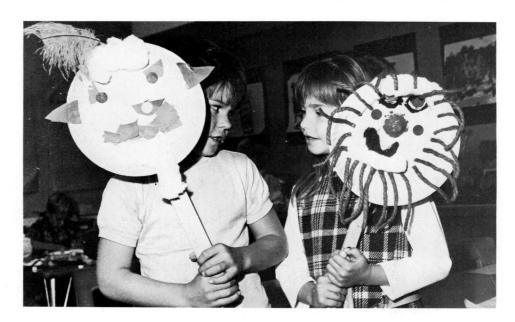

Paper-plate faces on sticks can be masks or puppets.

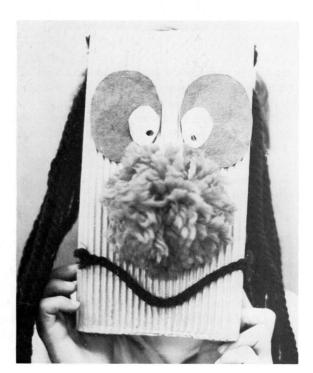

Corrugated paper forms the foundation of this simple mask, with yarn and construction paper used to represent hair and facial features.

Found-Object Masks

In most cultures, people used materials from their environment to create masks. For that reason we find masks made of many diverse materials. Some masks are made of wood, some are made of woven fibers, and some are made of metal. Decorative items for the masks also vary from region to region, depending on the objects to be found.

To reinforce this concept, the teacher can provide each child with an oval piece of cardboard that is scored down the center and folded back to better fit the face. The cardboard also should have peek holes so that a child can see through it. The children should collect things from their environment that they can use to make an interesting

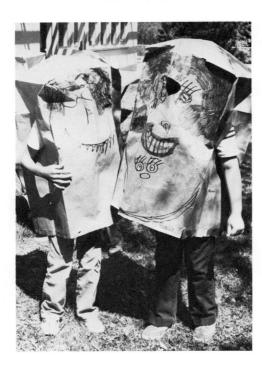

These students in a special education class enjoy their sack costumes. Their teacher made the oversized sacks out of various colors of butcher paper, and the students added facial features and other details with marking pens

mask. The collection period should last several days or a week. On mask-making day, children can select from their collections of found objects which ones they want to use to decorate their masks. Found-object masks often are decorated with such things as shells, bottle caps, steel wool, beans, parts of pinecones, paper clips, keys, coins, leaves, pebbles, plastic utensils, feathers, cloth, buttons, lace or rickrack, yarn, parts of engines or motors, nails or screws, bolts, and wire. These objects can be glued into place for facial features as well as for patterns and textures. A discussion can follow to determine which object or material was most frequently used, which was the most unusual, and which was the most imaginative.

Sack Masks

Large, brown, paper sacks can form the base of masks that not only cover the face but the entire head. Large eye holes, a flap for the nose, and sections cut out on the sides for the shoulders relieve children's feelings of claustrophobia. Large (5-gallon) ice-cream containers also make good foundations for masks that cover the entire head.

Paper-cutting or tempera-paint techniques can be used for decorating or embellishing the sack masks. This particular lesson can also introduce or reinforce knowledge about color, line, and texture. Students can be encouraged to use limited colors (only one or two colors), warm colors (red, yellow, orange), cool colors (blue, green, purple), or neutral colors (brown, beige, black, gray). Lines can be thick or thin, curved or straight, long, short, or broken. Texture can be actual (objects glued to the surface) or visual (small, repeated lines or shapes that give the appearance of texture; these can be cut from photographs in magazines or drawn and painted on by students). Actual texture can also be added with various fibers used as hair.

Paper-sculpture techniques are used in making this mask from torn, cut, scored, and curled paper. The base of the mask is part of a stocking that has been stretched over a frame made of cardboard and wire from a coat hanger.

Stocking Masks

Nylon stockings can be stretched over a wire frame to form the foundation of a mask that is easy to see through and offers great flexibility for decoration. The wire frame can be made by older children or adults by using a wire hanger that has a cardboard tube at the base. The tube is removed and used as a handle, and the wire is straightened, formed into an oval, and the ends stuck into the tube handle. Knee-high nylon stockings are a perfect length to stretch over the wire frame, but other stockings or pantyhose can be cut in lengths and tied off.

Once the frame is assembled, the children can use yarn, torn or cut paper, plastic tape, buttons, and other sewing materials to create features, hair, hats or crowns, collars, and jewelry. Possible themes might include characters from favorite books, someone in uniform, a person from history, or birds and beasts. After the masks have been completed, children can participate in a "Who am I?" session in which they wear their masks and give clues; other children can ask "yes" or "no" questions in an attempt to guess who each mask represents.

Paper Masks

Half or full masks can be cut from construction paper; slits and tucks help them to fit around the face. Sidebands of paper can be attached above each ear to hold the mask in place. Paper can be cut, curled, torn, and pasted into place to add interesting features.

Paper plates can also be used as masks, with features and decorations glued, painted, or drawn on the surface.

A symmetrical mask can be constructed by folding a piece of paper or thin cardboard in half and cutting it into an oval or other facelike shape. The paper or cardboard should have a slick surface (finger-paint paper or heavy butcher paper are suitable) so

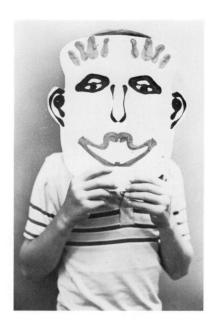

A simple mask is formed from folded paper. Half of the face is painted on one side of the fold and transferred to the other half while the paint is still wet.

that it does not absorb paint easily. The students should paint half of a face on one side of the fold line; there should be one eye, one eyebrow, half a nose, and half a mouth. When the paper is refolded, the painted features transfer to the other half, making a mirror image of the original painted features. Designs can be painted and duplicated in this way, or students may want to add asymmetrical lines and decorations with paint or crayons.

Strips of paper dipped in a starch-glue-water solution can be used to build up layers for a papier-mâché mask. The paper should be porous (newspaper or newsprint is good) and torn into pieces or strips less than an inch wide. For the best results, the layers should alternate in direction. A metal bowl turned upside down can be used to form the mask. Students can also use heavy aluminum foil that has been pressed and molded to their own faces; the basic facial form can be preserved by placing wads of newspaper beneath the foil so that it will keep its shape while the strips of paper are applied. Three or four layers of paper strips should be used.

The last layer of papier-mâché should be plain strips of paper towels or paper bags. Once dry, the mask can be painted with thick, creamy tempera. When completely dry, clear spray, polymer gloss medium, or shellac can be added for a shiny finish.

For Discussion

- 1. Which of the elements of art are particularly applicable to most sculptures? Apply the elements of art to a sculpture in your community.
- 2. What are the similarities and differences between additive and subtractive sculpture? Between freestanding sculpture and bas-relief? Between architecture and sculpture?
- 3. Which age groups would respond more readily to working within a given framework? Develop specific motivations or topics for three-dimensional constructions and sculptures that would offer creative challenges to these children.
- 4. What have been the purposes of masks in cultures past and present? Which contemporary masks still serve these purposes?
- 5. Compare the two sculptures shown in the "Color Gallery" (Modigliani's *Head of a Woman* and Moore's *Reclining Figure*). Utilize the model for art criticism (pages 40-41) to evaluate or critique the two artworks.

12 Puppet People

"The world of reality has its limits; the world of imagination is boundless."

JEAN JACQUES ROUSSEAU

Puppets are three-dimensional, small-scale representations of people and animals. They are directly controlled by children's hands, both when the children design them and later when the children make them talk and move as animated creatures. They may even be extensions of the child's own personality, disguised somewhat in paper, paint, and cloth.

The exact origin of puppets is unknown. Some believe that the Egyptians invented puppets, yet some of the first puppets were made along the Ganges River in India. Oriental countries have a long tradition of puppetry, and the ancient Greeks even had puppet theaters. Roman puppeteers held performances in homes and public places and traveled as road shows. Italy is well known for its puppetry, and in the Middle Ages, Italian puppeteers took their portable theaters to France, Spain, Germany, and England. When young children make puppets, they are not only enjoying a playful art activity but are also joining in a long historical line of make-believe, laughter, and adventure.

Paper Puppets

Children delight in playing with puppets, and when they can make one quickly and easily to suit their own fancy, their pleasure is enhanced.

Flat-Stick Puppets

Probably the simplest puppet for the very young child to make is the flat-stick puppet. Children who are drawing figures and animals can make a flat-stick puppet by simply cutting out their drawing and gluing or stapling it to a tongue depressor or flat stick of wood. They may find it fun to glue on bits of fabric, felt, and yarn for items of clothing. By sitting below the level of a tabletop or behind an improvised puppet stage made from a cardboard carton or large blocks, the children can hold onto the stick and make their puppets move and talk.

A and B. Contrived and assembled stages for puppet and marionette shows can be made from corrugated cardboard or plywood. They should be sturdy and large enough to accommodate several children at one time. Youngsters enjoy decorating the stages and making backdrops. A table turned on its side can be used as a makeshift puppet stage.

Lollipop Puppets

From an assortment of cardboard pieces—rectangles, circles, and ovals—the children select one shape that they staple to a short, flat stick, such as a tongue depressor. Then the children make selections from an assortment of yarn, buttons, macaroni, colored paper, felt, and paint, and create a face, gluing on hair, a nose, and other features. The children enjoy naming their brightly colored puppets and creating impromptu dialogues between each other's puppets.

Paper-Plate Puppets

Paper plates are inexpensive and are available in white and a variety of colors. Thin paper plates can be folded in half to form the mouth of a simple puppet. A hand strap needs to be stapled or glued onto the top half of the plate. The puppet is manipulated by placing the hand through the strap and the thumb under the bottom of the plate. A tongue, teeth, eyes, whiskers, nose, hair, and other details can be added with glue or by stapling.

Another type of paper-plate puppet is very versatile in that it can double as a mask if eyeholes are cut at the proper places. A short, flat stick of wood is stapled and glued to the back side of the plate. If the stick is attached between two plates that are glued together, a two-faced puppet is possible. The puppet can be either human or animal in form. A tableful of interesting supplies and scrap materials, such as yarn, feathers, buttons, stick-on dots, tape, colored or metallic papers, egg-carton bumps, paint, cloth, scraps of felt or fur, and corrugated paper, is a necessity. If the group has just enjoyed a favorite fairy story or folktale, the children may wish to create characters to act out the story.

Folded-Paper Puppets

The next three puppet forms are all made by folding colored construction paper in basic shapes and adding features and clothing. They involve skills in folding, stapling, cutting, gluing, attaching, and overall designing. The puppets are completed quickly and have a very low frustration point for young children. In a few minutes, the children are ready to move into the world of fantasy and relate to their new talking friends. The techniques can be repeated often, with every child making a different form of puppet each time.

A

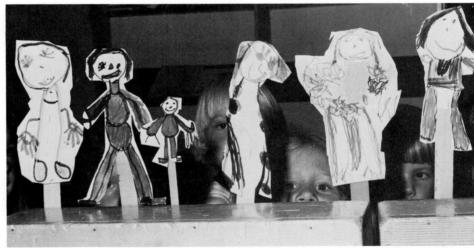

A. Kindergartner draws schema with felt pens or stiff paper and cuts it out for making a stick puppet.

B. A variety of symbols for people is evidenced in these stick puppets as kindergartners position themselves behind an improvised stage made of building blocks.

В

Fold-Over Puppets The fold-over puppet is made by folding a piece of 9-by-12-inch colored construction paper vertically, and then stapling the top and open side. The top is folded over about 3 or 4 inches, and the child's hand is inserted in the open end of the tube. Next, the children use cut paper, yarn, felt pens, gummed paper, stick-on dots, or whatever they choose to create the face and body of their puppets. They may add some hair, ears, or whatever decorative details they wish to the back side of the puppet also.

A simplified fold-over puppet can be made from small paper lunch sacks: The bottom of the sack becomes the puppet's face, and the natural fold of the sack forms the puppet's mouth.

M-Fold Puppets M-fold puppets are also made from a folded piece of 9-by-12-inch colored paper. The paper is folded vertically and the long, open side stapled. Then it is folded in half horizontally and the two ends folded back again in an M-shape. The fingers and thumb are then inserted in the pockets in the back side, and the puppet's mouth opens and closes as the hand moves. Colored-paper eyes, teeth, ears, whiskers, tongue, and so on are glued, taped, and stapled in place.

В

Cootie-Catcher Puppets To make cootie-catcher puppets, the children start with a 9- or 12-inch square of paper. This is folded diagonally twice to find the center, and then each corner is folded to the center. The entire piece is then turned over and the corners on the backside folded to the center point. The piece is then folded in half from both directions, horizontally and vertically. By inserting the fingers in the back openings, the child opens and closes the puppet's mouth. The talking mouth can be stapled together to keep it from splitting as the child opens and closes it. Eyes, ears, eyelashes, tongue, teeth, and beards can be attached.

Stuffed Paper-Bag Puppets

Stuffing a very small paper bag with a wad of newspaper and turning it into a delightful puppet by using bits of discarded materials and paint gives young children new friends to play with and talk to, while also rewarding them with positive feelings of personal accomplishment. A scrap box filled with a variety of yarns, fabrics, felt, feathers, pipe cleaners, buttons, and the like proves to be a valuable aid in generating ideas and approaches in design. Paint, brushes, tape, glue, and staplers should be accessible.

Number-1-size paper bags are available at hardware and variety stores. Because they are rather small, they are easier for small hands to handle than larger bags. First, a piece of newspaper should be wadded around the end of a short, wooden stick and pieces of masking tape wrapped around the wad to hold it firmly in place on the stick. This wad is then inserted into a paper bag, and a piece of masking tape is wound around the base of the bag at the puppet's neck.

Before children begin to work, they should be directed to think in detail about differences in facial features and the great variety of forms that they can imagine to create eyes, eyebrows, lashes, noses, mouths, teeth, ears, beards, and such. Hair, hats, crowns, horns, simple clothing, and arms can be cut from colored paper, yarn, and scrap materials. A piece of fabric, tissue, or crepe paper can be gathered up and taped around the stick at the base of the bag to serve as a garment. Arms and legs can be attached with a stapler. Egg-carton bumps, fringed paper, and stick-on dots help the child to think in terms of exaggerating and projecting the features and making use of decorative details. Adding objects that move, bounce, sparkle, and shine aid in making the puppet visible from a distance.

- A. Heads bob up and down on fold-over puppets.
- B. M-fold puppets offer many channels for the resourceful use of scrap materials.
- C. Moving, dangling, and projecting parts aid these puppets in being viewed and manipulated.

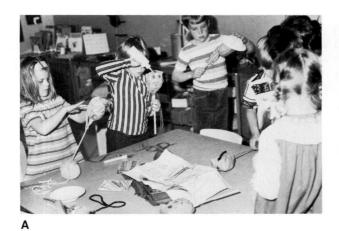

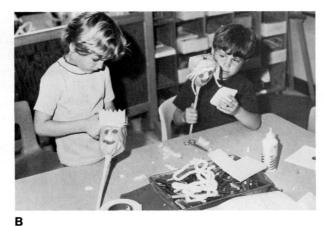

- A. Kindergarten children learn to handle glue, scissors, and all sorts of scrap materials when they make stuffed-bag puppets.
- B. Simple materials make for a success-oriented art task. Thick yarn, stick-on dots, and meat trays are easy for young hands to handle.
- C. Paper-bowl hat covers this puppet's yarn-covered head.
- D. Masking tape wrapped around a scrap of fabric at the neck holds the puppet's garment in place.

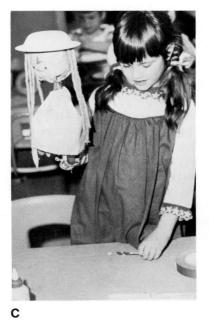

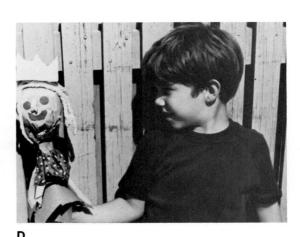

The children can make their puppets talk and move about while performing in an impromptu show, whether the story line they use is taken from a popular story or nursery rhyme or is one of their own invention.

Sock Puppets

Every household usually ends up with a few odd or mismatched socks that can be used as the foundation for a sock puppet. The sock is pulled over the hand, with the heel over the thumb to form a mouth. By making a fist and moving their fingers, children can make the puppet talk. Ears can be formed by shaping and pulling part of the sock out from the side or top of the puppet head; the ears will need to have rubber bands or elastic hair bands wrapped around the base to hold them in place. Rickrack, yarn, lace, buttons, beads, felt, or rug scraps can be glued on to decorate the puppet.

Box Puppets

Basically, a box-puppet foundation consists of two small boxes taped together with gummed paper or masking tape. The boxes are arranged so that, when they are opened out, using the tape as a hinge, the sides rest together and the open ends of the boxes both face in the same direction. The boxes form the jaws of the puppet, and the open ends provide spaces into which the puppet maker can fit a hand to manipulate the puppet's mouth. Individual cereal boxes or half-pint milk cartons are the right sizes for box puppets.

Although each box puppet begins with the same basic shape, imaginative decorations give each one an individual personality. Cardboard ears, wire or twine whiskers, candy cups cut and used for eyelashes, eyes formed from the cups of pressed fiber egg cartons, features and designs created from yarn, string, paint, or felt markers all work well in adding details. Teeth, tongues, and fangs can be cut or torn from paper and added to the mouth formed by the two boxes. A handkerchief or scrap of cloth can be wrapped around the wrist and the part of the hand that shows when the puppet maker is manipulating the puppet.

Finger Puppets

Tiniest of all, finger puppets are particularly appealing to the very young child. They are charming and adaptable to all sorts of play activities.

The two materials that work best for small, modeled, finger-puppet heads are baker's clay and salt ceramic. The children take a small wad of either of these doughlike materials and stick a finger inside it to create a hole. This opening enables the child to hold the completed puppet on a finger and should be made a little larger than the child's finger, since the puppet's cloth garment will be glued inside it.

The children should model a simple face, pinching out a nose, ears, chin, and such, and adding tiny lumps for other features. They can use a pencil or small tool to impress and imprint details. If the salt ceramic or baker's clay is colored, no paint need be added to the finished head. However, children may enjoy using paint for accents. Yarn, felt, cotton, wool, or other materials can be glued on for hair, hats, beards, and the like.

The puppet's garment is made from a small circle of cloth, upon which the child can draw designs with felt pens and glue on rickrack, buttons, pom-poms, beads, and ribbons.

When the garment and head are both complete, a bit of glue should be dropped in the opening of the puppet's head and the center of the garment poked into it.

Clay also can be used to make finger puppets. Plasticine is temporary but provides many colors, while water-based clay needs to be fired but is more permanent. The clay can be squeezed around fingers and the features, hair, and clothing can be pinched out or scratched into the surface. This technique of pulling the details out of the clay prevents problems with joining, of having poorly attached pieces fall off. Even very young children are able to squeeze and pinch characteristics into their finger puppet.

Finger puppets can also be made out of fingers that have been cut off of old rubber gloves, ski gloves, or children's knitted gloves. The children can decorate by sewing or gluing on thread, yarn, buttons, feathers, felt, or fur to make facial features, hair, a beak, whiskers, a mane, topknot, hat, crown, or anything else needed to create an interesting puppet.

- B. Feather is embedded in salt-ceramic bird's head when it is being modeled. Paint is brushed over the entire head after it is hardened.
- C. Yarn is glued on this painted head to complete the finger puppet's decoration.
- D. Circle of cloth is poked up inside the puppet's head to cover the child's hand.
- E. The smallness of finger puppets appeals to children, and they enjoy seeing those made by others. These woven puppets were made in Ecuador.

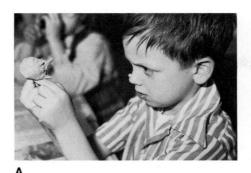

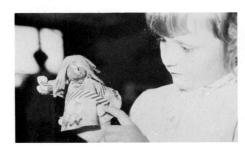

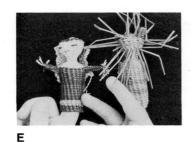

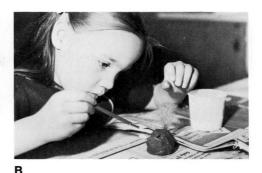

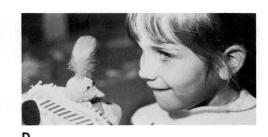

Stick Puppets

Tongue-Depressor Puppets

Either baker's clay or salt ceramic is suitable for children to use in forming small puppet heads and attaching them to tongue depressors. If salt ceramic is used, several colors of it are needed so that the child can create facial features of contrasting colors. If uncolored baker's clay is used, the head-on-the-stick can be baked in a 350-degree oven until it is thoroughly hard and lightly browned. The finished pieces must be covered with plastic wrap until they are baked, as the salt in the baker's clay tends to dry rapidly, making cracks and leaving a rather unattractive surface.

These puppets, being small, are particularly suitable for very young children to make. The children can add feathers, peppercorns, and cloves or bits of macaroni for eyes and teeth. Hair, hats, and ears can be attached with a bit of glue after the heads are either dry or baked. For a garment, a circle of fabric with a tiny slit in the center can be slipped onto the tongue depressor at the neck. The availability of a good assortment of scrap materials makes for unique creations.

Tongue-depressor puppets can be completed quickly so the children may enjoy making several of them. The kindergarten children who created the examples shown here made entire families.

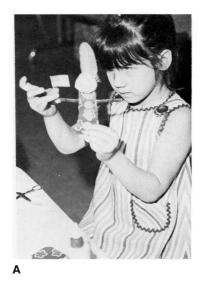

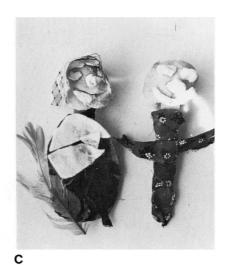

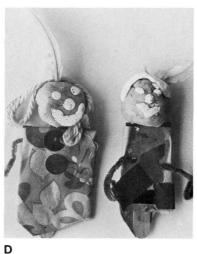

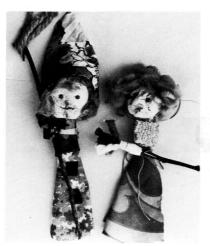

A. Kindergartner adds a flag to the pipe-cleaner arm of her tongue-depressor puppet.

B, C, and D. Tonguedepressor puppets are as different as the five-year-old children who create them.

E. Baker's clay gives crusty, wrinkled faces to these two witches. Children add clothing and wool hair after the puppets are baked in an oven.

Salt Ceramic on a Stick

Stick puppets with heads modeled of salt ceramic offer young children a wide design latitude, with the opportunity to depict facial features in three dimensions. Each child needs a small lump of salt ceramic for the basic head shape and several small pieces of other colors of the modeling material for details. For instance, the basic head shape might be green, and the child could add a yellow nose, red eyes, and a white beard. Although salt ceramic can be painted when it is dry, the use of brightly colored dough eliminates the need for this step. One recipe of the salt ceramic mixture should make enough modeling material for three to four children.

Ε

The teacher should demonstrate how to place the salt ceramic on top of the 9-or 10-inch stick of wood. To make it pliable and plastic, the dough should be kneaded for a few minutes before using. The children can pinch it, roll it in coils or into small balls, and use pencils and small gadgets to imprint textures.

Feathers, toothpicks, pipe cleaners, macaroni, buttons, nails, and other such articles, can be placed in the dough while it is pliable, and rope, yarn, and fabric can be glued to the dried piece. Several days are required for the heads to dry thoroughly.

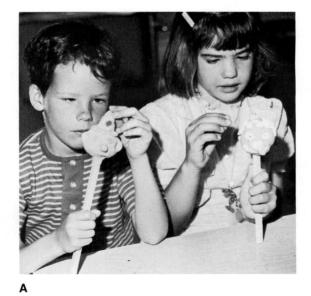

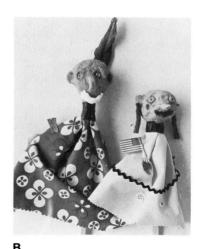

- re
- A. Salt-ceramic heads are modeled on top of a short stick.
- B. Tape is used for attaching wraparound garments on stick puppets.
- C. Contrasting colors of salt ceramic were added by this six-year-old girl to accent the features on her puppet's face.
- D. Projecting features make for interesting profiles on these two puppets.

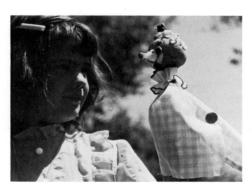

С

D

A square of fabric can be gathered or pleated and then attached to the neck of the puppet with masking tape or colored plastic tape. Braid, lace, rickrack, felt scraps, or ruffles can be attached to the garment with glue or needle and thread.

Puppet Situations

Once the artistic creation is complete, a child's creativity and imagination can continue to be stimulated with activities that develop language skills and cognitive ability. A successful puppet-making experience results in a diversity of colorful and interesting characters, each with a unique personality. Along with the puppet's head and facial features, the addition of fangs, horns, beaks, pigtails, and other interesting details can emphasize the puppet's character. Props, such as caps, hats, helmets, crowns, shawls, or even miniature masks, also can be added for interest. Children should have many opportunities to play with their puppets, either through plays or speech-making activities. While in front of a mirror, they can practice opening their puppet's mouth on

242 Puppet People

selected important words or syllables and also determine the best angle at which to hold the hand controlling the puppet. Possible situations for the children to act out with their puppets include:

- 1. A parent scolding a misbehaving child
- 2. Space people arriving on earth
- 3. A grandmother calling on the telephone
- 4. A waitress in a restaurant
- 5. A sleepy animal in the zoo
- 6. A child making cookies
- 7. A caterpillar about to make a cocoon
- 8. A puppy waiting for his dinner
- 9. A bird building a nest
- 10. An argument on the playground
- 11. Getting ready for a birthday party
- 12. Being late for school

For Discussion

- 1. How are puppets different from and similar to sculpture?
- 2. Formulate at least five additional puppet situations to add to the list in the chapter. Share your lists and ideas.
- 3. Utilize one of the puppet-making ideas in the chapter, and adapt it for use with one of the groups of special-needs students discussed in chapter 5.
- 4. What are some of the other subject areas that would have connections to a puppetry project in art? Plan drama activities using puppets that would motivate learning in these areas.
- 5. What abilities of young learners are stimulated in creating original puppets? Adapt the process and product questions (pages 118–119) to puppet-making activities.

13 Fabric and Fiber

"Art is thoughtful workmanship."

W. R. LETHABY British author

Working with fabric and fiber encourages spontaneity and fosters skills in cutting, gluing, stitching, weaving, and designing—both in picture-making activities and in craft objects. Fabric is an exciting, tactile material for young children to see, touch, and handle. It comes in an endless variety of colors, prints, and textures and lends itself well to both individual and group projects.

Fabric and felt should be collected and stored in a number of labeled cardboard boxes, cartons, or plastic containers. Pieces can be sorted by color to make it easier for the children to find the kinds of scraps they need. Having an iron available to press the fabric before the children begin cutting makes it easier for the children to work. In like manner, yarn should be wound loosely into balls from the skeins and kept sorted by color in boxes or cartons.

Good, sharp scissors are necessary when working with fabric and felt if children are to be expected to learn to cut with a degree of skill. The ordinary scissors for paper that are usually found in classrooms are inadequate if the child is to have a successful experience.

In becoming acquainted with fibers, children should begin to develop a basic knowledge, vocabulary, and understanding of the process of weaving and be able to warp and weave, making simple objects using several different elementary techniques, looms, and yarn.

Banners and Flags

Banners and flags are elegant and exciting, adding richness and meaning to various occasions. Many professional artists design both of these exciting art forms, and their work can be found in gallery exhibits, museums, churches, and at fairs.

The making and hanging of flags and banners has a long history. Banners and wall hangings were very popular during the Middle Ages, having originated in Rome during the period of military conquest. They were carried into battle to differentiate military groups. Heraldic flags helped to identify friend or foe, since the metal helmet and armor made recognition impossible. Standards were the personal flags of rulers, while small streamers and long, ribbonlike flags were carried by troops. During the Crusades, flags and banners were used by nobles and kings. Standards were used at an earlier time in Egypt and the Near East. Merchant and craft guilds in the Middle Ages used banners to identify themselves, and through the ages, countries have used flags.

C

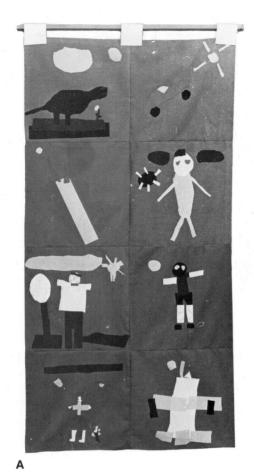

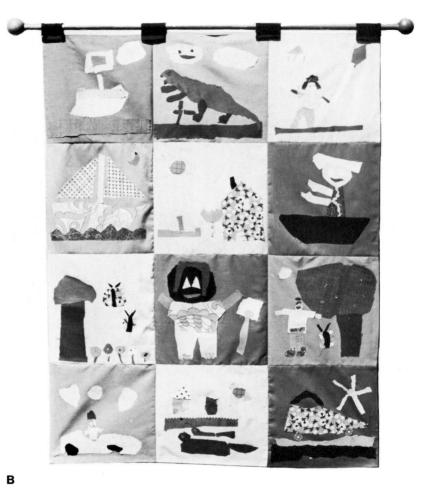

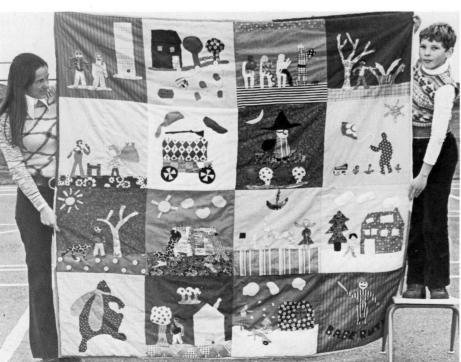

- A. Red and purple squares in a checkerboard arrangement make up this banner by sixyear-old children. Iron-on fabric was used for the instant appliqué technique.
- B. Appliqué banner made by first-grade children is made of red, yellow, and orange squares. Cutouts were adhered quickly with fabric adhesive.
- C. Sixteen third-grade children combined efforts for this large, lined, patchwork banner. Children attached their cutout shapes with running stitches. Each square represents a favorite book.

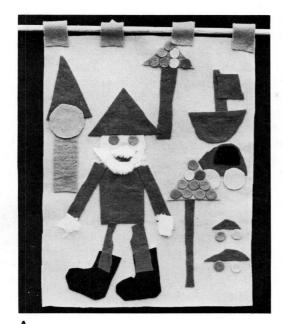

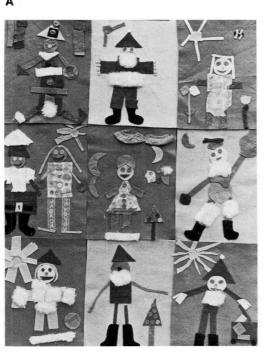

В

- A. Small, individual banner made by a five-year-old child is hung by felt tabs from a short dowel stick.
- B. Kindergartners made a "Santa and His Helpers" banner, using felt on felt and a bit of fake fur for textural emphasis. The banner was later disassembled so that the children could retain their individual panels.
- C. Preschoolers delight in playing with flags they made with felt, fabric scraps, and short sticks of wood.
- D. Colorful appliqué banners from Africa are living history books in that they tell of heroic deeds of a powerful dynasty of eleven kings who ruled for many years in what is now Dahomey. The banners appeal to the eye and heart of the viewer through their simplicity and boldness.

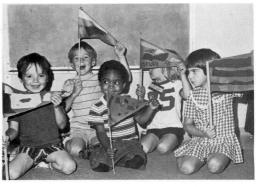

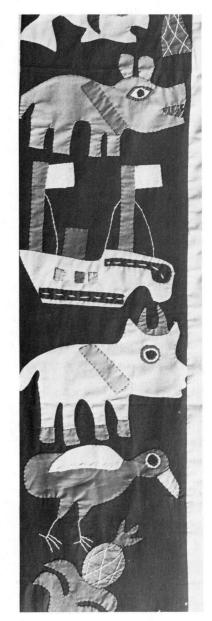

Banners and flags are a celebration in line, shape, color, and texture. They can be highly decorative with a unifying theme; they can be a culmination of a group's thoughts and feelings about an idea or an activity; they can convey a message, an emotion, or a story. A banner should present its message in a clear, effective display that is easily viewed from a distance. The project should utilize shapes, colors, and textures that contrast and reach out to communicate to all who see the finished product. Words and phrases can be used to clarify and enrich the general theme.

When children work together on a banner, they have a large space on which to organize their colors and shapes. Each child can actively participate in designing, cutting, pinning, and attaching the parts to the background, either with fabric glue or by sewing with simple running stitches. While first and second graders are able to pin their designs together and use a simple running stitch to hold the pieces in place, preschoolers and kindergartners should use fabric glue.

Banners can be made from many kinds of fabrics—in solid colors and in bright stripes and prints. Buttons, beads, lace, rickrack, braid, tiny mirrors, and mylar can be added to the designs. Yarn is sometimes used for linear details and for writing words. Both sides of felt banners can be used for designs.

Patchwork banners are recommended for group projects. Each child makes one square for the allover configuration, and then all of the squares are stitched together or adhered to a large felt or fabric backing. If regular fabric is used, it can be hemmed or bound with tape. Felt does not need hemming. These banners may hang in the room or school office for a number of weeks and then be dismantled in such a way that each child can retain his or her individual section.

As young children begin cutting fabric, they may need to have some demonstrations of a few techniques for using scissors—for example, how to hold the scissors, how to fold the fabric to cut out a small opening for an eye or similar small spot, how to snip fringe, and how to fold and cut a symmetrical shape. They should be encouraged to create figures in parts—cutting the body, legs, arms, hair, hands, and boots out of separate pieces of fabric. Children may wish to draw their designs with a piece of chalk first before cutting.

The top of the banner can be attached to a wooden stick or a metal rod by adding short straps of felt or fabric or by folding over several inches of the top and stitching it in place, leaving a narrow opening for the rod to slip through. Wooden balls or screw-on finials add adornment to the ends of this supporting pole. The bottom of the banner can have lead weights attached to make the banner hang evenly. Lightweight banners may need lining, although this is seldom necessary. Some banners have a rod or stick inserted through a hem in the bottom. A felt banner can be cut in a scallop or other decorative manner, with fringe, tassels, or ribbons attached.

Banners can hang flat against the wall, hang from a ceiling or beam, or be placed in a freestanding holder on the floor. Swinging wall brackets hold banners out from the wall, and, of course, banners can be carried in a procession or parade.

Older children enjoy the challenge of designing a room flag or a school flag that perhaps features the class motto, the team emblem, the initials or name of the school, or some other simple motif. Heavy canvas is a good backing for outdoor flags, and the edges should be hemmed before the flag is placed on a pole or holder.

Occasions for making banners and flags are endless. They may be created to welcome parents and friends to an open house, to say "Thank you" to the PTA for some project given to the school, to celebrate a special event or a change of season, to make a school picnic or musical performance more festive, or to wave in the wind at a school athletic event.

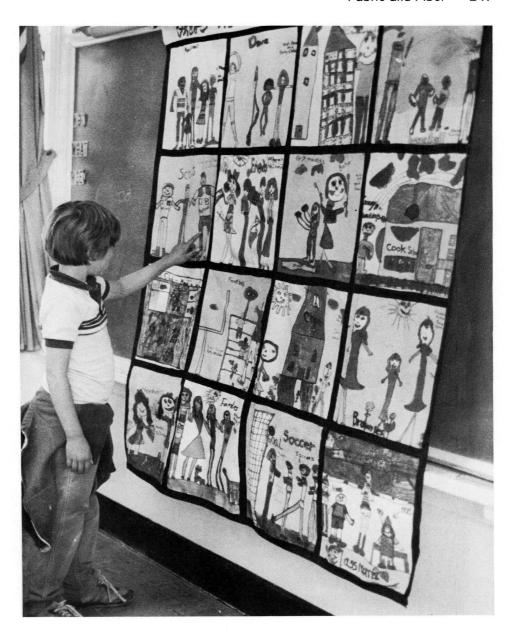

Permanent markers were used to make drawings on squares of muslin, and the squares were sewn together to make a quilt. The theme for this project was "Groups I Belong To," which the students were studying in social studies.

Stuffed Stuff

Drawing with felt pens on fabric or Dippity Dye paper takes on an added dimension when the figures are stitched to a backing and stuffed. The result is a type of soft sculpture that can be an individual production or an assembled group mural. When this sort of three-dimensional mural is disassembled, the individual parts are complete, and each child has a satisfying feeling of accomplishment.

Cotton muslin and Dippity Dye paper are inexpensive and provide a good base upon which the children can draw. If felt pens are used, the children should have an old magazine or several thicknesses of newspapers under the fabric or paper to protect the table or desk from ink stains.

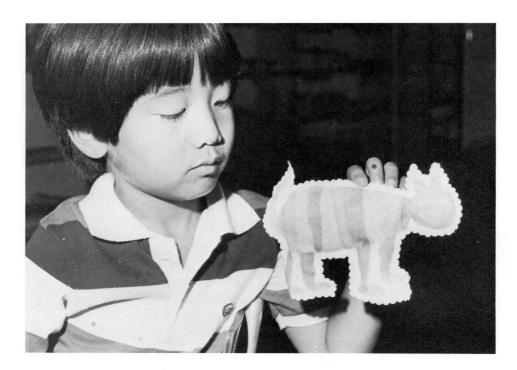

Fabric crayons were used on paper and the design ironed onto synthetic fabric to create this stuffed animal. Edges were trimmed with a scalloping scissors after stitching and stuffing.

After the children complete their drawings on fabric, the figures are placed on another piece of fabric and the two pieces stitched together on the sewing machine, with a few inches left open on one edge. It is easier to sew the two pieces together on the right side and then trim the raw edges with a pinking shears than it is to sew them on the wrong side and turn them inside out. The forms look neater if they are pressed before being stuffed. Polyester (available in pound bags), old nylon stockings, fine sawdust, or plastic bags are suitable stuffing materials. Small children can be taught a simple running stitch to use in sewing up the openings, or a sewing machine can be used by the teacher or a parent. Objects made on Dippity Dye paper can be stapled, glued, or stitched before stuffing.

The children should work with a fairly small piece of fabric or paper. In the case of the caterpillar shown, each child was given a circle approximately 7 inches in diameter, except for one child, who received a 10-inch circle with which he designed the head. The children decided to add pointed pieces of felt to each segment. Pipe cleaners and feathers were added to the face for antennae.

The first-grade children who drew themselves for the "Balloon Parade" had their choice of several sizes of fabric pieces. They were urged to use the entire height of the material for their figures. The stuffed figures were assembled on colored paper, and then a bit of bright yarn with a name balloon was attached to the hand of each figure.

The "Butterfly Tree" was done by a group of six-year-old children using felt pens. The variety in the allover designs and colors used is seen in each child's unique shapes and decorative details. The children perched their stuffed butterflies in a colorful swarm on a many-branched tree.

The "City Skyline" mural was drawn and assembled by seven-year-old children who had just completed a unit on city neighborhoods and who had studied the many kinds of buildings that make up a city. They had looked in detail at the shapes, sizes, and kinds of architecture—churches, factories, schools, apartment buildings, offices, and so on.

This type of soft sculpture offers a rich potential of creative tasks for young children. Backgrounds for murals can be made from paper, burlap, or felt. With each child drawing one or two elements for the total concept, the entire class feels the pride of

group effort, yet individual expression is paramount within the whole configuration. Children enjoy exploring the following topics for "stuffed stuff" murals:

- 1. Birds in a bush
- 2. An airport
- 3. A boat harbor
- 4. Houses on a hill
- 5. On our playground
- 6. Witches and goblins
- 7. Easter eggs hidden in the flowers
- 8. Dancing around the maypole
- 9. Children flying kites
- 10. Below the waves
- 11. Zoo parade
- 12. Birds, bees, butterflies, and blossoms
- 13. Burrowing animals, below the earth

Δ

C

В

Ε

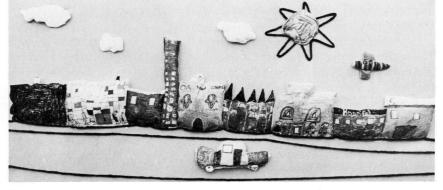

- A. A caterpillar is made of individual circles of fabric that are colored with oil pastels. Each child designed one section.
- B. In this "Balloon Parade," kindergarten children introduced themselves for an open house by drawing figures with felt pens and assembling the stuffed forms with name balloons on a colored-paper background.
- C. A butterfly tree was made by first-grade children, using felt pens on white fabric. When the tree was disassembled, each child retained his or her own contribution.
- D. Six-year-old girl draws a butterfly freely on fabric and fills in areas with felt pens.
- E. This city skyline is 7 feet long and epitomizes a study of urban architecture. Buildings show great diversity of shape and exterior ornamentation. Car, plane, sun, and clouds unify allover design.

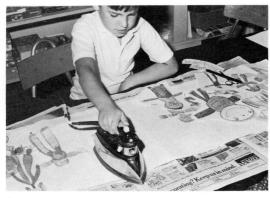

Α

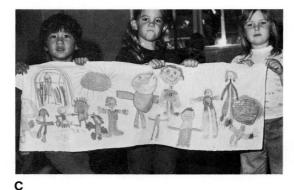

A. Each child's drawing, done with special fabric crayons, is cut out and ironed onto synthetic fabric.

B. The drawing is lifted from the fabric after being ironed.

C. Kindergartners display the group project after all the drawings have been transferred to fabric.

RUNNING

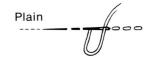

COUCHING

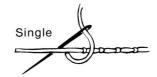

CHAIN

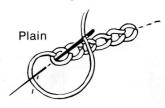

CROSS

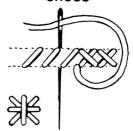

(Diagrams courtesy Lily Mills, Shelby, N.C.)

Basic stitches.

Fabric Crayons

With fabric crayons, children can make a drawing on a piece of ditto or typing paper, and then the paper is placed, crayoned side down, on a piece of 100 percent polyester fabric or pellon. A piece of ditto or typing paper is placed on top of the drawing while it is being ironed, with the iron set at "cotton." (The top paper protects the fabric from the high heat necessary to transfer the crayon.)

A large wall hanging can be prepared by having each child draw a small building, figure, flower, animal, or whatever and then ironing the drawings onto the fabric in a harmonious and unified arrangement. Individual projects include fabric pictures, pincushions, tree ornaments, and pillows. Also, small squares of fabric can be mounted on heavy paper for greeting cards. Fabric crayons are useful for making stuffed items, in that the fabric with the transferred drawing can be sewn to a piece of felt or other fabric as a backing, stuffing placed inside, and the edges pinked, scalloped, or just cut with a plain scissors. Since fabric crayon marks are permanent when applied to polyester fabric, teachers may enjoy making a garment for themselves, with each child drawing a small design and transferring it to the material before it is sewn together.

Stitchery—Basic Beginnings

Learning to express ideas in media other than crayons and paint is an important part of artistic growth in early childhood. Stitchery can be introduced by giving each child a 10- or 12-inch square of natural or colored burlap, some yarn, and a large-eyed, blunt needle. The teacher should pull threads in the burlap to assure straightness when cutting it and then should fold masking tape around all four sides to prevent the burlap from unraveling. Burlap is best sprayed with starch and ironed before the child uses it. An embroidery hoop or a wooden stretcher frame helps young children to control their stitches, although this is not absolutely necessary.

Blunt needles cannot be used for piercing fabric and felt, but they easily penetrate the loosely woven burlap. Children will want new pieces of cloth frequently, especially when they are just beginning stitchery, and therefore the teacher should have plenty of small pieces cut and available, along with short, cut pieces of colored yarn.

The first stitches of preschoolers usually are straight stitches arranged in a random fashion. The size and number of stitches will vary, since the child's attention span is quite short. Gradually, children become aware that they can consciously make their needles go up and down, right and left. They are not sewing a recognizable object at this stage. It is enough that they are learning to control their hands and fingers. By age four, they may begin naming what they have stitched, either before or after they have made it. Five-year-olds are eager to begin gaining more skill with the needle, and this is a good time to extend their vocabulary with color and texture words. Enthoven suggests that inspiration for a five-year-old could come from "taking a walk with stitches" by thinking of stitches walking quietly, running suddenly, going along a straight road or along a curving road, turning left, skipping, and taking long and short steps. Two people could go on the walk, with a second color for the second person.

Six-, seven-, and eight-year-olds are ready to learn more about specific stitches if they have had previous experiences with needle and thread. A sample of a few basic stitches made by the teacher and mounted in a display area encourages children to master a variety of stitches. Children can also invent their own stitches or variations of the basic ones. Four basic stitches are:

- 1. The **running stitch** is a basic in-and-out movement with the needle and yarn. The stitches on the top surface of the burlap can be tiny and the ones on the underneath long, or vice versa, or the stitches can all be somewhat the same size. Several rows of running stitches can be placed closely together to create a special effect.
- 2. The **chain stitch** is very useful for filling areas, and children may choose chaining to make a border entirely around the perimeters of their burlap.
- 3. The **cross-stitch** is made by making two stitches on top of each other in an X arrangement.
- 4. The **couching stitch** is very good for outlining and making borders. A piece of yarn is placed on the burlap in the desired linear configuration and secured with a few pins. Then another piece of yarn or embroidery floss is used to stitch it down. (See the diagrams.)
- A. Chain-stitched picture made by a Peruvian child is examined by a kindergartner.
- B. Stitchery from Colombia embodies symbols for houses, trees, and spatial concepts that are comprehensible to young children.

В

A. Masking tape keeps edges from fraying while child works on burlap. Here, a chain stitch is used for a border, while the animal is outlined with a running stitch. The child completes a French knot for an eye.

B. Couching is used as an outline for the face, with felt eyes and mouth attached with a running stitch and a chain-stitched nose added. Some children prefer embroidery hoops or a wooden stretcher frame to hold their fabric while they work.

While some of the technical needs of children during stitchery may seem cumbersome, the problems can be solved by working with small groups of children at one time, rather than the whole class. Several parents or intermediate-age children can aid in threading needles and securing the end of the yarn when the child finishes. Children often enjoy helping each other when a new stitch is introduced. The size of the fabric should be fairly small so that the child can finish the project before losing interest or patience.

Perfection in stitches should not be the primary aim in early childhood. The process should be relaxing and pleasurable, with the emphasis on spontaneity, inventiveness, and stimulating the child to want to continue developing stitchery skills. Once started, a stitchery can be something that the children can work on during their free time.

Some children like to stitch directly on the cloth in a spontaneous manner. Such children proceed in a "doodling" manner and let a design evolve, or else they have a preconceived idea of just what it is they want to create. Sometimes, children wish to make a preliminary drawing with crayons or cut paper. They can then cut out the main shapes and secure the shapes to the burlap with pins. Next, they can stitch around the shapes, remove their patterns, and fill in details with additional colors and stitches of yarn. Some children choose to make their drawing in chalk on the burlap before they begin to stitch. It is also prudent to save some of the children's drawings and have them use the drawings as ideas for their stitcheries.

Subject matter for stitcheries can be drawn from flowers, insects, animals, trees, butterflies, favorite stories, the sun, rockets, special holidays, poems, songs, and so on. An entire class can make alphabet squares, with each child selecting an alphabet letter and making an object to illustrate that letter. Later, all of the squares can be stitched together for a wall hanging.

For a large-group stitchery, a piece of burlap about 3 by 6 feet can be securely stapled to a wooden frame, with the children taking turns adding both appliqué and stitchery to represent houses, trees, people, and so on, perhaps on a multiple-base-line background. The edges of pieces of fabric for appliqué need not be turned under by young children; rather, they can simply be fastened to the background with a running stitch.

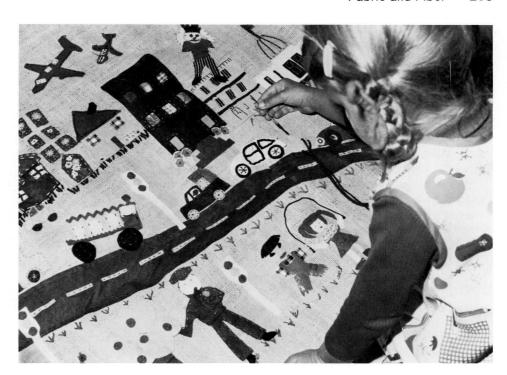

Large burlap mural can be a group project incorporating felt appliqué and four basic stitches.

Weaving

Weaving is the process by which fibers—yarn, string, and thread—are interlaced. It is an ancient craft, the basic principles of which have not changed through the ages. As long as thirty thousand years ago, cave dwellers mastered the weaving of simple baskets with straw, reed, and other natural materials. Perhaps, their inspiration came from observing birds building nests. Later, these prehistoric people wove with fibers and made cloth.

Young children can use a number of simple looms to create woven items for both utilitarian and decorative purposes. They find the over-and-under process fascinating and are delighted with their new skills. Even the youngest children are able to learn the terminology of weaving, and their finger muscles develop dexterity and control as they become sensitive to color, texture, and the elements of design.

By examining the woven artifacts of other times and cultures, as well as the works of contemporary craftspeople, young children come to value woven forms as genuine creative expressions.

Paper Weaving

Very young children find paper weaving easy to do and understand. Each child needs a weaving unit made from construction paper. The base is a piece of 12-by-18-inch construction paper or tagboard. Four strips that are 3 inches wide and 18 inches long are stapled to the base at one end. Two of the strips should be of light-colored paper, and the other two should be of dark-colored paper. The four strips should be attached to the base so that they alternate: one dark, one light, one dark, one light. These long strips, stapled at one end, become the warp of the weaving.

Each child has a weaving unit and eight strips of 2-by-12-inch black paper. To operate the weaving unit, the children first pick up both of the dark-colored strips in one hand. They then push in a black strip (the weft) with the other hand. Once the

black strip is in place, the children drop the dark-colored strips, pick up the two light-colored strips, and push in a new black strip. This is repeated until all eight of the black weft strips have been used, and the weaving is complete. The outside two warp strips should be stapled so that they are attached to the last weft strip and to the base piece. Other loose ends can be pasted by the children.

This weaving method also can be used to teach the alphabet, numbers, or color families. For example, the horizontal strips (warp) could all be white and marked with letters or names of colors or numbers (Arabic or Roman). Directions to children could be to pick up numbers one and three, or two and four. Or a child could be asked to pick up the strips that have the words *red* and *purple*, or *blue* and *orange* on them.

More horizontal strips could be added by making the strips only 2 inches wide (this would allow six strips to be stapled to the 12-inch base piece). Colored strips that are color related can be used so that children pick up first all the warm colors, then all the cool colors. Older children could number the strips and weave using the odd-numbered and then the even-numbered strips.

Advanced Paper Weaving

Again, a loom or base piece for the weaving is made from construction paper. The size will vary according to the size of a magazine picture selected by the child. The picture needs to be trimmed so that it is a square or rectangle. The construction paper should be the same width as the picture but needs to be 4 or 5 inches longer than the picture.

To make the construction paper into the loom, the children start at the bottom and make several cuts to within $1\frac{1}{2}$ inches of the top; a light pencil line drawn across the paper at the $1\frac{1}{2}$ -inch spot helps children to remember to stop. The width of the strips being cut by the students can vary according to the children's age, ability, and dexterity. The weaving is most effective if the strips are less than a half-inch wide, but this is only possible with older students.

When the children are ready to weave, they should cut one crosswise (horizontal) strip from the top of their magazine picture and weave the strip before cutting the next one. This eliminates confusion. The picture strip is woven over and under the construction paper strips. After a second strip is cut from the top of the picture, it is woven so that it is the opposite of the first one; that is, every place that the first strip went over the construction paper, the second one should go under. The converse is also true: Every place that the first strip went under the construction paper, the second strip should go over it. This over/under/over pattern is, of course, the foundation of all weaving.

The woven-in magazine picture creates an interesting effect in the completed weaving. Pictures cut from magazines like *National Geographic* are particularly good for use in this project since the pictures are colorful and the paper is sturdy.

Weaving on Cardboard Looms

A cardboard loom can be made by cutting ¼- to ½-inch notches along the upper and lower ends of an 8-by-10-inch piece of corrugated cardboard. Inexpensive chipboard looms with slits already cut are available from art-supply catalogs.

Any kind of nonstretchy yarn or string can be used to warp the loom. An end of the string should be attached to the back of the loom with a piece of masking tape. Then the string should be wound around and around the loom, fitting the string into each notch, top and bottom. When all the notches are covered, the end of the warp string should be tied to the end of the string that was taped to the back of the loom at the beginning. The youngest children should be given precut lengths of yarn, called wefts, to weave with. This enables them to put each piece of yarn over and under the warps separately and not have to go back and forth with a long, single weft string. The lengths should be cut about 3 or 4 inches wider than the width of the loom, and the loose ends project or hang down the sides.

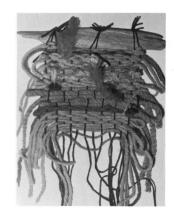

Weaving on a cardboard loom with weft threaded on a needle is an enjoyable task that challenges the child's ingenuity and skill. When the woven piece is finished, the warp threads should be cut from the loom and the top of the piece attached to a piece of wood.

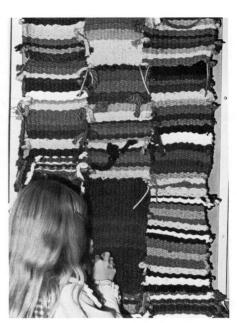

A. A cardboard loom is strung with warp, and short pieces of yarn are woven back and forth with the fingers.

B. Striped mats were made on cardboard looms by eightyear-old children and stitched together for a wall-hanging.

Mistakes on a cardboard loom are easy to correct by simply pulling out the weft. After the children have mastered the over/under process, they can thread a longer length of yarn on a large-eyed blunt needle or even a paper clip and use this as a shuttle to take the yarn over and under, and back and forth, in alternating rows across the warp strings. Different colors, textures, and thicknesses of yarn enable the children to create their own designs in their woven piece. They can arrange thick and thin stripes and alternate rows of different colors. The weft can be pulled up between each set of warp strings to create raised loops, adding a variety in height. The weft can be placed across the warps in a curved line and then the spaces created filled in with different colors of yarn. The children may choose not to weave all the way across the warps each time; rather, they may weave a column of eight or ten warp strings with one color and another column of four or five strings with a different color, thereby giving them more latitude in designing their woven pieces.

В

Probably the greatest problem that children encounter in weaving on a cardboard loom is how to avoid the "hourglass" effect; that is, the woven piece of fabric becoming pulled in and narrow in the middle because the weft yarn is being pulled too tightly as the children go back and forth with it. The teacher should demonstrate the proper procedure by weaving a piece of yarn across the the loom several times and leaving a small loop of yarn on either side before going back with it across the warp strings.

A pickup stick can be used to speed up the weaving process. A pickup stick is a flat stick of wood, perhaps a ruler, that is woven in and out across the warp strings and left in place. Then, each time the weaver desires to go from left to right with the needle and yarn, the ruler is lifted upright. This creates a "shed" in which every other warp string is lifted. The pickup stick on a simple cardboard loom can only be used when going in one direction. When returning in the other direction, children must use the over/under process with the blunt needle. The pickup stick is also very useful for packing the weft tightly in place. Generally speaking, the wefts completely cover the warp strings in the finished woven piece.

When the piece is finished, the warps across the backside of the loom are cut. Then the warp strings are tied together at the top and bottom of the woven piece to keep the weaving from coming unraveled. Additional clumps of yarn can be tied to the

bottom of the woven piece to make fringes. The top can be mounted by stapling it onto a stick of wood. In addition to wall hangings, woven pieces can also be made into mats and purses.

An attractive holder for dried flowers or pencils can be made from a flat piece of weaving after it has been cut off the cardboard loom. The two sides of the flat piece should be brought together to form a hollow cylinder and then stitched up. The bottom warps can all be tied together in a single overhand knot, or a large bead might be threaded onto all of them. The top warps can each be threaded on a needle and woven back inside the piece. After a loop has been attached to the top, the little tube can be hung on the wall and filled with dried flowers or pencils.

Soda-Straw Weaving

One of the simplest techniques for teaching young weavers is that of using a few soda straws and almost any kind of yarn. The finished product is a band or strap that can be used for belts, headbands, hatbands, purse straps, and so on. It can also be made into an attractive pencil or dried flower holder or napkin ring.

Each child needs five large plastic soda straws, with about 2 inches snipped from each one. Next, the desired length of the finished product needs to be determined, with 12 inches added for tying, and one piece of yarn cut to this length for each straw. It is best to use rather heavy yarn for threading through the straws as this gives more body to the finished item. The pieces of yarn are called "warps." One piece of yarn is then threaded through each straw and about an inch of the end of the yarn attached to the top of the straw with masking tape to keep the yarn from pulling down into the straw. The other ends of the yarn, extending out the bottom ends of the straws, are then tied together in one overhand knot.

A ball of yarn is used for the weft. A slipknot is tied onto the middle of one of the straws. Then the straws are fanned out—like a deck of cards—with one hand, and the weft yarn is moved in and out around the straws, going back and forth. When several inches of the straws are covered with the woven yarn, some of the woven part can be pushed gently downward on the straws and weaving continued. As the straws continue to fill and the woven part is pushed downward, the woven band soon is transferred onto the warp yarn that is hanging out of the lower ends of the straws. Weaving is continued until the desired length is obtained. Then the masking tape is removed from the tops of the straws, and the straws are pulled carefully upward and out. This leaves the warp yarns that were inside the straws inside the woven band. Next, the weft yarn should be cut, leaving a piece about 6 inches long. This "tail" should be threaded onto a large-eyed needle and inserted up inside the woven piece so that it does not come unraveled. The warp strings can be tied one to another at both top and bottom. A pencil or dried flower pouch can be made by weaving a band about 12 inches long, folding up a little less than half of the lower portion, and sewing up the sides with a matching piece of yarn. The small flap that is left at the top can be used for attaching a loop for hanging the pouch to the wall.

Wood Frame Looms

An entire class of young students can participate in making a woven wall hanging or table mat with a sturdy wooden loom about 14 by 24 inches or 18 by 30 inches. Finishing nails should be placed about ½ inch apart on both ends of the loom. Then string should be wrapped back and forth to form the warps.

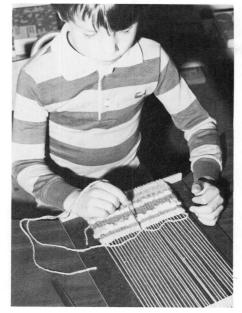

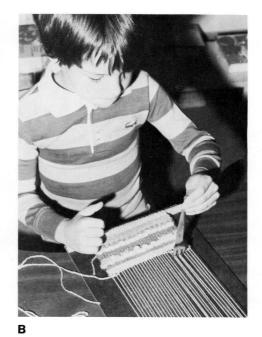

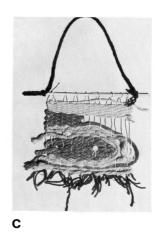

A

A and B. Weft yarn is woven over and under across warps and then "bubbled" downward in several places with a needle (A) before being packed neatly with a comb or fork (B). This helps to prevent an "hourglass" or pulled-in effect on sides of the finished piece.

C and D. Straw, braid, and lichen, as well as yarn, were woven into the warp strings on cardboard looms by sixyear-old children. Fringe tied on the bottom and a dowel through the top added finishing details.

E and F. Baker's clay beads, feathers, and other decorative objects can be added to a finished woven piece in a balanced or assymetrical arrangement.

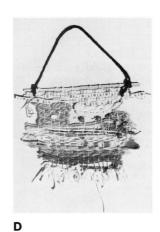

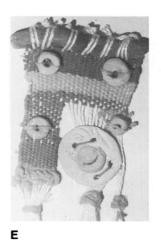

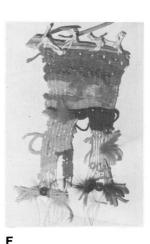

Individual wefts should be cut the width of the loom plus about 10 or 12 inches. The variety of materials that can be used for wefts is challenging: ribbons; strips of felt and other fabrics, including terry cloth, satin, muslin, and calico, of various widths; long pieces of straw and reeds; tissue paper, crepe paper, and newspaper twisted into strips; lichen; and, of course, thick roving.

A box of precut wefts that are all either warm or cool colors enables the children to make choices as to colors and textures that are harmonious, varied, and compatible. Students can take turns choosing several wefts and weaving over and under the warp strings, pushing each weft up snugly in place against the one above it. The ends of each weft extend beyond the sides of the loom and form fringe in the finished wall hanging

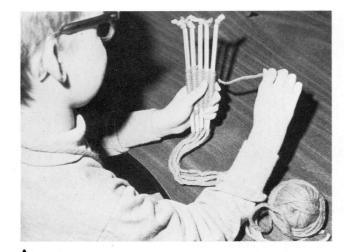

В

opportunities for multiple colors and textures. The weft strips are left loose at the end of each row to add decorative interest and to prevent the "hourglass" tightening that often occurs when students pull their weaving threads too tight.

Strip weaving provides

or mat. Older children can control the over/under, back-and-forth process more skillfully than the very young children and, using wefts that are several yards long, could weave back and forth several times with one piece, rather than dropping the ends on either side of the loom. When the wall hanging is completely filled from top to bottom with wefts, the warps can be eased off the loom, and the piece is finished. A metal rod across the top makes a good hanging device.

Rug Pictures

Rug making requires a minimum of space and equipment, yet the results are beautiful and the process quickly learned. A large rug picture takes a class a number of weeks to complete. Several children may work on it at one time, and children enjoy seeing their efforts add to the color patterns appearing in the cut pile.

Canvas mesh or scrim for the backing can be purchased in most department stores and yarn shops. It comes in widths of about 36 inches and should have 3½ or 4 holes to the inch. A practical length to buy for a class project is about three-fourths of a

A. Yarn is moved in and out around soda straws, back and forth, and the woven area is then moved downward gradually onto the yarn that is extending downward from the bottom of the straws.

B. The completed pouch for dried flowers is made by folding over soda-straw weaving, stitching up sides, and adding a loop at the top for hanging.

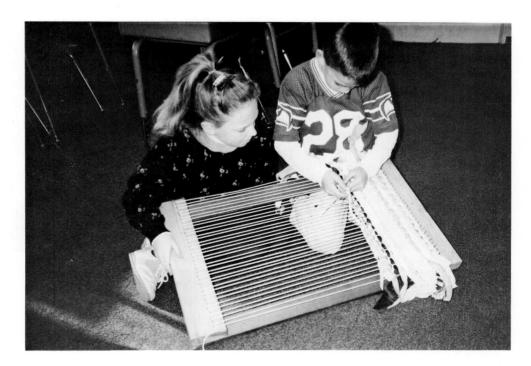

A group project—weaving on a wood-frame loom warped with string—provides an ongoing invitation to students to add precut wefts. Students find and collect all sorts of materials for wefts: lengths of fabric and felt, ribbons, twisted tissue paper, twisted newspaper, etc.

- A. Fold a piece of cut yarn in half behind the latch. Then push the hook down through the first hole, under the horizontal threads of the canvas, and up through the hole directly above. The hinged latch will fall open.
- B. Then, holding both ends of the yarn in the fingers, pull them around in front of the latch under the hook. Pull the hook toward you until the latch closes. Then let go of the loose ends.

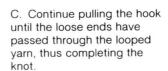

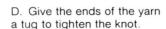

E. Each child can make a small square, hooking or tying the yarn in a simple design of his or her creation. When all the squares are completed, they can be whipped together on the reverse side to make a large patchwork-rug picture.

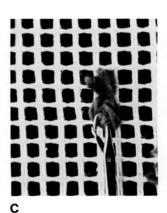

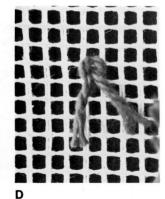

E

yard. It should be covered on the cut edges with masking tape to keep it from coming undone as the work progresses. Acrylic, Orlon, or rayon-cotton blended rug yarns can be used for rug pictures and are inexpensive and available in a wide range of colors. The skeins should be loosely wound in balls to prevent them from becoming tangled.

In talking with the children as they work on design ideas for a rug picture, the teacher should point out that, due to the nature of the yarn and pile, the motif should had and simple without too many small details.

be bold and simple, without too many small details.

Two techniques are recommended for transferring the children's design to the canvas backing. In the first, each child paints a picture with tempera on paper the same size and shape as the canvas. The class votes on its choice, and the picture is then placed on a table with the mesh on top of it. Next, several children draw the outline on the mesh with marking pens of matching colors. When the different areas are filled in with the pens, the children will know where to hook or tie knots with the different colors of yarn.

The second method for transferring a design to canvas is to have each child make a small drawing. These drawings are then placed one at a time in an opaque projector and viewed on a piece of white paper that is the exact size of the piece of canvas mesh. By moving the projector back and forth, the teacher can reduce or enlarge the image as desired to fit the shape of the paper. The students can then decide which design to use, or perhaps they will select parts of several different drawings to combine within one composition. The mesh should then be taped over the paper, and several children can draw the design on the mesh with marking pens, being careful not to stand in the way of the beams of light coming from the projector.

Two ways of filling in the areas with pile are described here. Small groups can be instructed at one time in how to use either the latch hook or how to tie rya knots. These children can, in turn, teach their peers, until all the class has learned the technique. Hooking and knotting are no more complicated for young children to learn than shoelace tying.

Latch hooks can be purchased in department stores or yarn shops. A latch hook is a small tool with a hinged latch that opens and closes to hold and pull the yarn before releasing it in a neat knot. The yarn is cut before it is used, and the cut length determines the height of the pile. Usually, about $2\frac{1}{2}$ inches is a workable length of yarn for finishing with a pile about 1 inch high.

The yarn can be precut by wrapping it a number of times, without stretching it, around a piece of cardboard 2½ inches wide. Then, a rubber band can be wrapped around the middle of the cardboard to hold the yarn in place, and the top and bottom of the yarn can be snipped with a scissors. These short pieces should be kept sorted by color in boxes or plastic bags.

The children should work on a table and try to hook across the canvas, starting at the bottom and working up, so that the pile falls evenly and in the same direction. However, they may enjoy filling in areas of the rug solidly in one color and completing the background later.

The rya knot is formed like the Ghiordes knot that is used in Oriental rugs, and the resulting short pile that it makes is called flossa, which is Scandinavian in origin. The rya knot is tied with a large-eyed needle. When a row of knots is completed, the row above it should be tied in every other hole to those knots of the preceding row. It is better to work from the bottom up so that the knots are all tied in the same direction and the pile falls evenly.

When the rug picture is finished, a narrow, flat piece of wood can be attached to the top to make it easy to hang. A class might like to present the finished work to the school office for all the children and teachers to enjoy.

- A. Canvas mesh can be placed on top of a child's drawing or painting and the picture drawn on the mesh with felt pens.
- B. A small drawing of "Cat with Flowers" is being enlarged by an opaque projector, while a six-year-old girl traces the images on the canvas mesh with felt pens.
- C. Six-year-old children enjoy the challenge of latch-hooking and delight in seeing their individual work contribute to the group production.
- D. The entire class of firstgrade children worked on this 2-by-3-foot rug picture.
- E. For the rya knot, cut a length of yarn about 2 feet long and thread it through the eye of the needle. Then poke the needle down through a hole in the mesh, leaving a 1-inch tail of yarn sticking up. A short piece of inch-wide cardboard is helpful in measuring the length of this tail.
- F. Then, holding onto this tail with the left hand, poke the needle back through the mesh immediately to the right of the hole where the tail is sticking out. Pull the yarn up. Then poke the needle down in the hole immediately to the left of the hole where the tail is, leaving a loop about as big as your finger.
- G. Now poke the needle up through the same hole where the tail is, coming out below that loop you just left. Pull both tails to the same 1-inch length as measured against the cardboard, and snip them with a scissors.
- H. Six-year-old youngsters are justifiably proud of their rya-knotted rug picture.

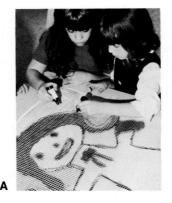

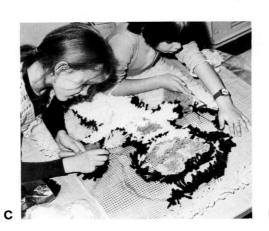

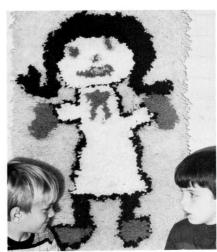

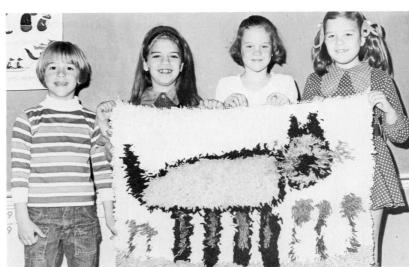

For Discussion

- 1. What was the purpose of banners and standards in the past? How are they utilized in contemporary times?
- 2. Which of the elements of art are particularly applicable in discussions about fiber art? If possible, bring in an actual weaving or banner and formulate appropriate questions for evaluation.
- 3. How does weaving lend itself to invention and exploration? In what ways can a teacher make connections to history and other cultures when introducing weaving to young children?
- 4. Refer to the four styles of art on page 40, and determine which one(s) could be used to design rug pictures.
- 5. Compile a list of local artists and craftspeople who work in fibers and who would be willing to demonstrate their art form to young children. Plan questions to ask that would focus the young learners' attention on such valuable concepts as color, texture, line, shape, and the ways the artist uses these in creating a design.

Notes

1. Jacqueline Enthoven, Stitchery for Children (New York: Van Nostrand Reinhold, 1968).

14 Celebrations

"If we want our world to be still, gray, and silent, then we should keep the arts out of school, shut down the neighborhood theatre, and baracade the museum doors. When we let the arts into the arena of learning, we run the risk that color and motion and music will enter our lives."

DAVID ROCKEFELLER, JR.

Seasons and holidays throughout the year offer exciting art opportunities for young children. However, the celebration concept can be abused if it is thought of only as a time to decorate the classroom with thirty look-alike turkeys, Santa Clauses, cupids, or bunnies. Patterns and copy work rob children of the chance to express their own feelings and thoughts in unique ways. They become obstacles to developing self-confidence, and they destroy a child's ability to respond imaginatively, joyously, and flexibly in a new situation.

The human need to celebrate and make an event festive is universal. It has been perpetuated and fostered by both young and old throughout history. In children, it can manifest itself in a variety of creative activities. Children's feelings about celebrations and their awareness of each holiday's meanings and symbols can be proclaimed when they draw, paint, cut, model, and construct with art materials. Several ways to encourage children to celebrate special days with original and unique art expression are suggested here.

Familiar Ideas with a New Twist

Placing holiday subjects and symbols in personalized settings or observing them in an incongruous or humorous activity humanizes a holiday or arouses children's sense of humor and causes their imaginations to soar in new directions.

The following list of topics for painting, drawing, cutting and gluing, print-making, modeling, and constructing incorporates familiar cultural symbols for the month of December and provides models for ways to encourage both imaginative and cognitive/affective responses:

- 1. Very fancy winter sun, snowflake, or star
- 2. Cherub rocking on a crescent moon or riding on a comet
- 3. Santa dancing, skiing, or playing a violin
- 4. Elf with a goat or riding a sled
- 5. Boy playing with a dreydl
- 6. Reindeer with bells on his antlers
- 7. Lighting candles on a menorah
- 8. Angel dancing or playing a guitar, banjo, trumpet

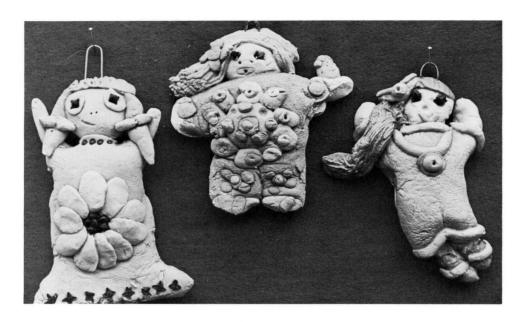

Dancing angels are modeled of baker's clay for holiday decorations.

- 9. Rocking horse, rocking lion, or rocking reindeer
- 10. Boy or girl drummer
- 11. Toy soldier blowing a horn
- 12. Mouse with holly
- 13. Elephant with a horn
- 14. My dove of peace
- 15. Quails in a bush
- 16. King or queen with a fancy crown
- 17. Alligator with a Christmas bird on his back
- 18. Raggedy Ann or Andy with a balloon

Backgrounds and Origins

Resource materials from the library can provide information about the origins of holidays and their traditional symbols—background that children need and upon which they can base fresh and insightful approaches in their image making.

The description that follows of how Valentine's Day came to be provides a number of motivations for art tasks. People long ago felt, loved, and thought the same as we do, and children find it easy to identify with these human drives and emotions and to make artistic responses.

It is believed that Valentine's Day had its beginnings in a Roman festival called Lupercalia, when the men wore hearts, pinned to their sleeves, on which were the names of women who would be their partners during the celebration. Sometimes, the couple exchanged presents—gloves or jewelry. In later times, a day honoring Saint Valentine preserved some of the old customs. Seventeenth-century maidens ate hard-boiled eggs and pinned five bay leaves to their pillows before going to sleep on Valentine's Eve in the belief that this would make them dream of their future husbands.

In 1415, the Duke of Orleans was imprisoned in the Tower of London. He wrote love poems or "valentines" to his wife in France, which are believed to be the first valentines. Sweethearts in the seventeenth and eighteenth centuries exchanged handmade cards trimmed with paper hearts and real lace. During the Civil War, valentine cards became popular in the United States. Satin ribbons, mother-of-pearl ornaments, and spun glass trimmed these elaborate cards.

The following themes for drawing and painting about Valentine's day stimulate original and personal art productions that incorporate historical and sometimes whimsical comments about February 14th:

- 1. Roman men wearing hearts on their sleeves
- 2. Seventeenth-century maiden dreaming of her future husband
- 3. The Duke of Orleans in the Tower of London
- 4. Civil War soldier giving a valentine to his sweetheart
- 5. Cupid using a bow to shoot heart-tipped arrows
- 6. Mermaid with a loving heart
- 7. Lion with a heart of gold
- 8. House made of hearts and flowers
- 9. Automobile with heart-shaped tires
- 10. Valentine bugs and butterflies in a valentine flower garden
- 11. The most beautiful and loving heart in the world
- 12. Lovebirds and lovebugs
- 13. Cupid with a daisy
- 14. The Queen or King of Hearts

Festivals and Parades

Preparing for and participating in a special festival or parade has much meaning and memorable enjoyment for the children. Folk festivals are characterized by ritual and tradition. Such occasions as harvest, seasonal changes, or the reenactment of historical or religious events are celebrated. Such is the innate human need that is satisfied by folk festivals and parades that they are found the world over. Sweden's Midsummer Eve festivities, Belgium's Procession of Penitents, Japan's Shinto Festival, China's New Year festivities, Munich's Oktoberfest, the Mummer's Parade in Philadelphia, the Pueblo Indian's Corn Dance, and the Rose Bowl Parade are examples.

Children's spirits and imaginations are stirred by parades. Children love parades—big ones, small ones, serious ones, and funny ones. They love the music, the color, and the costumes, and they especially love to be in a parade. A parade can be structured around almost any event. It can be small, casual, and impromptu, such as marching to a drumbeat to visit another classroom with all the children wearing their newly finished paper crowns or carrying paper-plate puppets on sticks. A parade can help the children to appreciate and remember a special event; for example, on "Space Day," the children can have a parade as they wear box or ice-cream-carton helmets. The children may wish to carry decorated balloons and to make banners on brightly colored pieces of paper and then move in a procession to celebrate the lives of Jacob Grimm and Hans Christian Andersen, tellers of fairy tales. All parades must have some central theme, some organization, pattern, or arrangement, some aspect of rhythm, and certainly color and spectacle.

The Coming of Spring

The celebration of the vernal equinox, or the coming of spring, can be made resplendent by the combined participation and efforts of several grade levels. A procession and a short program, complete with banners, simple costumes and headgear, flags, music, dances, food, poems, and stories can involve all the children in all of the arts.

In keeping with the spirit of spring, the children can embellish long cardboard tubes for make-believe horns and trumpets. Paper plates can be painted and mounted on sticks, with crepe-paper streamers attached to trail in the breeze. Short cardboard tubes with waxed paper wrapped around the ends become kazoos for the children to

Parents assist an all-day celebration, to enable young children to each take home a special silk-screen banner commemorating the annual event.

decorate and hum into. Aluminum pie pans taped together with pebbles inside make a satisfying rattling noise. Narrow strips of fabric or crepe paper tied to the ends of sticks serve as streamers to wave. Large, felt banners to celebrate the three spring months can be mounted, carried on poles, and incorporate symbols and words associated with the customs and historical proclamations of spring.

A maypole dance can be staged around a tether pole or around a long stick embedded in a bucket of sand. Long crepe-paper or fabric streamers should be attached to the top of the pole, with each child grasping the end of one strip. Each child then faces another child, and they walk around the pole, going over and under and carrying their streamers in what becomes a woven wrapping at the top of the pole. Very young children enjoy the simpler version—holding a streamer and walking around and around the pole in follow-the-leader fashion.

Large-size paper bags from the grocery store can be quickly converted into costumes for celebrations and imaginative play activities. At the same time, they provide young children with an opportunity to develop their painting and designing skills.

A large hole should be cut in the bottom of the bag for the head opening and small holes in the sides for the arms to go through. The edges of these holes should be covered with masking tape for reinforcement to prevent them from tearing when the children put on or remove their costumes.

Designs and pictures can be applied with paint and brushes or with paint from a tube. The children should be encouraged to make designs on the sides and backs of their costumes after the paint is dry on the front. Older children enjoy gluing on paper fringe, egg-carton bumps, and other shiny and textured materials in combination with their painted areas and designs.

Folded paper hats and crowns, crepe-paper headbands, and sashes can be made and worn by the children for the procession. The children can sing a few songs about spring and perhaps hear a poem written by several of the older children in honor of the first day of spring. The children are, of course, eager to eat cookies, candy, or bread that they have made in symbolic spring forms.

In designing banners and in making special drawings and paintings for a spring art exhibit, the children need to know the story of spring. Such information, provided in books and films, is helpful resource data for all sorts of stimulating art productions.

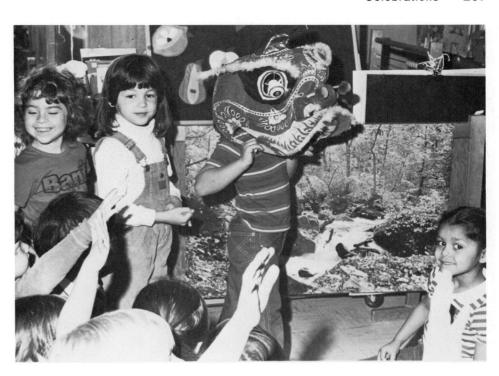

Kindergarten class participates in Lion Dance in celebration of Chinese New Year.

Mini-Celebrations

Consideration of some not-so-familiar days as possible vehicles for mini-celebrations provides many occasions for creative merrymaking and significant festivities. An interesting story or film about some historical first or important event gives children ideas for all sorts of art tasks—mural making, painting, dioramas, living pictures, construction activities, kite making, and puppet shows, to name but a few. In like manner, when birthdays of famous people are solemnized or celebrated at school, children are able to identify more closely with and appreciate those men and women who made important contributions to our lives.

The following is a sampling of noteworthy birthdays and events:

Sept. 15	Native American Day
Sept. 26	Johnny Appleseed's birthday
Oct. 2	Gandhi's birthday
Oct. 3	Universal Children's Day Celebration (Write to: U.S. Committee
	for UNICEF, 331 E. 38th St., New York, NY 10016)
Oct. 20	Circus Day (Barnum Circus opened in 1873)
Oct. 25	Picasso's birthday
Nov. 6	Basketball Day (game invented by James Naismith in 1891)
Nov. 9	Smokey Bear Day
Nov. 24	Pinocchio Day
Dec. 3	Gilbert Stuart's birthday
Dec. 16	Beethoven's birthday
Jan. 4	Louis Braille's birthday
Jan. 5	George Washington Carver Day
Jan. 9	First balloon flight in America, 1793
Jan. 31	Anna Pavlova's birthday
Feb. 15	Susan B. Anthony Day
Feb. 20	Buffy Sainte-Marie, American Indian singer, wrote song for
	Brotherhood Week

268 Celebrations

Feb. 24	Winslow Homer's birthday
Feb. 26	Buffalo Bill's birthday
Mar. 3	Dolls' Day in Japan
Mar. 6	Michelangelo's birthday
Mar. 7	Luther Burbank's birthday
Mar. 10	Harriet Tubman's death
Mar. 13	Uncle Sam Day (Date of first cartoon showing our national symbol
	as a character)
Mar. 22	Marcel Marceau's birthday
Mar. 26	Robert Frost's birthday
Mar. 30	Van Gogh's birthday
Apr. 8	Buddha's birthday, flower festival in Japan
Apr. 12	Imogen Cunningham's birthday
Apr. 13	Thomas Jefferson's birthday
Apr. 26	Audubon's birthday
May 2	Leonardo da Vinci's birthday
May 3	Solar energy day, "Sun Day"
May 6	Penny Black's birthday (world's first postage stamp, Great Britain)
May 23	Mary Cassatt's birthday
June 2	Martha Washington's birthday

Celebrating with Gifts

Throughout the school year, there are a number of celebrations when children want to give a present to a relative or friend.

Unfortunately, holidays and gifts are frequently excuses for dictated art, when teachers feel pressure to plan a project that will please parents and result in a product that is a guaranteed success. Many holiday arts and crafts books feature projects with patterns and finished products that can only be made one way, following step-by-step directions given by the adult. Little creativity or personal involvement is required, and children involved in this sort of activity develop the feeling that what they do on their own is inadequate. It is essential that children not become secondary to the product or gift they make. For this reason, it is educationally advisable to use as gifts some of the artwork that the child has produced during the regular instructional lessons.

The finest gift that a child can give is what truly comes from within. For this reason, art activities that require creativity and imagination and not all-just-alike products as gifts at holiday time are best.

The art production activities that follow are suggested for gift time. All of them are designed to result in a final product that is conceived and designed by the children to incorporate their skills of drawing, modeling, cutting, and assembling.

Creative Gifts

If the teacher has been collecting the children's artworks in portfolios, paintings can be selected and attractively mounted as gifts. Interesting parts of drawings can be cut to fit the fronts of inexpensive note paper. Greeting cards can be drawn, painted, or printed. Arrangements of dried flowers can be placed in a child's pinch pot or hanging weed pot. Fabric projects, such as batiks, stitchery, or fabric crayon designs, can be made into pillows, stuffed animals, or pincushions. Children can paint or draw selfportraits as gifts for parents or grandparents. They can decorate and bake cookies as a class project. They can create a collage of materials related to the holiday. Children can make mosaics out of holiday-related materials, such as pumpkin seeds or colored eggshells or herbs and spices associated with holiday cooking.

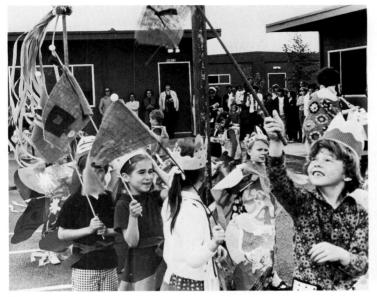

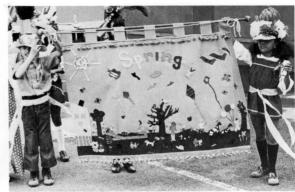

Δ

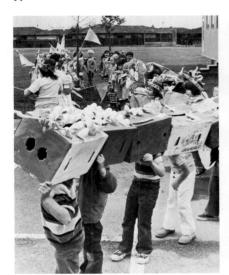

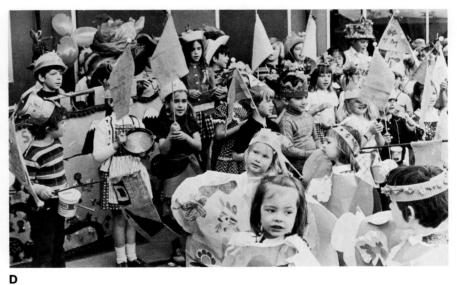

С

A. Pennants, crowns, and a maypole made colorful additions to the "Coming of Spring" festivities in which preschoolers through third graders participated.

B. Felt banners incorporating springtime activities were draped on a pole and carried in lead positions in the procession.

C. Kindergartners designed a many-legged caterpillar with cardboard boxes to represent the concept of new life in the springtime.

D. Imaginative musical instruments, individually designed hats, balloons, and paper butterfly costumes contributed to an awareness of the changing season and the warm, sunny days to come.

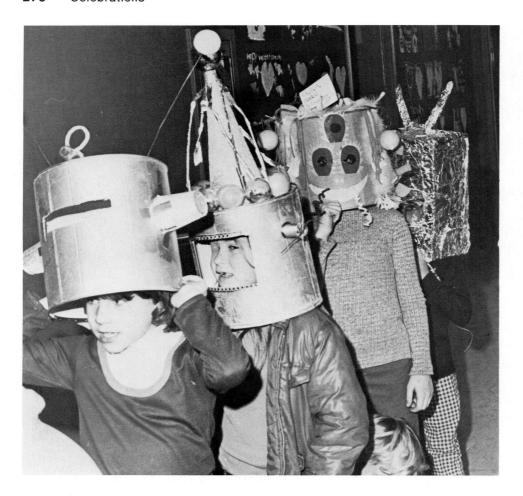

"Space Day" was celebrated by all the second-grade classes after they had studied the planetary system and human explorations into space. A special space-food luncheon was prepared, and each child created his or her own helmet for the afternoon parade held to honor the first space explorers.

Calendars

Colorful drawings, paintings, or cut-paper pictures that the children have made and of which they are particularly proud or, perhaps, artwork that they especially create for the occasion can be mounted and made into an attractive and useful calendar. Such calendars are a suitable gift project for preschoolers as well as older children because the artwork itself depends entirely upon the imagination and maturity of the individual child.

The child's drawing or painting should be attached to a contrasting piece of construction paper, colored tagboard, or poster board. Small, printed calendars are available in stationery stores and variety shops. They are inexpensive and have a gummed backing, making it easy for the young child to fasten onto the bottom of the frame or mat.

During the year, children may wish to replace the pictures they have put on their parents' calendar, changing them to ones that fit the season or that tell about an event that month. In such an instance, the teacher can stack eleven sheets of paper of the same size under the top picture and staple them all to the backing so that, as the months pass, the child can create a new picture on each of the eleven sheets.

By thus putting the child's art on permanent display, adults show their valuing and appreciation of the child's ideas. Since the artwork is original with each child, no two gift calendars are ever alike.

В

A and B. Mirrors and clown makeup prepare a student for commemorating Barnum's first circus performance in 1873.

C. A kindergartner's painting of a clown was made more detailed and aesthetically whole by the child's experience of applying makeup to his own face.

C

- A. These tiny pincushions with designs drawn on them with felt pens make attractive and unique gifts.
- B. A small funnel is helpful in filling pincushions with fine sawdust. The side opening is then stitched closed, and the pincushion is finished.

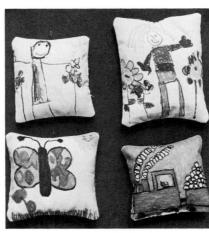

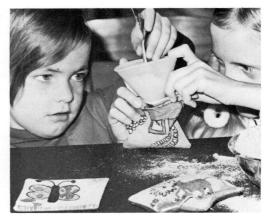

В

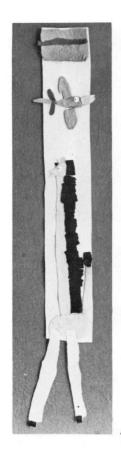

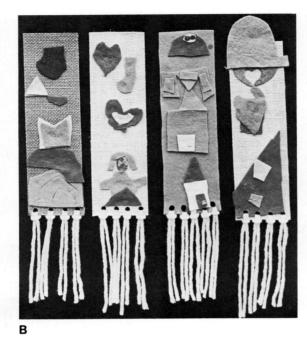

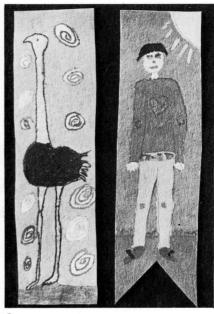

С

Bookmarks

Making bookmarks involves drawing, or cutting and gluing, with paper, felt, or burlap stripping, which can be purchased by the yard in hobby and craft stores. If children are to make bookmarks of paper or felt, the paper or felt should be cut in strips that are 2 or 3 inches wide and 7 or 8 inches long.

Children can snip out designs from assorted scraps of paper if their bookmark has a paper-strip base, or from felt scraps if their bookmark has a felt- or burlap-strip base. Paste should be used for paper bookmarks, while fabric glue is used to attach pieces to burlap or felt strips. The children may choose to make a realistic representation or an abstract design. Before they begin cutting, the children should think about tall, long, or thin things that fit the narrow shape of a bookmark; for example: a long-necked bird, a clown on stilts, an alligator, a fish, a mermaid, a tall building, a train, a skinny man or woman, a girl jumping rope, and a boy holding a balloon. Children should be encouraged to think in terms of adapting their design motif to the narrow shape.

The bottom of the paper, felt, or burlap bookmark can be cut diagonally, pointed, curved, or fringed, or finished in whatever manner the child chooses. A hole punch can make openings to tie on yarn loops for fringe.

Weed and Candle Holders

Young children love to work with baker's clay, rolling it into balls and coils, squeezing, poking, and imprinting it with any small gadget that is handy. A natural outgrowth of this play activity is the making of dried weed and candle holders. Children can gather

- A. A giraffe with fringed mane and a beady-eyed bird were designed by a six-year-old child to fit a long, narrow, felt bookmark.
- B. These bookmarks were made by four- and five-year-old children who cut out felt shapes and glued them to burlap strips.
- C. Pellon and felt pens were used for these drawn bookmarks.

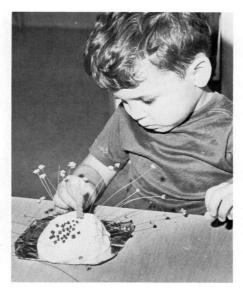

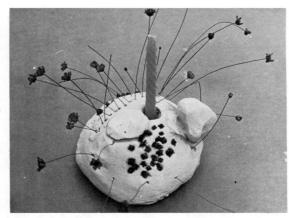

В

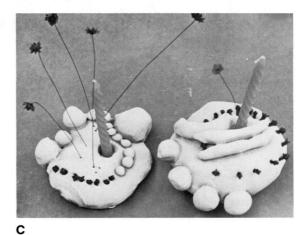

A. A preschool boy finds it intriguing to embed dried flower stems into baker's clay. Very young children enjoy participating in this art task and are proud of their products.

B and C. Small balls and coils of clay, as well as cloves, candles, and strawflowers, are combined by young children for these attractive table ornaments.

Children should model and work with their baker's clay on a small piece of aluminum foil. This makes it easy to lift the finished piece onto a baking sheet and place it in the oven. Cloves and peppercorns are good design motifs for the young child to embed in the clay in a linear or grouped arrangement. The candles and stems of the dried flowers can be stuck into the clay while it is being modeled, the flowers remaining through the baking process and the candles being removed beforehand and glued back in place later.

The lump of baker's clay that the children use for their holders should be about the size of a lemon. It requires several hours of baking at 300 or 325 degrees before it is thoroughly hard and dry all the way through. Colored baker's clay also can be used for making weed and candle holders and is best left to air-dry.

Plastic Plates

For an inexpensive price, attractive plastic plates can be made directly from children's drawings. The process requires a package of round paper blanks that are the exact size of the finished plate. (These are available in art-supply catalogs.) The children draw

on the round paper with water-soluble felt pens. The manufacturer stresses the importance of keeping the paper free of grit, oily hands, and dirt. The circles are then sent in to the manufacturer, who transfers the designs to sturdy plastic plates that are nonbreakable and dishwasher proof.

The children should work out their ideas for their plates on another piece of round paper first. By carefully placing the round paper blank on top of the original drawing and securing with masking tape in several places around the edges, they can redraw their design.

Decorating Paper for Gift Wraps

Very young children are captivated by the old Japanese technique of folding and dipping paper in dye. They like to make several sheets of this decorative wrapping paper because no two ever come out of the dye baths looking exactly alike. Two and three dips in the dye baths create merged and blended tones, while the pleasing repetition of colored shapes results from the way in which the paper was folded before it was dipped in the dye.

The paper should be folded in an accordion-like manner as illustrated in the diagram, and the resulting packet should not be too thick, or the dyes cannot penetrate to the center. A paper folded very small produces small patterns, while a larger fold creates larger patterns. A special absorbent paper called Dippity Dye is available from art-supply sources.

Dye baths can be made from paste food colors since these colors come in a large assortment of tones and are highly concentrated. The paste should be mixed with a small amount of water in a small bowl, plastic carton, or can. The color should be rather intense since the wet paper dries to a lighter tint.

The folded packet of paper should be dipped in the dye bath, one corner or side at a time and lifted out when the desired amount of color has been absorbed by the paper. Children quickly learn how to control the spread of the color by the length of time they leave it in the dye. The dyed packet should then be squeezed with the fingers, letting the excess color drip back into the dye and forcing the color evenly through the layers of paper. The packet is then dipped in another color that should be darker than the first—either by dunking a corner or side that was not dipped before or by redipping the tip of a corner or edge that was dipped before and removing it before the dye completely covers the first color. After the packet is squeezed thoroughly, it can be carefully unfolded and placed on newspapers to dry.

The brightly patterned paper can be pressed with an iron after it is dry and used for gift wraps, stationery trims, program covers, or greeting cards, or for covering cartons, boxes, cans, books, and notebooks.

Making Paper for Greeting Cards

What would the world be like without paper, and what would art be like if there were no paper upon which and with which to create? A man named Ts'ai Lun invented papermaking in 105 A.D. in China. The process was kept secret for many years but was finally introduced into Europe in the twelfth century and by the fifteenth century was used widely. The Arabs had learned about it and taken it to North Africa, whence it was carried across the Mediterranean to Europe. The first paper mill was started in Philadelphia in 1690, but until the 1850s, most paper was made by hand.

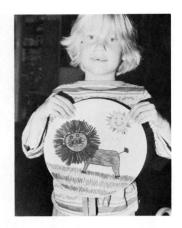

Plastic plates with the child's own drawing permanently applied make excellent creative gifts.

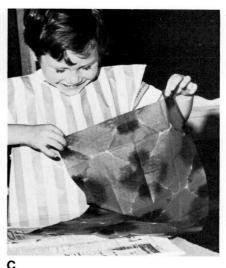

- A. A preschooler folds Dippity Dye paper in triangular accordion fold prior to dipping it in diluted food color.
- B. Corners or entire sides of the folded paper can be immersed in dye and removed when the desired amount of color has been absorbed.
- C. The magic moment comes when the child unfolds the paper and discovers the lovely pattern he has created.
- D. The paper can be folded in several ways before dipping and redipping it in dye baths.

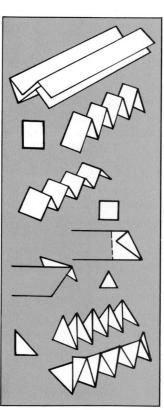

Paper is made from cellulose, which comes only from plant or vegetable fibers. Today, most paper is made of wood pulp in large mills, but old newspapers, wrapping paper, typing paper, paper towels, magazine pages, and advertising flyers can be broken down into pulp again and turned into clean new sheets of paper to be used for craft projects, greeting cards, or other types of artwork.

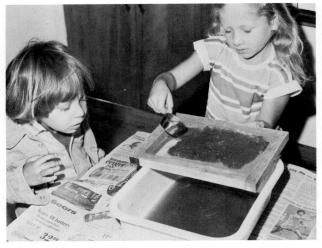

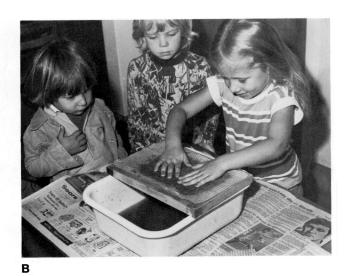

A. Slurry is poured through a screen, leaving the fibers in a layer on top, as the first step in making paper.

B. After a Handiwipe is placed on top of the screen, the child exerts gentle pressure to squeeze out the excess water.

Children are better able to appreciate Ts'ai Lun's original invention in the second century if they experience making their own paper for a special greeting card. The papermaking process, greatly simplified, can be duplicated in the classroom. Printing and drawing techniques can be used to illustrate the card, or tissue-paper collage designs can be adhered with liquid starch.

A food blender is needed to make the pulp for paper. The blender container should be about two-thirds full of water, and to this is slowly added about one cup of paper that has been torn in half-inch pieces. The mixture must be blended thoroughly. Separate colored sections of newspapers, comic sections, or any of the types of paper already mentioned can be used.

Such fibers as grass clippings, corn husks, dried leaves, rose petals, onion skins, hair, feathers, or any stringy vegetable matter finely cut up can be added to the torn paper and water mixture. All of this is blended until there is a pulpy mush called "slurry." Jars of different colors of slurry can be made.

A small piece of fine screening material, about 8 by 10 inches, is needed to make a sheet of paper from slurry. The screen should be attached to a wood frame. The children hold the screen, screen side up, over an empty plastic dishpan and use a plastic cup to dip out the slurry and pour it over the screen, distributing it as evenly as possible. Children may choose to use only one color of pulp, or they may pour, for instance, vellow pulp in one area and blue in another. At this time, the children can choose from bits of yarn, ferns, jute, butterfly wings, and so on, and place them on top of the slurry on the screen.

The slurry need not be placed in a regular rectangular shape on the screen. Children sometimes enjoy making a face or animal with different colors of slurry and leaving the outside shape of the paper the shape of the face or animal.

When the child is through pouring pulp through the screen, a Handiwipe should be placed on top of the screen and the water squeezed out gently, pressing from the center out. The screen is then turned over onto a stack of newspapers, with the Handiwipe on the bottom. The screen can now be carefully lifted off, leaving the Handiwipe on top of the newspapers. The handmade paper should be ironed until it is as dry as possible and then peeled off the Handiwipe.

For Discussion

- 1. Discuss and develop lists of topics for a month other than December and February. Research the origins of holidays, celebrations, and events for the selected month. (Be sure to include celebrations in the local community.)
- 2. Plan a parade or celebration to commemorate the birthday of a favorite artist. List appropriate activities, such as painting, puppets, mural making, and designing hats and costumes.
- 3. Select one of the gifts suggested in the chapter, and plan ways to guide the responses of a group of young children so that they tell how their own artwork is different and alike. (You may want to adapt one of the motivational strategies from chapter 2.)
- 4. Select one of the projects in the chapter, and plan ways to reinforce vocabulary and concepts presented in earlier chapters of the book. Discuss your approach, and give reasons for your emphasis.
- 5. Create a learning station that utilizes one of the ideas for celebrations.

Resources for Art Education

Student Textbooks and Packaged Programs for Elementary Classrooms

Art Image, grades 1-6, Monique Briere, Art Image Publications, Inc., P.O. Box 568, Champlain, NY 12919-0568

Art in Action, grades 1-8, Guy Hubbard, Holt, Rinehart and Winston, Inc., 1627 Woodland Ave., Austin, TX 78741 (800-782-4479)

Clear, Kay Alexander, Communicad, Wilton, CT, 1987.

Creative Expressions: An Art Curriculum, Lee Hanson, Dale Seymour Publications, Menlo Park, CA, 1986.

Discover Art, grades 1-6, Laura Chapman, Davis Publications, Worcester, MA 01608

Teaching Art 1-3, Laura Chapman, Henrick-Long Publishing Co., Austin, TX, 1989.

Through Their Eyes, Brooks et al., Primary level—A sequentially developed art program for grades 1-3, W. S. Benson and Co., Austin, TX, 1989.

Reproductions of Artworks

Abrams Art Reproductions, Haddad's Fine Arts, P.O. Box 3016C, Anaheim, CA 92804

Art Education, Inc., 2 E. Erie St., Blauvelt, NY 10913

Art in Action Enrichment Programs, 1 and 11, Holt, Rinehart & Winston, 1627 Woodland Ave., Austin, TX 78741 (800–782–4479)

Austin Reproductions, Inc., 815 Grundy Ave., Holbrook, NY 11741 (sculpture replicas)

New York Graphic Society, Ltd., P.O. Box 1469, Greenwich, CT 06482

Shorewood Reproductions, 27 Glen Rd., Sandy Hook, CT 06482 (203-426-8100)

Starry Night Distributors, Inc., 19 North St., Rutland, VT 05701 (800-255-0818)

University Prints, 21 East St., Winchester, MA 02890

Museum Reproductions (catalogs available)

Metropolitan Museum of Art, Special Services Office, Middle Village, NY 11381

Museum of Fine Arts, Boston, P.O. Box 74, Back Bay Annex, Boston, MA 02117

Museum of Modern Art, 11 West 53d St., New York, NY 10019-5401 National Gallery of Art, Publications Service, Washington, D.C. 20565

Filmstrips

Alarion Press, Inc., P.O. Box 1882, Boulder, CO 80306 (800-523-9177) Crizmac Art and Cultural Education Materials, 1641 N. Bentley, Tucson, AZ 85716

Crystal Productions, P.O. Box 2159, Glenview, IL 60025 (800–255–8629) Dale Seymour, P.O. Box 10888, Palo Alto, CA 94303

Watercolor, See for Yourself, Firstart, 1143 Snyder Ave., Philadelphia, PA 19148 (800-543-7746)

Wilton Programs, Reading and O'Reilly, P.O. Box 541, Wilton, CT 06897

Videos

Great American Artist series (available in art-supply catalogs)
Museum without Walls, video series (available in art-supply catalogs)
Queue Education Video (Home Vision Videos), 562 Boston Ave., Bridgeport,
CT 06610

Magazines

Art and Man, Scholastic Inc., 902 Sylvan Ave., P.O. Box 2001, Englewood Cliffs, NJ 07632

Arts and Activities, 591 Camino de la Reina, Suite #200, San Diego, CA 92108

School Arts, 50 Portland St., Worcester, MA 01608

Art Supply Catalogs

Beckley Cardy, One East First St., Duluth, MN 55802 (800–227–1178)
Dick Blick, Dept. A., P.O. Box 1267, Galesburg, IL 61401
Nasco, 901 Janesville Ave., Fort Atkinson, WI 53538; also 1524 Princeton
Ave., Modesto, CA 95352 (800–558–9595)
Sax Arts and Crafts, P.O. Box 51710, New Berlin, WI 53151 (800–558–6696)

Glossary

abstract

Abstract Expressionism

actual texture

adaptive tools

additive sculpture

aesthetic perception

aesthetics

allegory

ASTM

analogous colors

appliqué

ACMI

assemblage

asymmetrical balance

atmospheric perspective

background

balance

bas-relief

batik

A work or style that emphasizes design and a simplified presentation of shapes or forms. The subject matter may be recognizable but is transformed to emphasize colors, lines, textures, shape/form.

A 20th century painting style that features large-scale works and the expression of feelings through spontaneous, active brushstrokes.

Characteristic tactile quality of the surface of an artwork resulting from the way in which the materials were used.

Regular or specially manufactured art tools that have been adapted for use by handicapped persons in order to reduce frustration and provide better opportunities for success.

A three-dimensional work of art in which the parts have been made separately and added (often refers to clay).

A designation for a specific aspect of art education which refers to learning to see the world metaphorically (through symbols) as well as directly (through the senses), in order to understand the expressive significance of an image, its import of message as aesthetically expressed.

The study of the qualities perceived in works of art; also the branch of philosophy dealing with concepts such as "beauty," on which criticism or judgments of artworks are based.

An imaginative device whereby a work contains a secondary meaning conveyed by symbols and illusions in addition to its literal content.

American Society for Testing Materials, a non-profit organization that issues certification seals on non-toxic art products.

Colors that are closely related. For example, blue, blue-violet, and violet have the hue of blue in common. Families of analogous colors include the warm colors (red, orange, and yellow) and the cool colors (blue, green, and violet). Analogous colors are found next to one another on the color wheel.

A textile technique in which separate pieces of material are sewn or otherwise attached to a larger piece of fabric. The entire work is also called an appliqué.

Art and Craft Materials Institute, which certifies materials for safety according to stringent standards.

A three-dimensional work of art composed of fragments of objects or materials (often found objects), which were originally intended for other purposes; the combining of unrelated materials into a new creation.

Having the type of balance in which the two sides of an object are not exactly alike but are in a state of equilibrium.

An illusion of space in a two-dimensional work of art purposely created by progressive fainter and cooler (or bluer) hues to represent more distant objects (also called aerial perspective).

Parts of an artwork that are in the distance. The background is seen to be located behind the foreground and middle ground.

The organization or arrangement of the elements in a work of art so that there appears to be a visual equilibrium or equality. There are three kinds of balance: symmetrical (formal), asymmetrical (informal), and radial.

Artwork in which parts project from the background to form actual depth and no part is entirely detached.

A coloring or dying process that uses wax to protect design areas from coloration during the dying of the cloth or paper.

282 Glossary

bisaue blend

To mix colors together; also to progress smoothly from one color to another without making a

The first firing of ceramics before it's glazed and fired again at a higher temperature.

line.

braver

ceramic

collage

creative

cutout

A small roller used for inking a printing block or plate. A kind of drawing made up of flowing lines and simple, curving shapes much like those used calligraphic drawing

in calligraphy.

The visual focal point of a work of art; the area toward which all visual movement is directed. center of interest

An object made from clay that has been fired in a kiln.

A soft black material used to make drawings; also an artwork made with charcoal. charcoal

A two-dimensional work of art showing a whole or partial view of a city. cityscape

Space that is completely enclosed by a line. For example, a triangle is a closed geometric closed shape

To wind into rings, one above the other. Also the technique of forming a pottery vessel by coil

building up a series of clay "ropes" coiled one on top of the other on a flat clay base. Much of the pottery of primitive cultures was made by the coil method.

A pictorial composition created by attaching paper, fabrics, and other materials to a panel or paper; may be combined with painting or other techniques. Also a work so-called. When

three-dimensional objects dominate, the work is called an "assemblage."

An element in art that identifies the hue of natural and manufactured objects. Color is color

perceived as a response to the stimulus of radiant energy of certain wavelengths acting on the

eye's sensors.

color scheme The colors an artist uses; also the way colors are combined in an artwork.

color wheel A system of showing the relationships among colors in the form of a circle. Colors that are

next to one another on the wheel are called analogous colors; colors opposite one another on the wheel are called complementary colors.

Colors that are opposites on the color wheel and contrast with one another. When complementary colors

complementary colors are mixed together, they tend to subdue the intensities and produce grayed hues. When placed next to one another, they produce optical vibrations. Examples of pairs of complementary colors are blue and orange, red and green, and yellow and violet.

The arrangement of the elements of art (line, color, value, texture, space, shape/form) in an composition artwork according to organizational principles, in order to create a unified, balanced artwork.

The term is also used to refer to any work of art.

A work of art that is put together out of different pieces (rather than cast, modeled, or construction

carved). An assemblage is one type of construction.

A single line or lines that define the outer and sometimes the inner edges and surfaces of contour

objects or figures.

A drawing of an object using lines to show the outer and inner edges of an object. contour drawing

A principle of design that refers to differences in values, colors, textures, and other elements contrast

in order to achieve emphasis and interest.

Inclined toward one another or come together at a point on the horizon line; converging lines converge

in a two-dimensional work of art give the illusion of depth or space.

The family of related or analogous colors, ranging from violet through the blues and greens. cool colors

Cool colors are so-called because they remind people of cool places, objects, or feelings.

Having the quality of originality in thought and expression.

In art, a piece of paper cut into a shape and often arranged with other cutouts to form designs

and pictures.

decorative Used as an embellishment or ornamentation.

depth In a work of art, the real or apparent distance from front to back or from near to far.

Techniques of perspective are used to create the illusion of depth in two-dimensional artworks.

The selection and arrangement of the elements in a work of art. Also, an organized, creative design arrangement of the elements of an artwork (the lines, colors, textures, spaces, values, shapes/

forms).

detail The distinctive feature of an object or composition that can be seen most clearly close up.

Also, a small part of a work of art enlarged to show a close-up of its features.

Having an oblique direction; a line that extends either from upper right to lower left or lower diagonal

right to upper left. Diagonal lines suggest motion and activity.

distort To stretch or change something out of its normal shape; change in an image (usually through exaggeration of proportions or space) purposefully made by an artist to make the work more

interesting or expressive.

dominant

egg tempera elements of art

embellish emphasis

empty shape

engraving

etching

exaggeration expressive filled shape

fixative

focal point folk art

foreground

form

formal balance free-form fresco

gallery genre

geometric

glaze

gradation hard-edged

harmonious colors

hatching

high key horizon horizontal line

hue

illusion

illustrate

The part of the composition that is the most important, powerful, or has the most influence; the most prevalent element (a certain color can be dominant, as can a line, shape, etc.).

A type of tempera paint consisting of pigments mixed with pure egg yolk.

The visual parts of an artwork, such as color, value, line, space, texture, and shape/form; the "building blocks" an artist uses to create an original work of art.

To adorn or enhance with additions; to elaborate or decorate.

A principle of art by which the artist organizes the elements in order to place greater attention on certain areas, objects, or feelings in the artwork.

An enclosed space that is left bare (instead of filled with pattern, color, texture); see filled shape.

The process of incising lines into a surface to create an image; also a print created by this method.

A technique in which a metal plate is incised by acid through scratches in a waxed coating; the metal plate is then inked and printed on paper; also a print made by this process.

Magnification or enlargement of parts of an object or artwork.

Emotion, feelings, or mood shown in such a way that others can see and identify it.

An enclosed space that contains solid areas of texture, color, values, or patterns of repeated lines, colors, shapes, and values.

A liquid binder sprayed over artworks that are made with pastels, charcoals, and other materials to prevent smudging.

The central or principal point of activity or attention.

Traditional art made by people who have had no formal art training and who practice art styles and techniques handed down through generations.

The part of a work of art that appears to be in front, nearest the viewer. In a two-dimensional composition, the objects that are in the lower part of a picture appear to be in the foreground.

An object that has depth as well as length and width. For example, a circle is twodimensional and is a shape; a sphere is three-dimensional and is a form. Also, the style or manner in which artists present their subject matter—the product of artistic organization, design, and composition.

See symmetrical balance.

Not organized according to regulations or conventional rules; spontaneous.

("fresh" in Italian) A painting technique for making murals in which water-based paint is used on wet plaster surfaces.

A space devoted to the exhibition of works of art.

Paintings showing common people involved in ordinary scenes of everyday life, such as a domestic interior or a rural or village scene.

Employing simple rectilinear or curvilinear lines or figures used in geometry such as the circle, square, and rectangle.

In ceramics, a thin coating that is fused to a ceramic piece by firing in a kiln; a glaze may be applied by dipping, pouring, or brushing before the ware is fired. A glaze in painting is a thin film of transparent color laid over a dried underpainting.

A gradual, smooth change from light to dark, rough to smooth, or from one color to another. A technique in which shapes are clearly and sharply defined, often in a simple application in which values and colors are even and flat in appearance.

Colors that are perceived as going together because they are analogous, complementary, or otherwise related.

Use of parallel lines to create shading. When lines are overlapped at right angles to one another, the technique is called "cross-hatching."

Dominated by light, bright, or pale colors.

A horizontal line where water or land seems to end and the sky begins.

A line that is straight across, parallel to the horizon or level ground. Horizontal lines in an artwork give the feeling of quiet and calm.

The name of a color (such as "blue," "green," "yellow," "orange," "red," or "violet"); hue is another word for color.

False mental image; inaccurate appearance or impression. A common illusion in a work of art occurs when an artist uses perspective techniques in order to create the appearance of depth on a two-dimensional surface.

To create designs and pictures for books or magazines in order to make clear or explain the text or to show what happens in a story.

image

A likeness or representation of objects and lifeforms used as the subject matter in a work of art. Also, a mental picture of something that is not in existence.

image banks

imagination

implied lines

Observations of the visual world stored in memory; these stored images serve as a resource from which the mind can create realistic or imaginative images in works of art.

The power of recombining experiences or memories to create new images and ideas.

The illusion of a line that does not exist in reality. Implied lines are created (1) when a visual series leads the eye from one point to another, or (2) when a change in surface suggests an

edge to a shape or form.

informal balance

See asymmetrical balance.

(in-tahl-ee-oh) A printmaking technique that transfers ink from areas (etched, engraved, or scratched) beneath the surface of a plate onto paper thus forming a type of two-dimensional art called a "print."

intensity

intaglio

The brightness, strength, or purity of a hue or color. For example, a pure blue is very intense or bright; when its complement (orange) is added, it becomes dull or less intense. The intensity of a color can also be changed by adding neutrals (black, gray, white).

intermediate colors

Any of the six colors that are located between the primary and secondary colors on the color wheel; hues created by mixing primary colors with their adjacent secondary colors.

irregular shapes

Shapes that are not geometric or predictible. (also called "free-form" or "natural") Many

shapes in nature are "irregular" or "natural."

manufactured or manmade.

landscape

A work of art that shows the features of the natural environment (trees, lakes, mountains). Although figures and manmade objects may be included in a landscape, they are of secondary importance.

latch hook

A hand tool with a hinged closure that holds a strand of yarn as it is pulled through backing; the hinge opens and releases the yarn to make a knot, and the yarn ends become part of the pile in a rug or wallhanging.

line

A continuous mark or stroke with length and direction, created by a tool such as a pencil or pen that leaves a mark as it moves across a surface. A line can vary in length, width, direction, curvature, and even in color; it can be 2-D (a mark on paper) or 3-D (string or wire), or even implied. Line can refer to the boundary or external/internal edges of a shape or

linear perspective

A system of drawing or painting to give the illusion of depth on a flat perspective surface. All lines that appear parallel converge on the horizon line at one or more imaginary vanishing

line drawing lithography

A picture composed only of lines, having no shading or areas of color.

A printmaking process in which a flat stone, previously marked with a greasy substance (suspended either in liquid or a special crayon) that will retain the printing ink, is processed, inked, and run through a printing press along with paper. The print that results is called a "lithograph."

loom

A frame or device in which yarns or other fibers are woven into fabric by the crossing of threads (called "weft") over and under stationary warp threads.

low key medium Dominated by dark or subdued colors.

A material used by an artist; often implies the technique of using that material. Plural is "media."

middle ground

Parts of an artwork that appear to be between objects in the foreground and those objects in the distance (background).

mobile

A balanced construction with moving parts, which is suspended from a single point above and which moves freely in the air currents; invented by Alexander Calder in 1932.

modeled

Using light and dark values on a two-dimensional surface to give the illusion of light falling on a three-dimensional form, delineating its form by means of shadow and light.

monochromatic

One color; refers to colors formed by changing the values of a single hue by adding the neutrals (black, gray, white).

mood

The feeling created through a work of art.

mosaic motif

A picture made by filling together small tiles, stones, pieces of paper, or other materials. In design, the recurrent configuration repeated in a pattern. Also the main subject or idea of a work of art (such as "landscape" or "still life").

movement

The arrangement of parts in a work of art to create a sense of motion by leading the viewer's eye through the work. Also a style or type of artistic practice (such as the Impressionist movement).

mural

museum

negative shape

neutral

non-objective art

non-toxic observation oil paint

one-point perspective

opaque open shape

optical original outline

overlapping palette

pastel

pattern perception

perspective

pigment pointillism

•

portrait

positive shape

primary colors

primitive

principles of art

print

process

product profile

progressive pattern

A painting on a wall, usually large in format; may also be a large piece designed to attach to a wall.

A building or place where works of art are kept and displayed.

(also called "negative space") The area around objects; called background in a painting or drawing. Can also exist as interior spaces in artworks such as open areas and shapes within a sculpture.

A color not associated with a hue. Neutral colors include black, white, gray, brown, and tan. A hue can be neutralized or dulled by adding some of its complement to it.

Art that has no recognizable subject matter; the focus may be on color or the composition of the work itself. Also called "non-representational art."

Substances that are not harmful; non-poisonous, safe.

The act of attentive viewing for a special purpose.

Opaque mixture of pigments dissolved in linseed oil, using turpentine as a solvent; used as paint applied to a panel or stretched fabric.

The representation of three-dimensional objects and space on a flat perspective surface; parallel lines appear to get closer together in the distance until they merge as a single, imaginary vanishing point on the horizon.

Not allowing light to pass through; not transparent.

Space that is partially enclosed by a line; in many cases, the viewer's eye will optically close the gap and perceive the implied shape.

Pertaining to the eye or what is seen.

Inventive or creative; new, fresh, never before seen.

The line by which an object is defined or bounded; a line that represents the edges of a shape or form (sometimes called the "contour").

Covering or extending over part or all of an object.

A board or flat surface on which a painter places and mixes the paint to be used. Also, the typical group of colors that a particular artist (or group of artists) uses.

A colored, chalky drawing stick; when pigment and oil are mixed and formed into a drawing stick, it is called an "oil pastel." Also, a tint of a color (such as pink).

A design in which the elements (such as lines, colors, shapes) are organized in recurrent series.

Gaining of knowledge and insight about the visual and tactile qualities of the world by means of the senses and the mind.

The representation of three-dimensional objects and space on a flat surface to produce the same illusion of distance and relative size as that received by the human eye.

A dry substance that supplies the coloring agent for paint, crayons, chalk, inks, and dyes. A method in which the principle of optical mixture of broken color is the foundation for applying colored pigment in tiny dots or small, isolated strokes. When viewed from a distance, the points of color appear to blend.

An image of a person's face made with any two-dimensional medium or sculptural material. (also called "positive space") The area that makes up an object; the objects themselves as opposed to the background or space around the objects.

The hues from which all other spectrum colors can theoretically be made: red, yellow, and blue are the three paint primaries. In practice, it is necessary to use secondary and intermediate colors such as green and violet to duplicate many hues because an artist's pigment is not "pure color." The three beam-of-light primaries are red, blue, and green.

Early or less sophisticated; also used to describe the art produced by untrained or self-trained artists.

A characteristic form of composition or organization that includes balance, emphasis, variety, proportion, movement, rhythm/repetition/pattern, variety and unity.

A multiple impression made from a master plate or block by an artist. (The three major categories of original prints are intaglio, relief, and planographic.)

A series of progressive and interdependent actions and thoughts directed toward specific learning, and often products, as part of meaningful art experiences.

A work of art; the end result of the art process.

The outline of an object, especially the human face or head as viewed from one side; also a picture of the human profile.

A pattern that develops step-by-step, as from larger to smaller or from smaller to larger.

proportion

A comparative size relationship between several objects or between parts of a single object or person. In art works depicting the human figure, the correct relationship between the size of

purpose

The reason for which a work of art was created by the artist. A design based on a circle with features radiating from a central point.

radial balance realistic

Art in which the subject matter is true to life without stylization or idealization.

relief prints

All those printing processes in which all nonprinting areas of a block or plate are carved, engraved, or etched away, leaving on the original plane surface only those lines and areas to be printed.

repetition

Motifs or elements shown over and over in a work of art; often creates movement and rhythm in an artwork.

representational reproduction

Any artistic style in which objects or figures are easily identified.

resist

A copy or duplicate of an original work of art.

rhythm

Process in which lines or surfaces are made with wax- or oil-based materials so that pigments suspended in water will not penetrate.

rubbing

Movement in an artwork or design, often developed by repeated shapes, lines, or colors. A handmade replica of an incised or carved surface made by laying a piece of paper tautly

rya knot

over the surface and rubbing it with some black or colored material. (also called a "frottage") Fibers tied tightly in a handwoven rug to form a thick pile, usually with a strong, colorful design (originated in Rya, Sweden).

schema

Organized set of marks forming recognizable images in drawings and paintings.

sculpture

seascape

A three-dimensional work of art; a type of artwork seen in the round.

secondary colors self-portrait

A work of art that shows part of the sea as the major image. Orange, green, and violet; hues produced by mixing adjacent primary colors.

A drawing, painting, or other representation of the artist, made by him/herself.

serigraphy

Creative silkscreen printmaking in which the artist designs, makes, and prints the stencils to create an original work of art.

(Italian for "smoke") Term used to describe the blending of edges of figures and objects, creating a hazy impression and aerial perspective.

shade

sfumato

Black added to a color to make it darker; shades are dark in value.

shape

An element of art that is an enclosed space, having only two dimensions. Shapes can be geometric (triangles, squares, circles, rectangles) or free-form (organic) with curving and irregular outlines.

silhouette silk screen A black or dark shape formed to represent the outline of an object, often a person's profile. See serigraphy.

sketch slab

A quick drawing that catches the immediate impression of a person, place, or situation. A manual technique of forming a ceramic object from wet clay that has been rolled and

slip

In ceramics, a very fluid mixture of clay and water used both as a clay glue and as a pigment on leather-hard ware.

space

An element of art that indicates open areas in an artwork; also the illusion of depth in a twodimensional work of art.

spectrum

The full range of pure colors; bands of colored light created when white light passes through a

stabile

Similar to a mobile but is rigid and stationary rather than flexible and suspended; invented and named by Alexander Calder.

stencil

A method of producing images by cutting openings in a mask of paper or other material so that paint or dye may go through the openings to the material beneath.

still life

A drawing or painting of an arranged group of inanimate objects; usually, a still life is set indoors and contains at least one object such as a vase, bowl, bottle, or goblet.

stipple

To make small dots with the point of a brush by tapping with repeated staccato touches.

studio

The workroom of an artist.

style

Distinctive characteristics contained in the works of art of a person, a period of time, or a geographic location.

subtractive sculpture Surrealism

Sculpture formed by cutting away excess material from a block to leave the finished work. A style of art in which artists combine normally unrelated objects and situations. Surrealist artists utilize the subconscious as a source of inspiration.

symbol symmetrical balance A form, image, sign, or object representing a meaning other than the outward appearance. Having the type of balance in which the two sides of a composition or object are mirror images of one another (also called "formal balance").

tactile

technical properties

technique

tempera texture theme

three-dimensional

tone toxic transparent

two-dimensional unity

value value scale

vanishing point

variation variety vertical viewfinder viewpoint

visual literacy

visual memory

visualize warm colors

warp

wash watercolor

weaving weft

woodcut

Pertaining to the sense of touch. Qualities of an artwork resulting from the use of materials, tools, and processes.

The manipulative skill an artist employs in use and mastery of materials; also the artist's general knowledge of the mechanical details of the artform.

A water-based paint using opaque pigments.

The element of art that refers to the quality of a surface, both tactile and visual.

Images related to a common idea or subject and used in an artwork. An example would be art that shows "my family" or "a rainy day."

Having length, width, and depth. An example of a three-dimensional artwork would be a sculpture.

A light value of a hue, made by adding white to the original color. The modification of a color through the addition of neutrals.

Substances that are harmful or poisonous.

Having the property of allowing light to pass through so that objects underneath can be seen; the opposite of opaque. Watercolor paints are said to be transparent. Having length and width; flat. An example of a two-dimensional artwork would be a painting.

Having length and width; flat. An example of a two-dimensional artwork would be a painting A principle of art in which the elements are organized or combined with one another so that they form a harmonious whole.

An element of art that relates to the lightness or darkness of a color or a tone.

A series of tints and shades of one color or tone ranging from the lightest at one end and

gradually changing into the darkest shade at the other end.

In linear perspective, an imaginary point or points on the horizon line at which all lines will appear to converge.

A change in appearance that makes an object different from the others it resembles. Being varied or diverse; changed to add interest to an artwork.

Perpendicular to the horizon; upright or going up and down.

A frame that shows a portion of the environment; used to find an image for use in an artwork. A position from which an object or scene can be observed.

The ability to perceive and differentiate the sensory and expressive qualities in the visual world and to decode the symbols or messages that are aesthetically contained in artworks and the environment.

The ability to remember the appearance of objects or scenes when they are no longer available for viewing.

The appearance of texture in surfaces that actually have none. A photograph of tree bark would be an example.

To form a mental picture; to see in the "mind's eye."

The family of related or analogous colors ranging from yellow through the oranges and reds. Warm colors are so called because they remind people of warm places, objects, or feelings. The set of yarns placed lengthwise in the loom, crossed by and interlaced with the weft to

form a woven fabric.

A thin, transparent layer of paint.

Any paint that uses water as a medium, including acrylic, tempera, and transparent watercolor. Also an artwork made with transparent watercolor paints.

A pattern or method for interlacing yarns or other fibers to create fabric.

The yarn or fibers that create the texture, color, and design of a textile; the filler or set of yarns placed crosswise to and interlaced with the warp.

A relief printing technique in which the printing surface is carved from a block of wood. Also an original print made by this method.

ant boxes en

Index

abstract, 15, 40 acting it out, 115-16 achievement expectations, 83, 144 actual objects, 105, 109, 136, 138 Aesop's Fables, 115 aesthetic judgment and criticism, 2, 4, 6-7, 14-17, 38-40, 41, 43, 187 aesthetic perception, 6, 7-9, 119, 136 aesthetics, 2, 6, 7, 17 alphabet stamps, 184 analogous colors, 20, 38, 144 analysis, 38, 39, 40-41 Architecture, 199-200, 232 Art Ark, 46 Art Boxes, 47 art elements (see elements) art fairs, 49 art history, 2, 6, 40 "Art-in-a-Trunk," 45-47 Art Learning Stations, 126-28 art principles, 4, 9 art production, 4, 5, 7, 9-13, 87 art program, sequential, 67, 132 art room, 94-96 art skills, 83, 116-18, 144, 146 Art Squares Game, 58 Artcentration Game, 58, 59 artistic expression, 4, 9-12, 110 artistic heritage, 1, 12-14, 38-40, 110-13, 136 artistically talented, identifying, 85-87 artists in schools, 48, 93 art education, xxii, 5 Arty-Knows Game, 59, 60 assymmetry, 32 attitudes, xxiii, 1 auditory learners, 107

badges, 16
Bag of Textures Game, 60
baker's clay, 211–13, 239, 245
baker's clay recipe, 208
banners, 243–47, 262, 266, 269
base line, concept, 76, 78–79, 106, 181
base-line deviations, 78–79
basic education, xxii
batik, 149, 150
batik, simplified, 152

beads, 208-10, 220, 255 big head symbol, 75 bisqueware, 206 board looms, 254-56 bookmarks, 272, 278 books, sources for, 278 box puppets, 238 boxy beings, 227 boxy constructions, 221-23 Boyer, Ernest, xxiv brain, hemispheres of, xvii-xix, 107 brayer, 189, 190, 192-93, 199 bread recipe, 216 bread sculpture, 214 Bruner, Jerome, 75 brushes, 127, 140 Bryant, Antusa, 102 bulletin boards, 1, 11, 122 buttercream frosting recipe, 218

calendars for gifts, 270 California Art Education Association, 83, 91 candle holders, 272-73 candy clay, 217, 218 carbon-paper prints, 193, 195 card prints, 194, 195 cardboard looms, 254, 255 cardboard strip prints, 196, 197 catalog clips, 126, 129, 148 celebrations, 263, 268, 274 Chagall, Marc (model for criticism), 40-41 chalk, 164, 168 Chapman, Gay, 102 Chapman, Laura, 6 Circle-in-a-Picture Game, 61 circles, derived from scribbles, 73 clay, 192, 201-5 clay prints, 192 coiling clay, 202, 205 collage pictures, 174 collages, tissue-paper, 180-81 color object relationship, 142-43 Color: Tint and Shades Game, 61 color wheels, 144 coloring books, 19, 68, 123 Coming to Our Senses, xxii, xxvi

community resources, 44, 45, 46, 48, 50, complementary colors, 20, 22, 38, 144 components of art, 4-6, 7, 9 construction activities, 199-210, 223 construction, clay, 201-20 contour, 23, 38, 138 controlled scribbling, 70 cool colors, 20, 21, 143, 144 cootie-catcher puppets, 236 copying, 68, 123 corrugated paper crowns, 176, 177 costumes, 265, 266 crayon melter, 162 crayon rubbings, 179, 180 crayons, 138, 146 creative characteristics, 2, 3, 121 Creative Expressions, 132 creative skills, 4 criticism (see aesthetic judgment) crowns, corrugated paper, 176, 177 cut-paper murals, 181-82 cutting fabric, 246 cutting paper, 171-72

decorating paper, 274 descriptions, 38, 40 development characteristics, 67 developmental needs, 2 developmental sequence, 67, 132 deviations from base line, 78-79 dictated art, xxiv, 100 direct observation, 84, 104, 109, 134 directed method, xxiv discipline-based art education, 6, 38, 40 discussion of art, 14, 15-17, 20, 21-37, 41-43, 56, 87, 90, 102, 117, 118-19 divergent thinking, xviii docents, 52-56 Dodds, Stephen, 6-7 drawing, 134-40 drawn batik, 152 dulled colors, 21, 144, 146

easels, 140-41 edible art, 214-21 edible jewelry, 218, 219 edible puppets, 220-21 Edwards, Betty, xx Eisner, Elliot, 16 elements of art, 7, 14-15, 20-30, 43, 116, 117, 232, 262 emphasis, 32, 33, 39 encaustic, 162, 163 encouragement, role of, 71-73, 117-18 Enthoven, Jaqueline, 256 environment, 91, 92, 94-95, 103, 126 evaluating artistic development, 116, exaggeration as expressive quality, 79–80, 136 exceptional talent, 87-93, 103 exhibitions, 127

expressive, 15, 40, 79 expressive content of art, 116, 117

fabric crayons, 250 fantasy, 73, 105, 116 felt prints, 191-92 festivals, 265 fibers, 50, 243-58 filmstrips, sources for, 219 finger puppets, 238 flags, 243, 246 flag starters, 153, 154-55 flat-stick puppets, 233 folded-paper puppets, 234-36 fold-over puppets, 235 folk art, 49, 52, 66, 200, 228 form, 26-28, 43 formal balance, 32 found object masks, 229-30 Fowler, Charles, xxii Froebel, Friedrich, 58 frosting glue recipe, 218 fruit and vegetable assemblage, 220

gadget prints, 196 galleries, 58, 126, 127 games for aesthetic and perceptual growth, 58-66 Gardner, Howard, 67 Getty Center, xxii-xxiii gifts, 268 gift wraps, 274 Girard, Alexander, 49 glue, drawing with, 160-61 glue-it-on drawings, 153-56 goals, NAEA, 5 Goertzels, V. and M., 122 graham cracker constructions, 218 greenware, 206 greeting cards, 274–77

handicapped children, 94, 100, 101 hardboard looms, 256 Harris, Rolf, 114 head-feet symbol, 73, 84 hemispheres of the brain (see brain, hemispheres of) heritage (see artistic heritage) holidays, 263, 264 hooked rugs, 259 houses, paper, 226 humor, 114, 115, 179

idea starters, 153 images, 8, 68, 90, 136, 169 imagination, 2, 117 informal balance, 32 insulation tape prints, 192 intaglio, 188 International Museum of Folk Art, 49 interpretation, 39, 40, 41, 168 interpretive skill, 4 IQ, 93, 102, 121 irregular scribbling, 69–76

jewelry, edible, 218 judgment, 4, 14-17, 38, 40, 41

kinesthetic enjoyment, 68, 107 kinesthetic learners, 107 Koestler, Arthur, xx, xxvi

language development, 184 latch hooks, 259–60
Lear, Edward, 115
Learning Stations, 128–32
Learning to Read through the Arts, xix limericks, use of, 115
Lindsay, Zaidee, 95
line, 23–25, 38
line characteristics, 23–24, 25, 38
line direction, 24
line quality, 24
lollipop puppets, 234
looms, weaving, 254, 256
Lowenfeld, Viktor, 76

m-fold puppets, 236 magazines, sources for art, 279 mainstreaming, 94 making paper, 274-77 maskmaking, 228-32 Maslow, Abraham, 1 Match the Paintings Game, 61 Match-It Game, 61 Matching Halves Game, 61 materials, suitable, safe, varied, 124-25 Mayhew, Nancy, 95 melted wax, painting with, 162, 163 mini-celebrations, 267-68 modeled cookies, 219 modeling activities, 199-220 monoprints, 197-98 Mother Goose rhymes, use of, 119 motivations, 41-43, 77, 79, 80, 104, 109, 114-16, 119 muffin-tin melter, 162 Multi-Card games, 61 murals, 13, 15, 78, 156, 182-83, 190, 211-14, 248-49 museums, 44, 101-2, 103, 127

National Art Education Association, xxii, 5-7, 68 negative shapes, 26, 199 non-toxic, 125 non-verbal, 109

oil pastels, 146, 148 Old Masters Game, 62 Ornstein, Robert, xix paint resist, 148 painting, 140–46 papermaking, 274-77 paper masks, 231-32 paper-plate puppets, 234 paper puppets, 233-37 paper weaving, 253 paper weaving, advanced, 254 papier-mâché, 51, 222-23, 225, 239 parades, 265 parents, 122 pass-it-on pictures, 178 paste batik, 150, 151 pasting skills, 173 pattern, 25, 32, 36, 39 peepface, figures, 164, 165 pendants, 208 perception, 7-8, 65, 229, 138 Perceptual Recall Game, 62 perspective, 30, 38 photographs, use of, 106, 107, 167 Piaget, 11 pinch pots, 202-3 pincushions, 271 plates, plastic, 273-74 poems, use of, 114-15 pointillism, 55 polliwog drawings, 75 positive shape, 26, 199 postcard puzzles, 62 potato prints, 113, 190-91 primary colors, 20, 21, 38, 143 principles of art, 32-37, 43 printmaking, 188-98 prints, sources for, 278 problem solving, 11 processions, 265, 266 production, 9-12 proportion, 32, 34, 35, 39, 119 public attitude toward art, xxiii puppet situations, 241-42 puppets, 220, 233-42 puppets, edible, 220 puppets, paper, 233-34 purposes of art, 12, 18

quality art program, xxiv, 5-7 quilt, 247

realism, 15
recipes, 206–8, 216, 217, 218
relief prints, 190, 198
repetition, 32, 39
replicas, sources for, 278
reproductions, sources for, 278
resist techniques, 148
rhythm, 32, 36, 39
Rockefeller, David, Jr., xxii
rolling clay, 202
round paper, 156, 158–59
rubbings, crayon, 179
rug pictures, 258–61
rya knots, 260, 261

sack masks, 230 safety, 124-25 Sagan, Carl, xx, xxvi salt ceramic, 208 salt ceramic on a stick, 240, 241 salt heads, 210 salt sculpture, 211 sand drawings, 160 Schaeffer, Charles, 2 schema, 73-78, 90, 156 schematic years (characteristics), 80 Schwann, Leroy, 102 science and art, 186 scissors, skills in use of, 171-72 Scratchfoam prints, 193 scribbler, communicating with, 71-72 scribbling, 68-73 sculpture, 184, 185-86, 199, 211, 214, 224-25, 232 seasons, 263 secondary colors, 20-21, 38, 143 Secret Guessing Game, 63 See, Touch, Tell Game, 62 seed starters, 153-54 self-portraits, 33, 81, 139, 168 sequential program in art, 6, 7, 67, 132 shades, 20, 21, 23, 38, 44, 144 shape, 26-28, 38, 43 shaped paper, 99, 156-60 shaping activities, 199-232 Silverman, Ron, 4-5 slabs (clay), 202 slurry, 276 smocks, 141 sock puppets, 237 soda-straw weaving, 256 songs, use of, 114 sources for teaching materials, 278-79 space, 30-32, 38 space, classroom, 126 Sparling, J. and M., 71, 72 spatial concepts, 78, 79 special needs, 94-102, 103 Sperry, Roger, xix square paper, 160 stabiles, 224, 225 stages of growth in arts, 67-81 Stations, Art Learning, 129-32 stick puppets, 239-40 stitchery, 250-52 stitches, basic, 250, 251 stocking masks, 231 string starters, 130, 131 strip weaving, 258 stuffed paper-bag puppets, 236-37 stuffed stuff, 247-48 styles, 15, 40, 262 Surrealism, 15, 40, 41 symbolic scribbling, 70 symmetry, 32

tactile dominoes, 63 Take 5!, 113, 119 talent, artistic, 85, 91, 92 tall paper, 150, 151 teacher, role of, 121 tearing paper, 170 Tell-About-It Game, 64 tempera, use of, 140 tempera prints, 198 textbooks, sources for, 278 thematic artwork, 14, 19, 52, 54-56, 66, 90, 97-98, 99, 103, 110, 146, 167, 176, 190, 211 three-dimensional jigsaw puzzles, 64 time for art, 123 tints, 20, 21, 23, 38, 44, 144 tissue-paper collages, 180-81 tongue-depressor puppets, 239 topics, 16-17, 76-77, 87, 90, 98, 157-58, 167, 176, 184, 214, 242, 249, 263-64 torn-paper people, 170, 171 Torrance, E. Paul, 2, 11, 91, 121 Touch and Guess Game, 64 touch pictures, 174 Toward Civilization, xxii transfer prints, 197

unity, 32, 37, 39

value, 22–23, 38
variety, 32, 37, 39
Verbal/Visual Match It Game, 66
videos, sources for, 219
visual imagery, 114
visual literacy, 7, 17
visual memory bank, 105, 114
visual mode of learning, 107
Visual Perception Game, 64
vocabulary, 15–16, 20, 38, 39
Voight, Ralph, 132

wadded paper creatures, 221 warm colors, 20, 21, 149 warming tray, 162, 163 warp, 254, 255 wax resist, 148 weaving, 253-58, 262 weed holders, 272-73 weft, 253, 254, 255 Welch, Audrey, xv-xvi Winzenz, Marilyn, xix Wiseman, Anne, 92 wood frame loom, 256-57 wood scraps and glue, 227-28

yarn starters, 130, 153, 155

zigzag books, 175, 176